el

sm

THE SALERNO
IVORIES

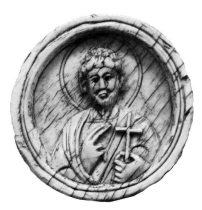

THE SALERNO IVORIES

Ars Sacra from Medieval Amalfi

ROBERT P. BERGMAN

HARVARD UNIVERSITY PRESS
Cambridge, Massachusetts, and London, England
1980

Publication of this book has been aided by a grant from The Millard
Meiss Publication Fund of the College Art Association of America.

MM

Library of Congress Cataloging in Publication Data

Bergman, Robert P 1945–
 The Salerno ivories.

 Bibliography: p.
 Includes index.
 1. Avori salernitani. 2. Ivories, Medieval—
Italy—Salerno. 3. Bible—Illustrations. I. Title.
NK5952.S24B47 736'.6 79-22616
ISBN 0-674-78528-2

PREFACE

Adolph Goldschmidt's magisterial corpus of the medieval ivory carvings of Western Europe was completed more than fifty years ago. In the most meticulous fashion Goldschmidt introduced into the scholarly domain hundreds of works from various countries and provided a framework for studying them that has remained the touchstone of all subsequent work in the field. The corpus was designed to be comprehensive, not to provide detailed analyses of individual objects or groups of objects. This was left to future generations. Yet, though many fine articles on individual ivory objects and a number of splendid catalogues of collections have appeared since then, book-length monographs on the more important groups of ivories have, with one or two notable exceptions, not been published.

In my consideration of the Salerno ivories I have combined a number of different art-historical approaches, and in at least two ways I have proceeded along other than strictly traditional lines. First, I have used the "cyclic" method originally developed for the study of manuscript illumination to analyze a group of narrative reliefs, primarily because this method is helpful in determining the sources used by the carvers of the Salerno ivories. Second, I have tried to integrate my art-historical conclusions into a picture of the ivories' historical and cultural milieu that has not before been drawn in such detail. These methods, I hope, offer a means of understanding the ivories in relation both to the microcosm of the artistic workshop in which they were produced and to the macrocosm of the society in which their makers lived.

I first became acquainted with the cyclic method in seminars offered at Princeton University by Professor Kurt Weitzmann. He suggested that I investigate the Salerno ivories and, eventually, he supervised the Ph.D. thesis of which this book is an outgrowth. My debt to Weitzmann's scholarship will be obvious at many points in the book, but equally important to me was the sense of scholarly continuity that he, Goldschmidt's student and scholarly heir, pro-

vided for my studies. Weitzmann's demanding tutelage has already gained semilegendary status among medievalists, but less widely recognized are his contributions to his students of untold amounts of time, thought, and energy. I am very grateful for the help and encouragement he gave me.

My interest in viewing the Salerno ivories in close connection with their historical setting was heightened by my participation in a seminar—"The History and Art of Monte Cassino"—offered at Harvard University in the spring of 1969 by Professors Ernst Kitzinger and Herbert Bloch. Professor Bloch kindly provided information included in his forthcoming book on Monte Cassino in the Middle Ages that has directly affected certain of my conclusions. Ernst Kitzinger has, in ways both obvious and subtle, made significant contributions to my views on the Salerno ivories and to my work in general.

If it were not for the great generosity and hospitality of Don Arturo Carucci, Canon of the Cathedral of Salerno and Director of the Museo del Duomo, I would not have had such easy access to the ivories. Those many mornings spent talking in his office at the Duomo were of as much help to me as his publications about the ivories and about the history of Salerno.

For assistance and suggestions of various kinds, I am happy to thank the following individuals: Professor Beat Brenk, University of Basel; Msgr. Generoso Crisci, Vicar-General of Salerno; Mr. David Ebitz, University of Maine; Dr. Victor Elbern, Berlin-Dahlem, Staatliche Museen, Preussischer Kulturbesitz; Dr. Danielle Gaborit-Chopin, Musée du Louvre; Dr. William Forsyth and Dr. Charles Little, The Metropolitan Museum of Art; Professor Herbert Kessler, The Johns Hopkins University; Professor Carl Nordenfalk, Stockholm; Professor Else Kai Sass, University of Copenhagen; Professor Gunther Urban, Technischen Hochschule, Aachen; and Mr. Henry Willard. I carried out research in a number of American and European libraries, and I am particularly indebted to Ms. Frederica Oldach, former Head Librarian of Princeton's Marquand Library, Professor Wolfgang Lotz, Director of the Biblioteca Hertziana, and Dr. P. Natella, Assistant Director of the Biblioteca Provinciale di Salerno, for their courtesies and assistance.

My research on the Salerno ivories was conducted with the aid of a Fulbright Fellowship to Rome in 1969–70, a Junior Fellowship at the Dumbarton Oaks Research Library and Collection of Harvard University in 1970–71, several travel grants from Princeton's Committee on Research in the Humanities and Social Sciences, and a sabbatical leave from the Department of Art and Archaeology at Princeton in the spring of 1974. Without the cooperation of my colleagues in Harvard's Department of Fine Arts in freeing me of major administrative duties for two years, the appearance of this book would have been considerably delayed. Publication of this volume was made possible by a subvention from the Millard Meiss Fund of the College Art Association of America.

My editor at Harvard University Press, Nancy Clemente, an ideal blend of sensitivity and severity, improved the text enormously. To all of these individuals and institutions, my thanks.

Finally, I must express my gratitude to my wife, Marcelle, for her forbearance, for her understanding, and for her faithful companionship in travels and circumstances ranging from the sublime to the worst imaginable.

CONTENTS

LIST OF ILLUSTRATIONS

Following Page 150

The Salerno Ivories (Salerno, Museo del Duomo, unless otherwise indicated)

1. Ensemble
2. *The Spirit over the Waters* and *The Separation of Light and Darkness—Creation of the Firmament*
3. *Creation of Plants and Trees—Creation of the Sun, Moon, and Stars*
4a. *Creation of Birds and Fish* (Budapest, Museum of Fine Arts)
4b. *Creation of Animals* (New York, The Metropolitan Museum of Art, gift of J. Pierpont Morgan, 1917)
5. *Creation of Eve—Temptation and Fall*
6. *Expulsion—Adam and Eve at Labor*
7. *Sacrifice of Cain and Abel—Murder of Abel* and *Condemnation of Cain* (Paris, Louvre)
8. *God Commands Noah to Construct the Ark—Construction of the Ark*
9. *God Closes the Door of the Ark—The Dove Returns to the Ark*
10. *God Orders Noah to Leave the Ark—Sacrifice of Noah*
11. *God and Noah Establish the Covenant—Making of Wine*
12. *Nakedness of Noah—The Tower of Babel*
13. *God Commands Abraham to Leave Haran—Sarah and Lot in Abraham's House*
14. *God and Abraham at Sichem—Abraham and Sarah before Pharaoh*
15. *God and Abraham at an Altar* (Berlin-Dahlem, Staatliche Museen, Preussischer Kulturbesitz)
16. *Sacrifice of Isaac—God Blesses Abraham*
17. *Jacob's Dream—Moses at the Burning Bush*
18. *Moses: Miracle of the Serpent—Moses: Miracle of the Withered Hand*
19. *Moses Receiving the Law*
20. *Visitation—Magi before Herod*
21. *Joseph Doubts Mary* and *Joseph's First Dream—Adoration of the Magi*
22. *Journey to Bethlehem—Joseph's Second Dream*
23. *Nativity—Flight into Egypt*
24. *Annunciation to the Shepherds—Massacre of the Innocents*
25. *Presentation—Miracle at Cana*
26. *Baptism—Transfiguration*
27. *Christ Adored by the Angels—Raising of the Widow's Son at Nain*
28. *Calling of Peter and Andrew—Healing of the Dropsical, Blind, and Lame*
29. *Christ and the Samaritan Woman—Resurrection of Lazarus* and *Entry into Jerusalem*
30. *Feeding of the Multitude—Last Supper* and *Washing of the Feet*

SOURCES OF PHOTOGRAPHS

Photographs of works in museums, libraries, and private collections, unless otherwise noted below, were provided by and are reproduced through the courtesy of the individuals and institutions indicated in the list of illustrations. Photographs not credited are the author's.

Alinari/Editorial Photocolor Archives: 49, 55, 61–62, 67, 71, 80, 87, 146, 147
A. Amelli, *Miniature sacre e profane illustranti l'enciclopedia medioevale di Rabano Mauro* (Monte Cassino, 1896): 73, 121
H. Belting, *Die Basilica dei SS. Martiri in Cimitile und ihr frühmittelalterlicher Freskenzyklus* (Wiesbaden, 1962): 122
Bildarchiv Foto Marburg: 119, 150
Osvaldo Böhm, Venice: 64
J. Clédat, in *Bulletin de l'Institut Français d'Archéologie Orientale* 2 (1902): 106
Courtauld Institute of Art: 69, 77–79, 85, 92, 107
Dumbarton Oaks, Center for Byzantine Studies, Washington, D.C.: 48, 50, 52–54, 56, 58–59
Foto Farina, Monza: 108
Fototeca Unione, Biblioteca Hertziana: 89, 123
Frick Art Reference Library: 130
Gabinetto Fotografico Nazionale, Rome: 1–3, 5–6, 8–14, 16–35, 38–44, 139, 149
Hirmir Fotoarchiv München: 125–127, 129, 141, 144
Millstätter Genesis-und Physiologus Handschrift (Cod. Sel. X: Akademische Druck- und Verlaganstalt, Graz, 1967): 88–90
Don Bernardo Mollari, Rome: 152–155
H. Omont, in *Mémoires de la Société Nationale des Antiquaires de France* 53 (1893): 51
A. K. Porter Collection, Fogg Art Museum: 61, 135
T. Velmans, *La tetraévangile de la Laurentienne* (Paris, Editions Klincksieck, 1971): 103
Kurt Weitzmann, Princeton: 101, 111–116, 118, 128, 136, 148, 160–161
J. Wilpert, *Le pitture delle catacombe romane* (Rome, 1903): 45

THE SALERNO
IVORIES

ABBREVIATIONS USED IN THE NOTES AND CATALOGUE

Belting, *Cimitile*

H. Belting, *Die Basilica dei SS. Martiri in Cimitile und ihr frühmittelalterlicher Freskenzyklus,* Forschungen zur Kunstgeschichte und christlichen Archäologie, 5 (Wiesbaden, 1962)

Bergman, "Ivory Carving in Amalfi"

R. Bergman, "A School of Romanesque Ivory Carving in Amalfi," *Metropolitan Museum Journal* 9 (1974): 163–185

Bertaux, *Italie méridionale*

E. Bertaux, *L'art dans l'Italie méridionale* (Paris, 1904)

Carucci, *Avori*

A. Carucci, *Gli avori salernitani del sec. XII,* 2nd ed. (Salerno, 1972)

Demus, *Mosaics*

O. Demus, *The Mosaics of Norman Sicily* (London, 1949)

Goldschmidt, *Elfenbeinskulpturen*

A. Goldschmidt, *Die Elfenbeinskulpturen,* 4 vols. (Berlin, 1914–1926)

Goldschmidt and Weitzmann, *Byz. Elfenbeinskulpturen*

A. Goldschmidt and K. Weitzmann, *Die byzantinischen Elfenbeinskulpturen des X.-XIII Jahrhunderts,* 2 vols. (Berlin, 1930–1934)

Kessler, "Eleventh-Century Ivory Plaque"

H. Kessler, "An Eleventh-Century Ivory Plaque from South Italy and the Cassinese Revival," *Jahrbuch der Berliner Museen* 8 (1966): 67–95

Migne, *PL*

J. P. Migne, *Patrologiae cursus completus. Series latina,* 221 vols. (Paris, 1844–1864)

Morisani, *Affreschi*

O. Morisani, *Gli affreschi di S. Angelo in Formis* (Cava dei Tirreni, 1962)

Weitzmann, "Grado Chair"

K. Weitzmann, "The Ivories of the So-Called Grado Chair," *Dumbarton Oaks Papers* 26 (1972): 45–91

Waetzoldt, *Kopien*

S. Waetzoldt, *Die Kopien des 17. Jahrhunderts nach Mosaiken und Wandmalereien in Rom,* Römische Forschungen der Biblioteca Hertziana, 18 (Munich, 1964)

Wilpert, *Mosaiken und Malereien*

G. Wilpert, *Die römischen Mosaiken und Malereien der kirchlichen Bauten von IV bis XIII Jahrhunderts,* 4 vols. (Freiburg, 1917)

INTRODUCTION

THE EARLY MIDDLE AGES has left us few examples of large and complex works of art in one of its favorite materials, ivory. The largest unified series of carvings in ivory preserved from the pre-Gothic Middle Ages is a group of almost forty major figurative ivories and other secondary plaques, most of which are in the Museo del Duomo in Salerno (Fig. 1). For this reason they are conventionally known as the Salerno ivories. Six panels or fragments of panels are preserved in other museums: *Creation of Birds and Fish* (Fig. 4a), Budapest, Museum of Fine Arts; *Creation of Animals* (Fig. 4b), New York, Metropolitan Museum of Art; *Sacrifice of Cain and Abel—Murder of Abel and Condemnation of Cain* (Fig. 7), Paris, Louvre; *God and Abraham at an Altar* (Fig. 15) and *Christ at Emmaus* (Fig. 36), Berlin-Dahlem, Staatliche Museen, Preussischer Kulturbesitz; *Christ figure* (Fig. 37), a fragment of *Christ Appears at Bethany*, Hamburg, Kunstgewerbe Museum.[1] Comprising cycles drawn from both the Old and New Testaments, this group is important both because of its iconographical scope and density and because of the richness and diversity of its stylistic components. The artistic vitality of the series arises to a great extent out of the artists' attempts to forge from a variety of sources a sequence of carvings possessing an aesthetic and narrative unity. An understanding of the complex issues raised by the ivories should yield valuable insights into the working methods of the medieval artist, the genesis of Italian art, and the relations between Byzantine and Western art during the early Middle Ages.

Although portions of the Salerno series have been destroyed or lost over the centuries, the group is, by and large, remarkably well preserved. Sixteen whole panels (one divided into two halves) and two half panels are preserved representing Old Testament subjects (Figs. 2-19). These measure approximately 10 cm. in height, but their widths vary: the nine panels from *The Spirit over the Waters* and *The Separation of Light and Darkness* (Fig. 2) through the *Sacrifice of Noah* (Fig. 10) are about 22 cm. wide, while the remaining seven Old Testament plaques measure about 24 cm. in width. Two panels—representing *God and Abraham*

1. For measurements and condition of all the ivories and for specific bibliographical references to the panels outside Salerno see the Catalogue.

1

at an Altar (Fig. 14) and *Moses Receiving the Law* (Fig. 19)—are approximately 12 cm. wide by 9 cm. high. These may be fragments of larger panels. Eighteen whole panels and two halves of panels remain depicting New Testament episodes (Figs. 20-39); on the average these measure about 24 cm. high by 12 cm. wide, although there is considerable minor variation in their dimensions. In addition, ten smaller panels, about 6 cm. square (Figs. 40-41), are carved with medallions displaying bust-length figures with halos, clearly the Apostles. Originally these undoubtedly numbered twelve. Three further little squares (Fig. 41), only slightly smaller than the Apostle panels, show half-length figures without halos and dressed in simple tunics. Fourteen fragments of decorative borders showing three different designs—inhabited vine scroll (Fig. 42), rosette and grape cluster (Fig. 43), and cornucopia frieze (Fig. 44) —are preserved in various lengths. The inhabited vine scroll and cornucopia frieze fragments are approximately 7 cm. wide; the rosette and grape cluster fragments have a width of 5.5 cm. Two paired colonnettes with spiral columns (Fig. 44)—one measuring 24 × 2.5 cm., the other 23.5 × 1.75 cm.—complete the complex. These were surely part of the mounting of the group.

Except for a number of major cracks, the condition of the panels is almost uniformly excellent. Occasionally a face is abraded or a hand broken off, but in general the low relief of the figures and accessories has maintained its original profile. The rich golden tan color of the ivories has surely become warmer with age; the years have also lent an attractive craquelure to the smooth ivory surface. There are holes and indentations for mounts on some—but not all —of the plaques. None of these appears original, and so they will not be considered further here.

THE GENERAL ICONOGRAPHIC PROGRAM

The designers of the program of the Salerno ivories were ambitious. They presented in epitomized form sacred history, from the creation of the world until Pentecost. The series commences with the appearance of the Holy Spirit (in the form of a dove) over the waters of an as yet unformed universe (Fig. 2); the epic of Old Testament history then unfolds in a succession of narratives recounting the stories of Creation, Adam and Eve, Cain and Abel, Noah, Abraham, Isaac, Jacob, and Moses. This cycle of scenes devoted to a depiction of the world *ante legem* is appropriately concluded by the representation of *Moses Receiving the Law* (Fig. 19). Christ's life is then presented in scenes that detail his birth, Infancy, Ministry, Passion, Resurrection, and post-Resurrection appearances; originally this cycle must have begun with the *Annunciation,* now lost, illustrative of the moment of Incarnation and, in historical terms, of the beginning of a new era *sub gratia.* The Christological sequence terminates just as the Old Testament series began, with the appearance of the Holy Spirit, in this case its manifestation to the Apostles at Pentecost (Fig. 39). The historical and theological unity of the two Testaments is thus profoundly signified, a notion emphasized by the virtually identical appearance of God the Father in the Old Testament section and Christ in the New Testament portion; only Christ's cruciform nimbus distinguishes the Father from the Son (compare, for example, Figs. 2 and 28).

HISTORY AND TYPOLOGY

The flow of the narrative in the Salerno cycles is primarily linear; that is, events depicted are meant to be read as continuous his-

tory. This is evident both from the broad sweep of the content and from the lack of a thorough-going system of correspondences between themes from the two Testaments. Despite this fact, however, and given the nature of medieval theological speculation concerning the relation-ship of the Old and New Dispensations, it would seem almost impossible for there not to have been some kernel of typological thought behind the juxtaposition of these scriptural cycles. After all, ever since earliest Christian times New Testament events were seen as fore-shadowed, if not prophesied, by those in the Old; this method extends back to the New Tes-tament, to St. Paul, the Epistle to the Hebrews, and to the Gospels themselves.[2] The typological relationship between the Old and New Testa-ments is a generating force in patristic exegesis, both Eastern and Western. The notion is already codified in the famous rhetorical question of St. Augustine: "What is the Old Testament but the New veiled; what is the New Testament but the Old revealed?"[3] This mode of thought was handed down, or filtered through, to the Middle Ages via the writings of Bede, Isidore of Seville, and Hrabanus Maurus, among others.[4] If it was generally true in the Middle Ages that works of classical mythological content were interpreted

in a moralized or Christianized manner, it ap-pears to have been equally true that works of Old Testament historical content tended to be viewed in terms of their broadly typological (Christianized) character.

The Salerno ivories are not typological in the strict sense of the late medieval *Speculum humanae salvationis* or *Biblia pauperum,* where an episode from the New Testament is depicted in the company of two or three types from the Old Testament, side by side.[5] While such specificity of association may occasionally be discovered in extensive early medieval pic-torial cycles, by and large the relationships drawn are more general.[6] In the case of the Sa-lerno ivories (and the whole tradition with which they are associated), for example, it ap-pears that in most instances the representation of a specific Old Testament scene is not intended to allude to some specific event in the New Testament. Instead, a series of images is employed to recount the "biographies" of sev-eral Old Testament figures—Adam, Abel, Noah, Abraham, Isaac, Jacob, and Moses—all of whom were interpreted as types of Christ in medieval exegesis.[7] Even the Creation itself was interpreted by exegetes as prefiguring a "new Creation," namely, the Incarnation.[8]

2. The literature on the subject is vast. L. Goppelt, *Typos: Die typologische Deutung des alten Testaments in Neuen* (Darmstadt, 1939), is still basic. See note 4 below.

3. *De civitate Dei* 16.26 (Migne, *PL,* 41:505): "Quid est enim quod dicitur Testamentum Vetus nisi occultatio Novi? Et quid est aliud dicitur Novum, nisi Veteris rebelatio?"

4. An illuminating introduction to the typological exegesis of the Fathers is Erich Auerbach's "Figura," in *Scenes from the Drama of European Literature* (New York, 1959), pp. 11–76. Basic to any understanding of patristic typology is J. Danielou, *From Shadows to Reality: Studies in the Biblical Typology of the Fathers* (London, 1960), with its extensive references. For the medieval writers in general, see C. Spicq, *Esquisse d'une histoire de l'exégèse latine au Moyen Age* (Paris, 1944), and B. Smalley, *The Study of the Bible in the Middle Ages,* 2nd ed. (Oxford, 1952).

5. For the *Speculum* see J. Lutz and P. Perdrizet, *Speculum humanae salvationis,* 2 vols. (Leipzig, 1907). H. Cornell, *Biblia pauperum* (Stockholm, 1925), remains the basic source for that

family of illustrations, but is now supplemented by G. Schmidt, *Die Armenbibeln des XIV. Jahrhunderts* (Graz, 1959), and E. Sol-tesz, *Biblia pauperum: The Esztergom Blockbook of Forty Leaves* (Budapest, 1967).

6. The fifth-century wooden doors of Santa Sabina in Rome (see J. Weigand, *Des altchristliche Hauptportal an der Kirche des hl. Sabina,* Trier, 1900) juxtapose miracles of Moses with mira-cles of Christ. The *tituli* of Rusticus Helpidius (early sixth cen-tury) describe sixteen scenes having typological relationships (see J. Schlosser, *Quellenbuch zur Kuntgeschichte der abendländis-chen Mittelalters,* Vienna, 1896, pp. 34–36).

7. These typological connections are commonplace in medieval literature; refer to the index of Old Testament figures in Migne, *PL.*

8. This analogy is drawn countless times by early Christian and medieval exegetes; see J. Danielou, *The Bible and the Liturgy* (Notre Dame, 1956), pp. 70–113.

For the most part this rather general approach defined the typological outlook of the Salerno cycles, but in certain cases individual scenes from the Old Testament might have had a more specific typological import. A number of Old Testament reference points were so often repeated in a typological context by medieval theologians that they could not fail to be seen in relation to events from the New Testament and the sacraments. Could the *Sacrifice of Isaac* be viewed without thinking of the *Crucifixion?* Or could the *Spirit over the Waters* or the *Dove Returns to the Ark* be seen without suggesting the *Baptism* or the rite of baptism itself? One would hesitate before suggesting that such typological links were the main generative force behind the Salerno cycles—in the end the ivories remain fundamentally narrative and historical—but they were nevertheless a contributing factor. The overall applicability of typological thinking to the Salerno program is supported by the choice of scenes terminating the two cycles, *Moses Receiving the Law* (Fig. 19) and *Pentecost* (Fig. 39). More than once in the Middle Ages interpreters of scripture viewed the two events as analogous; the descent of the Holy Spirit upon the Apostles was seen as a renewal of God's covenant with Moses.[9]

Among medieval writings one theologian's work stands out as having been conceived in time and place close to the Salerno ivories. The scriptural exegesis of Bruno of Segni, abbot of Monte Cassino shortly after 1100, has as one of its central themes the unity of the two Testaments; indeed, Bruno's whole sense of history is predicated on this idea.[10] As Réginald Gregoire points out in his masterly analysis of Bruno's work, the abbot's exposition of this *historia* is supported and enriched by the use of "allegory."[11] And a reading of Bruno's *Expositio in Pentateuchum*[12] does reveal a remarkable flexibility; while explicating the content of the Old Testament in purely literal, historical fashion, he will suddenly burst into a flurry of typological interpretation. The "veil" described by St. Augustine is lifted at critical points to reveal the future.

The Salerno ivories reflect an attitude toward the relation of the Old and New Testaments similar to that of Bruno of Segni. Although fundamentally conceived as a historical series, the ivories also manifest a generally typological mode of thought, and specific typological references do occasionally appear in the panels. Bruno, in describing the relationship between the two Testaments, compared it to the combined music of the harp and the lyre.[13] The musical metaphor might be even further extended as regards the relationship of the Old and New Testaments both in Bruno's writing and in the Salerno ivories, since the harp and the lyre, while combining their tones in harmony at all times, may at certain moments resolve into chords that are described in musical parlance as "responsive." And just as Bruno of Segni's interpretations of the scriptures are seen as related to an ancient and potent exegetical tradition, so the general program of the Salerno ivories should be recognized as perpetuating a pictorial tradition that was almost equally venerable.

9. St. Augustine, *Epistola 55* (Migne, *PL*, 33:218–219); Isidore of Seville, *De ecclesiasticis officiis* (Migne, *PL*, 83:768); Bruno of Segni, *Expositio in Exodum* (Migne, *PL*, 164:275).
10. R. Gregoire, *Bruno de Segni, exégète médiéval et théologien monastique* (Spoleto, 1965), pp. 153–155.

11. Ibid., p. 192.
12. Migne, *PL*, 164:147–148.
13. *Expositio in Psalmos* (Migne, *PL*, 164:903).

THE PICTORIAL TRADITION BEHIND THE PROGRAM

Visual juxtapositions of events from the Old and New Testaments were made as early as the catacombs and sarcophagi of the third and fourth centuries. In keeping with their mortuary functions, these were generally devoted to expressions of hope for a coming salvation or resurrection. For instance, on a wall in the catacomb of the Vigna Massimo in Rome (Fig. 45)[14] are interspersed a number of Old Testament episodes (*Noah in the Ark, Moses Striking the Rock, Daniel in the Lion's Den, Tobias and the Fish*) and New Testament scenes (*Healing of the Paralytic, Raising of Lazarus, Adoration of the Magi, Multiplication of Loaves*). Despite allusions to the Incarnation and to the Eucharist, the main promise of the whole is one of salvation, and it is to this theme that programmatic juxtapositions of Old and New Testament scenes were dedicated until c. 400.[15]

In the early fifth century the pictorial conjunction of the two Testaments began to be employed in the decoration of basilicas in Rome and elsewhere. Still extant, though in less than pristine condition, are the mosaics of Santa Maria Maggiore in Rome, executed during the pontificate of Sixtus III (432–440).[16] Here the mosaic panels in the nave depict the stories of Abraham, Isaac, Jacob, Moses, and Joshua, while the triumphal arch, in a literal and figurative sense the culmination of the program, displays scenes of the Incarnation and Christ's childhood. The emphasis of the program lies in its detailing of the lives of Old Testament patriarchs who prefigure Christ; the small Christological cycle exists as a necessary dogmatic conclusion of the program rather than as a logical continuation of the narrative.

An even more far-reaching historical conception of the two-Testament configuration may also be found in early Christian times, but unfortunately not among the extant monuments. This lack of preserved examples is, however, counterbalanced by a wealth of literary testimony; the *Dittochaeon* of Prudentius, the *Carmine* of Paulinus of Nola, and the Ambrosian *tituli* from Milan (all c. 400)[17] suggest that in the early fifth-century programs at least as comprehensive in scope as the Salerno ivories' scheme had considerable popularity. Far more important for the present inquiry, though, is the probability that already by the middle of the fifth century the nave walls of the great basilica of St. Peter in Rome (Old St. Peter's) displayed counterpoised cycles of scenes from the two Testaments. The major evidence for these fresco cycles, each of which occupied approximately forty separate picture fields, consists of several very precious early seventeenth-century drawings by Jacopo Grimaldi now preserved in two Vatican manu-

14. J. Wilpert, *Le pitture della catacombe romane* (Rome, 1903), pl. 212.

15. For the catacombs in general, see ibid.; for the sarcophagi, see J. Wilpert, *I sarcophagi cristiani*, 5 vols. (Rome, 1929–1932), passim. For succinct comments on the meaning of these catacomb and sarcophagi programs, see C. R. Morey, *Early Christian Art*, 2nd ed. (Princeton, 1953), pp. 60–68; and A. Grabar, *Christian Iconography: A Study of Its Origins* (Princeton, 1968), pp. 12–30.

16. See C. Cecchelli, *I mosaici della basilica di S. Maria Maggiore* (Turin, 1956); H. Karpp, *Die frühchristlichen und mittelalterlichen Mosaiken in Santa Maria Maggiore zu Rom* (Baden-Baden, 1966); and B. Brenk, *Die frühchristlichen Mosaiken in Santa Maria Maggiore zu Rom* (Wiesbaden, 1975).

17. For the Prudentius text, see Schlosser, *Quellenbuch*, pp. 3–10; see also J. P. Kirsch, "Le Dittochaeum de Prudence et les monuments de l'antiquité chrétienne," in *Atti del II congresso internazionale di archeologia cristiana* (Rome, 1902), p. 127. Paulinus' *Carmine* 28 is reproduced in Schlosser, *Quellenbuch*, pp. 26–29; and with an English translation and commentary in R. Goldschmidt, *Paulinus' Churches at Nola* (Amsterdam, 1940), p. 81. The Milanese *tituli* are published in S. Merkle, "Die ambrosianischen Tituli," *Römische Quartalschrift* 10 (1896):185–222. See also E. Steinmann, *Die Tituli und die kirchliche Wandmalerei in Abendlande* (Leipzig, 1892).

scripts (see Figs. 46, 47).[18] These sketches were made during the period when the old church was gradually being demolished to make way for the present building. They record only fragments of the original architecture and decoration; only eleven intercolumniations of the nave arcade remained on each side, half the original number. Above the architraves, twenty-two picture fields were visible on the Old Testament wall, of which fourteen retained discernible compositions. The Old Testament sequence must originally have depicted scenes of Creation, Adam and Eve, Cain and Abel, Noah, Abraham, Isaac, Jacob, Joseph, and Moses. Nineteen picture fields were extant on the New Testament wall, of which five preserved recognizable remnants of their contents. Despite this scanty evidence, we can be sure that in the approximately forty frames originally provided, Christ's life was comprehensively illustrated. Such a program, depicting what might be called "universal sacred history," is a very specific scheme within the broader group of works that present Old Testament–New Testament "harmonies."

The iconography of the New Testament section at Old St. Peter's appears to reflect one of the medieval restorations of the frescoes, but the remains of the Old Testament cycle relate closely to the drawings based on the destroyed frescoes of San Paolo fuori le mura. These drawings, contained in yet another Vatican manuscript, were commissioned in 1634 by Cardinal Francesco Barberini.[19] The San Paolo Old Testament cycle, itself restored toward the end of the thirteenth century by Pietro Cavallini, surely originated in the fifth century.[20] The San Paolo frescoes help us to imagine what appeared in the lost portions of the cycle at Old St. Peter's. Among the Old Testament scenes at St. Peter's only episodes concerning Noah, Abraham, Isaac, Jacob, and Moses have been preserved in the drawings. The San Paolo cycle suggests that the eleven missing picture fields preceding Noah in Old St. Peter's depicted Creation, Adam and Eve, and Cain and Abel, while the eleven that came before the Mosaic plague sequence showed further episodes from the Jacob and Moses stories and scenes from the life of Joseph.

Some scholars have dated both the Old St. Peter's and San Paolo frescoes during the pontificate of Leo I (440–461), while others, accepting this date for the San Paolo frescoes, have tended to attribute the Old St. Peter's paintings to the time of Pope Formosus (891–896), when work is known to have been done on that church.[21] In addition to the striking parallels with the San Paolo drawings, three other factors support the earlier date for the Old St. Peter's frescoes: (1) the term used to describe Formosus' activity in the church is *renovavit*, a word that clearly does not denote a new or original creation; (2) the pontificate of Formosus is a logical time for a restoration because it follows by not many years the devastation of the church by the Sara-

18. Fig. 46 is from Archivio San Pietro, Album, fol. 13; and Fig. 47 is from Vatican Library, cod. Barb. lat. 2733, fol. 114. See Wilpert, *Mosaiken und Malereien*, 1:376–388; and Waetzoldt, *Kopien*, pp. 69–71, nos. 931–934, figs. 484–485a.

19. Vatican Library, cod. lat. 4406, fols. 23–60. See Wilpert, *Mosaiken und Malereien*, 2:565–626; and Waetzoldt, *Kopien*, pp. 56–58, nos. 590–627, figs. 328–365.

20. On the question of Cavallini's restoration and its relation to the preexisting frescoes, see J. White, "Cavallini and the Lost Frescoes in S. Paolo," *Journal of the Warburg and Courtauld In-*

stitutes 19 (1956):84–95; J. Gardner, "S. Paolo fuori le mura, Nicholas III, and Pietro Cavallini," *Zeitschrift für Kunstgeschichte* 34 (1971):240–248; and G. Matthiae, *Pietro Cavallini* (Rome, 1972), pp. 39–52.

21. J. Garber, *Wirkungen der frühchristlichen Gemäldezyklen der alten Peters- und Pauls-Basiliken in Rom* (Berlin, 1918), p. 59, dates both cycles to the time of Leo I; Waetzoldt, *Kopien*, p. 70, and G. Matthiae, *La pittura romana*, vol. 1 (Rome, 1966), pp. 57–58, suggest Formosus' pontificate as the time of origin for the Old St. Peter's cycles.

cens in 846; and (3) the frescoes in the aisles of Santa Maria Antiqua (see note 6 to Chapter 1) may have been inspired by those in Old St. Peter's; their date in the early ninth century (at the latest) indicates a date before the pontificate of Formosus for the Old St. Peter's frescoes.

The question of when the Old St. Peter's frescoes were first conceived, though important for understanding the history of the program in general, is not critical to the relationship between them and the later medieval programs (including that of the Salerno ivories) discussed in this Introduction. In the eleventh and twelfth centuries the Old Testament–New Testament nave decoration of Old St. Peter's must have been relatively intact; for that age the program, regardless of its actual date, must have defined the decorative mode of the interior of the early Christian church.

In the early Middle Ages comprehensive programs like that in Old St. Peter's appeared sporadically—for example, in the frescoes of Santa Maria Antiqua in Rome mentioned above,[22] in those of the ninth century at the palace church in Ingelheim,[23] and in those of the early eleventh century in the Cathedral of Mainz.[24] Then the program reached a new apogee of influence in Italy, particularly from Rome southward, from the late eleventh century through the thirteenth century. Beginning with the destroyed atrium frescoes of the Desiderian basilica at Monte Cassino dedicated on October 1, 1071, the scheme became a primary mode of decoration for Italian churches for the next two hundred years or more.[25] Sant'Angelo in Formis,[26] the Cathedral of Atina,[27] San Pietro in Ferentillo,[28] San Pietro in Marcellina,[29] San Giovanni a Porta Latina in Rome,[30] the Cappella Palatina in Palermo[31] and the Cathedral of Monreale,[32] Santa Maria di Ronzano at Castel Castagna,[33] Santa Maria ad Cryptas in Fossa,[34] Santa Cecilia in Trastevere in Rome,[35] Santa Maria in Vescovio in Sabina,[36] the Baptistery in Florence,[37] San Nicola in Castro dei Volsci,[38]

22. See Wilpert, *Mosaiken und Malereien,* 2:653–726. Garber, *Gemäldezyklen,* pp. 28–29, places them in the pontificate of Nicolas I (858–867), while E. Kitzinger, *Römische Malerei des 7. bis zur Mitte des 8. Jahrhunderts* (Munich, 1934), p. 33, dates them to the time of Hadrian I (772–795). P. Romanelli and P. J. Nordhagen, *S. Maria Antiqua* (Rome, 1964), p. 62, put them in the reign of Paul I (757–767).

23. See Schlosser, *Quellenbuch,* pp. 126–129. C. Davis-Weyer, *Early Medieval Art* (Englewood Cliffs, N. J., 1971), p. 84, provides an English translation.

24. Schlosser, *Quellenbuch,* pp. 158–181.

25. N. Acocella, *La decorazione pittorica di Montecassino dalle didascalie di Alfano I (sec. xi)* (Salerno, 1966).

26. See, most recently, J. Wettstein, *Sant'Angelo in Formis et la peinture médiévale en Campanie* (Geneva, 1960); Morisani, *Affreschi;* A. Moppert-Schmidt, *Die Fresken von S. Angelo in Formis* (Zurich, 1967); and O. Demus, *Romanesque Mural Painting,* trans. M. Wittall (New York, 1970), pp. 294–297.

27. Bertaux, *Italie méridionale,* p. 253. The decoration is dated 1087–1099.

28. A. Schmarsow, "Romanische Wandgemälde der Abteikirche S. Pietro bei Ferentillo," *Repertorium für Kunstwissenschaft* 28 (1905):391–405; E. Wüscher-Becchi, "Sopra un ciclo di affreschi del Vecchio e Nuovo Testamento nella Badia di S. Pietro presso Ferentillo," *Dissertazioni della Pontificia Accademia Romana di Archeologia* 2nd ser. 9 (1907):197–222; and Demus, *Romanesque Mural Painting,* p. 302.

29. G. Matthiae, "Les fresques de Marcellina," *Cahiers Archéologiques* 6 (1952):71–81; idem, *Pittura romana,* 2:pl. 116.

30. Wilpert, *Mosaiken und Malereien,* 4:pls. 252–255; P. Styger, "La decorazione a fresco del sec. XII della chiesa di S. Giovanni ante portam Latinum," *Studi romani* 2 (1914):261–322; and Matthiae, *Pittura romana,* 2:102–119.

31. Demus, *Mosaics,* pp. 25–72, 245–294.

32. Ibid., pp. 91–177, 245–294; and E. Kitzinger, *The Mosaics of Monreale* (Palermo, 1960).

33. Garber, *Gemäldezyklen,* p. 42; and G. Matthiae, *Pittura medioevale abruzzese* (Milan, 1969), pp. 17–26.

34. Garber, *Gemäldezyklen,* p. 42; and Matthiae, *Pittura medioevale abruzzese,* pp. 45–64.

35. Garber, *Gemäldezyklen,* p. 48; and G. Matthiae, *Pietro Cavallini* (Milan, 1969), pp. 89–99.

36. R. van Marle, "Gli affreschi del duecento in Santa Maria in Vescovio, Cattedrale della Sabina, e Pietro Cavallini," *Bollettino d'arte* 7 (1927):3–30.

37. E. W. Anthony, *Early Florentine Architecture and Decoration* (Cambridge, Mass., 1927); and A. DeWitt, *I mosaici del battistero di Firenze,* vol. 4 (Florence, 1957).

38. A. Marabottini, "Affreschi del XIII secolo a Castro dei Volschi," *Commentari* 6 (1955):3–17.

and San Francesco in Assisi[39] are the most prominent examples of a tradition that was to influence the creations of the Quattrocento masters and Michelangelo in the Sistine Chapel, and the frescoes of the Raphael school in the Vatican Logge.[40] No two of these examples are identical in the number or choice of scenes represented, nor is there perfect correspondence in the iconography of each individual scene. Yet the idea of representing sacred history in juxtaposed cycles that reach from the Creation through the Era of Grace is constant, and the individual iconographic parallels are frequent and close enough to indicate that these monuments arise from a common tradition.

The tenacity of this tradition suggests the existence of a venerable prototype. The nave decoration of Old St. Peter's has been cited more than once as the probable prototype, and with good reason.[41] As the site of Peter's tomb, the church was the central shrine of Western Christendom, an object of the most holy veneration and of constant pilgrimages throughout the Middle Ages. Its association with the "Prince of the Apostles," with Constantine, and with the golden age of the early Christian Church lend it such authority and importance that one would be surprised were it not to have engendered a tradition. We know that its architectural form was revived more than once during the Middle Ages; most important for study of the Salerno ivories, it was taken as the model for Desiderius' new basilica at Monte Cassino.[42] With Monte Cassino acting as the intermediary, the type became remarkably widespread in southern Italy from the eleventh century onward. The Cathedral of Salerno, for which the ivories were presumably made, was itself an architectural derivative of Monte Cassino and thus, indirectly, of Old St. Peter's.[43] Furthermore, we know that at least one other part of the pictorial decoration of Old St. Peter's—the Dugento frescoes in the portico illustrating the life of St. Peter—was copied during the Middle

39. B. Kleinschmidt, *Die Wandmalereien der Basilika San Francesco in Assisi* (Berlin, 1930); P. Toesca, *Gli affreschi dell'Antico e del Nuovo Testamento nel santuario di Assisi,* (Florence, 1947); J. White, *Art and Architecture in Italy, 1250–1400* (Baltimore, 1966), pp. 132–136; and, most recently, H. Belting, *Die Oberkirche von San Francesco in Assisi* (Berlin, 1977), pp. 68–72, 93.

40. See L. Ettlinger, *The Sistine Chapel before Michelangelo* (Oxford, 1965). C. de Tolnay, *Michelangelo,* vol. 2, *The Sistine Ceiling* (Princeton, 1947), p. 20, suggests, without going into detail, that in completing the preexisting decoration of the Sistine Chapel with a Genesis cycle, Michelangelo was emulating Old St. Peter's. F. Hartt, "Lignum Vitae in Medio Paradisio: The Stanza d'Eliodoro and the Sistine Ceiling," *Art Bulletin* 32 (1950):181–232, offers a typological interpretation of the Genesis frescoes. The Raphael school frescoes in the Vatican Logge (the so-called Bible of Raphael) have yet to receive the comprehensive treatment that they deserve. C. G. Stridbeck, *Raphael Studies,* vol. 2, *Raphael and Tradition* (Stockholm, 1963), hints at their early Christian connections in a work that deals primarily with Raphael's tapestries for the Sistine Chapel, themselves heavily influenced by early Christian models. Most recently, N. Dacos, "La Bible de Raphael," *Paragone* 22 (1971):11–36, has mentioned the debt these frescoes owe to an old tradition.

41. Both Garber (*Gemäldezyklen,* passium) and Demus (*Mosaics,* pp. 205–209) traced this tradition back to Old St. Peter's. I have added a number of monuments to their lists.

42. H. M. Willard and K. J. Conant, "A Project for the Graphic Reconstruction of the Romanesque Abbey at Monte Cassino," *Speculum* 10 (1935): 144–146; E. Scaccia-Scarafoni, "Note su fabbriche ed opere d'arte medioevale a Monte Cassino," *Bollettino d'arte* 30 (1936):97–121; and A. Pantoni, *Le vicende della basilica di Montescassino* (Monte Cassino, 1973). For the earlier revival of the form, see R. Krautheimer, "The Carolingian Revival of Early Christian Architecture," *Art Bulletin* 24 (1942):1–38 (reprinted in idem, *Studies in Early Christian, Medieval, and Renaissance Art,* New York, 1969, pp. 203–256.

43. G. Chierici, "Il Duomo di Salerno e la chiesa di Monte Cassino," *Rassegna storica salernitana* 1 (1937):95–109; and A. Schiavo, "Montecassino e Salerno, affinità stilistiche tra la chiesa cassinese di Desiderio e quella salernitana di Alfano I," in *Atti del II convegno nazionale di storia dell'architettura* (Rome, 1937), pp. 159–176. On the influence of the Cassinese basilica in general, see R. Krautheimer, "San Nicola in Bari und die apulische Architectur des 12. Jahrhunderts," *Wiener Jahrbuch für Kunstgeschichte* 9 (1934):16–18; and H. Thümmler, "Die Baukunst des 11. Jahrhunderts in Italien," *Römische Jahrbuch für Kunstgeschichte* 3 (1939):210–216.

Ages.[44] Thus the persistence of the Old St. Peter's tradition is affirmed in both art and architecture.

It would not be accurate to describe the series of derivatives of the Old Testament–New Testament program at Old St. Peter's as "copies" of these frescoes, at least not in terms of our contemporary use of the word. Yet the connections between these later examples of the program and the early Christian prototype are surely profound enough to indicate a "model-copy" relationship of that peculiarly medieval variety so brilliantly described with regard to architecture by Richard Krautheimer.[45] In the case of Krautheimer's architectural examples, if certain salient characteristics of the prototype appear in the copy, then it may serve as a "figure" of the model, practically its reembodiment. In the case of the iconographical program of the Salerno ivories and the other Italian monuments, the salient characteristics —juxtaposition of cycles that begin with Creation and encompass much of Old and New Testament history, as well as numerous specific iconographical details—can be taken as an indication of the profound impact of the prototype, if not of its evocation.

Recognition of the nature of this tradition

of juxtaposed Old and New Testament cycles illustrating universal sacred history helps explain why the Salerno ivories are the unique example of this program in the medium of ivory carving, and in virtually all of the smaller-scale media of the Middle Ages: it was primarily a monumental decorative scheme with a public, didactic function.[46] Only the creators of the Salerno ivories took on the challenge of adapting this scheme to a minature scale. Employment of this Old Testament–New Testament scheme in the Salerno ivories places them in the midst of a revival of the program that manifested itself in central and southern Italy from the late eleventh through the thirteenth centuries. Long ago Otto Demus suggested that Monte Cassino was the important link between this derivative tradition and Old St. Peter's.[47] According to Demus, the scheme was disseminated from the mother house of Benedictinism, a theory supported by the Benedictine connections of many of the churches that display the program. The spread of the Old Testament–New Testament arrangement, then, parallels the south Italian revival of the architecture of Old St. Peter's. In the case of the Salerno ivories this theory of the pivotal role of Monte Cassino is particularly appropriate, for if the panels were executed for the

44. The now largely destroyed Dugento frescoes were copied not only in the frescoes of S. Piero a Grado near Pisa (P. D'Achiardi, "Gli affreschi di S. Piero a Grado presso Pisa e quelli già esistenti nel portico della Basilica Vaticana," in *Atti del congresso internazionale di scienze storiche*, vol. 7, pt. 4, Rome, 1905, pp. 193–285; and Waetzoldt, *Kopien*, pp. 66–67, nos. 862–883, figs. 465–472), but also in the embroidered antependium made for the Cathedral of Anagni in the late thirteenth century (C. Bertelli, "Opus romanum," in *Kunsthistorisches Forschungen Otto Pächt*, ed. A. Rosenauer and G. Weber, Salzburg, 1972, pp. 105–117). The frescoes at Old St. Peter's, of which some fragments are preserved, have recently been attributed to one of the painters who worked in the north transept of the Upper Church at Assisi by I. Hueck, "Der Maler der Apostelszenen im Atrium von Alt St. Peter," *Mitteilungen des Kunsthistorischen Institut in Florenz* 14 (1969–70):115–144.

45. R. Krautheimer, "Introduction to an 'Iconography of Medieval Architecture,'" *Journal of the Warburg and Courtauld Institutes* 5 (1942):1–33 (reprinted in idem, *Studies*, pp. 115–150).

46. The only possible exception is the program of the bronze doors at Hildesheim (early eleventh century), which begins with the *Creation of Eve* (see R. Wesenburg, *Bernwardische Plastik*, Berlin, 1955, pp. 65–116). However, the doors can hardly be considered small in scale; nor is their decoration nearly as comprehensive as that of the Salerno ivories.

47. Demus, *Mosaics*, pp. 206–209. As far as I know, Amatus of Monte Cassino's statement concerning the influence of the abbey's new church and its decoration has been noticed only by H. Bloch, "Monte Cassino, Byzantium, and the West in the Earlier Middle Ages," *Dumbarton Oaks Papers* 3 (1946):196n102.

Duomo at Salerno during the episcopate of Alfanus I (1058–1085), as I believe they were, then they were made for the very man who composed the *tituli* that accompanied the Old and New Testament frescoes painted in the atrium of the basilica at Monte Cassino.[48] There is no doubt that before the execution of the Salerno ivories Alfanus had already been intimately connected with the conception of a similar cycle at Desiderius' Monte Cassino.

The following three chapters consider how the creators of the Salerno ivories realized this general program. Chapters 1 and 2 concern problems of iconography, concentrating on the question of sources. Only after the character of the "models" used by the ivory carvers has been determined can the analysis of the ivories' style (along with considerations of date and place of origin) in Chapter 3 proceed on solid ground. In Chapter 4 I have attempted to reconstruct the original arrangement of the panels; Chapter 5 provides a view of the ivories in relation to their political and cultural context. A catalogue is appended in which the Salerno panels and their relatives are brought together for the convenience of the reader who seeks an overall view of the production of the workshop that created the Salerno ivories.

48. Acocella, *La decorazione pittorica,* passim. For Alfanus' life and work see idem, "La figura e l'opera di Alfano I di Salerno," *Rassegna storica salernitana* 19 (1958):1–24; and A. Lentini and F. Avagliano, *I carmi di Alfano, I* (Monte Cassino, 1974).

1. THE ICONOGRAPHY
OF THE OLD TESTAMENT

THE AIM of my iconographical investigation of the Salerno Old and New Testament cycles is twofold: to provide a secure and precise identification for each of the scenes represented (and in this way to facilitate the ordering of the plaques) and, on a broader level, to discover the nature of the sources that lie behind the Salerno cycles. Isolation of the sources available to the ivory carvers is the first step toward recognition and reconstruction of the historical process through which the ivories came into being. This inquiry should produce an outcome as relevant to aesthetic assessment of the ivories as to their historical place, because one can never hope to understand the contribution of the carvers who made the ivories until one is aware of the models that were at their disposal. Recognition of their sources, then, brings not only an understanding of cultural interplay but also the possibility of a truer assessment of the artists' creativity.[1]

The following analysis of the Salerno ivories' Old Testament cycle proceeds to a great extent on a methodological foundation developed for the investigation of the sources and nature of Old Testament manuscript illumination.[2] Largely formulated by Kurt Weitzmann, this method, the "cyclic" approach, emphasizes the transmission of narrative illustration in cycles and the recognition of "families" of cycles. The cyclic method is appropriate here because the extent and character of the Salerno cycle, its discursiveness and density, indicate its ultimate derivation from a manuscript source. In other words, the Old Testament cycle at Salerno, despite the fact that it is executed in the medium of relief carving in ivory, and despite whatever intermediate sources might have intervened, was first developed in the context of the illuminated manuscript.

Two traditions of Old Testament illustration that have been isolated through the cyclic method are of particular importance for study of the Salerno ivories. The first of these is the Cot-

1. The iconographical analyses in these first two chapters therefore properly precede the stylistic discussion in Chapter 3.

2. See, in particular, K. Weitzmann, *Illustrations in Roll and Codex* (Princeton, 1947) (2nd ed., 1970), passim; idem, "Die Illustration der Septuaginta," *Münchner Jahrbuch der bildenden Kunst* 3/4 (1952–53):96–120 (reprinted in translation in idem, *Studies in Classical and Byzantine Manuscript Illumination*, ed.

H. Kessler, Chicago, 1971, pp. 45–75); idem, "Observations on the Cotton Genesis Fragments," *Late Classical and Mediaeval Studies in Honor of Albert Mathias Friend, Jr.*, ed. K. Weitzmann (Princeton, 1955), pp. 112–131; idem, "Zur Frage des Einflusses jüdischer Bilderquellen auf die Illustration des Alten Testamentes," *Mullus: Festschrift Theodor Klauser* (Munich, 1964), pp. 401–415 (reprinted in translation in *Studies*, pp. 76–95).

ton Genesis recension, named after the fifth- or sixth-century Greek manuscript that is its earliest representative (London, British Library, cod. Cotton Otho B IV). Unfortunately, the manuscript was almost totally destroyed by fire during the eighteenth century and is today a mass of charred fragments. Aside from these remnants, some engravings made of them soon after the fire, and watercolor copies of two of the miniatures made before the fire, the most important evidence for the original appearance of the manuscript's more than three hundred miniatures (we learn of the number from collations made both before and after the fire) is the Genesis cycle represented in the thirteenth-century atrium mosaics of San Marco in Venice. Although the mosaics, which perhaps were copied from the Cotton Genesis manuscript itself, depict less than half the number of scenes illustrated in the manuscript and although omissions and changes have occurred

between the miniature and monumental formats, the mosaics do preserve the greatest number of scenes from the Cotton Genesis recension.[3]

Other members of this pictorial family to which I will refer—usually where a scene is lacking in the San Marco mosaics—are: (1) the Millstatt Genesis (Klagenfurt, Museum, cod. VI, 19), a twelfth-century manuscript of a German vernacular poem that illustrates its text with biblical scenes;[4] (2) the *Hortus deliciarum* (destroyed), a famous late twelfth-century compendium of knowledge and behavior formulated by the Alsacian abbess Herrad of Landsberg for the edification of her nuns, which derives its myriad illustrations from a multiplicity of sources and whose Genesis cycle has been shown to belong, at least in part, to the Cotton Genesis recension;[5] and (3) the Carolingian bibles of Tours (ninth century), whose Genesis frontispieces are abbreviations of a more extensive cycle of the

3. The watercolors by Daniel Rabel were first published by II. Omont in "Fragments du manuscrit de la genèse de R. Cotton, conservés parmi les papiers de Peiresc," *Mémoires de la Société Nationale des Antiquaires de France* 53 (1893):163–172. The engravings based on the fragments are in *Vetusta monumenta rerum Brittannicarum*, vol. 1 (London, 1787), pls. 66–68, and are reprinted in R. Garrucci, *Storia dell'arte cristiana*, vol. 3 (Prato, 1876), pls. 124–125. In addition to the publications listed in note 2, of primary importance for the study of the Cotton Genesis manuscript and the associated tradition of Genesis illustration are: J. J. Tikkanen, "Die Genesismosaiken von San Marco in Venedig und ihr Verhältnis zu den Miniaturen der Cottenbibel," *Acta societatis scientiarium Fennicae* 17 (1891):205–358; W. R. Lethaby, "The Painted Book of Genesis in the British Museum," *Archaeological Journal* 69 (1912):88–111; K. Weitzmann, "The Mosaics of San Marco and the Cotton Genesis," in *Venezia e l'europa*, Atti del XVIII congresso internazionale di storia dell'arte (Venice, 1956), pp. 152–153; G. Bonner, "The Cotton Genesis," *British Museum Quarterly* 26 (1962):22–26; H. Voss, *Studien zur illustrierten Millstätter Genesis und Physiologus Handschrift* (Graz, 1962); S. Tsuji, "Un essai d'identification des sujets des miniatures fragmentaires de la Genèse de Cotton," *Bijutsushi: Journal of the Japan Art History Society* 17 (1967):35–94 (In Japanese, with a short summary in French); idem, "La chaire de Maximien, la Genèse de Cotton et les mosaïques de Saint-Marc a Venise," in *Synthronon* (Paris, 1968), pp. 43–51; idem, "Nouvelles observations sur les miniatures fragmentaires de la Genèse de Cotton: Cycles de Lot, d'Abraham et de Jacob," *Cahiers Archéologiques* 29 (1970):29–46; H. Kessler, "Hic Homo Formatur: The

Genesis Frontispieces of the Carolingian Bibles," *Art Bulletin* 52 (1971):143–160; K. Koshi, *Die Genesisminiaturen in der Wiener "Histoire universelle"* (Vienna, 1973); idem, "Der Adam-und-Eva Zyklus in der sogenannten Cottongenesis-Rezension: eine Übersicht über mögliche Mitgleider der verzweigten Cottongenesis-Familie," *Bulletin Annuel du Musée National d'Art Occidental* (Tokyo) 9 (1975):46–87; H. Kessler, *The Illustrated Bibles from Tours*, Studies in Manuscript Illumination, 7 (Princeton, 1977).

Kurt Weitzmann has generously allowed me access to his unpublished collation and reconstruction of the Cotton Genesis manuscript.

4. Weitzmann, *Roll and Codex*, pp. 139–141; H. Menhardt, "Die Bilder der Millstätter Genesis und ihre Verwandten," in *Beiträge zur älteren europäischen Kulturgeschichte: Festschrift für Rudolf Egger*, vol. 3, ed. G. Moro (Klagenfurt, 1954), pp. 248–371; and Voss, *Studien*, passim. Menhardt's attempts to connect the Millstatt Genesis with the Octateuchs rather than with the Cotton Genesis recension have been refuted by Voss. A facsimile edition of the manuscript, edited by A. Kracher, has been published: *Millstätter Genesis- und Physiologus-Handschrift*, Codices selecti, B, X (Graz, 1970).

5. R. Green, in "The Adam and Eve Cycles in the Hortus deliciarum," in *Late Classical and Mediaeval Studies in Honor of Albert Mathias Friend, Jr.*, ed. K. Weitzmann, (Princeton, 1955), pp. 340–347, demonstrated the connection between the Adam and Eve scenes in the *Hortus* and the Cotton Genesis recension. Until Green's reconstruction of this destroyed manuscript is published, one must consult A. Straub and G. Keller, *Herrade de Landsberg, Hortus deliciarum* (Strasbourg, 1879–1899).

Cotton Genesis type.[6] The destroyed frescoes of San Paolo fuori le mura in Rome, known only from the seventeenth-century drawings preserved in the Vatican (cod. Barb. lat. 4406), have also been related to the Cotton Genesis recension. This cycle, later restored by Pietro Cavallini, is surely early Christian in origin, and although it does relate to the Cotton Genesis tradition in certain repects, it differs in ways too significant to allow it to be designated simply as another member of that recension. Yet even though its affiliations remain less than fully disclosed, the San Paolo cycle will be of considerable importance to this inquiry.[7]

The second iconographic tradition pertinent to this investigation is represented by the Middle Byzantine Octateuch manuscripts.[8] Six of these manuscripts are known, and although

the earliest dates from the eleventh century, it has been demonstrated that the origins of the tradition go back to early Christian times. Where the Cotton Genesis recension had its impact primarily or even exclusively in the Latin West (despite its probable Greek origin), the Octateuch tradition, from the preserved evidence, appears to have been the most potent Old Testament pictorial tradition in Byzantium.

Two other manuscripts will be of primary importance in this investigation, neither of which has yet been adequately integrated into the overall history of Old Testament narrative pictorialization. Both manuscripts are English and both date from the early eleventh century. The first contains the text of the Old Testament poems of Caedmon (Oxford, Bodleian Library, Junius 11),[9] and the second preserves Aelfric's

6. Bamberg Bible (Bamberg, Staatliche Bibliothek, cod. msc. Bibl. 1[A.1.5], fol. 7v); Grandval Bible (British Library, cod. Add. 10546, fol. 5v); Vivien Bible (Bibliothèque nationale, cod. lat. 1, fol. 10v); San Paolo Bible (San Paolo fuori le mura, Rome, Bible, fol. 7v). The standard reference for the Tours manuscripts is W. Köhler, *Die karolingischen Miniaturen 1: Die Schule von Tours*, 3 vols. (Berlin, 1933). This must now be supplemented with Kessler's *Bibles from Tours*. Kessler's study of the character and origins of the Genesis frontispieces requires a radical revision of Köhler's theories.

7. The San Paolo frescoes originated in the fifth century and have maintained a good deal of their early iconography in later restorations. I view the Creator on the globe here as elsewhere as a variant of the Salerno type of the standing Creator, although I am not sure whether this variant was of early Christian or later medieval invention; see Kessler, "Eleventh-Century Ivory Plaque," pp. 90–92.

Several of the San Paolo scenes compare well with those in Grimaldi's drawing based on the program of Old St. Peter's (Fig. 46: Archivio San Pietro, Album, fol. 13; see Waetzoldt, *Kopien*, fig. 484), e.g., *Sacrifice of Isaac, Isaac and Esau*, and certain of the plagues. On San Paolo and Old St. Peter's, see the Introduction, note 18.

8. The known Octateuchs are: Vatican Library, cod. gr. 747 (eleventh century); Florence, Laurentian Library, cod. Plut. V.38 (fragments of Genesis miniatures, eleventh century); Vatican Library, cod. gr. 746 (twelfth century); Smyrna, Evangelical School, cod. A.1 (twelfth century; destroyed in 1922); Istanbul, Seraglio Library, cod. 8 (twelfth century); and Mt. Athos, Vatopedi Monastery, cod. 602 (thirteenth century; Genesis and Exodus now lost). In general, see K. Weitzmann, *The Joshua Roll* (Princeton, 1948), pp. 6–38; idem, "Septuagint," passim; and idem, "The Octateuch of the Seraglio and Its Picture Recension," in *Actes du X. Con-*

gress d'Etudes Byzantines (Istanbul, 1957), pp. 183–185. Only the Smyrna manuscript has been fully published (see D. Hesseling, *Miniatures de l'octateuque grec de Smyrne*, Leyden, 1909). Many of the Seraglio miniatures are reproduced in T. Ouspensky, *L'Octateuque de la bibliothèque du Serail à Constantinople* (Sofia, 1907). Kurt Weitzmann has long been planning a comprehensive publication of all the Octateuch manuscripts and has kindly allowed me access to the illustrations for this volume. See, most recently, M. Bernabò, "Considerazioni sul manoscritto laurenziano plut. 5.38 e sulle miniature della Genesi degli ottateuchi bizantini," *Annali della scuola normale superiore di Pisa* 3rd ser. 8 (1978):135–157.

9. All of the miniatures are reproduced in I. Gollancz, *The Caedmon Manuscript of Anglo-Saxon Biblical Poetry* (Oxford, 1927). See also F. Wormald, *English Drawings of the Tenth and Eleventh Centuries* (London, 1952), pp. 40, 76, no. 50; O. Pächt, *The Rise of Pictorial Narrative in Twelfth-Century England* (Oxford, 1952), pp. 5–7; G. Henderson, "Late Antique Influences in Some English Mediaeval Illustrations of Genesis," *Journal of the Warburg and Courtauld Institutes* 25 (1962):172–198; idem, "The Sources of the Genesis Cycle at Saint-Savin-sur-Gartempe," *Journal of the British Archaeological Association* 26 (1963):11–26; idem, "The Programme of Illustrations in Bodleian Ms. Junius XI," in *Studies in Memory of David Talbot Rice*, ed. G. Robertson and G. Henderson (Edinburgh, 1975), pp. 113–145; T. Ohlgren, "The Illustrations of the Caedmonian Genesis," *Medievalia et humanistica* 3 (1972):199–212; idem, "Five New Drawings in the Ms. Junius 11: Their Iconography and Thematic Significance," *Speculum* 47 (1972):227–233; and idem, "Some New Light on the Old English Caedmonian Genesis," *Studies in Iconography* 1 (1975):38–75; E. Temple, *Anglo-Saxon Manuscripts*, A Survey of Manuscripts Illuminated in the British Isles, 2 (London, 1976), pp. 76–78, no. 58.

paraphrase of the Heptateuch (London, British Library, Cotton Claudius B VI).[10] Both works show pictorial cycles that combine strictly biblical iconography with features derived directly from the vernacular texts themselves. We shall learn more about the character of these unusual and fascinating minature cycles as the analysis proceeds. Despite their clearly critical importance in answering questions about the nature and sources of the Salerno Old Testament cycle, these manuscripts have never before been mentioned in connection with the ivories.

One further group of monuments will be alluded to at various points in the analysis. There are a rather large number of contemporary or near contemporary Italian Old Testament cycles related to the Salerno ivories. In general, I have avoided reference to these works, because a mere cataloguing of their relationships would serve little purpose, but where they can shed some new light on problems relating to the Salerno series itself, I have brought them into the discussion. The most important of these Italian

cycles are those of the eleventh century in the Berlin *Crucifixion-Genesis* ivory (Catalogue no. B2) and at Sant'Angelo in Formis,[11] and those of the twelfth century in the Cappella Palatina[12] at Palermo, in the great church of Monreale,[13] and at San Giovanni a Porta Latina in Rome.[14] The exact nature of the relationships among the Italian cycles is a subject that would require a study of its own.

THE GENESIS CYCLE

As early as 1893 the Finnish scholar J. J. Tikkanen related the Salerno Genesis cycle to the Cotton Genesis manuscript in the British Library and its mosaic copy in San Marco.[15] Wilhelm Koehler reasserted this connection,[16] and Kurt Weitzmann refined the view of the nature of the relationship between the ivories and the Cotton Genesis recension in such a manner that the ivory cycle emerges as part of the Cotton Genesis tradition but with "essential variants."[17]

10. C. R. Dodwell and P. Clemoes, *The Old English Illustrated Hexateuch (Brit. Mus. Cotton Claudius BIV)* (Copenhagen, 1974). See also Wormald, *English Drawings*, pp. 39, 67, no. 28; Pächt, *Pictorial Narrative*, pp. 5–11; Henderson, "Late Antique Influences," passim; and idem, "Saint-Savin," passim; C. R. Dodwell, "L'originalité iconographique de plusieurs illustrations anglo-saxonnes de l'Ancien Testament," *Cahiers de Civilisation Médiévale* 14 (1971):319–328; Temple, *Anglo-Saxon Manuscripts*, pp. 102–104, no. 86.

The frescoes of Saint-Savin (c. 1100), the subject of Henderson's 1963 article, are related in significant ways to the English manuscripts and to the Salerno cycle. They will be referred to several times in the remainder of the chapter. For a complete reproduction in line drawings and the most representative selection of plates, see G. Gaillard, *Les fresques de Saint-Savin* (Paris, 1944).

11. For several recent book-length studies, see note 26 to the Introduction. Most of the extant Old Testament frescoes from this church remain unpublished.

12. Demus, *Mosaics*, pp. 25–72, 245–254, and figs. 8–44.

13. Ibid., pp. 91–177, 245–294, and figs. 59–111; and E. Kitzinger, *The Mosaics of Monreale* (Palermo, 1960), passim.

14. See note 30 to the Introduction. The large group of related Italian monuments is by no means homogeneous, but significant connections unify the group. For the members of this group, see Demus, *Mosaics*, pp. 250–251; and E. B. Garrison, "A Note on the Iconography of Creation and of the Fall of Man in

Eleventh- and Twelfth-Century Rome," in *Studies in the History of Mediaeval Italian Painting* 4 (1960–1962):201–210. To these monuments must be added the fresco cycles at Marcellina of the twelfth century and at Castro dei Volsci of the thirteenth century (see notes 29 and 38 to the Introduction).

Although most of these cycles show connections with the Salerno series in the scenes of the *Creation of Eve* and *Expulsion* (as well as later sections), very few contain individual scenes for each of the days of Creation. In most cases the action of the first six days has been condensed into a single scene, followed directly by the *Creation of Adam*. This condensed first scene is also in the drawing based on San Paolo fuori le mura, and the testimony provided by the description of a Neonian cycle in Ravenna of the fifth century leads me to believe that such a scene was probably part of the early cycle at San Paolo; see A. Weis, "Der römische Schöpfugzyklus des 5. Jahrhunderts im Triclinium Neons zu Ravenna," *Tortulae: Festschrift J. Kollwitz*, ed. N. Schumacher (Freiburg, 1966), pp. 300–316. The condensed scene was probably invented for monumental art; its appearance in later manuscripts is the result of the influence of this monumental tradition.

The other cycles besides Salerno that include scenes for each of the days of Creation are: Berlin ivory, Cappella Palatina, Monreale, and Sant'Angelo in Formis.

15. Tikkanen, "Genesismosaiken," passim.

16. Köhler, *Schule von Tours*, text vol. 2, p. 186.

17. Weitzmann, "Observations," p. 123.

Most recently, Herbert Kessler, in an article primarily concerned with the *Crucifixion-Genesis* ivory in Berlin (Catalogue no. B2; Figs. 156-157) related to the Salerno group, analyzed the Creation section of the Genesis cycle in much greater detail and emphasized its relationship to the Cotton Genesis recension.[18] Although his views on most points are well founded, the instances in which I disagree with him foster a very different view of the Salerno cycle's origins. Kessler, of course, was interested only in the iconography of the early scenes of the cycle as they related to the Berlin ivory, and so did not have the perspective afforded by an analysis of the entire Salerno Genesis cycle. But because Kessler's treatment of the Creation section is so detailed, it would be superfluous to repeat all his work here. Hence, where his analysis is not controversial I have simply summarized our common point of view and referred to the relevant portions of his article.

The Spirit over the Waters and *The Separation of Light and Darkness* (Fig. 2), Genesis 1:2–5

The bottom third of the picture field is taken up by a series of wavy horizontal lines intended to represent the water. In the center of the composition a dove, wings outstretched, alights on the water. Above the bird and flanking it are two large discs identified by raised inscriptions as LUX and NOX.

This first scene in the Salerno series is a conflation of the first two mosaic panels at San Marco (Fig. 48), as Kessler suggests.[19] At Salerno, however, the full-length Creator who appears in the second San Marco scene has altogether disappeared and the dove is shown without a nimbus. Furthermore, a fundamental departure that the Creation scenes in the ivories will make from the Cotton Genesis recension is already evident here in the absence of the personification of the day (in the form of an angel) that appears in the second San Marco panel. In the Cotton Genesis and San Marco versions such personifications appear in each scene of the six days of Creation in a number corresponding to the day represented, that is, one angel for the first day, two for the second, and so on.[20] The omission of this characteristic element from the Salerno Creation cycle immediately establishes that the ivories differ in important ways from the Cotton Genesis recension. At the same time, however, it must be realized that other elements basic to the Salerno version are paralleled in this recension, as opposed to the depiction in the Byzantine Octateuchs, where an entirely different tradition is in evidence.[21]

In the Berlin ivory (Fig. 157) the figure of the cross-nimbed Logos of the San Marco mosaic is maintained in the form of a bust in a medallion in this first scene. As in the Salerno ivory, two discs intended to represent light and darkness appear, here inscribed LUX and TEN-[EBRAE], along with a dove without a halo. A new addition is the head of Abyssus in the water, an element that Kessler admits is alien to the Cotton Genesis tradition but is found in the Octateuchs. Basically, however, the Berlin ivory and the Salerno version derive from the same source.

18. Kessler, "Eleventh-Century Ivory Plaque," pp. 67–95.
19. Ibid., p. 79.
20. For the "angel-days," see Marie-Thérèse D'Alverny, "Les anges et les jours," *Cahiers Archéologiques* 9 (1957):271–300.
21. For instance, the Octateuchs show neither of the characteristic discs representing darkness and light, but instead depict two full-length torch-bearing figures of markedly classical type. See Smyrna, fol. 27v (Hesseling, *Miniatures*, fig. 3); Seraglio, fol. 4v (Ouspensky, *Octateuque*, fig. 12); Vat. gr. 746, fol. 20v; and Vat. gr. 747, fol. 15r.

One may say, then, that this first scene is connected with the Cotton Genesis recension, although it departs from this tradition in important respects.

Creation of the Firmament (Fig. 2), Genesis 1:6–8

The Creator, bearded and with a plain nimbus, stands at the left, facing toward his right and extending his right hand in benediction. In his left hand, kept tightly against his waist, he holds a scroll. To the right four angels appear, facing the Creator and bowing deeply in his direction.

This scene is completely different from that at San Marco, where the story is told in two stages, each containing a large disc representing the firmament.[22] In the first of these scenes two angel-days appear; in contrast, four worshiping angels are shown in the ivory panel. In the mosaic the Creator is shown as the cross-nimbed Christian Logos, carrying a cross-staff instead of a scroll. The Logos figure at San Marco (and in the Cotton Genesis recension in general) is youthful and unbearded, while at Salerno the Creator is invariably bearded. All these are evident differences between the Salerno cycle and the Cotton Genesis recension as represented by the San Marco mosaics. However, the appearance of the Creator in anthropomorphic form at both Salerno and San Marco in itself serves to establish a profound relationship between the two cycles. This anthropomorphic Creator is absent in the recension associated with the Octateuchs,[23] whose version of this scene bears no relation to the ivory type.

Not only is the Salerno scene unparalleled in the Cotton Genesis and Octateuch recensions, but it is extremely rare in medieval art. In fact, only two other examples of this composition with the angels have come to light: in the Monreale mosaics (Fig. 49)[24] and on the Berlin *Crucifixion-Genesis* ivory (Fig. 157).[25] At Monreale the scene is firmly identified by its inscription as the *Creation of Light,* and this is further accentuated by the jagged rays that emanate from the heads of the seven angels in the mosaic.[26] Furthermore, the following scene in the mosaic cycle is identified by inscription as the *Creation of the Firmament.*

The versions at Berlin and Salerno could not represent the *Creation of Light* as at Monreale because in both instances this event was included as part of the previous scene. Clearly, the Salerno and Berlin carvers intended that one scene be devoted to each of the days of Creation up to the *Creation of Adam.* But the episodes in the two ivories on the one hand and the mosaic on the other are too similar—and too unusual—for us not to suppose that a common model lay behind them, despite the difference in the actual event the composition was used to represent. The further question then arises of which was the original (and presumably correct) use of the composition, a problem to which I shall return shortly.

If the angel scene at Salerno does not represent the *Creation of Light* as at Monreale, then what does it illustrate? Its place in the cycle points to an identification as the *Creation of the Firmament* because this was the action completed on the second day. The preceding

22. An illustration of the San Marco cupola showing all of the creation scenes is in O. Demus, *Die Mosaiken von San Marco in Venedig* (Vienna, 1935), fig. 27. More detailed illustrations are in S. Bettini, *Mosaici antichi di San Marco a Venezia* (Bergamo, 1944), pls. 50–65.

23. Smyrna, fol. 5r (Hesseling, *Miniatures,* fig. 4); Seraglio, fol. 28r; Vat. gr. 746, fol. 22r; and Vat. gr. 747, fol. 15v.

24. Kitzinger (*Monreale,* p. 54) suggests that because the number of angels depicted in this scene at Monreale is seven, they are intended to represent the days of Creation.

25. Kessler, "Eleventh-Century Ivory Plaque," pp. 80–81.

26. Demus, *Mosaics,* p. 167: DEC[IT] DS LUCE APPELLA VITQ L[U]CE[M] DIE ET TENEBRAS NOCTE.

and subsequent scenes show the activities of the first and third days, respectively. The logical deduction that the scene should represent the action of the second day does not, however, explain the presence of the angels. Kessler has come up with an ingenious solution that finds in this scene the remnants of an iconography based on a Jewish exegetical tradition that identified the creation of the angels as the act of the second day. According to Kessler, Christian writers were never to make this assertion, but the idea was apparently common in the Hellenistic Jewish community. He suggests that the scene must have been part of a Jewish Genesis cycle created in the Hellenistic period that served as the archetype for the tradition with which the Salerno and Berlin ivories and the Monreale mosaic are connected. In most of the Christian copies of this archetype the scene would have been replaced because it no longer would have made any sense to the Christian spectator, but for some unknown reason it managed to remain intact in the copy that became current in south Italy and Sicily and with which the ivory carvers and mosaicists had contact.[27]

Any suggestion of a Jewish model for this scene could be valid only if it were demonstrated that the angels were not connected with the activity of the second day of Creation in any Christian source. Kessler himself alludes to one such Christian source, Walafrid Strabo, who identified the firmament as the home of the angels, thus providing evidence that Christian writers did indeed identify the angels with the second day of Creation.[28] This connection of the angels with the firmament is, in fact, a rather constant theme in early medieval Christian exegesis.[29]

It appears, then, that this scene should more properly be interpreted as the *Creation of the Firmament* than as the *Creation of the Angels*, although the latter is sometimes included as part of the former. Rather than assume some lost Jewish prototype, it is more appropriate to accept the Christian exegetical tradition that identified the firmament as the home of the angels as the origin of and explanation for such unusual iconography. But, the possibility of a Jewish source having had some influence on the composition cannot be completely discounted because the interpretation of the subject is found in Jewish tradition.[30]

Kessler is justified in separating the present scene from certain other representatives of the Cotton Genesis recension. The scene's iconography is characteristic only of that branch of the recension that was available in south Italy and Sicily in the eleventh and twelfth centuries. Clearly, the carvers of the Salerno and Berlin ivories were able to grasp the meaning of this unusual iconography, but the Monreale mosaicist confused it and transformed it into the *Creation of Light*.

Creation of Plants and Trees (Fig. 3), Genesis 1:9–13

The Creator stands toward the left and gestures to his right as in the previous episode. He is accompanied by two angels, the first of whom raises his right hand to his chest in a gesture of astonishment. These angels appear behind the Creator; in front of him, to the right, two trees

27. Kessler, "Eleventh-Century Ivory Plaque," p. 84.
28. Ibid., p. 81.
29. See, for example, Bede, *De sex dierum creatione* (Migne, *PL*, 18:210–211); R. Maurus, *De universo* (Migne, *PL*, 111:263–265); and W. Strabo, *Glossa ordinaria: liber genesis* (Migne, *PL*, 118:73). St. Augustine considers the problem in *De civitate Dei* (Migne, *PL*, 11:34): he mentions an interpretation of Genesis 1:6 that places the angels above the firmament and the rest of the world below. Although Augustine here refutes this view (held by many others, including Origen), he had apparently accepted it earlier; see St. Augustine, *City of God*, vol. 3, trans. D. S. Wiesen (Cambridge, Mass., 1958), p. 567.
30. See *The Jewish Encyclopedia*, s.v. "Cosmogeny," where it is mentioned that the Pesikta Raba says that the "firmament is made of water, and the stars and angels of fire." Cf. also ibid., s.v. "Angeology."

grow out of a stylized patch of ground. The branches of the trees intertwine as they rise, bearing leaves, fruit, and berries.

A strong connection with the Cotton Genesis recension is again evident here. This scene not only is contained in the San Marco cycle (Fig. 50), but is also preserved in a seventeenth-century watercolor copy made from the Cotton Genesis manuscript itself (Fig. 51).[31] Comparison of the watercolor copy with the mosaic demonstrates both the clear dependence of the mosaic on the Cotton Genesis manuscript and the accuracy of the watercolor artist. Aside from the replacement of the cross-nimbed, beardless Logos figure with one of the bearded Creator and the substitution of a roll for a cross-staff in his hand, the ivory version is also practically identical.[32] Of course, the ivory lacks the three personifications of the days found in the Cotton Genesis recension, but perhaps the two angels who accompany the Creator are remnants of this motif. The gesture of astonishment of the first Salerno angel also appears in the three personifications at San Marco, but the number of the Salerno angels—two—shows that they do not fulfill the original function of designating the third day of Creation.[33]

Creation of the Sun, Moon, and Stars (Fig. 3), Genesis 1:14–19

To the left is a figure of the Creator similar to those in the earlier scenes. To his right, and taking up most of the space in the composition, is a large circle within which appear two smaller discs that contain personifications of the sun and moon and seventeen eight-pointed stars.

Except for the type of the Creator figure and the absence of the four personifications of the days, the Salerno ivory is very similar to the version of the scene in San Marco (Fig. 52). A small detail in which the two differ is the way in which the sun and moon are represented. In the Mosaic they are shown simply as heads; in the ivory the personifications are considerably more ambitious in that they are depicted as half-length figures who carry torches (one of them appears also to be crowned) and bow toward the Creator. The type of personification used in the Greek East in the Middle Ages is similar to that found in San Marco, so that this is what we might expect to find in the ultimate model for the scene. The torch-bearing figures of the sun and moon at Salerno are specifically Western motifs not found in the East.[34] They appear, among other places, in the *Creation of the Sun, Moon, and Stars* in the Aelfric manuscript.[35] The very unusual gesture of supplication of the personifications at Salerno might be a specifically south Italian element, since the only other places where I have been able to find such gestures are the tenth-century frescoes at

31. Bibliothèque nationale, fr. 9530, fol. 32. See Weitzmann, "Observations," fig. 3.

32. The type of Creator without cross-nimbus and carrying a scroll (as in the Salerno ivories) probably represents the older type.

33. The angels at Salerno are cast as the Creator's helpers rather than as personifications of the days. They also occur in the Berlin ivory (Catalogue no. B2). See Kessler, "Eleventh-Century Ivory Plaque," p. 84.

34. The type of personification used for the sun and moon in Byzantium is exemplified by those found in the Octateuchs. They

are distinct from those in the Salerno ivories; generally only a face appears (see, for example, Hesseling, *Miniatures*, figs. 6, 7, 9).

35. Henderson, "Saint-Savin," fig. 2 (fol. 3r). This type of personification was widespread in the West during the Middle Ages. See, for instance, the examples in the Stuttgart Psalter (Württembergische Landesbibliothek, Bibl. fol. 23, fols. 151v, 162v: F. Mütherich et al., *Der Stuttgarter Bilderpsalter*, Stuttgart, 1965) and in the Bernward Gospels (Hildesheim Cathedral, Gospels of Bernward, fol. 118v: S. Beissel, *Das hl. Bernward Evangelienbuch*, Hildesheim, 1891, pl. 19; and F. J. Tschan, *Saint Bernward of Hildesheim*, vol. 3, South Bend, Ind., 1952, fig. 71).

Calvi[36] and the Exultet Roll in Bari (eleventh-twelfth century).[37]

Creation of Birds and Fish (Fig. 4a), Genesis 1:20–23

Again the familiar Creator figure appears at the left and gestures toward the right, where there appear, above, a number of birds arranged in two rows and, below, numerous fish shown on a wavy ground intended to suggest water. Among both the birds and the fish numerous different species may be discerned.

At San Marco (Fig. 53) this episode is depicted in two phases. In the first, one sees only the many birds and fish, while in the second appear the Logos, five angel-days, and a few more birds and fish. The ivory version is merely a conflation of these two stages with the elimination of the personfications and the substitution of the Creator for the Logos.

Creation of Animals (Fig. 4b), Genesis 1:24–25

The standard Salerno Creator figure appears at the left; to his right a large group of animals of all different species face toward their maker.

In this case the Salerno ivory version is remarkably close to the San Marco mosaic (Fig. 54) save for the usual differences in the Creator. At San Marco no personifications appear in this panel because they are placed in the scene of the other activity of the sixth day, the creation of Adam. At San Marco the animals are all grouped in pairs; in the ivory each species, probably because of lack of space, is represented by only one member. Despite this change, however, the lion that bows at the feet of the Creator in the Salerno panel is perfectly paralleled in shape and position by a pair of lions at San Marco.

I suggest that following the *Creation of Animals* there was originally a panel, now lost, that contained in its first section the *Creation of Adam*. This scene is too crucial to the Creation narrative to have been omitted in such a comprehensive cycle. It occurs in all the contemporary Italian cycles[38] in basically the same from (Fig. 55), and it is easy to imagine that in the lost ivory the Creator would again have appeared at the left gesturing toward a figure of Adam sitting up on the ground at the right. This iconography of the *Creation of Adam* differs from the three-stage version in the San Marco mosaics and represents a further departure from the Cotton Genesis recension.[39]

The second half of this lost panel most probably showed *God Resting*, a scene that appears in a comparable position in the Palermo and Monreale cycles.[40] Other scenes that might possibly have appeared after the *Creation of Adam* are *Adam Introduced into Paradise* (San Marco, Palermo, Monreale)[41] or *Adam Naming the Animals* (San Marco).[42]

36. H. Belting, *Studien zur beneventanischen Malerei* (Wiesbaden, 1968), fig. 122.

37. M. Avery, *The Exultet Rolls of South Italy* (Princeton, 1936), pl. 8. The type of the Berlin ivory (Catalogue no. B2) is different; it is related to that in the Aelfric manuscript (Henderson, "Saint Savin," fig. 2), in Saint-Savin (Gaillard, *Fresques*. pl. 1), and in the thirteenth-century frescoes of Santa Maria "ad Cryptas" near Fossa in the Abruzzi (Bertaux, *Italie méridionale*, fig. 114). The origin of this composition, where the Creator actually places the sun and moon in the heavens above, remains obscure. Henderson's explanation of a source in the Octateuchs is not convincing.

38. For example. Palermo, Monreale (Demus, *Mosaics*, figs. 27B and 95A), and the Berlin ivory (Fig. 163).

39. There are marked similarities between this type and the Octateuchs: for example, see Smyrna, fol. 9r (Hesseling, *Miniatures*, fig. 10) or Seraglio, fol. 36v (Ouspensky, *Octateuque*, fig. 21). In the Octateuchs there is, of course, a *manus dei* in place of a full-length Creator.

40. Demus, *Mosaics*, figs. 27B (Palermo) and 95A (Monreale).

41. Bettini, *Mosaici antichi*, pl. 54 (San Marco); Demus, *Mosaics*, figs. 28A (Palermo) and 95B (Monreale).

42. Bettini, *Mosaici antichi*, pl. 50.

Creation of Eve (Fig. 5), Genesis 2:21–22

In front and to the right of the usual Salerno Creator figure is a fruit-bearing tree from whose base flow the four rivers of Paradise. In front of the tree (actually it looks as if he is in the tree) Adam, his head resting in his left hand, reclines in sleep. From his side emerges a half-length figure of Eve, facing the Creator and gesturing toward him with both hands.

Kessler thinks that the scene in the Salerno ivory simply represents a conflation of the two phases of the episode in the Cotton Genesis recension (Fig. 56)[43]—the taking of the rib and the forming of Eve, one scene rather horizontal, the other rather vertical in format. But the composition of the ivory, in which a fully-formed Eve emerges directly from the side of the sleeping Adam, has such close affinities with the corresponding miniature in the Octateuchs (Fig. 57)[44] that they cannot be accidental. In the Octateuchs, as in the ivory, the figure of Eve raises both hands toward the Creator as she emerges from Adam's side. The event clearly takes place at the foot of a single tree. It is likely that the appearance of Adam and Eve virtually in the tree in the Salerno relief is a misunderstanding of this setting in the Octateuchs.

There is one fundamental difference between the ivory and the Octateuchs: the Salerno panel represents the Creator as a full-length figure, while the Octateuchs include only the hand of God in the sky. I would explain this divergence by suggesting that the Salerno version of the scene was derived from a model of the Octateuch type, and the full-length anthropomorphic Creator figure characteristic of the Cotton Genesis tradition was inserted to make the scene conform to the overall scheme of the Salerno Creation panels, which is clearly based on the Cotton Genesis recension. Similar instances of compositions derived from one tradition and then augmented to conform to another tradition that governs the cycle as a whole occur elsewhere among the Salerno ivories.[45] This explanation is far more convincing than Kessler's idea of a simple conflation of the San Marco scenes, because it accounts for the close similarities between the Salerno and Octateuch versions. It also explains the differences between these renderings and the Cotton Genesis type: the Cotton Genesis tradition shows the Creator in the act of physically forming Eve with his hands; in the Octateuchs, and in the Salerno panel, he calls her forth miraculously, without the aid of any physical contact.

The Palermo and Monreale mosaics[46] show exactly the same iconography as the Salerno ivory. This iconography, either with the hand of God or with the full-length Creator, is by far the most common in the Middle Ages. The Berlin ivory version (Fig. 157) is very similar to the Salerno panel except that the Creator seems to touch Eve's shoulder as he does at San Marco, and that Eve does not perform the two-handed gesture characteristic of the Octateuchs and related examples.

Temptation and Fall (Fig. 5), Genesis 3:2–7

The scene is divided into two parts. In the first half, to the left, Eve plucks a piece of fruit from the branch of a tree around whose trunk the serpent is coiled. To the right, in the second half of the picture field, appear Adam and Eve,

43. Kessler, "Eleventh-Century Ivory Plaque," pp. 88–89.

44. Smyrna, fol. 12v (Hesseling, *Miniatures*, fig. 18); Seraglio, fol. 42v (Ouspensky, *Octateuque*, fig. 24); Vat. gr. 746, fol. 37r; and Vat. gr. 747, fol. 22r.

45. See the scene *God and Noah Establish the Covenant*

(Fig. 11). The Salerno carvers did not themselves combine elements from the different traditions. These were undoubtedly features of the ivories' model.

46. Demus, *Mosaics*, figs. 28A (Palermo) and 96A (Monreale).

both naked and eating the fruit as Eve hands Adam yet another piece.

In the San Marco mosaics (Fig. 58) this story is recounted in four episodes: Eve talking to the serpent (not shown); Eve plucking the fruit from the tree; Eve handing the fruit to Adam, who eats it; and Adam and Eve realizing their shame (not shown). The ivory seems to condense elements from the first three of these scenes into its two-part composition. From the first scene is preserved only the serpent wrapped around the tree, while the other two scenes are taken over almost intact. A very similar condensation had already appeared in the Genesis miniature of the Carolingian Moutier-Grandval Bible, a work associated with the Cotton Genesis recension.[47]

Expulsion (Fig. 6), Genesis 3:24–25

An impressively monumental angel appears on the left, placing his hands on Adam's right arm and shoulder and ejecting him from Paradise. Adam raises his right hand to his chest in astonishment; his left is raised to his chin and then curiously bent at the wrist so that it points downward and seems to hang limp. Eve, moving off to the right in front of Adam, gestures in this same strange way with her right hand, while with her left she holds her head. Both Adam and Eve are half nude, wearing short pants to cover their nakedness.

At San Marco (Fig. 59) the agent of the *Expulsion* is the Logos, and not an angel as at Salerno. Although an angel does appear in the Touronian bibles, members of the Cotton Gensis recension, the Salerno composition seems to have more in common with the corre-

sponding scene in the Octateuchs (Fig. 60).[48] In these miniatures not only does the angel appear but he pushes Adam from the garden with the same two-handed gesture found in the Salerno panel; in contrast, the angel of the Touronian Vivian Bible[49] uses one hand and carries a staff in the other. Moreover, Adam's gesture of raising his hand to his chest and Eve's of putting her hand to her face are also paralleled in the Octateuchs. Thus the *Expulsion* scene in the Salerno series clearly was based on the Octateuch tradition.

In the Berlin ivory (Fig. 157), at Sant'Angelo in Formis,[50] and in the mosaics at Palermo and Monreale,[51] the angel is the agent of the *Expulsion* and he acts with the characteristic two-handed gesture. Hence in all of these cycles, which are very similar to the Salerno ivories in instances where they derive from a branch of the Cotton Genesis recension, we find the same correspondences with the Octateuchs.

Adam and Eve at Labor (Fig. 6), Genesis 3:24

Adam is at the bottom of the panel, bending over with his hoe raised, tilling the soil. Above him Eve appears in an almost identical pose, wielding a scythe. Both wear the short pants seen in the *Expulsion*. To their right are two stylized leafy plants.

The sequence of *Expulsion-Labor* was not employed in the Octateuchs, and there the iconography for this scene is altogether different.[52] The Cotton Genesis recension does provide a parallel for the placement of this scene after the *Expulsion*, but the scene itself is different in

47. Kessler, "Eleventh-Century Ivory Plaque," fig. 24.
48. Smyrna, fol. 16r (Hesseling, *Miniatures*, fig. 23); Seraglio, fol. 49r (Ouspensky, *Octateuque*, fig. 26); Vat. gr. 746, fol. 44r; and Vat. gr. 747, fol. 25r.
49. Kessler, "Eleventh-Century Ivory Plaque," fig. 28.
50. Morisani, *Affreschi*, fig. 59.

51. Demus, *Mosaics*, figs. 29A (Palermo) and 97B (Monreale).
52. The examples cited in note 8 show a preliminary and a final *Expulsion* from the Garden and, placed between them, the scene of the *Labor*, in which Adam and Eve are seated looking sorrowful while nearby their plow stands idle.

one important way. Although the Cotton Genesis examples invariably show Adam hoeing the ground as at Salerno, they differ markedly from the ivory version in depicting Eve seated, sometimes with a child, spinning with a distaff. Nowhere in works related to the Cotton Genesis tradition is Eve shown tilling the soil along with her husband.[53]

In fact, we know but one other example of the *Labor* that shows both figures working the soil with long-handled tools: an early twelfth-century stone relief on the façade of the Cathedral of Modena (Fig. 61).[54] Here Adam and Eve face each other and are dressed in long garments. Adam works the plot of ground with a hoe while Eve wields a scythe.

Although the Modena relief is the only example depicting Adam and Eve in poses similar to those in the Salerno panel, the iconographical type of Eve engaged in some sort of manual labor with Adam—as opposed to the Cotton Genesis recension type where she sits spinning —is found elsewhere in medieval art. In the eleventh-century Catalan Farfa Bible, for instance, a kneeling Eve cuts the stalks while a standing Adam hoes the ground;[55] in a tenth-century Byzantine ivory in the Metropolitan Museum of Art Eve carries a bale of stalks on her shoulder while Adam continues to cut the grain.[56] These examples clearly derive from iconographical traditions different from that employed in the Salerno scene. But they do demonstrate that the interpretation of the labor of Adam and Eve as a collaborative act of working the fields was common in medieval art, and it is therefore possible that the carver of the Sa-

lerno panel drew inspiration from this tradition. Then, having decided to show the pair working together, he chose to depict Eve in the same posture as Adam, replacing the hoe with the scythe to vary the task performed.

Clearly, the overall iconography of the Salerno composition follows neither the Octateuchs nor the Cotton Genesis tradition, despite the appearance of the toiling Adam in both the latter tradition and the ivory. The final iconography in which both figures work in the fields must be derived from some other source. Possibly it was invented entirely by the ivory carver himself, or possibly he borrowed the figure of Adam from the Cotton Genesis recension but either invented Eve or drew her from another medieval source and combined her with the figure of Adam.

In the mosaics at Palermo and Monreale only Adam works the soil with a hoe, while Eve sits behind him, one hand worriedly raised to her face. At Monreale the other hand holds a distaff, while at Palermo this element has been omitted.[57] These versions follow the Cotton Genesis tradition, whereas in the Salerno panel a new invention or a version from another source has been substituted.

Sacrifice of Cain and Abel (Fig. 7), Genesis 4:3–4

Cain approaches from the left and Abel from the right, each carrying his offering in veiled hands: the former a sheaf of wheat, the latter a calf. The two brothers are dressed identically in short tunics, striped pants, and knee-length boots. Above, in the center, appears an

53. This is true not only at San Marco but in other members of the recension as well, such as the *Hortus deliciarum* (Straub and Keller, *Hortus deliciarum*, pl. 9).

54. R. Salvini, *Wiligelmo e le origini della scultura romanica* (Milan, 1956), fig. 37.

55. Vatican Library, cod. lat. 5729, fol. 6r (W. Neuss, *Die ka-*

talanische Bibel-illustration um die Wende der ersten Jahrtausends und die altspanische Buchmalerei, Bonn, 1922, fig. 5).

56. Goldschmidt and Weitzmann, *Byz. Elfenbeinskulpturen*, p. 54, no. 92, pl. 55.

57. Demus, *Mosaics*, figs. 29A (Palermo) and 98A (Monreale).

arc of heaven, from which a hand of God emerges. It points toward Abel, thus indicating God's favorable reaction to his sacrifice.

The Cotton Genesis recension type for this scene (as reflected in the San Marco mosaics) shows Abel at the left bearing the calf across his shoulders in the manner of the ancient Moscophorus, while Cain approaches from the right carrying a cornucopia filled with wheat (Fig. 62). A hand of God emerges above and points to Abel; and, more significant, a large altar appears at the center of the scene between the two brothers. Although Cain and Abel are represented here in short tunics with high boots, as in the Salerno panel, it seems probable that the San Marco and ivory iconographies stem from different origins. Much closer to the Salerno version is that in the Octateuchs (Fig. 63),[58] where Abel approaches from the right and where both participants again hold their offerings out in front of them in veiled hands. As in the ivory, no altar is represented and the sacrifices are made directly to the hand of God above. In the Octateuchs Abel is given a nimbus. This is not present in the ivory, and, in fact, no figure in the Salerno Old Testament cycle other than the deity and the angel of the *Expulsion* is shown with a nimbus. Apart from this omission, the ivory version is very similar to the Octateuch iconography.

Murder of Abel and *Condemnation of Cain* (Fig. 7), Genesis 4:8,9–16

Abel is on the ground at the left; Cain leans over him. One of Cain's feet rests on Abel's left arm, pinning it to his body. With his hands Cain

grabs Abel by the throat and strangles him. At the top center of the picture field is a large arc of heaven from which a half-length figure of the Creator—as I shall continue to call the figure of the Lord throughout the Genesis cycle—leans out toward the right. He gestures toward a second figure of Cain turning to leave at the far right. Cain holds one hand up in astonishment, keeping the other in the same strange position as the hands of Adam and Eve in the *Expulsion*.

In the Cotton Genesis recension Cain invariably murders his brother by hitting him with a club;[59] in the Octateuchs he is always shown hurling stones at Abel.[60] The manner in which the act is performed at Salerno, then, is paralleled in neither of these traditions. The strangling of Abel seems to be unique, and we must reckon here with the possibility that the ivory carver invented his own method for the murder. Since the biblical text mentions no weapon but merely says that Cain "rose up" and killed his brother, one might suggest that the panel's carver was only trying to render a scene as close to the biblical description as possible. Although this motive may have contributed to the invention of the iconography, I suggest that it was primarily the artist's penchant for realism that caused him to cast the scene in this manner.

For the *Condemnation of Cain* the Cotton Genesis and Octateuch traditions present very similar renditions (Figs. 64 and 65).[61] The Salerno version differs from both types by substituting a half-length figure of the Creator for the simple hand in the sky. More important, in neither the Octateuchs nor the Cotton Genesis re-

58. Smyrna, fol. 16v (Hesseling, *Miniatures*, fig. 24); Seraglio, fol. 50r (Ouspensky, *Octateuque*, fig. 28); Vat. gr. 746, fol. 45r; and Vat. gr. 747, fol. 25v.

59. See, for example, the Millstatt Genesis, fol. 19v (Kracher, *Millstätter Genesis*, fol. 19v) or the San Marco mosaics (unpublished).

60. See note 58 above.

61. Smyrna, fol. 17r (Hesseling, *Miniatures*, fig. 25); Seraglio, fol. 50v (Ouspensky, *Octateuque*, fig. 29); Vat. gr. 746, fol. 46r; and Vat. gr. 747, fol. 26r. The San Marco *Condemnation* is unpublished.

cension version of the *Condemnation* does Cain appear moving off to the right, out of the scene, as he does in the Salerno panel. This active figure is evidence that the scene is actually a conflation of two actions in the text: the first is the actual condemnation of verses 10–15 and the second is the result of this activity, Cain's departure for the land of Nod, described in chapter 8:16. These two episodes may have been in the archetype of the Cotton Genesis recension but are not preserved in any of the extant monuments associated with that tradition. The two events are represented separately in the Octateuchs. In the first scene the hand of God appears at the top, with Cain standing below, facing it and gesturing toward it. The second scene shows only the figure of Cain moving off to the right, his left hand raised to his face. If the figure of Cain in the first scene is replaced by the one from the second, the resulting composite would be very close to the Salerno ivory version. This is exactly what I propose happened in the evolution of the composition. For one reason or another, the hand of God was transformed into a half-length Creator figure. Cain is characterized by the same unusual gesture used in the *Expulsion*. The appearance of this gesture in these two places provides sufficient basis for me to propose that the meaning of the motif must be shame or guilt, qualities equally applicable to both situations. That the Cotton Genesis tradition might also have included this two-stage approach to the narrative of the *Condemnation* is possible, but the parallels with the Octateuchs seem to make an affiliation with that recension more likely.

It should be noted that the Salerno ivory is neither the first nor the only place where the scenes of the *Murder* and *Condemnation* were united in a single picture field. The device is found in drawings copied from the fifth-century frescoes of San Paolo fuori le mura in Rome[62] (despite a different iconography), and appears in the frescoes of Saint-Savin[63] and Sant'Angelo in Formis,[64] and in the mosaics in the Cappella Palatina.[65]

God Commands Noah to Construct the Ark (Fig. 8), Genesis 6:14

The Creator, of the same full-length type found in the Creation panels, stands at the left and gestures toward the figure of Noah at the right. Noah faces the Creator and stretches forth both hands in a gesture of veneration.

The ivory differs from both the Octateuch (Fig. 66)[66] and the Cotton Genesis versions (Fig. 67)[67] in that it includes an anthropomorphic figure of the Creator instead of a simple hand emerging from an arc of heaven. We have already seen that in the *Creation of Eve* the fundamental arrangement of the Octateuch composition was augmented by a full-length Creator figure so that the scene would conform with the earlier scenes in the cycle, which were based on the Cotton Genesis tradition. In the present instance a different transformation occurred. From the marked similarity between the Noah figures in the ivory and in the San Marco mosaic, particularly their characteristic two-handed gesture (and from the differences between the Octateuchs and the ivory in this respect), it is clear that the Cotton Genesis recension ultimately lies behind the Salerno rendition of this scene. However, the preserved monuments of this recension do not maintain

62. Waetzoldt, *Kopien*, fig. 337.
63. Gaillard, *Fresques*, pl. 3.
64. Morisani, *Affreschi*, fig. 59.
65. Demus, *Mosaics*, fig. 298.

66. Smyrna, fol. 19v (Hesseling, *Miniatures*, fig. 30); Seraglio, fol. 56v (Ouspensky, *Octateuque*, fig. 30), Vat. gr. 746, fol. 52r; and Vat. gr. 747, fol. 28v.
67. Bettini, *Mosaici antichi*, pl. 58.

the full-length Creator figure beyond the *Expulsion*. The tradition followed by the carvers of the Salerno group in this regard represented him in full-length form throughout most of the cycle.

That the full-length Creator figure in this composition was not the invention of the Salerno carver is supported by the appearance of the same feature in the same scene in the Caedmon manuscript (Fig. 68),[68] the Aelfric paraphrase (Fig. 69),[69] the Saint-Savin frescoes,[70] and the eleventh-century Roda Bible.[71] The presence of the Creator figure in this scene in all these monuments strongly suggests that it was already present in the model used for the Salerno ivory.

Construction of the Ark (Fig. 8), Genesis 6:22

At the left stands Noah, facing the right and gesturing with both hands. Four smaller figures are hard at work on the ground in front of Noah, hammering, chopping, and sawing, while two additional figures do their work mounted on the ark itself, a rectangular structure whose top forms a trapezoidal arch.

The general compositional scheme of Noah at the left and the construction at the right appears in both the Octateuchs (Fig. 70) and in the San Marco mosaic (Fig. 71).[72] But recognition of small details points to a closer relationship with the Cotton Genesis tradition. In the mosaic and in the ivory the most prominent labor is the cutting of a large plank with a two-man saw. Of the two figures who work the saw, one

is seated and the other is standing. This latter figure, in both examples, places his left foot on the plank being cut. In the Octateuchs no such activity takes place and the scene is less cluttered with figures. The figure of Noah in the Salerno panel is very similar to the Noah of the San Marco mosaic. In both versions he gestures toward the workmen in exactly the same manner: his hands are extended, the right one indicating speech, perhaps in imitation of the Creator. By contrast, the Noah of the Octateuchs is much more subdued in fulfilling his role as supervisor of the project; he seems to be an outside observer rather than the catalyst he is in the ivory and the mosaic. Clearly, this scene is more closely connected to the Cotton Genesis recension than to the Octateuchs.

In one detail, though, the ivory differs from the Cotton Genesis tradition: the latter version shows no ark. The ark does appear in the Octateuchs, but it is so different in shape and relationship to the figures from the Salerno ark that no connection between them can be made. An ark on which a figure actually sits pursuing his work is found in the frescoes of Sant'Angelo in Formis and the mosaics of Palermo and Monreale,[73] and one must therefore consider the possibility that this is a detail peculiar to the Italian Genesis cycles.

God Closes the Door of the Ark (Fig. 9), Genesis 7:16

The Creator stands at the left and with his left hand pushes the door of the ark on his right.

68. Gollancz, *Caedmon Manuscript*, p. 65.
69. Fol. 13v. See Dodwell and Clemoes, *Ullustrated Hexateuch*, fol. 13v.
70. Gaillard, *Fresques*, pl. 2.
71. Bibliothèque nationale, lat. 6, fol. 9r. See Neuss, *Bibel-illustration*, fig. 8.
72. Smyrna, fol. 20r (Hesseling, *Miniatures*, fig. 31); Seraglio, fol. 57v (Ouspensky, *Octateuque*, fig. 36); Vat. gr. 746, fol. 53v;

and Vat. gr. 747, fol. 29r. For San Marco, see Bettini, *Mosaici antichi*, pl. 58.
73. The Sant'Angelo in Formis fresco is unpublished. For the Sicilian examples, see Demus, *Mosaics*, figs. 30B and 99B. The two men who work the saw are also present in the San Paolo drawing but the ark is missing (Waetzoldt, *Kopien*, fig. 339). In the Caedmon manuscript (Gollancz, *Caedmon Manuscript*, p. 65) the ark is present, but only Noah is shown building it.

He gestures with his right hand toward the faces of Noah and two of his sons who peer through the window of the ark. A series of wavy lines beneath the ark represent the rising water. Although in the previous scene the rectangular ark was undecorated and had a trapezoidal roofline, here the ark terminates in a rounded arch and it is decorated with rectangular diaper-patterned strips.

This episode is not extant in either the Cotton Genesis recension cycles or the Octateuchs. In both these traditions the building of the ark is followed by the animals entering the ark, which in turn is followed immediately by the scene of the ark adrift on the waters. That the present scene was included in the archetype of either or both of these recensions is of course possible. Given the density of other parts of the Noah cycle at San Marco—for example, the filling of the ark is shown in three scenes—it would be surprising if it were omitted.[74] But its form would have differed from the Salerno version, at least to the extent that the Creator would not have been shown in human form, since, as noted earlier, he is represented only in the form of a hand at San Marco in the scenes following the *Expulsion*.

The only other examples of the scene of *God Closes the Door* are contained in the fourteenth-century Rovigo Bible[75] and in the Caedmon manuscript (Fig. 72).[76] In the latter, the Creator stands at the entrance to a three-tiered ark filled with animals and people. Noah is shown at the rudder with two of his sons addressing him. Two women stand in the open

doorway, while a third man and a third woman make their way up the gangplank. In both the manuscript and the ivory the Creator gestures with his right hand, and closes the door with his left. Despite the differences between this version and the ivory, the appearance of the full-length Creator figure in the Caedmon illustration (and in the Rovigo Bible) suggests that the source used by the Salerno carvers showed the Creator in this form.

The Dove Returns to the Ark (Fig. 9), Genesis 8:11

The ark, similar to the one in the previous scene, floats on the water; Noah appears at the window, sticks out his arm, and accepts the olive branch from a dove who brings it in his beak. A raven perches atop the roof of the ark.

Both the San Marco mosaics and the Octateuchs abbreviate what must have been a more extensive Noah cycle, and in the present scene they generally conflate a number of episodes.[77] Even so, it is evident that the iconography of both of these traditions reflects basically the same approach seen in the ivory. In this case there is no clear-cut differentiation between the two traditions, and it is therefore impossible to decide which of them was the source for the Salerno version.

There is one detail of this scene that appears neither in the Octateuchs nor at San Marco: the raven, whose appearance at the top of the ark contradicts the biblical text, which states explicitly that the raven never returned

74. San Marco: Bettini, *Mosaici antichi*, pls. 56 and 58. Octateuchs: Smyrna, fols. 20r and 20v (Hesseling, *Miniatures*, figs. 31–32; Seraglio, fols. 57v and 58v (Ouspensky, *Octateuque*, figs. 36–37); Vat. gr. 746, fols. 53v and 54r; and Vat. gr. 747, fols. 29r and 29v. The Cotton Genesis manuscript originally included no less than eleven scenes illustrating the story of the ark; see Weitzmann, "Septuagint," pp. 46–48.

75. G. Folena and G. Melini, *Bibbia istoriata padovana* (Ven-

ice, 1963), pl. 9. This manuscript clearly relates to an early tradition.

76. Gallancz, *Caedmon Manuscript*, p. 66.

77. San Marco: Bettini, *Mosaici antichi*, pl. 56. Octateuchs: Smyrna, fol. 21r (Hesseling, *Miniatures*, fig. 33); Seraglio, fol. 59v (Ouspensky, *Octateuque*, fig. 38); Vat. gr. 746, fol. 55v; and Vat. gr. 747, fol. 30r.

to the ark. Both in the San Marco mosaic and in the Octateuchs the raven is in the water picking at a cadaver. The raven perched on the ark is found on a third-century coin from Apamea,[78] but far more significant here is the appearance of the identical motif in the illustration for the chapter *De diluviis* in the *De universo* of Hrabanus Maurus illuminated at Monte Cassino in 1023 (Fig. 73).[79] The Hrabanus text does not explain the raven's presence, and thus both the origin and meaning of the motif, if it was not introduced purely for formal reasons, remain obscure. What is not obscure, however, is the probability that the Cassinese manuscript is directly connected with the appearance of this motif in the Salerno panel; after all, the Hrabanus manuscript was made in just that artistic center, Monte Cassino, that so strongly influenced the art of southern Italy. It is conceivable that both the Hrabanus illustration and the ivory revert to the same source for this scene; if so, it was a model outside the Cotton Genesis and Octateuch traditions.[80]

God Orders Noah to Leave the Ark (Fig. 10), Genesis 8:15–19

In the upper left corner is an arc of heaven containing a half-length figure of the nimbed Creator, who extends his hand out of the arc in a gesture toward Noah. Followed by two of his sons, Noah stands at the open door of the ark, about to emerge. He extends both hands and inclines his body in veneration of the Creator. The stylized groundline is intended to represent the dry earth. The ark here is similar to the two preceding examples in general form but lacks the diaper-work decoration.

Neither the Cotton Genesis recension nor the Octateuchs in their present state contain this exact scene; instead, they show the following stage in the narrative: the actual disembarkation from the ark.[81] No image of the Creator in any form appears in these scenes, probably because he is not mentioned in the text describing the exit proper (8:18–19), but only in the three preceding chapters (15–17). The Salerno scene probably represents a conflation of these two moments in the narrative; in the ivory, (1) the Creator is shown imploring Noah to leave the ark, and (2) Noah is shown actually stepping forth from the ark. Neither at San Marco nor in the Octateuchs are there examples of the actual moment when Noah steps forth. At San Marco he is shown standing with his family before the ark, helping to take out the animals. Thus the action of verse 18, where Noah and his family depart from the ark, is not shown at San Marco. The version in the Octateuchs shows the family still in the ark, while the animals stand outside.

The only composition even remotely parallel to the Salerno scene is in the Caedmon manuscript. On page 68 (Fig. 74), we see the Creator standing outside the door with one hand still on it and the other in a gesture of speech. This scene must depict God ordering Noah to leave the ark. In the next illustration, on page 73 (Fig. 75), we see the Creator holding open the door, while Noah and his family emerge from the ark.[82] These are the two scenes conflated in the

78. A. Grabar, "Images bibliques d'Apamée et fresques de la synagogue de Doura," *Cahiers Archéologiques* 5 (1951):fig. 1.

79. Monte Cassino, Monastery Library, ms. 132, p. 292. See A. Amelli, *Miniature sacre e profane illustranti l'enciclopedia medioevale di Rabano Mauro* (Monte Cassino, 1896), pl. 70.

80. The appearance of the raven pecking on an impaled head in the Aelfric manuscript may be related to the unusual iconography in the Salerno ivories. See M. McGatch, "Noah's Raven in Genesis A and the Illustrated Old English Hexateuch," *Gesta* 14 (1975):11–12.

81. San Marco: Bettini, *Mosaici antichi,* pl. 56. Octateuchs: Smyrna, fol. 21r (Hesseling, *Miniatures,* fig. 33); Seraglio, fol. 59v (Ouspensky, *Octateuque,* fig. 38); Vat. gr. 746, fol. 55v; and Vat. gr. 747, fol. 30r.

82. Gollancz, *Caedmon Manuscript,* pp. 68 and 73.

ivory. Lack of space in the Salerno rendering must be the reason for the half-length Creator in an arc of heaven instead of the full-length figure.

Sacrifice of Noah (Fig. 10), Genesis 8:20

In the center appears a flaming altar, upon which is an offering of three animals: an ox, a bird, and a ram. Noah stands to the left of the altar and cuts open the ram, while his three sons, dressed in short tunics, stand at the right, the central one holding his hands in front of his chest, perhaps in a gesture of prayer. At the center top of the scene is an arc of heaven from which the *manus dei* emerges, pointing toward Noah.

The Cotton Genesis recension as represented in the San Marco mosaics offers a totally different interpretation of the scene: only Noah (without his sons) appears at the altar, carrying his sacrifice in his hands. Although no arc of heaven appears at San Marco, one does appear in the Millstatt Genesis (fol. 22r.), a member of the Cotton Genesis recension; so the motif might very well have been in the archetype.[83] It would seem to be required by the text.

It is clear that the Salerno version of this scene has close affinities with the iconography used in the Octateuchs (Fig. 76).[84] There, too, the altar is the central feature in the composition, and the three sons stand to the right and Noah to the left. Noah is accompanied also by his sons' wives, who were omitted at Salerno

for lack of space. As in the Salerno panel, an arc of heaven with a hand of God appears directly over the altar. A significant difference exists, though: in the Octateuchs Noah is shown praying over the altar; in the ivory he is actually engaged in the performance of the sacrifice.[85]

God and Noah Establish the Covenant (Fig. 11), Genesis 9:1–18

The Creator stands to the left, blessing Noah and his three sons, who bow deeply before him. The wives of Noah's sons accompany them, standing behind their husbands.

Surprisingly enough, no monument connected with the Cotton Genesis recension preserves this important scene.[86] The Octateuchs do represent the scene in a form that may ultimately be related to the Salerno version,[87] but the only really close parallels to this scene are found in the Aelfric manuscript (Fig. 77)[88] and the frescoes of Saint-Savin.[89] In the Aelfric miniature the Lord's rainbow arches over the entire scene, while Noah, accompanied by his sons and daughters-in-law, bows before the figure of the Creator. Even the gestures of the women— holding their hands up to their chests—are similar to those of figures in the ivory. The absence of the rainbow would seem to be an oversight on the part of the Salerno carver or a result of the curtailed format of his panel. It is possible, however, that the rainbow was represented in the previous scene of the *Sacrifice of Noah* in

83. San Marco: Bettini, *Mosaici antichi*, pl. 56. Millstatt Genesis: Kracher, *Millstätter Genesis*, fol. 22r.

84. Smyrna, fol. 21v (Hesseling, *Miniatures*, fig. 34); Seraglio, fol. 60v; Vat. gr. 746, fol. 57r; and Vat. gr. 747, fol. 30v.

85. The scenes at both Sant'Angelo in Formis (unpublished) and Monreale (Demus, *Mosaics*, fig. 101) are close to the Salerno type, but all figures are on one side of the altar and Noah does not actually perform the sacrifice. At Monreale the rainbow is depicted.

86. At San Marco the only remnant of this scene is the inclusion of the rainbow in the *Disembarkation from the Ark* (see Bet-

tini, *Mosaici antichi*, pl. 56). There is room for this scene, however, in Weitzmann's reconstruction of the Cotton Genesis manuscript.

87. Smyrna, fol. 22r (Hesseling, *Miniatures*, fig. 35); and Seraglio, fol. 62r (Ouspensky, *Octateuque*, fig. 39); Vat. gr. 746, fol. 57v; and Vat. gr. 747, fol. 31r.

88. Henderson, "Late Antique Influences," fig. 35b.

89. Gaillard, *Fresques*, pl. 4. Here the scene appears out of sequence; it is followed by the *Sacrifice*. Nevertheless, the presence of the full-length Creator establishes a connection with the Salerno cycle.

the top layer of the unusual two-level arc of heaven at the top of the composition. The rainbow clearly appears in the *Sacrifice* scene in the mosaics at Monreale.[90]

Making of Wine (Fig. 11), Genesis 9:20–21

In the upper left portion of the composition is a sizable trellis over which hang grape-bearing vines. Noah, standing to the right of the trellis, eats some of the grapes he has obviously just picked. Behind him appear two figures, one above the other, shown on a considerably smaller scale than Noah. The one on top is handing down a basket of grapes he had just picked to the second figure, who stands in a vat stamping grapes. A third small-scale figure stands in front of Noah under the trellis, pouring the wine from a two-handled jar through a funnel into a barrel.

The Cotton Genesis tradition provides no precedent for the genrelike approach of the Salerno scene, with its details of the actual production of wine. In the Cotton Genesis recension Noah appears alone in what were probably originally two stages of the story, the making of the wine and the drinking of the wine.[91] Although the Octateuchs are closer to the Salerno version in that they present Noah's three sons as assistants in the wine-making process,[92] the Octateuch iconography bears little specific resemblance to the ivory. Although no version of this scene forms a precise parallel to the Salerno rendering, the Aelfric manuscript offers interesting correspondences (Fig. 78).[93] Here the story of the growing of the grapes and the making of the wine is told in two phases. In the first Noah, spade in hand, stands before a trellis on which the vines are draped; in the second all the members of Noah's family help operate a large wine press that takes up most of the central section of the composition. The Aelfric illustration, and the related version at Saint-Savin,[94] appear to provide the sole parallels for the image of Noah standing before the trellis. The Aelfric manuscript also shows details of the wine-making process, but the methods of production differ: the mechanization of the process in the Aelfric picture contrasts markedly with the manual labor shown at Salerno. The Salerno scene appears to be a conflation of the two phases of the narrative shown in the Aelfric manuscript.

Nakedness of Noah (Fig. 12), Genesis 9:22–27

In the foreground Noah lies asleep on a bed, his head to our right. At the head of the bed a bottle, surely of wine, is prominently displayed. Three other figures, all wearing short tunics, are present. Standing above Noah, Ham, one of his sons, gestures toward his father with one hand and away with the other, as if to indicate the presence of the sleeping man to someone else. A second son, either Shem or Japheth, is shown with his back to Noah, placing a cover over his body. The third figure, Canaan (Ham's son), moves off to the left, his right hand raised to his face. Canaan's left hand is held at his waist, but the wrist is bent so that the hand points down to indicate shame in much the same manner found in the *Expulsion* and the *Condemnation of Cain*. The whole scene is placed against a background of domed buildings that appear to be contained behind a city wall.

The ivory's composition represents a con-

90. Demus, *Mosaics*, fig. 101.

91. San Marco: Bettini, *Mosaici antichi*, pl. 59. For the *Hortus*, see Straub and Keller, *Hortus deliciarum*, pl. 9.

92. Smyrna, fol. 22v (Hesseling, *Miniatures*, fig. 36); Seraglio, fol. 62v; Vat. gr. 746, fol. 58r; and Vat. gr. 747, fol. 31v.

93. See Dodwell and Clemoes, *Illustrated Hexateuch*, fol. 17r.

94. Gaillard, *Fresques*, fig. 11, pl. 5.

flation of several points in the narrative, and these many best be unraveled by comparison with the Aelfric manuscript (Fig. 79).[95] Here, three separate minatures depict four events recounting the story: (1) Ham discovers Noah; (2) Ham tells Shem and Japheth of his discovery (these scenes are shown in reverse order); (3) Shem and Japheth cover Noah while Ham speaks with them; and (4) Noah blesses Shem and Japheth and curses Canaan. In the Salerno ivory, elements from at least three of these stages appear to be present. Ham, who points to the figure of Noah, comes from the second stage; the brother who keeps his back to Noah while covering him is from the third (only one brother is shown instead of the two required by the text); and the figure of Canaan, who leaves the scene at the left, is derived from the fourth stage.

Although both the Octateuch[96] and Cotton Genesis[97] recensions offer general parallels for certain aspects of this scene in the ivories, the most significant correspondences are with the Aelfric manuscript. The figure of Ham who points to Noah with his left hand and toward his brothers with his right is similar in both examples. In both the ivory and the manuscript Noah is covered not with a tunic as in the Octateuch and Cotton Genesis recensions but with a bedcover. Finally, the figure of the cursed Canaan, one hand at his waist, the other raised to his face, is virtually identical in the Aelfric and Salerno renderings.[98]

Only in the ivory is the scene represented against the background of a cityscape. The text does not call for such a setting, and it is clearly the invention of the carver, who derived inspiration for it from certain of the models employed for his New Testament scenes. These models will be discussed at some length in the following chapter.

The Tower of Babel (Fig. 12), Genesis 11:1–9

At the left appears the usual Salerno full-length Creator figure, gesturing toward ten smaller men in short tunics who are engaged in various activities connected with building the tower, at the right. The tower is rather narrow, and only twice the height of the men who build it. Among the workmen are two who point toward their mouths to indicate the confounding of their tongues.

The illustration in the Octateuchs clearly has nothing to do with the Salerno panel,[99] but the iconography of the building of the tower in the Cotton Genesis tradition is closely related to the ivory version. Both in the Cotton Genesis manuscript itself and in the San Marco mosaic the tower is shown as a rectangular structure (Fig. 80); in the manuscript its proportions are very close to those of the tower in the ivory. Despite the fact that the Salerno and San Marco renderings represent different conflations and transformations of the scenes as they must have appeared in the archetype,[100] we can still find close connections between certain figures, for instance, the young man who mixes the mortar

95. See Dodwell and Clemoes, *Illustrated Hexateuch.* fols. 17v and 18r.

96. Smyrna, fol. 23r (Hesseling, *Miniatures*, fig. 41); Seraglio, fol. 64r; Vat. gr. 746, fol. 59v; and Vat. gr. 747, fol. 32r.

97. San Marco: Bettini, *Mosaici antichi*, pl. 59.

98. Neither in the San Marco version nor in the Octateuchs are the sons dressed in short tunics. The use of the bed with a frame in the Salerno scene is more like the portrayal in the Cotton Genesis recension than that in the Octateuchs. These ele-

ments, of course, are not decisive for establishing recensional affiliations.

99. Smyrna, fol. 24v (Hesseling, *Miniatures*, fig. 42); Seraglio, fol. 65v (Ouspensky, *Octateuque*, fig. 43); Vat. gr. 746, fol. 61v; and Vat. gr. 747, fol. 33v.

100. San Marco: Bettini, *Mosaici antichi*, pl. 62. For the manuscript fragment, see Henderson, "Late Antique Influences," fig. 34b, and Tsuji, "Essai d'identification," figs. 23a and 23b. The San Marco version of the scene is conflated and Christianized.

with a hoe to the right of the tower in both examples, or the one who reaches down from the center of the left side of the tower and the figure who reaches up toward him. Probably the most characteristic feature of the Salerno version, the half-length figure at the top of the tower leaning out and gesturing with his right hand, does not appear in the mosaic; but the same motif appears in an engraving made after one of the Cotton Genesis fragments in the eighteenth century (Fig. 81).[101]

The Cotton Genesis manuscript had three illustrations for the story of the tower: the building, the confounding of the tongues, and the scattering of men.[102] The Salerno ivory conflates all three of these episodes: the workmen who actually wield tools are derived from the first, those who indicate their mouths from the second, and the gesturing figure at the top of the tower from the third. The ivory, of course, also differs from the Cotton Genesis tradition by including the full-length Creator figure, which, as noted earlier, never appears in the Cotton Genesis recension following the *Expulsion*.

Also important for an understanding of the origins of the Salerno version is the rendering of the scene in the Caedmon manuscript (Fig. 82).[103] Here, too, the tower is of modest proportions and is characterized by the same half-length figure at its top found in the ivory and in the Cotton Genesis tradition. In this case, however, his action is made more rational through the inclusion of an axe in his outstretched hand. A second figure emerges from the left side of the tower, as in the Salerno panel. Although the Caedmon picture represents a conflation of elements different from

those incorporated at Salerno (some invented, others taken from different sources), its inclusion of a full-length Creator figure carrying a scroll and talking to a group of workers indicates reliance on a source available to the Salerno artist; the full-length Creator type in the *Tower of Babel* scene is so unusual as to make a dependence on a common tradition virtually certain.[104] This means that the iconography of the Salerno ivory is not the invention of the carver himself, made through his own initiative in transforming a scene based on the Cotton Genesis recension; rather, the Salerno iconography is derived from a model in which the full-length Creator figure was an integral part.

God Commands Abraham to Leave Haran —Sarah and Lot in Abraham's House (Fig. 13), Genesis 12:1–3, 4–5

In the left half of the panel appears the Creator, gesturing downward toward a figure who bows and extends his hands toward the Lord. A cityscape appears in the background to the right, but the area behind the figures is left blank. The right half of the panel shows, on the left, a male figure with a short beard who is dressed in a chlamys; he gestures toward a female figure who stands to his right and faces him. A stylized architectural form stands at the extreme right of the scene.

In every other scene of the Old Testament cycle the main character in the episode— Adam, Eve, Noah, Abraham, Jacob, or Moses— is clearly predominant. Since there is no main figure in the second section of this panel, one may presume that the figures here are intended to be part of the scene in the first half of the

101. The engraving is pl. 67, no. 5, in vol. 1 of the *Vetusta.*
102. Henderson, "Late Antique Influences," pp. 179–180.
103. Gollancz, *Caedmon Manuscript*, p. 82.
104. The full-length Creator of the *Babel* scene appears in no monuments associated with the Cotton Genesis or Octateuch traditions. The only example other than the Caedmon and Salerno versions is the fresco at Saint-Savin (Gaillard, *Fresques*, pl. 8).

panel. For this reason I consider the two halves of this panel together.

Identifying this panel's subject has always presented a problem. Goldschmidt proposed two different subjects: *Abraham with Sarah and Lot in Egypt* (Genesis 13:1) or *Abraham's Prayer with Sarah and Abimelech* (20:16–17).[105] But, neither of these episodes includes any appearance of God before Abraham. And the latter does not seem to fit because the male figure represented is not given the crown worn by kings in other Salerno panels and is thus hard to identify as Abimelech. Carucci proposed the *Calling of Abraham* (15:5–7) and *Hager with Ishmael.*[106] Again the explanation seems wanting: in Genesis 15 God tells Abraham to look up and count the stars, not to bow toward the ground; and the male figure at the right would hardly be bearded if he were meant to be a thriteen-year-old boy.

Neither Goldschmidt nor Carucci was able to find any comparative visual material to support his proposal. But there is one representation that does parallel the Salerno plaque. On page 84 of the Caedmon manuscript (Fig. 83) a number of scenes from the Abraham story are illustrated.[107] The one in the middle shows the departure of Abraham and his family for Canaan. Depicted above this scene, at the top of the page, is a composition remarkably close to the rendition in the ivory. The Creator stands at the left holding a scroll, and Abraham, standing to the right, gestures toward him. Behind Abraham, in the right-hand portion of the page, is an architectural construction with a large arch in its center. Within this arch appear two figures, a young man and a woman, who gesture toward the main action of the scene. Simply from the placement of the scene on the page, its identification as *God Commands Abraham to Leave Haran* and *Sarah and Lot in Abraham's House* is clear. The parallel with the Salerno plaque is so close, and the two compositions are so unusual, that the identification of the ivory's subject as the same as that of the Caedmon illustration seems secure.[108]

There is no parallel for this scene in either the Cotton Genesis or the Octateuch tradition.[109] In both, the first part of the episode, wherein God orders Abraham, is represented simply by a figure of Abraham in front of a hand of God issuing from the sky. In neither place do we find the accompanying figures of Sarah and Lot, and both traditions, as already pointed out, omit the full-length Creator figure in all scenes following the *Expulsion*. The discovery of the scene, including the full-length Creator, in the Caedmon manuscript indicates that it was not an invention or interpolation of the Salerno carver but must have been contained in a tradition drawn on by those who executed both the Salerno and Caedmon scenes.

In this scene, as in the *Nakedness of Noah,* the architectural background used must not have been in the model; undoubtedly its origin was the Grado Chair ivories, which served as sources for part of the New Testament cycle in the Salerno group. The carver is probably responsible for the fact that Abraham bows in such an extreme way, with his upper torso almost horizontal, and for the unusual gesture of the Creator's right hand. This hand points

105. Goldschmidt, *Elfenbeinskulpturen,* 4:38.
106. Carucci, *Avori,* pp. 60–61.
107. Gollancz, *Caedmon Manuscript,* p. 84.
108. A similar iconography appears in only one other place: the Bible of Guyart Desmoulins of about 1400 (British Library,

cod. Harley 4381–4382, fol. 17r; unpublished photograph at Princeton University, Index of Christian Art).
109. San Marco: Bettini, *Mosaici antichi,* pl. 63. Octateuchs: Smyrna, fol. 26r (Hesseling, *Miniatures,* fig. 43); Seraglio, fol. 68v; Vat. gr. 746, fol. 64v; and Vat. gr. 747, fol. 34v.

straight down toward the ground and apparently indicates a negative attitude toward that particular spot. With the scene identified as *God Commands Abraham to Leave Haran,* the gesture makes sense as designating the land Abraham leaves on God's command.

God and Abraham at Sichem (Fig. 14), Genesis 12:7

A flaming altar appears at the center of the composition. The Creator stands to the left of the altar and gestures with his right hand toward Abraham, who stands to the right with both hands outstretched toward the Creator.

Although Goldschmidt identified the scene as *Abraham and God at the Flaming Oven* (Genesis 15:17),[110] the fact that the following episode illustrates Genesis 12:18–20 makes this unlikely. The story of Abraham at the altar of Sichem, from an earlier part of Genesis 12, amply fits the representation and maintains the chronology. Carucci, too, proposed this identification.[111]

The Salerno panel is in some ways similar to the Octateuch version,[112] but it differs in portraying a full-length Creator figure instead of the simple hand. As in some earlier panels, here it is possible that the creators of the Salerno scene altered the Octateuch type in this way to make the scene consistent with the Cotton Genesis approach of the earlier parts of the cycle. In other scenes, compositions fundamentally derived from the Octateuch or Cotton Genesis recension have been changed in significant ways (particularly by the inclusion of the full-length Creator), and I have adduced earlier examples of identical transformations to show that the Salerno type was not an invention of the carver. In the present instance, although no model is extant, I think that the model used by the Salerno carver would have incorporated the transformation. Admittedly, however, the iconography of this scene is too generalized to offer any certain indication of its affiliations.

Abraham and Sarah before Pharaoh (Fig. 14), Genesis 12:18–20

Pharaoh sits at the left on a high-backed throne, his feet resting on a footstool. Behind the throne stand two guards, only partly visible. Paraoh gestures with his right hand toward Abraham and Sarah, who stand before him. Abraham gestures toward the ruler with both hands, while Sarah raises her veiled hands to her face and bows her head.

Goldschmidt identified the scene as either *Abraham and Sarah before Abimelech* (Genesis 20:9 ff.) or *Abraham and Sarah before Pharaoh.*[113] I suspect that his proposing the Abimelech episode was an attempt to make this scene follow logically the previous one, which he had identified as that of the flaming oven described in chapter 15. With my identification of this prior scene as illustrating an episode in chapter 12, the need to associate the present scene with Abimelech no longer exists. Futhermore, it is more in keeping with the scene's simple nature to identify it as *Sarah and Abraham before Pharaoh* from chapter 12 than as the more complex Abimelech scene.

My identification is amply supported by comparison with the Octateuchs, where on the folio following the previous scene of *God and Abraham at Sichem* there appears the illustration of *Abraham and Sarah before Pharaoh* (Fig. 84).[114] The story is told in two phases in the

110. Goldschmidt, *Elfenbeinskulpturen,* 4:38.
111. Carucci, *Avori,* pp. 105–110.
112. Smyrna, fol. 26r (Hesseling, *Miniatures,* fig. 45); Seraglio, fol. 68v; Vat. gr. 746, fol. 64v; and Vat. gr. 747, fol. 34v.

113. Goldschmidt, *Elfenbeinskulpturen,* 4:38.
114. Smyrna, fol. 26v (Hesseling, *Miniatures,* fig. 47); Seraglio, fol. 69r; Vat. gr. 746, fol. 65r; and Vat. gr. 747, fol. 35r.

Octateuchs, and the composition at Salerno seems to come closest to the second scene, where Sarah is restored to Abraham.

From the general similarity with the Octateuchs, one might conclude that the Salerno composition derives from that recension. However, since this scene is not extant in the Cotton Genesis monuments (it was on a lost page in the Cotton Genesis manuscript), it is not possible to make a decision on the matter. The scene of *Abraham and Sarah before Pharaoh* is, in fact, very rarely depicted except in the densest manuscript cycles, and its appearance in the Salerno cycle indicates the ultimate derivation of the cycle from a manuscript tradition. Owing to the paucity of comparative material, the question of which pictorial tradition was responsible for the invention of this scene must, for the time being, remain unanswered. One should, however, note that a similar version of the scene appears in the Aelfric manuscript.[115]

God and Abraham at an Altar (Fig. 15), Genesis 13:3–4 or 13:18

This scene is represented on one of the surviving square plaques that may be only one-half of a panel originally having a format similar to that of the other Old Testament reliefs. The Creator stands to the left facing the altar and raising his right hand in a gesture of speech. Abraham, his hands outstretched toward the Creator and the altar, the main feature of the scene, appears to the right. The altar itself is a cloth-covered table over which rises an impressive domed ciborium, three columns of which are visible.

It is difficult to decide precisely which epi-sode of the text is illustrated here. There are four moments in the Abraham narrative when God and Abraham communicate at an altar. The first occurs in Genesis 12:7, at Sichem, an episode already represented in the Salerno cycle. The second is recounted in the next verse, 12:8, but this can hardly be the scene represented here because intervening between the two scenes is *Abraham and Sarah before Pharaoh* from Genesis 12:18–20. We are left with two alternatives, both from chapter 13: (1) the episode from Genesis 13:3–4, where Abraham returns to the place where he had earlier built an altar (between Bethel and Haggai) and "calls upon the name of the Lord"; or (2) the episode in Genesis 13:14–18, where God appears to Abraham after he and Lot had parted and tells him of all the land that is to be his. After this, Abraham goes to Mambre and there builds a tabernacle to the Lord. I would argue that the Salerno scene portrays the second event. The structure with the baldachin may well be the "tabernacle" rather than a simple altar. My identification requires that we envision a conflation of two events in the biblical text, God appearing to Abraham and the building of the altar, and precedent exists for just such a depiction: the Aelfric manuscript contains an illustration for Genesis 13:14–17 with Abraham shown bowing at an altar, above which the hand of God appears issuing from heaven.[116]

None of the monuments of the Cotton Genesis recension preserves this scene, although it may once have been in the Cotton Genesis manuscript.[117] In the Octateuchs the episodes in Genesis 13:14–18 are represented in two scenes:[118] the first shows God speaking to Abraham and the second represents Abraham

115. Dodwell and Clemoes, *Illustrated Hexateuch*, fol. 22v.
116. Ibid., fol. 24r.
117. There is room for this scene in Weitzmann's reconstruction of the Cotton Genesis manuscript.

118. Smyrna, fol. 27r (Hesseling, *Miniatures*, fig. 50); Seraglio, fol. 70r; Vat. gr. 746, fol. 66v; and Vat. gr. 747, fol. 35v.

twice, standing before and sitting next to a flaming altar. Aside from the expected absence of the full-length Creator figure, the form of the altar and the specific pose of Abraham are completely different from those elements in the Salerno ivory. Because this part of the Genesis story is missing from the Cotton Genesis recension cycles, it is impossible to know how this scene would have appeared there. One thing is certain, though: in the Cotton Genesis recension the Creator would not have appeared in full length as he does in the ivory. Thus, if we assume that the Salerno artist did not invent his iconography, we must postulate a model distinct from both the Octateuchs and the Cotton Genesis tradition in this respect.

The Caedmon manuscript (Fig. 86) provides the closest parallel to the Salerno rendition.[119] There, in two scenes, as yet unsatisfactorily identified, we see the full-length Creator standing before Abraham and then at the right Abraham again, this time carrying some sort of offering toward a city, probably intended to represent the tabernacle. It is a conflation of these two scenes that I envision as having occurred at Salerno. It is significant that the Caedmon illustration preserves the full-length figure of the Creator at this late point in the narrative.

Between this scene of *Abraham and God at an Altar* and the *Sacrifice of Isaac*, the next episode preserved in the ivories, there intervene nine chapters of Genesis for which no panels are extant. This is surprising considering the density of the Abraham story in the Salerno cycle: the earlier scenes are never separated by more than two chapters. This suggests the possibility that indeed there is a loss at this point, an idea supported by the fact that an event of great importance in the narrative of Abraham occurs almost midway in the text between *God and Abraham at the Altar* and the *Sacrifice of Isaac.* This is the episode of *Abraham and the Three Angels* (Genesis 18:1–15), a story whose Trinitarian overtones had made it an important focal point of the Christian typological tradition of Old Testament exegesis and that had a long tradition in visual form.[120] That the scene originally appeared at Salerno is suggested by its occurrence in virtually all of the related Italian cycles that include Abraham and in the drawings made from the San Paolo fuori le mura frescoes.[121] Since the ivory plaque almost certainly was originally in two parts, the episode probably was shown in its two-stage version—*Abraham's Encounter with the Angels* and *The Hospitality of Abraham*—as in the mosaics at Monreale (Fig. 87).

Sacrifice of Isaac (Fig. 16), Genesis 22:9–13

Abraham stands at the center of the scene, holding in his right hand a knife or short sword; with his left he grabs and holds by the hair the nude figure of Isaac. Isaac, blindfolded, is bound at the wrists and ankles and rests upon a square altar facing his father. Abraham turns his head around to face backward and beholds a bust-length figure of the Creator within an arc of

119. Gollancz, *Caedmon Manuscript*, p. 87.

120. On the subject in general, see F. Cabrol and H. Leclercq, *Dictionnaire d'archéologie chrétienne et de liturgie*, vol. 15, pt. 2 (Paris, 1953), cols. 2787–2788; and W. Braunfels, "Dreifaltigkeit," in *Lexikon der christlichen Ikonographie*, vol. 1 (Rome, 1968), cols. 525–537. Among the early important examples are those in the Via Latina catacomb of the fourth century (A. Ferrua, *Le pitture della nuova catacomba di Via Latina*, Rome, 1960, pl. 24) and in Santa Maria Maggiore of the fifth century (H. Karpp,

Die frühchristlichen und mittelalterlichen Mosaiken in S. Maria Maggiore zu Rome, Baden-Baden, 1966, pl. 32).

121. Waetzoldt, *Kopien*, fig. 341 (San Paolo). For Palermo and Monreale, see Demus, *Mosaics*, figs. 33 and 103; for San Giovanni a Porta Latina, see Wilpert, *Mosaiken und Malereien*, 4:pl. 255. The Sant'Angelo in Formis fresco is unpublished. San Marco also showed this episode, in a two-part version (Bettini, *Mosaici antichi*, pl. 64).

heaven in the upper left corner of the scene. The Creator gestures toward Abraham with his right hand; with his left he points to a ram directly beneath him.

The San Marco mosaics lack this scene, as does the Cotton Genesis manuscript (although an old collation shows that the scene was lost at an early date),[122] so that the primary witness for the *Sacrifice* in the Cotton Genesis recension is the illustration in the Millstatt Genesis (Fig. 88).[123] Here important parallels with the Salerno version do appear. Isaac, although dressed in a tunic and fettered in front, is placed on the altar and faces Abraham, who holds him by the head and raises a sword. Abraham does not turn around to confront the hand of God, however, but faces forward (the hand is missing but presumably would have been there in the archetype). The ram appears at the bottom right of the scene.

The Octateuch iconography differs significantly from the Cotton Genesis type, and from the ivory, in that Isaac is shown in front of the altar and facing away from his father, who holds him by the hair with one hand and holds a knife to his throat with the other.[124]

Certain elements of the composition are not accounted for by the preserved monuments of the Cotton Genesis tradition. For example, in the Millstatt Genesis Isaac does not appear nude, but wears a short tunic. He is nude, though, in the frescoes at Old St. Peter's and at San Paolo fuori le mura in Rome.[125] Except for this one detail, the San Paolo fresco agrees with the Millstatt Genesis representation. Whether the nude Isaac of the frescoes, and thus the Sa-

lerno ivory type, represents the version in the ultimate archetype, or whether the clothed type in the Millstatt Genesis was more faithful to the original, is a debatable point, although I suspect the nude Isaac was the earlier rendering.

Among the contemporary monuments closest to the ivory is the fresco in Sant'Angelo in Formis (Fig. 89). Here Isaac is found on the altar facing his father, who grasps him by the hair with one hand and raises a sword in the other. Even the manner of raising the sword—in front of the face instead of pulled back behind the head—is similar. There are two important differences, however, between the two works. At Sant'Angelo Isaac is clothed and the Lord is represented by a three-quarter-length angel who appears out of the sky. In order to face the angel, who is mentioned in the biblical narrative, Abraham turns his head as at Salerno; the bust of the Creator at Salerno, as far as I can tell, not only contradicts the text, but is unique among the monumental evidence. His peculiar gesture, pointing with one hand to the ram below and with the other communicating with Abraham, seems to be an anecdotal detail introduced by the Salerno artist. Surely this is an instance in which the Creator bust was used to replace something else, perhaps a hand, perhaps the angel described in the text.

Almost as unusual as the appearance of the Creator bust in this scene is the fact that Isaac is blindfolded. As far as I can ascertain, this device is found in only three other examples of the *Sacrifice,* the most relevant of which is a fourth-century Roman gold-glass in the Vatican.[126] There, although the general iconography is

122. Weitzmann, "Observations," p. 122.

123. Kracher, *Millstätter Genesis,* fol. 29r. Weitzmann ("Observations," p. 123) had already pointed to the connections between this ivory and the *Sacrifice of Isaac* in the Millstatt Genesis.

124. Smyrna, fol. 35r (Hesseling, *Miniatures,* fig. 80); Seraglio, fol. 88r; Vat. gr. 746, fol. 83r; and Vat. gr. 747, fol. 43v.

125. Waetzoldt, *Kopien,* figs. 343 (San Paolo) and 484 (St. Peter's). In general, see I. Speyart van Woerden, "The Iconography of the Sacrifice of Abraham," *Vigiliae Christianae* 15 (1961):214–255.

126. See C. R. Morey, *The Gold Glass Collection of the Vatican Library,* Catalogo del Museo Sacro della Biblioteca Apostolica Vaticana, 4 (Vatican City, 1959), p. 17, no. 71, pl. XII.

clearly related to another tradition, the appearance of the blindfold suggests its origin in a Roman tradition.[127]

In characterizing certain of the iconographic elements of the *Sacrifice* in the Salerno ivories, I mentioned that the Cotton Genesis tradition included the figure of Isaac on the altar facing his father, who grabbed him by the hair. In the ivory position of Abraham, whose body faces toward the altar but whose head is turned 180 degrees in order to look back at the Creator, probably resulted from considerations of space, but in fact, these very elements were not combined for the first time at Salerno. Representations of the scene on two practically identical sixth-century Coptic textiles show the same combination.[128] There, Isaac is nude and his hands are fettered behind his back. One might expect this to have been the case also in the Cotton Genesis recension archetype. Possibly the only original contribution of the Salerno artist to the iconography of this scene was the substitution of a bust of the Creator for a half-length angel.

God Blesses Abraham (Fig. 16), Genesis 22:16–18

The Creator stands to the left, his right hand extended toward Abraham, his left holding a scroll. As in the previous scene, he is unnimbed. To his right, facing him, appears Abraham, bowing from the waist and extending his arms outward and downward toward the feet of the Creator.

None of the monuments of the Cotton Genesis tradition preserves this scene, although it was portrayed on a missing leaf of the Cotton Genesis manuscript. In the Octateuchs the scene does occur, but in conflated form.[129] An angel, half-length, appears out of the sky at the upper left corner of the picture and gestures down toward Abraham, who is moving off to the right but who turns his head to receive the angel's blessing. At the right are the two servants whom Abraham is described as rejoining after the blessing and the "well of the oath" at which they then began to dwell.

The Octateuchs lack the full-length Creator figure, and the missing scene from the Cotton Genesis recension would certainly not have included it. In this scene, the use of the full-length Creator in the ivory diverges not only from the two main sources for the Salerno cycle but from the biblical text itself, which says an angel communicated with Abraham. As has become clear, the presence of this full-length Creator in this and the other post-*Expulsion* scenes is one of the most significant characteristics of the Genesis iconography associated with the Salerno ivories.[130]

Jacob's Dream (Fig. 17), Genesis 28:10–15

Jacob lies in the lower right corner, curled up asleep on the ground, his head resting on a

127. The other two examples are the closely related mosaic in the Cappella Palatina (Demus, *Mosaics*, pl. 34) and the ninth-century Sedulius manuscript in Antwerp (Museum Plantin-Moretus, cod. M.17.4, fol. 8r; photograph at Princeton University, Index of Christian Art), which relates to a different iconographic tradition.

128. One is in the Cooper-Hewitt Museum in New York (see Brooklyn Museum, *Pagan and Coptic Egypt* [exhibition catalogue], New York, 1941, p. 80, no. 253); the other is in the Musée historique des tissus in Lyon (see W. de Grüneisen, *Les caractéristiques de l'art copte*, Florence, 1922, pl. 24, no. 5). These textiles are dated in the sixth century by the editor of the Brooklyn Museum catalogue.

129. There is room for this scene in Weitzmann's reconstruction of the Cotton Genesis manuscript. Octateuchs: Smyrna, fol. 35r (Hesseling, *Miniatures*, fig. 81); Seraglio, fol. 89r; Vat. gr. 746, fol. 83v; Vat. gr. 747, fol. 43v.

130. The only place among the monuments of the Cotton Genesis group where the Lord appears in full figure is in *God Promising Abraham His Posterity* in the Millstatt Genesis (Kracher, *Millstätter Genesis*, fol. 25v). Several other bust-length Creator figures appear in the Noah and Abraham sections of this manuscript. They could represent inventions of the German miniaturist but they could also indicate a model related to but distinguished from the Cotton Genesis recension proper.

pile of four stones. A ladder stretches diagonally from the lower left corner to the upper right, where it meets an arc of heaven enclosing five incised stars. On the ladder are two angels moving up toward the arc, the second of whom turns to look toward the ground. In the upper left-hand corner is a second arc of heaven, which frames a large eight-pointed star.

Although this scene is lacking in the San Marco mosaics, it is represented in the Cotton Genesis tradition by similar versions in the Millstatt Genesis (Fig. 90) and the *Hortus deliciarum*.[131] In these examples the ladder with two angels (one goes up, one comes down) is placed to the right of the scene and leads up to a cloud from which emerges a cross-nimbed head of Christ. Jacob lies on the ground with his head facing the ladder at the right. As in the ivory, he is portrayed as a mature man with a beard, dressed in a long tunic in the *Hortus* and in a mantle in the Millstatt Genesis.

The version in the Octateuchs[132] differs greatly from the Salerno rendering. In these manuscripts, as in the Cotton Genesis tradition, Jacob is shown sleeping with his head, not his feet, toward the ladder. The Octateuchs also differ from the ivory in that they depict Jacob as a young, beardless man wearing a short tunic.

Two elements of the Salerno composition, the position of Jacob with his head facing away from the ladder and the absence of the bust of Christ at the top of the ladder, are paralleled in the drawing after the fresco in San Paolo fuori le mura (Fig. 91).[133] Significantly, the lower angel on the ladder looks down, as in the ivory. But the drawing differs from the ivory in two ways:

Jacob is beardless and young, and he wears a short tunic, as in the Octateuchs.

Clearly, elements associated with the Cotton Genesis recension have been included in the ivory, but this source does not account for all the details of the Salerno version. The curled-up posture of the sleeping Jacob is not found in any other monument, and I think it is safe to say that it is the invention of the Salerno carver, who was forced to deal with a restricted square space. Another feature unique to the Salerno ivory is the second arc of heaven with its huge star. Although this motif is not found anywhere else, its meaning and motivation is explained by Carucci, who notes that the "star of Jacob" is discussed not only in the Book of Numbers but also in the liturgy of both the Roman and Byzantine church.[134]

Another detail of the ivory, the four stones that serve as Jacob's pillow, has an even more intriguing background. The number of stones is not specified by the biblical text, which says merely that Jacob took for his pillow "*of the stones of that place.*" Four stones are found in the representation of the Dream in the Aelfric manuscript, where Jacob also appears with his feet facing the ladder, as in the ivory (Fig. 92).[135] Four stones also appear under Jacob's head in an illustration in the Duke of Alba's Bible, and their occurrence there led Carl Nordström to investigate the motif.[136] He discovered that in rabbinical literature the number of stones used had been much debated, with various numbers being mentioned for different symbolic reasons. Four is one of those numbers, and Nordström suggests that the presence of the four stones in

131. Kracher, *Millstätter Genesis*, fol. 37v. *Hortus deliciarum*, fol. 36: Straub and Keller, *Hortus deliciarum*, pl. 12.

132. Smyrna, fol. 41v (Hesseling, *Miniatures*, fig. 99); Seraglio, fol. 102v (Ouspensky, *Octateuque*, fig. 57); Vat. gr. 746, fol. 97r; and Vat. gr. 747, fol. 50r.

133. Waetzoldt, *Kopien*, fig. 345.

134. Carucci, *Avori*, pp. 124–128.

135. Henderson, "Late Antique Influences," fig. 33e.

136. C. O. Nordström, "Rabbinic Features in Byzantine and Catalan Art," *Cahiers Archéologiques* 15 (1965):183–205; and idem, *The Duke of Alba's Castilian Bible* (Uppsala, 1967), pp. 63–66.

the Salerno ivory is a preservation of an early Jewish source that entered the Christian tradition and was somehow maintained through the course of many centuries of copying.

If we are to accept the idea that the four stones stem ultimately from a Jewish source, and I see no reason not to, then it is clear that their appearance in the ivory is an unusual survival of an early non-Christian motif. That the Salerno carver would not have invented this device is obvious, because he surely would not have had knowledge of the Jewish texts. The Jewish element must have been included in the early Christian prototype with which the Salerno cycle and the Aelfric illustration obviously have connections. At this early time Christians must have been in the process of adapting for their own use the narrative pictorial art that the Jews of the Diaspora had applied to the illustration of their literature. As the early Christian recensions of Old Testament illustrations evolved through the course of the Middle Ages, much of their Jewish legendary material must have been lost because Christian copyists no longer could understand the significance of the iconography. In some instances, however, this material survived in later derivatives of the early Christian models owing to chance, curiosity of the copyist, or the conservatism of the tradition of copying. The four stones in the Salerno *Dream,* as Nordström suggests, are just such an example of the rare survival of a Jewish element.[137]

THE EXODUS CYCLE

When we turn to scenes in the Salerno group derived from Exodus, we find many fewer depictions than in the Genesis series, and the comparative material is less clearly differentiated. A number of iconographical traditions do seem to assert themselves, but with nothing like the authority of the traditions of Genesis iconography in the earlier scenes. Furthermore, the only surviving Exodus cycles that maintain anything approaching their original complement of scenes are those in the Octateuchs.

Moses at the Burning Bush (Fig. 17), Exodus 3:2 ff.

Moses appears at the right, removing the sandal from his right foot. His left foot, bare, remains on the ground; the right leg is raised so that he can take off the sandal with both hands. At the bottom left is a conventionalized bush, afire with stylized flames. Above the bush is an arc of heaven in which there is a bust-length figure of the Lord, whose right arm overlaps the arc as he gestures toward the figure of Moses below.

The episode of Moses at the Burning Bush was one of the most important events of the Old Testament to the typologically minded Christians, and this scene was widely disseminated in art from early Christian times on. The sixth-century mosaic in the church of St. Catherine's on Mt. Sinai includes the basic elements of the version at Salerno.[138]

137. Nordström, *Duke of Alba,* p. 65. The problem of whether in pre-Christian times there was a highly developed Jewish narrative art that influenced the earliest Christian Old Testament cycles (and through them the later medieval tradition) has received much attention in the last several decades. Aside from Nordström's works, see, in particular, Weitzmann, "Septuagint," passim; idem, "Jewish Pictorial Sources," passim; O. Pächt, "Ephraimillustration, Haggadah und Wiener Genesis," *Festschrift Karl M. Swoboda,* ed. O. Benesch (Vienna, 1959), pp. 218–221; H. L. Hempel, "Zum Problem der AT Illustration," *Zeitschrift für*

die alttestamentliche Wissenschaft 69 (1957):103–131; idem, "Jüdische Tradition in frühmittelalterlichen Miniaturen," in *Beiträge zur Kunstgeschichte und Archäologie des Frühmittelalterforschung* (Graz, 1962), pp. 53–65; C. Kraeling, *The Excavations at Dura-Europas, Final Report 8, Part 1: The Synagogue* (New Haven, 1958); and J. Gutmann, "The Illustrated Jewish Manuscript in Antiquity," *Gesta* 5 (1966):39–44.

138. G. Forsyth and K. Weitzmann, *The Monastery of St. Catherine at Mount Sinai: The Church and Fortress of Justinian* (Ann Arbor, 1973), pl. 103.

That the scenes from the life of Moses also came to the Salerno carvers through a manuscript intermediary will become clear in a moment, and we must keep this in mind when considering the Burning Bush scene. The basic elements of the composition appear in the Octateuchs (Fig. 93).[139] Here Moses, this time with a nimbus, raises his right foot and removes his sandal with both hands while looking straight ahead. In the Octateuchs he looks toward a half-length angel who appears over the bush; in the ivory he looks toward the bust of the Lord in an arc of heaven in the sky. The half-length figure of the Lord in this scene seems only to be found in the West.[140]

In the drawing after the fresco in San Paolo fuori le mura, a slightly different composition appears: Moses does not remove his sandals, but simply stands (or kneels) before the bush.[141] This change might have been a copyist's error, but it also might indicate that a different time in the narrative is represented. Before Moses is ordered to remove his sandals, the text describes a moment when he discovers the Burning Bush itself. This episode of the "discovery" of the bush maintained itself as a separate scene in the Octateuchs. Thus the San Paolo fresco could represent a stage in the narrative just preceding the removal of the sandals.

Moses: Miracle of the Serpent—Moses: Miracle of the Withered Hand (Fig. 18), Exodus 4:2–3, 6–7

In the first of the scenes the Lord stands at the left, gesturing toward the right. In the center of the picture field is a hissing snake, sitting up on its tail. Moses, his hands raised in shock and surprise, runs off to the right. The second episode again shows the Lord at the left gesturing toward Moses, who stands before him displaying a diseased and swollen right hand covered with spots.

I am considering these two scenes together because they represent two parts of the narration of a single event that, in fact, is part of the episode of Moses at the Burning Bush. After the Lord revealed himself to Moses and commanded him to deliver his people from bondage, Moses asked the Lord what he should do if the people did not believe him when he brought them his message. The Lord replied by changing Moses' staff into a serpent and back again and by deforming and healing his hand; he then told Moses to show these miracles to his people should he need proof.

Both of these scenes are rare in medieval art, and I know of only one other place where the two episodes are illustrated together, represented as separate entities: the fourteenth-century Paduan Bible now in the British Library (Fig. 94) (second part of the Rovigo Bible), in which a very old iconography survives.[142] These episodes are related in three different scenes: (1) the rod becomes a serpent and Moses recoils from it; (2) Moses bends down and picks up the serpent, which has turned back into a staff; and (3) Moses holds out his right hand and indicates its deformity with his left. In all three scenes the action takes place from left to right, and a bust of the Lord appears in an arc of heaven in the upper right corner. It is difficult to say what connection this manuscript has to the ivory. The recoiling figure of Moses in the serpent scene and his position in the second miracle

139. Smyrna, fol. 66r (Hesseling, *Miniatures,* fig. 156); Vat. gr. 746, fol. 157r; and Vat. gr. 747, fol. 74r (here slightly different).
140. See Moulins, Musée municipale, Bible of Souvigny (twelfth-century), fol. 22v; photograph at Princeton University, Index of Christian Art.

141. Waetzoldt, *Kopien,* fig. 355.
142. Cod. add. 15277, fols. 3r and 3v (see Folena and Melini, *Bibbia,* pls. 81–82).

indicate the possibility that the two cycles are connected through a common parentage. However, the Paduan Bible lacks the full-length figure of the Lord that appears in both ivory scenes. Another Italian example, the lost San Paolo fresco (Fig. 95), shows a similar rendition of the serpent scene, although a hand replaces the figure of the Lord.[143] The only other related example that I know appears in the panels of the bronze doors at Augsburg, perhaps dating from the early eleventh century. Here again, although the version is generally similar, it lacks the figure of the Lord.[144]

The extremely small number of text verses depicted by these two separate illustrations makes one think of manuscript illumination as their natural place of invention; such a density of narrative scenes is natural in this medium. One would therefore expect to find these scenes in manuscripts such as the Octateuchs, but in these books only one scene is illustrated, and it appears at first to represent only the first scene of the serpent (Fig. 96).[145] Moses, his hand raised toward the sky, faces an arc of heaven with a hand that appears in the upper right corner. On the ground in front of him is his staff, shown in the process of turning into the snake. One might easily assume that this is merely a representation of the serpent scene with a different type of Moses than that which appears in the ivory. However, the fleeing Moses is specifically required by the text, and the Octateuch version would therefore be deviating from the Bible in omitting such a figure. That this fleeing figure was replaced by the present one for a reason is amply demonstrated by the arm that

Moses raises toward the heavens. It is painted with a rather heavy impasto of white, the color that it is said to have turned in the Septuagint text. Furthermore, the inscription next to Moses' head describes not the story of the serpent but the miracle of the afflicted hand.[146] Clearly, the Octateuch scene is a conflation of the two episodes in the narrative that are represented independently in the ivories. Probably in the model or archetype for the Octateuchs these scenes would have been shown separate and distinct also. It is not clear that there is any direct connection between the Octateuchs, even in their preconflated state, and the Salerno ivory scenes, for surely the Octateuch versions would never have contained a full-length figure of the Lord. But since the Octateuch iconography influenced certain scenes in the Salerno Genesis series, such as the *Creation of Eve* and *God and Noah Establish the Covenant*, perhaps it also influenced these scenes from Exodus. In the absence of adequate comparative material the question must remain open.

For many of the Genesis scenes in the Salerno ivories I established connections with the Cotton Genesis or Octateuch traditions, but noted that neither tradition could supply a model for the full-length Creator figure in the ivories. In the case of the Moses scenes I can find no parallels for the presence of the full-length figure of the Lord. On purely theoretical grounds, one might propose that here, too, one must turn to the same source that provided the unusual Genesis iconography to explain the appearance of this full-length figure. I shall return later to the problem of what this source might

143. Waetzoldt, *Kopien*, fig. 356. The drawing reflects Cavallini's restoration rather than early Christian style.

144. A. Goldschmidt, *Die deutschen Bronzetüren des frühen Mittelalters* (Marburg, 1926), pl. 63.

145. Smyrna, fol. 68r (Hesseling, *Miniatures*, fig. 157); Sera-

glio, fol. 167v (Ouspensky, *Octateuque*, fig. 97); Vat. gr. 746, fol. 162v; and Vat. gr. 747, fol. 76v.

146. Exodus 4:6. The inscription reads: He tes dexias Moyseos chionodes leukansis ("The right hand of Moses became as white as snow").

have been and where it might have come from.[147]

Moses Receiving the Law (Fig. 19), Exodus 31:18

Moses stands at the right, facing to the left. He leans forward, his hands veiled, and looks slightly up as he receives the Law, in the form of a tablet, from a hand that emerges from an arc of heaven in the upper left corner. In front of Moses and below the arc appears a stylized mountain inscribed MOT SINAI.

Clear-cut traditions for this scene are difficult to discern in medieval art. But, undoubtedly because the episode of Moses on Sinai was so important to Christians, numerous depictions survive from the early Christian period onward, some of which have much in common with the Salerno ivory.[148] The Octateuchs present a version of the scene that was perhaps the most popular type in the post-Iconoclastic period in Byzantium and was repeated numerous times in various contexts (Fig. 97).[149] Moses is shown striding up the mountain, a motion sometimes more, sometimes less emphasized.[150] His veiled arms reach out to receive the Law (a book) from the hand of God that emerges from an arc at the top right.

The Salerno ivory version agrees with the Octateuchs in most essentials except that in the ivory Moses lacks a nimbus. The iconography in the Salerno panel is closer to the Octateuch tradition than it is, for example, to the Western type of iconography shown in the Carolingian

Stuttgart Psalter, where Moses stands flat-footed on the ground. Admittedly, though, it is mainly by association that I propose that the scene of *Moses Receiving the Law* stems from the same source as the other Exodus scenes, a source that has some connections with the Octateuchs but that in all probability is distinct from the Octateuchs themselves. Somewhere in the background of the Salerno Exodus scenes probably lies a model similar to the one that stands behind the scenes in the Octateuchs. For the present it is not possible to say.

CONCLUSIONS

The iconography of the Old Testament scenes in the Salerno ivories has significant parallels with renditions in the Cotton Genesis recension and a number of connections with the Octateuchs. But these associations cannot account for the origins of the entire ivory cycle, because the iconography of the ivories departs significantly from these traditions. Even the Creation cycle, which displays so many connections with the Cotton Genesis recension, in the end diverges from this tradition. The figures of the angel-days personifying the six days of Creation are absent in the first Creation scenes in the ivories, and, furthermore, the scenes of the *Creation of the Firmament, Creation of Eve,* and the *Expulsion* represent types completely different from those in the Cotton Genesis tradition. Although the types used for the figure of Eve in her Creation and for the general scheme

147. Although illustrations of Genesis and Exodus would have originated in individual books, they could easily have been combined in larger formats (Pentateuchs, Heptateuchs, and Octateuchs) in early Christian times.

148. See those illustrated by H. Buchthal (*The Miniatures of the Paris Psalter,* London, 1938, figs. 58 [ivory pyxis] and 60 [Santa Sabina door]) and the mosaic in St. Catherine's on Sinai (Forsyth and Weitzmann, *St. Catherine,* pl 127). Perhaps the earliest example is in the Dura Synagogue (Kraeling, *Synagogue,* fig. 60).

149. Smyrna, fol. 106v (Hesseling, *Miniatures,* fig. 211); Seraglio, fol. 252r (Ouspensky, *Octateuque,* fig. 142); Vat. gr. 746, fol. 247r; and Vat. gr. 747, fol. 114v.

150. In Vat. gr. 746 there is practically no movement upward. There is very little such movement in the Cosmas Indicopleustes manuscripts: see K. Weitzmann, "The Mosaic in St. Catherine's Monastery on Mount Sinai," *Proceedings of the American Philosophical Society* 110 (1966):fig. 15 (Mt. Sinai, cod. 1186, fol. 101v).

of the *Expulsion* relate to those of the Octateuchs, the Eve scene in the ivories differs from this recension in depicting a full-length Creator figure, which never appears in the Octateuchs. In sum, most of the scenes in the ivories' Creation cycle, although similar to types seen in the established recensions, appear to derive from a separate tradition, one that has drawn mainly on the Cotton Genesis recension and somewhat on the Octateuchs for its inspiration, but that is, in the end, a new tradition altogether.

It is significant that the characteristic features of the Salerno ivories, Creation cycle appear in an extensive group of central and southern Italian monuments dating from the eleventh and twelfth centuries. The scene of the *Creation of the Firmament* in the guise of the creation of angels is paralleled in the Berlin ivory, and the same composition is used for the *Creation of Light* at Monreale. The Octateuch-related *Creation of Eve* and the Octateuch-like *Expulsion* scene (with the anthropomorphic Creator added to the *Creation of Eve*) may be found in any number of these Italian monuments, for instance, the Berlin ivory, the mosaics at Palermo and Monreale, and the frescoes at Ferentillo and San Giovanni a Porta Latina in Rome.[151] An *Expulsion* scene of the Octateuch type is also found at Sant'Angelo in Formis. There, the previous scenes of the Creation cycle are missing, but it is clear that they were similar in number to those in the ivories,[152] and from comparisons with other south Italian cycles, it is safe to conclude that the Adam and

Eve scenes would have been like those common to the Italian tradition. By analogy, one would assume that the iconography of the Creation scenes at Monte Cassino, of which Sant'Angelo in Formis was a dependency, would have been similar.

The general similarity of the iconography of the Creation scenes in these later cycles indicates the possibility that they all relate to some venerated model or type. The fact that eleventh-century Monte Cassino was probably the earliest of the Romanesque centers in Italy to use the cycle points to a possible origin of the tradition in early Christian Rome, because Abbot Desirderius of Monte Cassino was known to be an ardent Roman revivalist in matters relating to art and architecture.[153] The appearance of these characteristic elements of iconography in Rome itself, in the twelfth-century frescoes of San Giovanni a Porta Latina, adds further support to this hypothesis. That these frescoes are closely related to the Salerno ivories is suggested by the appearance at both places of the four rivers of Paradise under the tree in the *Creation of Eve*, an extremely rare motif.[154]

In medieval Rome there were two famous (and related) Genesis cycles painted on the walls of the naves of Old St. Peter's and San Paolo fuori le mura, the two most important churches of the city. Although, as noted earlier, there is some argument as to when these cycles were executed and when they were restored, it seems certain that in some form they probably go back to the fifth century and Pope Leo the

151. For Ferentillo, one of the related twelfth-century cycles, see note 28 to the Introduction. For the San Giovanni a Porta Latina frescoes, see note 30 to the Introduction.

152. That the Sant'Angelo cycle included individual scenes for the days of Creation is assured by the amount of space in the destroyed section of the wall where this part of the cycle was located (outer wall of the south aisle). There is room for at least eight or nine scenes to precede the preserved *Expulsion*. On this

problem, see G. de Jerphanion, "La cycle iconographique de Sant'Angelo in Formis," in *La voix des monuments* (Paris, 1930), p. 267; Wettstein, *Sant'Angelo in Formis*, p. 36 (see plan of the church on p. 35); and Moppert-Schmidt, *Fresken*, pp. 42–43.

153. See H. Bloch, "Monte Cassino, Byzantium, and the West in the Earlier Middle Ages," *Dumbarton Oaks Papers* 3 (1946):199; and my Chapter 5.

154. Wilpert, *Mosaiken und Malereien*, 4:pl.253.

Great.[155] Unfortunately, the frescoes in Old St. Peter's were destroyed in the sixteenth century when the old basilica gave way to the new Renaissance church; those in San Paolo, after having been restored in the thirteenth century by Pietro Cavallini, were lost in the fire of 1823 that consumed the church. There is, however, a substantial record of the San Paolo frescoes in a group of seventeenth-century drawings now preserved in the Vatican.[156] These drawings, of course, reproduce the frescoes after their restoration by Cavallini so that we do not know for sure what is early Christian and what is the addition of Cavallini. However, comparisons of a few of the panels with the scanty evidence for the St. Peter's frescoes, along with the stylistic characteristics of certain others, make it probable that the iconography of the cycle left at San Paolo after Cavallini's restoration resembled its early Christian predecessor to a significant degree.[157] In these drawings the same type is used for the *Creation of Eve* that appears in the Italian group, and an angel, here a cherubim, is substituted for the Creator in the *Expulsion* scene.[158] Furthermore, the *Murder of Abel* and *Condemnation of Cain* are combined at San Paolo as at Salerno;[159] there are profound relationships between the two versions of the *Sacrifice of Isaac*;[160] and both depict the rare episode

of *Moses: Miracle of the Serpent.*[161] Like many of the later Italian cycles, the series at San Paolo has a first scene in which all the acts of the first six days of Creation (except for the *Creation of Adam*) are condensed, instead of the individual scenes for the days found in the ivories. Although the designers of the San Paolo frescoes decided to sacrifice the representation of each of the individual acts of Creation (perhaps in order to include a more extensive portion of the Moses cycle), the discursiveness of other parts of the Genesis cycle suggests that in the model for the fresco cycle the days were included as separate scenes.[162]

I think the evidence is sufficient to propose that the Genesis cycle at Salerno derived from an early Roman tradition. Elements of this tradition appear to relate ultimately to the Cotton Genesis recension or to the Octateuchs, and the coming together of these elements seems to have occurred (or at least to have been popularized) at Rome in the early Christian period. From then on it was to have a lasting influence on later Genesis iconography in Italy, probably both through the dissemination of its model and through the impact of the monumental cycles in Old St. Peter's and St. Paul's.[163] Monte Cassino may have been an intermediary.

155. J. Garber, *Wirkungen der frühchristlichen Gemäldezyklen der alten Peters- und Pauls-Basiliken in Rom* (Berlin, 1918), pp. 27–28; Waetzoldt, *Kopien,* pp. 56–57; and note 18 to the Introduction.

156. Waetzoldt, *Kopien,* nos. 590–627.

157. The cycles in San Paolo and St. Peter's, on the basis of the preserved scenes, were closely related iconographically.

158. Waetzoldt, *Kopien,* figs. 329, 330, and 334.

159. Ibid., fig. 337. The combined scenes are also found at Sant'Angelo in Formis (Morisani, *Affreschi,* fig. 62).

160. Waetzoldt, *Kopien,* fig. 343. The version at San Giovanni a Porta Latina is also related (Wilpert, *Mosaiken und Malereien,* 4:pl. 255).

161. Waetzoldt, *Kopien,* fig. 356.

162. The inclusion of two scenes of God accusing and admonishing Adam and Eve (ibid., figs. 332–333) indicates that the frescoes were based on a rather densely illustrated manuscript model.

163. At the same time that I was developing this thesis of an early Roman model for the Salerno ivories' Old Testament cycle that combined elements from the Cotton Genesis and Octateuch traditions, L. Kötzsche-Breitenbruch was demonstrating in her Ph.D. thesis for the University of Bonn that these very traditions were combined in the fourth-century paintings of the Via Latina catacomb in Rome. Her discovery provides welcome support for my hypothesis. See now L. Kötzsche-Breitenbruch, *Die neue Katakombe an der Via Latina in Rom: Untersuchungen zur Ikonographie der altestamentlichen Wandmalereien* (Münster, 1976), esp. pp. 106–108. K. and U. Schubert, in "Die Vertreibung aus dem Paradies in der Katakombe der Via Latina in Rom," in *Christianity, Judaism, and Other Greco-Roman Cults: Studies for Morton Smith at Sixty,* ed. J. Leusner (Leiden, 1975), pp. 173–180, have emphasized the presence of elements in the Via Latina catacomb related to the Cotton Genesis tradition.

The thesis of a Roman model for the Old Testament cycle of the Salerno ivories is supported by the relationships between the ivories and the English manuscripts of Caedmon and Aelfric. In the scene-by-scene analysis of the Salerno cycle, I pointed to four instances in which there were correspondences between the Salerno series and the Aelfric manuscript (*God and Noah' Establish the Covenant, Making of Wine, Nakedness of Noah,* and *Jacob's Dream*); four in which the ivories significantly paralleled the Caedmon illustrations (*God Closes the Door of the Ark, Tower of Babel, God Commands Abraham to Leave Haran—Sarah and Lot in Abraham's House,* and *God and Abraham at an Altar*); and two scenes for which both the Aelfric and Caedmon manuscripts offer compositions closely related to the Salerno version (*God Commands Noah to Construct the Ark* and *God Orders Noah to Leave the Ark*). In addition, by analogy connections with the tradition of these manuscripts can be drawn for at least two other scenes in which the full-length Creator is included, an element absent in the entire Octateuch cycle and in the post-*Expulsion* scenes of the Cotton Genesis recension (*God and Abraham at Sichem* and *God Blesses Abraham*).

All scholars who have dealt with these English manuscripts have emphasized the fact that they must derive from early Christian models. No one has identified these models, although some authors have pointed out various connections with the Cotton Genesis and Octateuch recensions, some valid, some not.[164] But even if some of these connections are valid, they do not explain the origins of iconographical elements common to the English works and the Salerno ivories but absent from works associated with the Octateuchs or the Cotton Genesis tradition.

Unfortunately, no monument has turned up that contains all these elements and could thereby be or be derived from the source from which they all spring. For the moment we must pose the question of where the source for an early eleventh-century manuscript from England and a late eleventh-century ivory group from south Italy would have sprung, expecting an answer based partially on theoretical rather than monumental evidence.

After Augustine the Apostle was sent on his mission to England in 597 by Pope Gregory the Great, he received from the pope numerous works of art and a great many books.[165] Augustine established himself at Canterbury. There is still in existence part of a Gospel book that was definitely in the possession of St. Augustine's monastery at Canterbury in the eleventh century and was perhaps there as early as the seventh.[166] For many years the manuscript was associated with Augustine himself. The importance of this book for this inquiry lies in the fact that scholars are now virtually unanimous in attributing the manuscript to a sixth-century Italian source on the basis of both paleography and the style of the miniatures.[167] Thus there is proof of the presence of an illuminated Italian (probably Roman) manuscript on English soil (in just that center where the eleventh-century manuscripts were probably made) perhaps as early as the seventh century.[168]

164. Wormald, *English Drawings*, p. 40; Pächt, *Pictorial Narrative*, pp. 5–6; Henderson, "Saint-Savin," passim; idem, "Late Antique Influences," passim.

165. Bede, *Historia ecclesiastica*, bk. 1, chaps. 25 and 29.

166. F. Wormald, *The Miniatures in the Gospels of St. Augustine* (Cambridge, Eng., 1954), p. 1.

167. Ibid., pp. 2, 14–16.

168. Ibid., p. 1. The Aelfric manuscript belonged to St. Augustine's, Canterbury, and the Caedmon manuscript probably belonged to Christ Church in the same city. See Wormald, *English Drawings*, pp. 67, 76.

Some time after the middle of the seventh century Benedict Biscop, abbot of the monastery of Wearmouth-Jarrow, made several trips to Rome and brought back many relics, works of art, and books. Bede records specifically that he carried with him from Rome, among other works of art, pictures of the Old and New Testament.[169] This is ample evidence that the early Christian art of Rome was influential in England's important monastic communities. The Old Testament, and even a scene from Genesis, are specifically mentioned as being among the subjects depicted in the "paintings" brought to Wearmouth by Benedict Biscop, and one might also easily imagine the inclusion of an illustrated Book of Genesis among the manuscripts imported from Rome.[170] When in the early eleventh century, artists, perhaps from Canterbury, sought to illustrate their own vernacular poets' reinterpretations of the Book of Genesis, they did not need to invent new pictures in most cases, although they might have embellished or emended them according to the vernacular text; they could simply refer—and I argue they did refer—to the repertoire provided them in the models that had come to the English monasteries centuries before from Rome. It now becomes clear how the relationships between several of the Salerno Genesis scenes and the English manuscripts could have derived from their genesis in this early "Roman" tradition.

The cycle that we must envision standing behind the Salerno ivories is related to but not identical with the one from which the frescoes at Old St. Peter's and San Paolo fuori le mura derived. It would have contained all the days of Creation in individual scenes, but would have lacked the personifying angels of the Cotton Genesis recension. In place of the compositions for the *Creation of Eve* and *Expulsion* that are associated with the Cotton Genesis tradition, it would have contained transformed types, perhaps related initially to the Octateuchs in the first case, and certainly so in the case of the *Expulsion* scene.

All of the above would also have been true of the model for the early Roman frescoes. Where the model for the ivories differs from the model for the frescoes is in the later scenes. There the prototype of the ivories and of those sections in the Caedmon and Aelfric manuscripts represented the Creator in full-length form; in the Roman frescoes, and presumably in their model, there appeared instead a *manus dei* in scenes after the *Expulsion*. Although the other Italian monuments for most scenes followed the tradition in which only the hand was used in post-*Expulsion* scenes, the carvers of the Salerno ivories reverted to the model that consistently anthropomorphized the deity and that had already had an impact on English manuscript illumination.[171]

Recognition of the sources that lie behind the iconography of the Salerno panels can never fully explain their essential qualities, for the carvers who made them were wont at every turn to express their content with their own particular vocabulary of form. They might recompose what they found in their model, enlarging figures to fill the space of the sculptural field, adjusting elements to the frame, and enlivening the composition by altering the ar-

169. Bede, *Vita sanctorum*, chaps. 6 and 9.
170. We know of the importation of other Italian manuscripts around this time. See T. J. Brown, "The Latin Text," and R. L. S. Bruce-Mitford, "Decoration and Miniatures," in *Evangeliorum Quattor Codex Lindisfarnensis*, vol. 2 (Olten-Lausanne, 1960), pp. 56–57, 147–149.

171. The relationship between the English manuscripts (at least the Caedmon) and an early Roman model has been further explored by H. Broderick, "The Iconographic and Compositional Sources of the Drawings in Oxford, Bodleian Library, Junius 11," Ph.D. thesis, Columbia University, 1977.

rangement or gestures of figures. Perhaps in the end these factors are better treated as matters of style, but they have a direct impact on the ultimate iconography of the work and mitigate the powerful influence of the sources. My investigation of these sources was designed to discover the nature of the prototypes available to the carvers of the Salerno ivories. It in no way intimates that they slavishly copied their models. On the contrary, it has shown that in numerous instances they freely reinterpreted the sources according to their own artistic standards, even inventing new iconographical types when they found their models wanting.

2. THE ICONOGRAPHY
OF THE NEW TESTAMENT

EIGHTEEN FULL PLAQUES and two halves of plaques illustrating forty scenes of Christ's life survive among the Salerno ivories. My reconstruction of the cycle (pp. 106–107) suggests that originally there were twenty-four panels representing some fifty different events in the Christological story. Generally, the New Testament ivories are divided into upper and lower halves, and each of these sections contains a single scene. Occasionally, however, one of these areas is further subdivided horizontally, as is the case with the *Resurrection of Lazarus* and *Entry into Jerusalem* panel (Fig. 29); or two scenes may simply be placed side by side within a single picture square, as in the plaque that shows *Joseph Doubts Mary* and *Joseph's First Dream* (Fig. 21). In one case, the *Ascension* (Fig. 38), the composition is enlarged to fill the entire height of the panel; in the *Crucifixion* (Fig. 31) the scene fills the upper two-thirds of the panel with the *Entombment* and the gambling soldiers appended at the bottom, almost as footnotes.

The episodes represented are listed on pp. 50–51 in the order of their original disposition (in four rows) and accompanied by the text pas-sages that they illustrate. Parentheses indicate proposed reconstructions of lost sections.

The designers of the Salerno New Testament cycle created a harmonized pictorial narrative of Christ's life based on all four of the Gospels. Of the fifty different episodes that I propose were originally part of the cycle, twenty-three are mentioned in Matthew, fifteen in Mark, twenty-five in Luke, and fourteen in John. Seven of the events are described only in Matthew, ten only in Luke, and nine only in John; no scenes are attested exclusively by Mark. One scene, *Pentecost*, has its textual basis in the Acts of the Apostles; *Joseph Doubts Mary* is not mentioned at all in the canonical New Testament but comes from the apocryphal Protevangelion of James. The *Anastasis* is derived from the apocryphal Gospel of Nicodemus.[1]

The Christological series in the Salerno ivories is noteworthy for its comprehensiveness. Virtually no important phase of Christ's story is neglected in a cycle that may be subdivided into sections illustrating his Infancy, Ministry, Passion, and Resurrection.

This chapter is devoted, first, to the identi-

1. The relevant texts are in M. R. James, *The Apocryphal New Testament* (Oxford, 1924), pp. 44, 117–146. The question of apocryphal elements in the Salerno Infancy cycle is dealt with more fully later in the chapter.

fication of problematical and lost scenes in the cycle and to a determination of the original sequence of scenes—the results of this inquiry are reflected in the appended list—and, second, to the question of iconographical sources for the panels.

IDENTIFICATION OF SCENES

For the most part the identification of the New Testament episodes is not problematical, because their compositions are well known or their content is made clear by internal evidence. In a few cases, however, the subject is more difficult to determine.

Healing of the Dropsical, Blind, and Lame (Fig. 28)

This scene is identified on the basis of the afflictions suffered by the figures who appear to the right. Jerphanion mentioned only the dropsical man, while Goldschmidt added the lame man as well. Only Carucci has correctly identified all three invalids. What he failed to realize, however, was that this scene is probably a conflation of two events in the narrative, the *Healing of the Dropsical* from Luke 14 and the *Healing of the Lame and Blind* from Matthew 21. The former scene is often represented in Middle Byzantine art and the dropsical man is generally shown with a distended stomach, as in the ivory.[2] The *Healing of the Lame and Blind* appears less frequently, but examples are extant from both early Christian and Middle Byzantine times, for example, the sixth-century cathedra of Maximianus[3] and the eleventh-century miniature in Paris, Bibliothèque nationale, cod. gr. 74.[4]

Christ Appears at Lake Tiberius (Fig. 35)

Goldschmidt[5] mistook this scene for the much earlier event *Peter Walking on the Water* from Matthew 14; Bertaux[6] suggested that it represented only the *Miraculous Draught of Fish,* a part of this earlier story. That it could not be connected with the episode from Matthew 14 is clear from its place in the cycle among the post-Resurrection plaques (this location is certain from the identity of the scene in the top section of the plaque), the appropriate position for the appearance at Tiberius.

The Marys Announce the Resurrection to the Apostles (Fig. 35)

Jerphanion identified the scene as the *Return of the Disciples to Emmaus.*[7] This cannot be correct, because the two figures on the left are obviously women and thus could not represent the two male disciples to whom Christ appeared at Emmaus. Moreover, the scene's position in the cycle, immediately following *Christ Appears to the Marys* (see Reconstruction, pp. 106–107), amply supports my identification.[8]

2. G. de Jerphanion, "La cycle iconographique de Sant'Angelo in Formis," in *La voix des monuments* (Paris, 1930), p. 274; Goldschmidt, *Elfenbeinskulpturen,* 4:39; Carucci, *Avori,* pp. 117–118. For Byzantine examples see Bibliothèque nationale, cod. gr. 510, fol. 170r (H. Omont, *Miniatures des plus anciens manuscrits grecs de la Bibliothèque nationale,* 2nd ed., Paris, 1929, pl. 36); Florence, Laurentian Library, cod. Plut. VI, 23, fol. 139v (T. Velmans, *La tétraévangile de la Laurentienne,* Bibliothèque des Cahiers archéologiques, 6, Paris, 1971, fig. 236); Paris, Bibliothèque nationale, cod. gr. 74, fol. 140r (Paris, Bibliothèque nationale, Département des manuscrits, *Evangiles avec peintures du XI siècle,* ed. H. Omont, Paris, 1908, fig. 122).

3. C. Cecchelli, *La cattedra di Massimiano ed altri avori romano-orientali* (Rome, 1936–1944), pl. 32. A similar representation may be found in the Rabbula Gospels, Florence, Laurentian Library, cod. Plut. I, 56, fol. 11r, the identification of which is disputed. See C. Cecchelli et al., *The Rabbula Gospels* (Olten-Lausanne), 1959, p. 64, and E. B. Smith, *Early Christian Iconography and a School of Ivory Carvers in Provence* (Princeton, 1918), p. 98.

4. Fol. 41v (*Evangiles avec peintures,* fig. 35).

5. Goldschmidt, *Elfenbeinskulpturen,* 4:39.

6. Bertaux, *Italie méridionale,* p. 431.

7. Jerphanion, "Cycle iconographique," p. 274.

8. Similar versions of the scene may be found on the ninth-century silver and gilt casket of Paschal I from the Sancta Sanctorum treasure (C. Cecchelli, "Il tesoro del Laterano I," *Dedalo* 7 [1920–1921]:fig. on p. 160) and in the eleventh-century gospels, Bibliothèque nationale, cod. gr. 74, fol. 162r (*Evangiles avec peintures,* fig. 140). The latter example illustrates the episode in Luke.

Row 1	Matthew	Mark	Luke	John
(Annunciation)			1:26 f.	
Visitation (Fig. 20)			1:39 f.	
Joseph Doubts Mary (Fig. 21)		Protevangelion of James		
Joseph's First Dream (Fig. 21)	1:20			
Journey to Bethlehem (Fig. 22)			2:4 f.	
Nativity (Fig. 23)	1:25		2:6–7	
Annunciation to the Shepherds (Fig. 24)			2:8–14	
(Magi See Star?)	2:2			
Magi before Herod (Fig. 20)	2:7			
Adoration of the Magi (Fig. 21)	2:11			
Joseph's Second Dream (Fig. 22)	2:13			
Flight into Egypt (Fig. 23)	2:14			
Massacre of the Innocents (Fig. 24)	2:16			

Row 2				
Presentation (Fig. 25)			2:22 f.	
(Christ among the Doctors?)			2:41 f.	
Baptism (Fig. 26)	3:13 f.	1:9–12	3:21–2	1:32 f.
(Temptation)	4:1–10	1:12 f.	4:1–13	
Christ Adored by the Angels (Fig. 27)	4:11	1:13		
Calling of Peter and Andrew (Fig. 28)	4:18 f.	1:16 f.		
Miracle at Cana (Fig. 25)				2:1–10
(Miracle?)				
Transfiguration (Fig. 26)	17:1 f.	9:1–7	9:28 f.	
(Miracle?)				
Raising of the Widow's Son at Nain (Fig. 27)			7:11 f.	
Healing of the Dropsical, Blind, and Lame (Fig. 28)	21:14 (Blind, lame)		14:1–4 (Dropsi-cal)	

Row 3	Matthew	Mark	Luke	John
Christ and the Samaritan Woman (Fig. 29)				4:6 f.
Feeding of the Multitude (Fig. 30)	14:15 f.	6:32 f.	9:10 f.	6:5–14
(Miracle?)				
Healing of the Paralytic at Bethesda (Fig. 32)				5:1–9
Healing of the Blind Man at Siloam (Fig. 33)				9:1–7
Resurrection of Lazarus (Fig. 29)				11:1 f.
Entry into Jerusalem (Fig. 29)	21:7 f.	11:7 f.	19:35	12:12 f.
Last Supper (Fig. 30)	26:20	14:17	22:14	
Washing of the Feet (Fig. 30)				13:4–14
(Arrest)	26:47	14:43	22:47	18:3 f.
Crucifixion (Fig. 31)	27:35	15:25 f.	23:33	19:18 f.
Entombment (Fig. 31)	27:57 f.	15:46 f.	23:50 f.	19:41 f.
Anastasis (Fig. 32)		Gospel of Nicodemus		
The Marys at the Tomb (Fig. 33)	28:1 f.	16:1 f.	24:1 f.	

Row 4	Matthew	Mark	Luke	John
Christ Appears to the Marys (Fig. 34)	28:9	16:12 f.		
The Marys Announce the Resurrection to the Apostles (Fig. 35)	28:8 f.	16:13	24:8 f.	
Christ at Emmaus (Fig. 36)			24:30 f.	
(Emmaus II?)			24:32	
Christ Appears in Jerusalem (Fig. 39)				20:22 f.
Incredulity of Thomas (Fig. 34)				20:24 f.
Christ Appears at Lake Tiberius (Fig. 35)				21:1 f.
(An Appearance?)				
Christ Appears at Bethany (Fig. 37)			24:50	
Ascension (Fig. 38)		16:19	24:51	
Pentecost (Fig. 39)			Acts 2:1 f.	

Christ Appears in Jerusalem (Fig. 39)

This scene is particularly difficult to identify because its form can readily be adapted to the illustration of numerous Gospel events. Goldschmidt's suggestion of *Christ Showing His Wounds* from Luke 24:36 meets the requirements of the iconography perhaps better than any other episode in that both the number of the Disciples (eleven) and Christ's display of his wounds are explicitly described in the text.[9] However, this scene is rarely represented in medieval art, either Byzantine or Western; and when it is shown, it almost never takes the symmetrical form of the Salerno composition, where Christ stands in the center flanked by groups of Apostles. Aside from the *Mission of the Apostles* described in Matthew (an event with which the Salerno scene is not to be associated because Christ does not display his wounds then), the Salerno compositional type is perhaps most often employed for the scene *Christ Appears in Jerusalem* (John 20:22). This is the event that immediately precedes the *Incredulity of Thomas* in the text as well as in the sequence of the ivories. It, too, describes Christ showing his wounds. Despite the fact that strictly speaking only ten Disciples were present during this episode, medieval iconography as often as not depicted Christ in the presence of eleven Apostles.[10] I propose that this is also the case at Salerno.

Christ Appears at Bethany (Fig. 37)

Jerphanion identified the scene as the *Appearance behind Closed Doors* (John 20:26).[11]

This could not be correct for several reasons. First of all, the Apostles number twelve instead of the ten required by that text. Second, the fragment was the bottom half of a panel and thus, because the *Incredulity of Thomas* is the first scene in the sequence of scenes in the bottom sections of the post-Resurrection plaques (see pp. 106–107), such an identification of a subsequent scene would be radically anachronistic. In fact, the number of the Disciples, twelve, is incorrect for almost all of the post-Resurrection appearances, but an association with the event at Bethany is indicated by the unusual pose of Christ, who turns back to bless the Apostles as he moves out of the scene. Nowhere else in the cycle does Christ appear in this twisted pose. It seems to be an almost literal rendering of the Gospel text that describes the Bethany scene: "and it came to pass, while he blessed them, he was parted from them." Goldschmidt, too, proposed this identification for the episode, although he gave no explanation for it.[12]

There is no doubt that a number of plaques showing New Testament scenes are lost. In proposing identifications of lost scenes, probability based on the evidence of contemporary cycles must play a major role. The *Annunciation* could not well have been omitted. In fact, it must have been the initial scene in the series. This is the case in almost every New Testament cycle of the time; also the *Annunciation* is among those scenes depicted in the group of ivories with New Testament subjects based on the Salerno series (Fig. 161) and executed in the same workshop during a later stage of its de-

9. Goldschmidt, *Elfenbeinskulpturen*, 4:39.
10. See the tenth-century Basilewsky situla in the Victoria and Albert Museum (J. Beckwith, *The Basilewsky Situla*, London, 1963, pl. 13) or the twelfth-century miniature in London, Victoria and Albert Museum, 661 (single leaf), verso (G. Schiller, *Ikonographie der christlichen Kunst*, vol. 3, Gütersloh. 1974, fig. 288).

For a Byzantine example see Mt. Athos, Dionysiou, cod. 587, fol. 14v (S. Pelakanides et al., *The Treasures of Mt. Athos, 1: The Protaton and the Monasteries of Dionysiou, Koutloumousiou, Xeropotamou, and Gregoriou*, Athens, 1974, fig. 199).
11. Jerphanion, "Cycle iconographique," p. 274.
12. Goldschmidt, *Elfenbeinskulpturen*, 4:39.

velopment.[13] In the bottom section of the *Annunciation* plaque—if we assume that this scene did not occupy the whole plaque—may have appeared the *Journey of the Magi*.[14] Since the subsequent five plaques are extant and their positions are fixed by the chronology of the scenes, the inclusion of this plaque with the *Annunciation* establishes the number of panels in this row as six. Study of the list of scenes and the texts they illustrate in conjunction with my reconstruction (pp. 106–107) will demonstrate that in order to maintain basic chronological consistency the panels must be separated into four distinct rows. If each row contained the same number of plaques—six—the New Testament series originally comprised twenty-four panels.

In the second row, therefore, two plaques are missing. The first probably held the second position from the left and showed in its top section *Christ among the Doctors,* a very popular part of the narrative that one would expect to find in such an extensive cycle.[15] Another lost plaque must have occupied the fourth position in the row. It would have depicted some aspect of the *Temptation,* a standard scene in such a large cycle.[16] In addition, and even more important, the *Temptation* scene is needed to explain the content of the following panel, containing *Christ Adored by the Angels* (Fig. 27), which depicts the conclusion of the *Temptation* story. If the Adoration scene had stood alone, its meaning would be obscure.[17] It is not possible to determine the content of the bottom sections of these two missing panels, but since they do occupy places near the beginning of the Miracle cycle, probably they, too, showed scenes of Christ's miracles.[18]

In the third row the Passion narrative lacks one of its most important episodes, the *Arrest of Christ.* Not only is this scene current in most contemporary cycles, but it is also found among the group of ivories that derive from the Salerno series (Fig. 171).[19] The panel with the *Arrest* would have occupied the third place in the third row, the *Arrest* scene filling the bottom section. A miracle scene was probably shown in the upper half of the panel, but the evidence is in-

13. See the Catalogue, no. B6. Among the roughly contemporary Italian cycles that commence with the *Annunciation* are those at Monreale (Demus, *Mosaics,* pl. 65A), San Giovanni a Porta Latina (Wilpert, *Mosaiken und Malereien,* 4:pl. 252), and Sant'Urbano alla Cafarella (G. Ladner, "Die italienische Malerei im 11. Jahrhundert," *Jahrbuch der kunsthistorischen Sammlungen in Wien* 5 [1931]:fig. 72).

14. Among the Middle Byzantine examples of this scene is the miniature in the Gospel book in Florence, Laurentian Library, cod. Plut. VI, 23, fol. 6r (Velmans, *Tétraévangile,* fig. 11). The Italian cycles at Sant'Urbano alla Cafarella (Ladner, "Italienische Malerei," p. 106) and Monreale (Demus, *Mosaics,* pl. 66a) both represent the episode, although in rather different forms.

15. *Christ among the Doctors* forms part of the cycles at Sant'Angelo in Formis (unpublished photograph; Jerphanion, "Cycle iconographique," p. 275), Monreale (Demus, *Mosaics,* pl. 65b), and San Giovanni a Porta Latina (Wilpert, *Mosaiken und Malereien,* 4:pl. 253).

16. See, for example, the scenes at Sant'Angelo in Formis (unpublished photograph; Jerphanion, "Cycle iconographique," p. 275) and Monreale (Demus, *Mosaics,* pl. 66b).

17. The only parallels to the rare symmetrical arrangement of the scene are in the Coronation Gospels of King Vratislav (Prague, National and University Libraries, cod. XIV a, fol. 24v), which dates in 1085 (*Codex Vyschradensis,* ed. J. Masin, Prague, 1970, fol. 24v), and among the prefatory miniatures of the English Psalter, c. 1200, in Paris, many of which are based on the Utrecht Psalter (Bibliothèque nationale, cod. lat. 8846, fol. 3r: see Bibliothèque nationale, Département des manuscrits, *Psautier illustré XIII^e siècle,* Paris n.d., pl. 6). The more narrative version of the scene, where both angels appear to one side of Christ, is found in Bibliothèque nationale, cod. gr. 74, fol. 7r (*Evangiles avec peintures,* fig. 9).

18. Two miracles that were particularly popular in Italian cycles of the time and that fit well into the chronology of the Salerno series are the *Healing of the Leper* (Matthew 8:1–2, Mark 1:40–1, Luke 5:12–3) and the *Healing of the Woman with the Issue of Blood* (Matthew 9:20–1, Mark 5:25–6, Luke 8:43–4). Both are represented in the cycles at Sant'Angelo in Formis (Jerphanion, "Cycle iconographique," p. 276) and Monreale (Demus, *Mosaics,* pls. 85a, 86a).

19. See the Catalogue, no. B16. The scene appears at Sant'Angelo in Formis (Morisani, *Affreschi,* fig. 39) and Monreale (Demus, *Mosaics,* pl. 70).

sufficient to show which miracle was depicted.

Although the two extant halves of plaques that show *Christ at Emmaus* (Fig. 36) and *Christ Appears at Bethany* (Fig. 37) are clearly a top and a bottom, they did not originally form one whole plaque, but came from two different panels. Not only are the breaks in the bottom border of the Emmaus plaque and the top border of the Bethany plaque incompatible, but the original widths of the two panels may have differed by a centimeter. The chronology of events suggests that the *Christ at Emmaus* fragment formed the top half of the third plaque in the row (with some unknown scene on the bottom); the fourth panel, with the Bethany scene on the bottom, may have shown a later part of the Emmaus story on top.[20]

SEQUENCE OF THE SCENES

Because the carvers were representing events drawn from different Gospels and, as we shall see, were combining compositions derived from different pictorial sources, they had to make certain choices as to the ordering of scenes. For much of the cycle this presented little or no problem, because most episodes fit easily into a logical sequence based on the textual chronology. For the Miracle and post-Resurrection sections, however, the ambiguous textual chronology of events necessitated the carvers' making a more idiosyncratic choice of sequence (see Reconstruction, pp. 106–107). In the case of the post-Resurrection scenes I am unable to determine a principle guiding the arrangement. The scenes of the Marys (Figs. 34-35) had to come first because they are the ear-liest people mentioned as having seen the risen Christ. The text explicitly requires that the *Pentecost* (Fig. 39) be last, the *Ascension* (Fig. 38) be next to last, and *Christ Appears at Bethany* (Fig. 37) immediately precede the *Ascension*. What is not obvious is the grouping of the rest of this series of scenes: *Christ at Emmaus* (Fig. 36), *Christ Appears in Jerusalem* (Fig. 39), *Incredulity of Thomas* (Fig. 34), and *Christ Appears at Tiberius* (Fig. 35). These last two scenes follow the order in which they occur in John's Gospel, but it cannot be determined from the text whether these events preceded or followed the Emmaus episode or *Christ Appears in Jerusalem*; and the sequence does not appear to reflect the influence of any liturgical practice.

The other section of the New Testament narrative that left room for chronological decision is the miracle cycle. Here more scenes are derived from John than from any other Gospel, and I propose that his text was taken as the basis of the organization of the miracles. The chronology of John is broken only once in this series: the *Feeding of the Multitude* (Fig. 30) precedes the *Healing of the Paralytic at Bethesda* (Fig. 32). This anachronism may be accounted for by a desire to juxtapose the *Feeding of the Multitude* above with the *Last Supper* below on the same plaque, both events alluding to the institution of the Eucharist. The other scene in this section out of chronological sequence is the *Transfiguration* (Fig. 26). Here again I propose that the chronology was deliberately broken, this time in order to bring together the scenes of *Baptism* and *Transfiguration*, two important epiphanies. The arrangement of the remainder of the miracle sequence

20. At both Monreale (Demus, *Mosaics,* pl. 73) and San Giovanni a Porta Latina (Wilpert, *Mosaiken und Malereien,* 4:pl. 155), the *Supper at Emmaus* is followed by a representation of the two Disciples telling the rest of the Apostles of their experience. This might well have been the scene now missing at Salerno. If so, it would form a perfect counterpart to the episode of the Marys telling the Apostles of their vision.

is understandable given John's Gospel as its basis.[21]

From this general analysis of the Salerno New Testament cycle, it seems clear that these ivories were originally divided into four independents rows of six panels each (Reconstruction, pp. 106–107). The sequence of panels is virtually assured by the fact that they are divided into upper and lower scenes belonging to different stages in the narrative. This arrangement provides a basis for checking the proper position of each panel with respect to the others. The different parts of the narrative of Christ's life, however, do not strictly follow this division into rows. The entire first row is devoted to the Infancy cycle, while the entire second row plus the top sections of the plaques in the third row describe the ministry (mainly miracles). The bottom sections of the third row depict the Passion, and the entire last row, top and bottom, is given over to representations of events, mainly appearances of Christ, after the Resurrection.

ICONOGRAPHICAL SOURCES

Investigations of the origins and history of New Testament iconography necessarily proceed along different lines from those dealing with the Old Testament. New Testament illustration provides no counterparts to the recognizably different traditions embodied in Old Testament imagery. In most instances, New Testament scenes display such an overall uniformity, regardless of time and place of origin, that it is often exceedingly difficult to assign them convincingly to different traditions. In the following discussion I shall rely on the isolation of certain principles, or at least of certain iconographical details, that distinguish earlier from later stages in the development of the iconography of a New Testament event or that may characterize regional variations. In certain cases, it is possible to specify whether certain elements are of pre- or post-Iconoclastic (mid-Byzantine) invention, are Eastern or Western, or, sometimes, can be attributed to even more specific origins.[22]

A number the New Testament scenes are cast in a virtually standardized iconography that recurs in several places at various times. For this reason, the scene-by-scene analysis adopted for the Old Testament material is unsuitable here. Instead, I shall discuss only those episodes that aid in discovering the sources. Rather than examining the New Testament scenes chronologically, I shall group them according to their affiliation with the different models that I have been able to isolate.

THE GRADO CHAIR IVORIES

For several of the New Testament scenes the precise models used for the iconography

21. For the problem of chronology in representations of Christ's miracles see P. Underwood, "Some Problems in Programs and Iconography of Ministry Cycles," in *The Kariye Djami*, vol. 4, ed. P. Underwood (Princeton, 1975), pp. 145–302.

22. A rigorous system of classification for New Testament scenes is yet to be devised. The early attempts of G. Millet (*Récherches sur l'iconographie de l'Evangiles*, Paris, 1916) and E. B. Smith (*Early Christian Iconography*), though greatly erudite, are less than adequate. A somewhat different course for the study of the relationships among New Testament scenes was tentatively charted by K. Weitzmann in "The Narrative and Liturgical Gospel Illustrations," in *New Testament Manuscript Studies*, ed. M. Parvis and A. Wikgren (Chicago, 1950), pp. 151–174 (reprinted

in *Studies*, pp. 247–270). These ideas were further elaborated in Weitzmann's "Byzantine Miniature and Icon Painting in the Eleventh Century," in *Proceedings of the XIIIth International Congress of Byzantine Studies* (Oxford, 1966), pp. 207–224 (reprinted in *Studies*, pp. 271–313).

In addition to the more specific literature cited later in the chapter, the following general works shed light on the iconography of individual New Testament scenes: *Reallexikon zur deutschen Kunstgeschichte* (Stuttgart, 1937–); *Reallexikon zur byzantinischen Kunst* (Stuttgart, 1966–); *Lexikon der christlichen Ikonographie*, vols. 1–3 (Freiburg, 1968–1970); G. Shiller, *Ikonographie der christliche Kunst*, 3 vols. (Gütersloh, 1966–1974).

may be determined. These prototypes, all of which must actually have been before the eyes of the Salerno carvers, form part of another sizable group of ivories known collectively as the Grado Chair series because of the object—a throne in the north Italian city of Grado—for which they were purportedly made. Fourteen plaques of the group are extant.[23] A majority show episodes from the life of St. Mark, but a number depict New Testament scenes. The date and place of origin of these ivories have been the subject of controversy since 1899, when Hans Graeven proposed that they were part of a throne that, according to legend, was given to the archbishop of Grado by the Emperor Heraclius c. 600.[24] Graeven suggested that the panels were carved around that time in Alexandria, sent to Constantinople, eventually given to Grado's archbishop, and then sometime afterward dispersed. Several scholars accepted Graeven's view, but others, such as Venturi, Bertaux, and Volbach, stressing the relationship between the Grado Chair group and the Salerno ivories, considered both groups eleventh or twelfth century in date and Italian in origin.[25] Neither attribution was conclusive. In 1972 Weitzmann published his study of the Grado Chair ivories, in which he demonstrated that neither proposal was correct.[26] He placed the style of the ivories at a halfway point in the gradually more schematizing style of the seventh to ninth centuries in the East, proposing the seventh or eighth century as the date and

Syria-Palestine as the place of origin. Certain reflections of contemporary Islamic art in the ivories bear out this attribution. But regardless of the exact date or place of origin of the group, it can be shown, beyond any reasonable doubt, that the carvers of the Salerno scenes copied the iconographical configurations, in whole or in part, of a number of plaques associated with these earlier ivories.[27]

The Nativity (Fig. 23)

The *Nativity* from the Grado Chair series (Fig. 98), preserved in the Dumbarton Oaks Collection in Washington,[28] clearly served as the model for the corresponding scene at Salerno. Besides the general similarities in the two versions, such rare details as the bottle on the stand beneath the bed, the niche in the altar-manger, the appearance of the seated Salome at the foot of the bed, and the placement of Joseph on a low stool further demonstrate the obvious reliance of the Salerno version upon the earlier rendering.

Yet despite the numerous and extensive similarities, many changes have occurred between model and copy. First of all, the Salerno artist faced the problem of adapting a wide horizontal composition to an almost square picture field. His solution was simply to squeeze together the elements of the composition, particularly those at the sides, to fit the new format. In the Dumbarton Oaks plaque, the Virgin lies comfortably on her mattress; in the Salerno

23. For illustrations of the extant Grado Chair plaques, see Goldschmidt, *Elfenbeinskulpturen,* 4:3, 34–36, nos. 112–124, pls. 39–41.

24. H. Graeven, "Die heilige Markus in Rom und in der Pentapolis," *Römische Quartalschrift* 13 (1899):110–126.

25. A. Venturi, *Storia dell'arte italiana,* vol. 2 (Milan, 1902), pp. 618–621; Bertaux, *Italie méridionale,* pp. 430–437; W. F. Volbach, "Gli avori della cattedra di S. Marco," in *Arte del primo millenio,* ed. E. Arslan (Vislongo, 1950), pp. 134–136.

26. "Grado Chair," passim.

27. E. Maclagan, "An Early Christian Ivory Relief of the

Miracle at Cana," *Burlington Magazine* 18 (1921):178–195, and Goldschmidt, *Elfenbeinskulpturen* 4:3, 34–35, were the first to consider certain of the Salerno panels copies after plaques in the Grado Chair series. For more on the Grado Chair ivories see my Chapters 3 and 4.

28. Goldschmidt, *Elfenbeinskulpturen,* 4:135–136, no. 124, pl. 41; W. F. Volbach, *Elfenbeinarbeiten der Spätantike und des frühen Mittelalters,* 3rd. ed. (Mainz, 1975), p. 104, no. 249; K. Weitzmann, *Catalogue of the Byzantine and Early Medieval Antiquities of the Dumbarton Oaks Collection, 3: Ivories and Steatites* (Washington, D. C., 1972), pp. 37–39, no. 20, pl. 3.

ivory she seems to slide off it, as an even greater tendency toward two-dimensionality comes to the fore. The subtle, almost classical contours and lines of the Virgin's drapery in the earlier plaque have become simplified and much less supple at Salerno, and the folds of the drapery no longer follow the contours of the body beneath. The figure of Salome sitting with her right hand pensively held to her chin in the Dumbarton Oaks version, her legs convincingly folded one under the other, almost becomes a caricature at Salerno. As Weitzmann has remarked, she leans over, holding her jaw as if suffering from a toothache.

Although the architectural background of the panel in Washington clearly inspired the carver of the Salerno plaque, significant changes have been made. The walled city at the left of the scene has lost its plastic value in the Salerno ivory. The crenellated form appearing in one of the structures on the left in the Salerno panel's cityscape is not found in the earlier *Nativity*, and was probably inspired by another of the Grado Chair panels (Fig. 99). Built into the front of the city-gate in the Dumbarton Oaks *Nativity* is a baldachin with a hanging lamp and stone screen. According to Weitzmann, this shrine represents the actual monument at the site of the Nativity in Bethlehem.[29] In the Salerno version the shrine has been totally misunderstood (the baldachin is placed in front of the wall), and reduced to a thoroughly unfunctional structure.

Resurrection of Lazarus (Fig. 29)

The British Museum now owns the *Resurrection of Lazarus* plaque associated with the Grado Chair group (Fig. 100).[30] The panel is more stylized than the Dumbarton Oaks ivory but undoubtedly comes from the same workshop. In this case the carver of the Salerno scene had to adapt a model with a vertical format to a field that was wider than it was high. This more horizontal form called for him to combine sources, because the Grado Chair plaque did not provide enough material to fill the width of his new scene. From the British Museum *Lazarus* he took the group of Christ and the single Apostle on the left. The scepter that Christ carries in both examples is a sure sign of interdependence because it is a very rare motif, an unusual departure from the cross-staff usually carried by Christ in early Christian art. Also derived from the British Museum plaque is the overall diamond pattern of the shroud wound around Lazarus.

Distinct from the British Museum's *Lazarus,* though, are the types used for the two women; in the Salerno ivory they both have veiled hands and bow toward Christ, one with her head up and the other with her glance averted and cast downward; in the British Museum plaque one woman stands and the other crouches on the ground; both look toward Christ and neither has her hands veiled. The servant in the Salerno panel, grasping one end of the winding sheet with his left hand and holding his right hand to his nose, could not have been derived from the British Museum plaque either, because no such figure is included there. Evidently the Salerno ivory carver reverted to a second model in order to complete his version of the *Resurrection of Lazarus.* A very similar

29. See C. R. Morey, "The Painted Panel from the Sancta Sanctorum," *Festschrift Paul Clemen* (Bonn, 1926), p. 157; Weitzmann, *D.O. Catalogue*, pp. 38–39; idem, "Loca Sancta and the Representational Art of Palestine," *Dumbarton Oaks Papers* 28 (1974):36–39.

30. Goldschmidt, *Elfenbeinskulpturen*, 4:34, no. 118, pl. 40; O. M. Dalton, *British Museum, Catalogue of Ivory Carvings of the Christian Era* (London, 1909), p. 21, no. 27, pl. 12; Volbach, *Elfenbeinarbeiten*, p. 103, no. 246, pl. 67. On the iconography of the scene, see R. Darmstädter, *Die Aufwerkung des Lazarus in der altchristlichen und byzantinischen Kunst* (Bern, 1955).

group of two women along with a servant who holds his nose (his other hand must originally have been intended to hold the shroud) appears on a tenth-century Byzantine ivory of the *Resurrection of Lazarus* now in Berlin (Fig. 101).[31] Although these elements can be found as far back as the sixth-century Rossano Gospels,[32] a mid-Byzantine example was probably the direct source for the Salerno carver. I shall demonstrate shortly that mid-Byzantine iconography played an important role in the Salerno series.

Miracle at Cana (Fig. 25)

In the Victoria and Albert Museum is a fragment of a plaque that shows three servants and six large containers, obviously part of a *Miracle at Cana* scene (Fig. 102).[33] Originally the panel must have been of the same dimensions as the British Museum *Lazarus*; its style is generally close to the style of that panel. The figures of the servants in the Salerno *Cana* scene are clearly copied from those on the Victoria and Albert panel, but characteristic changes have occurred between the model and the copy. The *clavi* on the tunics in the earlier version have turned into elements that are not part of the tunics themselves but that are worn above the garment as if they were suspenders. The wine-lifter carried by the middle servant in the Victoria and Albert ivory becomes at Salerno a mixing rod thrust into one of the wine containers.[34] The lively form of the large wine jugs in the earlier scene is vastly simplified in the ivory, where the jugs lack the organic quality found in the earlier example. In general,

what remains of the classical vocabulary in the Grado Chair *Cana*, especially the easy grace of the three figures, disappears in the Salerno rendering.

As was the case with the *Resurrection of Lazarus*, the Grado Chair *Cana*, while serving as model for part of the Salerno version, could not have been the basis for the entire composition. The narrow width of the Victoria and Albert panel does not allow for the elaborate table scene that appears in the Salerno version; the earlier version would have included only figures of Christ and the Virgin, in keeping with the tradition of pre-Iconoclastic art. The more fully developed narrative version of the feast was popular in post-Iconoclastic Byzantium, and one would expect that a Byzantine work from this period was the model for the upper portion of the Salerno scene. A good example of the type is provided by the illustration of the Cana miracle in the eleventh-century Gospel book in Florence (Fig. 103),[35] where a group similar to the one in the ivory is seated about the table.

Additional Scenes Derived from the Grado Chair Group

The Grado Chair group originally contained many more New Testament scenes than now survive. Might other scenes in the Salerno series besides the three discussed above have been influenced by plaques from the earlier group that are now lost? It is reasonable to assume that some of them at least must have had some influence. The extant plaques of the Grado Chair series do not indicate what other

31. Goldschmidt and Weitzmann, *Byz. Elfenbeinskulpturen*, 2:28, no. 14, pl. 4; Weitzmann, "Grado Chair," fig. 26.

32. Fol. 1r; see A. Haseloff, *Codex purpureus rossanensis* (Berlin, 1898), pl. 1; A. Muñoz, *Il codice purpureo di Rossano* (Rome, 1907), pl. 1; Weitzmann, "Grado Chair," fig. 27.

33. MacLagan, "Miracle at Cana," pp. 178–195; M. Longhurst, *Victoria and Albert Museum, Catalogue of Carvings in*

Ivory (London, 1927), p. 33, pl. 10; Goldschmidt, *Elfenbeinskulpturen*, 4:60, no. 312, pl. 79; Volbach, *Elfenbeinarbeiten*, p. 104, no. 247, pl. 67.

34. Weitzmann, "Grado Chair," text fig. B.

35. Florence, Laurentian Library, cod. Plut. VI, 23, fol. 170v (Velmans, *Tétraévangile*, fig. 271; Weitzmann, "Grado Chair," fig. 30).

specific scenes were represented in that cycle, but one can be sure that the group was not restricted to any one phase of Christ's life: scenes from the Infancy, Passion, and Ministry cycles are represented in the preserved panels. Indeed, the most important available evidence for the lost Grado Chair plaques are the Salerno ivories themselves.

It is significant that the peculiar fringed garments with decorative *clavi* worn by the women in the Grado Chair group may be found throughout the Salerno Infancy scenes. Such garments do not appear anywhere else in the Salerno series save in the *Ascension* panel. Furthermore, the hanging lamps of the *Visitation* in the Salerno ivories (Fig. 20) resemble those in the Dumbarton Oaks *Nativity* (one of them is even shown under a baldachin, as in the earlier plaque). Other small details also suggest the influence of the Grado Chair ivories. The boots worn by the first figure opposite St. Mark in the panel depicting *St. Mark in Tripoli* from the Grado Chair series (Fig. 104)[36] are very much like those worn by the son of Joseph in the Salerno version of the *Journey to Bethlehem* (Fig. 22). As Goldschmidt has noted, the peculiar coiffure of the Magi and angels, featuring three locks of hair falling on the shoulders at either side of the head, is not a mid-Byzantine style, but relates to an early Eastern type. Goldschmidt thought the motif came from an Egyptian tradition because it appears on the Maximianus cathedra,[37] but it is more probable that this non-Byzantine element came to the Salerno group via the Grado Chair ivories. Unfortunately, no plaque of the early series is extant

that preserves this precise motif, although the coiffure of Gabriel in the *Annunciation* associated with the Grado Chair group is rather similar (Fig. 105).[38]

The evidence is clear that in addition to having been the source of the iconography of certain of the Salerno New Testament scenes, the Grado Chair series displays a number of specific and unusual elements that appear in the Salerno Infancy scenes. If, then, it can be demonstrated that the iconography of the Infancy scenes was current at the time of production of the Grado Chair group, it would be justifiable to propose that the carvers of the Salerno ivories derived their scenes basically from that source. Of course, as my comparisons of scenes from the Salerno series with the corresponding extant panels from the Grado Chair group showed, the Salerno carvers might well have combined elements from this source with elements from a mid-Byzantine source in a single scene.

In fact, for almost all of the Salerno Infancy scenes a parallel may be found in monuments predating Iconoclasm. In most cases the iconography has been influenced by the apocryphal narratives of the Gospel of Pseudo-Matthew and the Protevangelion of James, both of early date.[39] For instance, the maidservant of the *Visitation* (Fig. 20) is not accounted for in the Gospels: the Virgin is simply described entering Elizabeth's house. The Protevangelion, however, says that when the Virgin arrived Elizabeth threw down her spinning and ran to the door.[40] The woman peeking through the curtain has long been considered a feature of apocryphal origin whose presence emphasizes that the

36. Goldschmidt, *Elfenbeinskulpturen*, 4:34, no. 112, pl. 39.
37. Goldschmidt, *Elfenbeinskulpturen*, 4:3. For the Maximianus cathedra see Cecchelli, *Cattedra*, pl. 18. Note also the Isis ivory (probably of Egyptian origin) on the Aachen pulpit illustrated in pl. 37.
38. Goldschmidt, *Elfenbeinskulpturen*, 4:35, no. 123, pl. 41.

39. See James, *Apocryphal New Testament*, pp. 38–49, 70–74. For the impact of the Protevangelion on scenes of Christ's Infancy, see J. Lafontaine-Dosogne, "Iconography of the Cycle of the Infancy of Christ," in *The Kariye Djami*, vol. 4, ed. P. Underwood (New York, 1975), esp. pp. 197–241.
40. James, *Apocryphal New Testament*, p. 43.

event took place in front of Elizabeth's house. As early as the sixth century a similar maidservant appeared, in the mosaics at Parenzo; she was to become a very common component of the scene.[41] The iconography of *Joseph Doubts Mary* (Fig. 21), where Joseph sits at the right gesturing excitedly toward the Virgin at the left, also derives from the Protevangelion. This iconography is extremely rare. The only parallel is on one of the marble columns supporting the ciborium in San Marco in Venice; these have been shown to be of thirteenth-century date, although they undoubtedly revived early Christian formulas.[42] Probably, then, the Salerno scene was derived from an early model. Apocryphal scenes of the story of Joseph and Mary, albeit different specific episodes, were represented as early as the sixth century, and these scenes, especially the *Testing of Mary by Water*, become very popular in the Cappadocian frescoes, some of which may reflect early models.[43]

Joseph's Dream—either the first or second (Figs. 21 and 22 have the same basic composition)—is a standard composition that does not change very much from the sixth century to mid-Byzantine times.[44]

Also apocryphal in origin is the son of Joseph who leads the ass in the *Journey to Bethlehem* (Fig. 22); this figure is found at the beginning of the ninth century on the enamel cross of Paschal I in the Vatican.[45] There, as in the ivory, Joseph follows the ass, but he and the Virgin do not communicate as in the Salerno scene. This communication between the two, which might also derive from the apocryphal account where Joseph inquires after the Virgin's joys and sorrows,[46] is first seen on an early Christian (Syrian?) ivory formerly in the Stroganoff Collection; there the Virgin turns to speak with Joseph.[47] The motif may be found later in the Cappadocian frescoes.[48]

I can provide no specific parallel for the Salerno scene of the *Annunciation to the Shepherds* (Fig. 24), but it was probably based on an early source, because in mid-Byzantine times the scene was generally combined with the *Nativity* rather than being shown independently, as in the Salerno group and early Christian examples of the scene.[49]

41. B. Molajoli, *La basilica Eufrasiana di Parenzo* (Padua, 1943), fig. 54.

42. G. Costantini, "Le colonne del ciborio di S. Marco," *Arte cristiana* 3 (1915): fig. on p. 167 (left bottom). For the thirteenth-century date see O. Demus, "A Renascence of Early Christian Art in Thirteenth-Century Venice," *Late Classical and Mediaeval Studies in Honor of A. M. Friend, Jr.*, ed. K. Weitzmann (Princeton, 1955), p. 350. The scene also appears in the mosaics of the Kariye Djami, although in a different iconography: see J. Lafontaine-Dosogne, "Iconography of the Life of the Virgin," in *The Kariye Djami*, vol. 4, ed. P. Underwood (New York, 1975), pp. 190–191.

43. M. Restle, *Byzantine Wall Painting in Asia Minor*, vol. 2 (Greenwich, Conn., 1967), fig. 65 (Göreme, Tokali Kilise) and fig. 140 (Göreme, St. Eustace). In addition to J. Lafontaine-Dosogne's contributions to *The Kariye Djami*, her *Iconographie de l'enfance de la Vierge dans l'Empire byzantin et en Occident*, 2 vols. (Brussels, 1964–1965), should be consulted for many of the scenes that include the Virgin.

44. The cathedra of Maximianus (Cecchelli, *Cattedra*, pl. 24) provides an early example. For a post-Iconoclastic version see, among others, the miniature in the eleventh-century lectionary on Mt. Athos, Dionysiou, cod. 587, fol. 128r (Pelekanides et al., *Treasures of Mt. Athos*, fig. 248). For further information on this important manuscript see K. Weitzmann, "An Imperial Lectionary in the Monastery of Dionysiou on Mt. Athos: Its Origin and Its Wanderings," *Revue des Etudes Sud-Est Européenes* 7 (1969):339–353.

45. F. Stohlman, *Gli smalti del Museo Sacro Vaticano*, Catologo del Museo Sacro della Biblioteca Apostolica Vaticana, 2 (Vatican City, 1939), pp. 47–48, no. 103, pl. 24 (and notes on pp. 16–22 by C. R. Morey); K. Wessel, *Byzantine Enamels* (New York, 1967), pp. 47–50, fig. 7.

46. James, *Apocryphal New Testament*, p. 45.

47. Volbach, *Elfenbeinarbeiten*, p. 65, no. 128, pl. 45.

48. Restle, *Byzantine Wall Painting*, 2:fig. 66 (Göreme, Tokali Kilise). See also K. Weitzmann, *The Fresco Cycle of S. Maria di Castelseprio* (Princeton, 1951), pp. 52–53.

49. See, for example, the tenth-century ivory in the British Museum (Goldschmidt and Weitzmann, *Byz. Elfenbeinskulpturen*, 2:26, no. 5, pl. 2) or the miniature in the Menologium of Basil II, Vatican Library, cod. gr. 1613, p. 271: *Il menologio di Basilio II*, Codices et vaticani selecti, 8 (Turin, 1907), pl. 271.

The basic outlines of the *Magi before Herod* (Fig. 20) are already evident in the fifth-century mosaic of Santa Maria Maggiore,[50] and the iconography of the *Adoration of the Magi* (Fig. 21), featuring the half-length angel in the sky and Joseph behind the throne, may be found in the early eighth-century frescoes done for John VII in Santa Maria Antiqua.[51]

The *Flight into Egypt* (Fig. 23) has the very rare motif of the angel leading the ass, or at least pointing toward the city, an element that occurs on a bronze plaque (Western) now in Berlin whose origins remain obscure but that is dated before 700.[52] Another characteristic motif of this scene is the personification of Egypt presenting an offering to the Holy Family. Although this personification has generally been considered a mid-Byzantine feature,[53] it does in fact appear, crouched atop the cityscape, on an early Christian gold encolpium now in Istanbul.[54]

Most striking of all the Salerno Infancy scenes in its adoption of an early iconography is the scene of the *Massacre of the Innocents* (Fig. 24). The general outline of the scene was determined early and is repeated in numerous monuments both early and late. The appearance of the apocryphal *Flight of Elizabeth* as part of the *Massacre* occurs in mid-Byzantine as well as earlier works,[55] but the specific nature of this subplot in the Salerno scene points to an early source. The relationship that exists between Elizabeth and the child on the one hand and their pursuer on the other is perfectly paralleled in a fifth- or sixth-century fresco at Deir Abu Hennis in Egypt (Fig. 106).[56] Here, as in the ivory, Elizabeth and John in the mountain turn back to face the soldier who comes after them. This soldier carries a sword in his right hand that he keeps held to his side; with his left hand he gestures toward his mouth, perhaps indicating confusion. Not only does this exact gesture appear in both examples, but also the gesture of John, reaching toward the soldier with his left hand, is identical. Furthermore, the proportion and shape of the infant's arm are uncannily alike in the two versions. The similarities of the ivory and the Egyptian fresco become more evident still when these two are compared with post-Iconoclastic examples such as the miniature in the Paris Gregory manuscript of the late ninth century.[57] Here, although the figures of Elizabeth and the infant John are included, the form the scene assumes is rather different from that found in the ivories. There is little question that the iconography of the Salerno version finds its closest parallel in pre-Iconoclastic art.

It is possible that a number of scenes besides those in the Infancy cycle were derived in

50. Wilpert, *Mosaiken und Malereien,* 3:pls. 61–62; H. Karpp, *Die frühchristlichen und mittelalterlichen Mosaiken in Santa Maria Maggiore zu Rome* (Baden-Baden, 1966), pl. 26. Here, though, the costumes are quite different. For the iconography of the scene, see G. Vezin, *L'adoration et le cycle des mages dans l'art chrétien primitif* (Paris, 1950).

51. P. J. Nordhagen, *The Frescoes of John VII in Santa Maria Antiqua in Rome,* Acta ad archaeologium et artium historiam pertinentia, 3 (Rome, 1963), pp. 22–25, pl. 16.

52. See W. F. Volbach in *Amtliche Berichte aus der könglichen Kunstsammlungen* 38 (1917):23–25, fig. 74.

53. It appears, for example, in Bibliothèque nationale, cod. gr. 74, fol. 5v (*Evangiles avec miniatures,* 1:fig. 8) and in Vatican Library, cod. gr. 1156, fol. 280 (Millet, *Récherches,* fig. 94). See Weitzmann, "Narrative and Liturgical," pp. 250–251.

54. H. Pierce and R. Tyler, *L'art byzantin* (Paris, 1934), p. 95, pl. 73b. This is also pointed out by J. Lafontaine-Dosogne, "Infancy of Christ," p. 229.

55. For example, a sixth-century ivory pyxis in the Louvre (C. Rouault de Fleury, *La messe,* vol. 5, Paris, 1887, p. 65, pl. 367) among the early works, and the miniature in Bibliothèque nationale, cod. gr. 510, fol. 137r (Omont, *Miniatures grecs,* pl. 32) among the mid-Byzantine examples.

56. J. Clédat, "Notes archéologiques et philologiques," *Bulletin de l'Institut Francais d'Archéologie Orientale* 2 (1902):41–70; W. de Grüneisen, *Les characteristiques de l'art copte* (Florence, 1922), pp. 96–97, pl. 29. The exact date of the frescoes is in doubt, but they are surely pre-Iconoclastic.

57. Bibliothèque nationale, cod. gr. 510, fol. 137r (Omont, *Miniatures grecs,* pl. 32).

whole or in part from the Grado Chair series. For example, the episode of the *Raising of the Widow's Son at Nain* (Fig. 27) is given a generally similar composition in mid-Byzantine art,[58] but one feature in the ivory that never occurs in the Middle Byzantine examples is the figure of the mother bending over before the bier at the feet of Christ. This motif may be found, however, in certain Ottonian versions of the episode[59] and in later Syriac Gospel books of the thirteenth century.[60] Hugo Buchthal has proposed that these are reflections of a lost early Christian Eastern source.[61] If this is true, then the Salerno ivory scene would also relate to a similar early source, very likely a panel from the Grado Chair group. A small detail of costume helps confirm this view. The unusual type of tunic worn by the men who carry the bier at Salerno—tucked up at the sides—is the same as that worn by the servants in the *Miracle at Cana* (Fig. 25). In both places it seems to reflect a misunderstanding of the type shown in the Grado Chair *Cana* fragment (Fig. 102).

The detail of Christ carrying a staff instead of a scroll in his left hand—already noticed in the *Resurrection of Lazarus* as being derived from the Grado Chair group—also appears in the *Healing of the Dropsical, Blind, and Lame*

(Fig. 28) and in the *Healing of the Blind Man at Siloam* (Fig. 33). As noted earlier, the former scene is unique in its combination of the three sufferers. The narrative aspect of the *Healing of the Blind Man at Siloam,* showing in two stages the healing proper and the man washing his eyes, was fixed as early as the sixth-century Rossano Gospels[62] and was carried through the entire history of Byzantine art.[63] A small detail that would point to the origin of the Salerno version of the scene in the Grado Chair series is the type of decorated boot worn by the blind man. It is the same type worn by the Magi in the earlier scenes, which were most probably derived from the Grado Chair group.[64]

The Salerno ivory version of *The Marys at the Tomb* departs from the iconography popular in mid-Byzantine art. In the Byzantine examples (Fig. 107)[65] the central feature of the composition is invariably the angel, who sits atop a great stone. He looks toward the two women who approach from the left, indicating the empty tomb by bringing his right arm across his body to point to the cave behind him. Often the three soldiers, in diminutive scale, are shown asleep in the foreground. In the ivory (Fig. 33), by contrast, the center of the composition is the tomb itself—in the form of a strigilated sar-

58. For example, the two-stage narrative in Bibliothèque nationale, cod. gr. 74, fol. 121r (*Evangiles avec peintures*, 2:fig. 107), where, however, the youth is shown not as a mummy but simply as a clothed figure.

59. Munich, Staatsbibliothek, cod. Clm. 4453, fol. 155v, and the fresco in St. George, Reichenau, on which see A. Boeckler, *Ikonographische Studien zu den Wunderszenen in der ottonischen Malerei der Reichenau,* Bayerische Akademie der Wissenschaften, Philosophisch-historische Klasse: Abhandlungen, n.s. vol. 52 (Munich, 1961), pp. 27–28, figs. 64–66.

60. Vatican Library, cod. syr. 559, fol. 90r, and British Library, cod. add. 7170, fol. 100r (J. Leroy, *Les manuscrits syriaques a peintures conservés dans les bibliothèques de l'Europe et d'Orient,* Paris, 1964, pl. 84, nos. 3 and 4).

61. H. Buchthal, "The Painting of the Syrian Jacobites in Its Relation to Byzantine and Islamic Art," *Syria* 20 (1939):141–144.

62. Haseloff, *Codex purpureus,* pl. 9; Muñoz, *Codice purpureo,* pl. 11.

63. There are many post-Iconoclastic examples. See, for instance, Bibliothèque nationale, cod. gr. 510, fol. 216r (Omont, *Miniatures grecs,* pl. 46).

64. One detail never appearing in Eastern examples, either pre- or post-Iconoclastic, is the spout of water flowing into the basin in which the blind man washes his hands. This feature is common, however, in Western examples such as the Codex Egberti, Trier, Stadtbibliothek, cod. 24, fol. 50r (H. Schiel, *Codex Egberti der Stadtbibliothek Trier,* facsimile ed., Basel, 1960, fol. 50r) and may be found in contemporary Italian examples such as Sant'Angelo in Formis (Morisani, *Affreschi,* pl. 25). For the subject in general, see P. Singelenberg, "The Iconography of the Etschmiadzin Diptych and the Healing of the Blind Man at Siloe," *Art Bulletin* 40 (1958):105–112.

65. Parma, Palatine Library, cod. palat. 5, fol. 90r (V. Lazarev, *Storia della pittura bizantina,* trans. G. Fossati, Turin, 1969, p. 191, fig. 243).

cophagus beneath a baldachin above which appear further domed structures; while the angel is relegated to a position at the left. He leans toward the tomb and points to it with his right hand as the Marys approach at the far right, bearing ointment jars and swinging censers. At the bottom of the panel are the three sleeping soldiers.

The general iconographic type of the Salerno scene is very close to that found time and again in the early Christian art of Syria-Palestine. The lead ampullae of Monza and Bobbio repeat the scheme numerous times (Fig. 108),[66] although there the women are invariably shown to the left of the tomb and the angel to the right. The soldiers are missing in the examples from the ampullae, but they are found in the sixth-century Syriac Rabbula Gospels and in a later Syrian Gospel Book in the British Museum that clearly derives from early sources.[67] Even the complex architectural structure of the tomb in the Salerno scene may be partially explained by its relationship to an early Syro-Palestinian source; the structure within a structure that makes up the upper level of the tomb in the ivory is reminiscent of the construction in many of the Syro-Palestinian examples, which show the tomb within the confines of an enclosing building.[68]

In the *Ascension* (Fig. 38), it is the costume of the Virgin that first suggests an origin in the Grado Chair group, because it is of the same elaborate type found in these earlier ivories and in the Salerno Infancy scenes. Moreover, the form of the Virgin's figure, her exaggerated, emotional pose, her glance upward, are all features that are not common in mid-Byzantine art but that we would expect to find in an earlier Eastern version of the scene.[69] Similarly, the grape and wheat motif that appears beneath the mandorla, although seemingly peculiar to the Salerno ivory, is the type of straightforward Eucharistic symbol that one often finds in pre-Iconoclastic art. The stars which decorate Christ's mandorla are not common in Middle Byzantine monuments but may be found in earlier *Ascensions* in the East.[70]

A small detail in the *Baptism* (Fig. 26) also

66. A. Grabar, *Les ampoules des Terre Sainte* (Paris, 1958), pls. 9, 11–14, 16, 18, 22, 24, 26, 34–38, 45. On the iconography of the scene in general, see N. C. Brooks, *Sepulchre of Christ in Art and Liturgy*, University of Illinois Studies in Language and Literature, VII, 2 (Urbana, 1921); and P. Bloch, "Das Reighenau Einzelblatt mit den Frauen am Grabe im Hessischen Landesmuseum Darmstadt," *Kunst in Hessen und Mittelrhein* 3 (1963):24–43.

67. For the Rabbula Gospels see C. Cecchelli et al., *Rabbula Gospels*, fol. 13a; Leroy, *Manuscrits syriaques*, 2:pl. 34. For British Library, cod. add. 7169, fol. 12v, see Leroy, *Manuscrits syriaques*, 2:pl. 9, 2.

68. See Grabar, *Ampoules*, pls. 9, 14, 22, 24, 26, 28, 34–37, 45. On the tomb structure, see also Weitzmann, "Loca Sancta," pp. 41–42.

69. On two of the Monza phials not only does the Virgin look up and gesture emotionally, but also the Apostles are shown in rows one behind the other, as in the Salerno version (Grabar, *Ampoules*, nos. 14, 16, pls. 27, 29). These characteristics may be found in the *Ascension* fresco in the lower church of San Clemente, Rome, of the ninth century, itself probably based on an early model (Wilpert, *Mosaiken und Malereien*, 4:pl. 210). In the ampullae four angels support the mandorla in which Christ sits with a book in his left hand. As in the Salerno ivories, only Christ, the Virgin, and the angels have nimbi.

A. Carucci (*La "Parousia" negli avori salernitani*, Salerno, 1959) correctly identified the Eucharistic nature of the motifs that appear below the mandorla. However, identification of the scene as the *Second Coming* rather than the *Ascension* must be dealt with critically. Although the Parousia idea is surely contained in this type of iconography, the pictorial evidence, among other things, still speaks for an identification of the primary subject matter as the *Ascension*.

Wilpert (*Mosaiken und Malereien*, 2:911) explained the inclusion of the grape motif as a reflection of the "true vine" reference in John's gospel. E. R. Goodenough, "The Crown of Victory in Judaism," *Art Bulletin* 28 (1936):145, sees it as a survival of Dionysiac wine symbolism, which in pagan art often accompanied a central divine object supported by victories. This seems a bit fanciful. On the iconography of the scene, see E. DeWald, "The Iconography of the Ascension," *American Journal of Archaeology* 19 (1915):277–319, and H. Gutberlet, *Die Himmelfahrt Christi in der bildenden Kunst* (Strasbourg, 1934).

70. They appear within the mandorla of the sixth-seventh century Christ-Emmanuel icon on Sinai (G. and M. Sotiriou, *Icones du Mont Sinai*, Athens, 1958, 1:fig. 8; and K. Weitzmann, *The Monastery of St. Catherine at Mount Sinai: The Icons*, vol. 1, Princeton, 1976, no. B16, pl. 18); and in one of the Bobbio ampullae (Grabar, *Ampoules*, pl. 33).

points to an early Eastern source. Although, as will later be shown, the general composition of this scene was probably derived from a mid-Byzantine model, one element never found in post-Iconoclastic art is the wreath or crown held in the dove's beak as it descends toward Christ's head. In fact, the motif is extremely rare; the only other instances of its occurrence, besides the panel copied after the Salerno version, are on an ivory plaque in the British Museum and a gold medallion in the Dumbarton Oaks Collection (Fig. 109),[71] both of which have been assigned a sixth- or seventh-century Syro-Palestinian origin.

The exact meaning of the wreath has never been explained, but it obviously relates in some way to the eventual victory over death granted the initiate by the sacrament of baptism. The motif might have derived not from purely speculative theological interpretation, but from actual liturgical practice. This is indicated not only by a hymn composed by Ephraim the Syrian (fourth century) in which the baptized are crowned with wreaths of flowers but also by a rubric and prayer ascribed to Severus, Patriarch of Antioch from 512 to 519, in which the initiates receive crowns *quam reges desiderarunt*.[72] In summary, what is known of the origin and meaning of the motif of the crown would appear to reinforce its attribution to a Syro-Palestinian source.

One theme that has recurred throughout this analysis of the contribution of the Grado Chair group to the Salerno New Testament series is the uniqueness or rarity of many of the elements involved. The pensive Salome of the *Nativity*, the servants of the *Cana* scene, the staff of the Christ figure in the *Resurrection of Lazarus* occur only in the scenes associated with the Salerno ivories and the extant Grado Chair plaques. In scenes for which lost plaques from the earlier series have been proposed as models, rare and unusual elements again come to the fore: the three angels of the *Annunciation to the Shepherds*, the angel in the *Flight into Egypt*, the crown in the *Baptism*, the wheat and grape motif in the *Ascension* are all unique or very rare types.

This analysis will no doubt be refined and corrected in the future, with additions to or substitutions in the various scenes, but it remains certain that the Grado Chair ivories had a profound impact on the formation of the iconography of the Salerno New Testament series and that this effect went far beyond the copying of those panels of the earlier group that are extant today.

MIDDLE BYZANTINE ART

The compositions of post-Iconoclastic Byzantine art strongly influenced the creation of the Salerno ivories New Testament scenes. Indeed, aside from the Infancy scenes, the iconography of the Salerno New Testament cycle is primarily derived from mid-Byzantine models. Unfortunately, one cannot isolate the actual

71. For the ivory see Volbach, *Elfenbeinarbeiten,* p. 70, no. 141, pl. 46; for the medallion see M. C. Ross, *Catalogue of the Byzantine and Early Mediaeval Antiquities in the Dumbarton Oaks Collection, 2: Jewelry, Enamels, and Arts of the Migration Period* (Washington, D. C., 1965), pp. 35–37, no. 37, pl. 30.

72. The translation of the hymn of Ephraim Syrus is in *The Nicene and Post-Nicene Fathers,* vol. 13, 2nd ser., p. 283. For the text of the rite of Severus, see H. Denziger, *Ritus orientalium* (Graz, 1961) (reprint of 1863 edition), pp. 315–316, and J. Assemanus, *Codex liturgicus,* vol. 3 (Paris, 1902), pp. 180–182. For all

of the above, see J. H. Bernard, "The Odes of Solomon," *Journal of Theological Studies* 12 (1911):1–31. I am indebted to Mr. P. Corbey Finney for guiding me to this solution of the meaning of the wreath.

For further details concerning the relationship of the notions of "coronation" and baptism as they pertain to the iconography of the *Baptism,* see K. Hoffmann, *Taufsymbolik im mittelalterliche Herrscherbild* (Düsseldorf, 1968), pp. 9–13, and R. Deshman, "Otto III and the Warmund Sacramentary: A Study in Political Theology," *Zeitschrift für Kunstegeschichte* 34 (1971):1–20.

models used, as it was possible to do for scenes derived from the Grado Chair plaques. Instead, the debt owed by the Salerno New Testament cycle to specifically mid-Byzantine iconography must be described in a broader fashion.

Presentation (Fig. 25)

The *Presentation* was not a popular theme in early Christian art; aside from a few scattered examples, it is not consistently depicted until the early ninth century. By then it had already taken on the almost canonical form shown in the ivory version; five figures appear: the Virgin, holding the Christ child, and Joseph stand to the left of an altar, while the high priest Simeon, about to receive the child, stands at the right accompanied by the prophetess Anna. The event is depicted in an architectural setting, intended to allude to the Temple of Jerusalem. Although more or less subtle variations occur in the iconography of different versions of this scene, the basic form of the Salerno ivory composition is perhaps the most widespread, and therefore the most difficult to localize, in the Middle Ages.

Two details in the Salerno *Presentation* aid in determining the nature of the model used by the carver. Dorothy Schorr, in her exemplary article on the iconography of the *Presentation*, pointed to the unusual posture of the Christ child, who, although still in his mother's arms,

leans eagerly forward toward the outstretched grasp of the aged Simeon. Schorr suggests an origin for this motif in the antique representation of the newly born Dionysus emerging from Zeus's thigh and stretching forth his arms toward the waiting Hermes, a motif seen in a neo-Attic relief in the Vatican.[73] This feature of the *Presentation*, although rare, is not unique to the Salerno plaque; it is paralleled in a number of Middle Byzantine works, such as the panel from the bronze doors of San Paolo fuori le mura in Rome (Fig. 110), made in Constantinople in 1071.[74] The existence of such works suggests that the eager type of Christ child was an invention of the Middle Byzantine period. Schorr's proposal of a classical prototype would be particularly fitting for a detail created during the tenth-century Macedonian Renaissance, when Byzantine artists appear to have been particularly interested in using motifs from classical art to enrich the fund of Christian imagery.[75]

Another detail of the *Presentation* derives from the same source. The expressive posture of the prophetess Anna, with her glance directed upward and her hand raised to the sky, has recently been recognized as another invention of Byzantine artists working during the Macedonian Renaissance. In this case the new Anna type, used in lieu of a more subdued, frontal figure, was modeled after the classical representation of Phaedra's nurse.[76]

73. D. Schorr, "The Iconographic Development of the Presentation in the Temple," *Art Bulletin* 28 (1946):23. For the Vatican relief, see G. Lippold, *Die Skulpturen des vatikanischen Museums* vol. 3, pt. 1 (Berlin, 1936), no. 493, pl. 28.
74. G. Matthiae, *Le porte bronzee bizantine in Italia* (Rome, 1971), fig. 19. Other Middle Byzantine examples are Mt. Athos, Panteleimon, cod. 2, fol. 257r (P. Huber, *Athos*, Zurich, 1969, fig. 102); Venice, San Giorgio dei Greci, lectionary, fol. 367r (Lazarev, *Storia*, p. 189; photograph in the Department of Art and Archaeology, Princeton University).
The *Presentation* featuring the eager child was very popular in Campanian art of the late eleventh century. In addition to the Salerno ivories, it is found in at least three south Italian and one Sicilian example: Pisa, Museo civico, Exultet Roll (2), pict. 9 (M.

Avery, *The Exultet Rolls of South Italy*, Princeton, 1936, pl. 36); Monte Cassino, Monastery Library, cod. 98, p. 6 (P. Baldass, "Disegni della scuola cassinese del tempo di Desiderio," *Bollettino d'arte* 37 [1952]:fig. 1); Paris, Bibliothèque Mazarine, cod. 364, fol. 19r (H. Toubert, "Le Breviare d'Oderisius et les influences byzantines au Mont-Cassin," *Mélanges de L'Ecole Francaise de Rome* 83 [1971]:fig. 17); Palermo, Capella Palatina mosaics (Demus, *Mosaics*, pl. 11b).
75. K. Weitzmann, "The Character and Intellectual Origins of the Macedonian Renaissance," in *Studies*, pp. 176–223.
76. K. Weitzmann, "A Tenth-Century Lectionary: A Lost Masterpiece of the Macedonian Renaissance," *Revue des Etudes Sud-Est Européennes* 9 (1971):626–627.

Baptism (Fig. 26)

The basic outlines of the *Baptism* in the Salerno ivory may be seen in pre-Iconoclastic versions of the scene (and, noted earlier, the motif of the crown or wreath in the dove's beak probably derived from a lost plaque in the Grado Chair group), but certain details point to a mid-Byzantine origin of the ivory version. The motif of the cross on the column in the water can only be found in post-Iconoclastic works, though it may well go back to an earlier period because it is based on an actual monument erected in the Jordan River during early Christian times.[77] But the cross-legged position of Christ and his gesture of benediction toward the waters never occur in pre-Iconoclastic art.[78] The earliest example of the crossed legs and blessing gesture together is in the early eleventh-century mosaics of Hosios Lukas; the motifs are repeated, to choose just one example, in the miniature from the Dionysiou lectionary (Fig. 111).[79] The blessing motif appears by itself even earlier, in the Menologium of Basil II, c. 1000.[80] This gesture stems from a patristic tradition that described Christ, at the moment of his baptism, blessing the Jordan River and granting it the power to cleanse from sin.[81] As suggested earlier, the scene combines elements probably derived from a lost Grado Chair ivory with elements taken from a mid-Byzantine model.

Calling of Peter and Andrew (Fig. 28)

Depictions of the calling of the first Apostles were fairly well standardized in early Christian times, but one detail seen in later versions of the episode stands out as a contribution of post-Iconoclastic times. Only in the later examples of the scene, such as the marginal illumination from an eleventh-century lectionary in Venice (Fig. 112),[82] does Peter raise his hands toward Christ in greeting or acclamation as he does in the Salerno panel. In the earlier versions he is shown either passively seated in the boat or helping Andrew haul in the net.[83]

Miracle at Cana (Fig. 25)

In the analysis of the relationship between the Salerno and the Grado Chair ivories, I showed that the upper half of this scene—the group seated at the table—was derived from a Middle Byzantine model and combined with the earlier source used for the servants below the table.

Transfiguration (Fig. 26)

Unlike the *Calling of Peter and Andrew*, the *Transfiguration* was not portrayed in a standardized format in the early Christian period. It was represented in various forms during these early centuries, for example in the dramatic yet almost symmetrical sixth-century apse mosaic

77. Strzygowski thought that this motif was proof that a *Baptism* would date in the eleventh century at the earliest (*Ikonographie der Taufe Christi*, Munich, 1885, p. 23). See E. Diez and O. Demus, *Byzantine Mosaics in Greece* (Cambridge, Mass., 1931), pp. 58–59, where it is also mentioned that the monument was described by Theodosius, Antonius Placentius, Arculf, and Bede.

78. Strzygowski, *Taufe Christi*, passim.

79. Diez and Demus, *Byzantine Mosaics*, fig. 6. Mt. Athos, Dionysiou, cod. 587, fol. 141v (Pelekanides et al., *Treasures of Mt. Athos*, fig. 255).

80. Vatican Library, cod. gr. 1613, p. 299 (*Menologio*, pl. 299).

81. The text is from Pseudo-Chrysostom: Migne, *PG*, 50:804 (as quoted by Diez and Demus, *Byzantine Mosaics*, p. 58n2).

82. Venice, San Giorgio dei Greci, lectionary, fol. 63r (Lazarev, *Storia*, p. 189; photograph in the Department of Art and Achaeology, Princeton University). The acclamation gesture is mentioned by Belting, *Cimitile*, p. 106, and earlier by P. Schweinfurth, "Das goldene Evangelienbuch Heinrichs III and Byzanz," *Zeitschrift für Kunstgeschichte* 10 (1941–1942):58–59.

83. The most conspicuous example is the mosaic (fifth-century) in Sant'Apollinare Nuovo, Ravenna (F. Deichmann, *Frühchristliche Bauten und Mosaiken von Ravenna*, Baden-Baden, 1958, fig. 160).

of St. Catherine's on Mt. Sinai or the slightly later mosaic on the triumphal arch of Saints Nereo and Achilleo in Rome.[84] During the post-Iconoclastic period, however, one particular iconographical type, not found among the earlier works, predominated. This composition is distinguished by specific poses for the Apostles in the lower tier that remained fixed to a remarkable degree: Peter, glancing up, kneels on one knee and points to the three figures of Christ, Moses, and Elias above; John, the youngest, curled up in the center, looks down toward the ground; James, rising on one knee, faces to the right and down. The Salerno ivory version is clearly of this post-Iconoclastic type and is well paralleled by the mosaic version at Daphni[85] or in the eleventh-century lectionaries in the Panteleimon and Dionysiou monasteries on Mt. Athos (Fig. 113).[86] The absence of the mandorla surrounding Christ, Moses, and Elias and of nimbi, save for the figures of Christ and Peter, is an idiosyncrasy of the Salerno carver. This emphasis on Peter is surely a conscious "Romanism" on the part of the artist or patron. The suggestion has been made that this *Transfiguration* iconography had its origin in the monumental decoration of the church of the Holy Apostles in Constantinople.[87] This notion is based on the description of the Holy Apostles mosaic in the

ekphraseis of Nikolaos Mesarites, who wrote c. 1200.[88] Whether or not the Holy Apostles' mosaic was the model for the type, however, its appearance in the Salerno panel indicates the reliance of the ivory carver on a Middle Byzantine model.

Feeding of the Multitude (Fig. 30)

Aside from one isolated example, no pre-Iconoclastic version of this miracle shows the asymmetrical arrangement seen in the Salerno plaque, where Christ appears to one side handing the loaves to the Apostles, some of whom divide them among a group of seated people. In early Christian times the scene either showed Christ alone with some baskets or, if it was enlarged, depicted the Apostles symmetrically disposed on either side of Christ blessing the loaves.[89] In the ivory the scene is actually the distribution of the loaves: Christ hands them to the Apostles and they, in turn, divide them among the assembled. Such is the action that occurs in the versions in the eleventh-century Paris Gospels,[90] in an eleventh-century Gospel book in Vienna (Fig. 114)[91] and, in more elaborate form, in a number of later Byzantine Gospel books.[92] The probability of the Salerno scene's being derived from a Middle Byzantine model is thus very high.

84. For St. Catherine's see K. Weitzmann and G. Forsyth, *The Monastery of Saint Catherine at Mount Sinai: The Church and Fortress of Justinian* (Ann Arbor, 1973), pp. 11–18, pl. 103. For SS. Nereo e Achilleo see G. Matthiae, *Mosaici medioevale delle chiese di Roma*, vol. 2 (Rome, 1967), fig. 136.

85. Diez and Demus, *Byzantine Mosaics*, fig. 91.

86. For Mt. Athos, Dionysiou, cod. 587, fol. 161v, see S. Pelekanides et al., *Treasures of Mt. Athos*, fig. 270, and Weitzmann, "Tenth-Century Lectionary," pp. 637–638. For Mt. Athos, Panteleimon, cod. 2, fol. 252v, see Huber, *Athos*, fig. 105. The theme is further treated by K. Weitzmann, "A Metamorphosis Icon or Miniature on Mt. Sinai," in *Mélanges Djurdje Boskovic* (Belgrade, 1970), pp. 415–442.

87. Weitzmann, "Narrative and Liturgical," pp. 260–261; idem, "Metamorphosis Icon," passim.

88. Weitzmann, "Narrative and Liturgical," pp. 260–261. For the Mesarites text, see G. Downey, "Nikolaos Mesarites: De-

scription of the Church of the Holy Apostles at Constantinople," *Transactions of the American Philosophical Society* 47 (1957):pp. 871 ff. The reliability of this text has recently been assessed by H. Maguire, "Truth and Convention in Byzantine Descriptions of Works of Art," *Dumbarton Oaks Papers* 28 (1974):113–140, esp. pp. 123–127.

89. For example, the Maximianus cathedra (Cecchelli, *Cattedra*, pls. 29–30). The lone exception is an early Christian sarcophagus (G. Wilpert, *I sarcophagi cristiani*, vol. 2, Rome, 1929, pl. 130) whose iconography is not closely related to the tradition behind the Salerno ivory.

90. Fol. 29v (*Evangiles avec peintures*, 1:fig. 26).

91. Vienna, National Library, cod. theol. gr. 154, fol. 238r (Lazarev, *Storia*, pp. 177–178, fig. 197).

92. See, among others, the miniature in Bibliothèque nationale, cod. gr. 54, fol. 55r (Lazarev, *Storia*, fig. 386).

Healing of the Paralytic at Bethesda (Fig. 32)

The Bethesda scene was among the earliest and most popular of Christ's miracles to be represented in Christian art, undoubtedly because of its applicability to the sacrament of baptism and its saving effects. Although most early Christian representations of the scene are very simple, usually showing only the figures of Christ and the paralytic with his bed on his back, there are early as well as post-Iconoclastic examples of the two-part narrative sequence shown in the Salerno panel.[93] In these versions and in the ivory, the paralytic is shown twice: first lying on the ground before the miracle, and then walking away with his bed on his back. Although it is explicitly mentioned in the Gospel text, one detail of the scene shown at Salerno is never found in pre-Iconoclastic versions of the episode: the angel who "disturbs" the waters of the pool. The angel may be found in numerous Middle Byzantine versions of the scene, however, and it is surely from a Middle Byzantine model that the Salerno carver derived the iconography of this scene.[94]

Resurrection of Lazarus (Fig. 29)

Consideration of the role of the Grado Chair ivories indicated that the central section of this scene—the figures of the two women and the soldier holding his nose—was derived from a Middle Byzantine model and then combined with other elements based on the Grado Chair version of this episode.

Last Supper (Fig. 30)

The fundamental elements of the iconography used in the Salerno panel depicting the *Last Supper* were established in early Christian times. In the sixth-century Rossano Gospels the Apostles are seated around a semicircular table, with Christ at the far left and Peter opposite him.[95] Judas is shown reaching out toward the platter at the center of the table, as he does in the Salerno panel. What distinguishes the ivory from such pre-Iconoclastic examples is how Christ and Peter are seated. In the early examples, and indeed in many later ones, the two figures recline on couches in the antique manner. In the Salerno panel, Christ sits basically upright, with his left leg somewhat above his right. His left hand, holding a scroll, rests on his left thigh, while his right arm is brought across his body to gesture toward the seated Apostles. Exactly such a Christ figure, with the left leg shown frontally and the right in profile, appears in the Byzantine Chloudoff Psalter, which dates from the ninth century.[96] There, though, instead of Peter, Judas sits at the other end of the table, and instead of reclining, as does the figure at that end of the table in early Christian versions, Judas sits upright. In the ivory, Peter is at that end of the table, sitting upright on a stool, his right hand to his face, his legs in front of the table. Such a type for Peter is purely post-Iconoclastic, and appears, for example, in the mostly destroyed mosaic in Daphni of c. 1100[97] and in the twelfth-century Gospel book in Athens (Fig.

93. See, for example, the several sarcophagi discussed by M. Simon, "Sur l'origine des sarcophages chrétiens du type Béthesda," *Mélanges d'Archéologie et d'Histoire* 55 (1938):201–223.

94. For example, Bibliothèque nationale, cod. gr. 74, fol. 176r (*Evangiles avec peintures*, 2:fig. 152); Mt. Athos, Dionysiou, cod. 587, fol. 17v (Pelekanides et al., *Treasures of Mt. Athos*, fig. 202).

95. Fol. 3r (Haseloff, *Codex purpureus*, pl. 5; Muñoz, *Codice purpureo*, pl. 5).

96. Moscow, Historical Museum, cod. add. gr. 129, fol. 40v (Millet, *Récherches*, fig. 272).

97. Diez and Demus, *Byzantine Mosaics*, fig. 97. The characteristic type of Peter also appears in the Georgian Gelati Gospels, which might date in the eleventh century (K. Wessel, *Last Supper and Communion of the Apostles*, Recklinghausen, 1964, fig. on p. 63).

115).[98] The stool is quite prominently displayed in these examples, as it is also in the fresco at Sant'Angelo in Formis,[99] which is clearly derived from a Middle Byzantine prototype.

Washing of the Feet (Fig. 30)

In the pre-Iconoclastic Rossano Gospels the scene of the *Washing of the Feet* occurred in close connection with the episode of the *Last Supper*.[100] But attention to detail reveals that the Salerno ivory carver used a mid-Byzantine model rather than a pre-Iconoclastic source. Only examples dating from after Iconoclasm contain the motifs of Peter raising his hand to his head and the Apostles seated behind Peter removing their sandals. Both of these features occur in a tenth-century Byzantine ivory in Berlin, where the Apostles removing their sandals face one another, as seems to have been intended in the Salerno panel.[101] The earliest appearance of the motif of Peter with his hand to his head—obviously alluding to the words in the Gospel: "Not only the feet, but also my head and my hands"—is in the ninth-century Chloudoff Psalter, where the posture of Christ in the Salerno panel also has its closest parallel (Fig. 116). Both in the Salerno ivory and in the Psalter he seems to be talking with Peter rather than actually washing his feet; he points down with one hand and up with the other.[102] In the ivory he is bent over to a greater degree. In both examples Christ's apron is tied at the rear with a large and prominently displayed knot. The motif of the garment placed on the "bench" behind Christ, although justified by the Gospel text, appears to be unique to the Salerno panel and might have been introduced by the Salerno carver.

Crucifixion (Fig. 31)

Not only is the simple scheme of the Salerno ivory *Crucifixion*—Christ on the cross flanked by the Virgin and John the Evangelist with two angels hovering above the arms of the cross—the standard one in mid-Byzantine ivory carving,[103] but it is not until the post-Iconoclastic period that the torso of Christ is shown with such a dramatic curve as appears in the Salerno panel. The curve results in Christ's right hip being considerably thrust out, creating a marked concavity in his left hip. Such a torso appears in a tenth-century Byzantine enamel formerly in the Stroganoff Collection in Rome,[104] in the mosaics of Daphni[105] and Hosios Lukas (Fig. 117),[106] and elsewhere. The exact poses of the Virgin—with her left hand held across her chest and her right held up to indicate Christ on the cross, toward whom she looks—and of the Evangelist—whose left hand is held at the waist while his right is raised to support his head—are paralleled in mid-Byzantine works such as the mosaic of Hosios Lukas or the early twelfth-century enamel plaque from the Pala d'Oro in Venice.[107]

98. *Byzantine Art: An European Art,* Catalogue of the Ninth Exhibition of the Council of Europe (Athens, 1964), p. 320, no. 317, fig. 317.

99. Morisani, *Affreschi,* fig. 35.

100. Fol. 3r (Haseloff, *Codex purpureus,* pl. 5; Muñoz, *Codice purpureo,* pl. 5).

101. Goldschmidt and Weitzmann, *Byz. Elfenbeinskulpturen,* 2:28, no. 13, pl. 4. See Weitzmann, "Tenth-Century Lectionary," pp. 626–627.

102. H. Giess, *Die Darstellung der Fusswaschung Christi in den Kunstwerken des 4–12. Jahrhunderts* (Rome, 1962), p. 101,

fig. 9. On the meaning of the various gestures and of the scene in general, see E. Kantorowicz, "The Baptism of the Apostles," *Dumbarton Oaks Papers,* 9/10 (1956):234–242.

103. Goldschmidt and Weitzmann, *Byz. Elfenbeinskulpturen,* vol. 2, passim.

104. P. Thoby, *Le crucifix* (Paris, 1959), no. 102, pl. 45.

105. Diez and Demus, *Byzantine Mosaics,* fig. 92.

106. Ibid., pl. 13.

107. W. F. Volbach et al., *La Pala d'Oro,* (Florence, 1965), pp. 40–41, pl. 44.

Christ Appears to the Marys (Fig. 34)

In pre-Iconoclastic times the iconographical type used for *Christ Appears to the Marys* showed the women to one side and in front of Christ as he strode forward. This type, which may be described as the more narrative version, is found in the Rabbula Gospels,[108] where one of the women is identified as the Virgin by her dress and nimbus. In mid-Byzantine art this narrative type survived—see, for example, the tenth-century ivory in Dresden[109]—but was joined by a second version, a more hieratic one that featured Christ at the center of a more or less symmetrical composition with a Mary on either side. The earliest example of this new composition is in the late ninth-century manuscript of the Homilies of Gregory Nazianzenus, Paris gr. 510 (Fig. 118).[110] This is the same general type found in the Salerno ivory.[111]

Having demonstrated that a substantial number of the Salerno New Testament scenes were the invention of Middle Byzantine art, I suggest that when the iconography of a scene in the Salerno series was current in mid-Byzantine art, and when the Salerno scene does not reflect any internal evidence to the contrary, a Middle Byzantine model may be assumed to lie behind the Salerno composition. Clearly, mid-Byzantine art was a readily available and most attractive source for a south Italian work of this period. Thus, scenes such as *Christ and the Samaritan Woman* (Fig. 29), *Entry into Jerusalem* (Fig. 29), *The Marys Announce the Resurrection to the Apostles* (Fig. 35), *Christ Appears in Jerusalem* (Fig. 39), *Christ Appears at Lake Tiberius* (Fig. 35), and *Christ Appears at Bethany* (Fig. 37), which have parallels in both pre- and post-Iconoclastic art, or for which the evidence is presently insufficient, were probably derived from a Middle Byzantine source.[112]

A substantial number of scenes in the New

108. Florence, Laurentian Library, cod. Plut. I. 56, fol. 13r (Cecchelli et al., *Rabbula Gospels*, p. 13). Here and in other pre Iconoclastic examples one of the women is clearly identified as the Virgin. See J. Breckenridge, " 'Et Prima Vidit': The Iconography of Christ's Appearance to His Mother," *Art Bulletin* 39 (1957):9–32; K. Weitzmann, "Eine vorikonoklastische Ikone des Sinai mit der Darstellung des Chairete," in *Tortulae* (Freiburg, 1966), pp. 317–325.

109. Goldschmidt and Weitzmann, *Byz. Elfenbeinskulpturen*, 2:37, no. 41, pl. 17.

110. Fol. 30v (Omont, *Miniatures grecs*, pl. 21).

111. Belting (*Cimitile*, p. 83), among others, sees the Christ of the Salerno version reacting to one of the Marys as an adaptation from the *Noli me tangere* scene based on John's Gospel, in which only the Magdalene appears. The scene is commonly found in medieval European art. Such a conflation is not necessary to explain the Christ type at Salerno because he appears in this pose in at least one early example of the more narrative version of the Matthew episode: see I. Haug, "Erscheinungen Christi," in *Reallexikon der deutschen Kunstgeschichte*, 5:fig. 6.

112. *Christ and the Samaritan Woman:* Bibliothèque nationale, cod. gr. 74, fol. 173r (*Evangiles avec peintures*, 2:fig. 150); Athens, National Library, cod. 93 (Lazarev, *Storia*, p. 212; photograph in the Department of Art and Archaeology, Princeton University). The fluted basin of the well may be an Italian element; it is found at Sant'Angelo in Formis (Morisani, *Affreschi*, pl. 19), in the Pisa Exultet Roll (2) (Avery, *Exultet Rolls*, pl. 84), and at Monreale (Demus, *Mosaics*, pl. 67A).

Entry into Jerusalem: Florence, Laurentian Library, cod. Plut.

VI, 23 fols, 40r, 84r (Velmans, *Tétraévangile*, figs. 86, 163); Berlin, Staatsbibliothek, cod. gr. qu. 66, fol. 65v (Millet, *Récherches*, fig. 244). On the iconography of this scene, see E. Dinkler, *Der Einzug in Jerusalem. Ikonographische Untersuchungen im Anschluss auf ein bisher unbekanntes Sarcophag-fragment* (Cologne, 1970).

The Marys Announce the Resurrection to the Apostles: Bibliothèque nationale, cod. gr. 74, fol. 162r (*Evangiles avec peintures*, 2:fig. 140, here illustrating Luke); early fourteenth-century fresco at Gračanica, Yugoslavia (V. Petrović, *La peinture serbe du moyen âge*, vol. 1, Belgrade, 1930, pl. 48b). As far as I know, the earliest representation of this rare scene is on the ninth-century silver casket of Paschal I in the Vatican Museum (Cecchelli, "Il Tesoro," fig. on p. 160).

Christ Appears in Jerusalem: Mt. Athos, Dionysiou, cod. 587, fol. 14v (Pelekanides et al., *Treasures of Mt. Athos*, fig. 199).

Christ Appears at Lake Tiberius: Bibliothèque nationale, cod. gr. 74, fol. 211r (*Evangiles avec peintures*, 2:fig. 184); Mt. Athos, Dionysiou, cod. 587, fol. 173r (Pelekanides et al., *Treasures of Mt. Athos*, fig. 277). The versions at Sant'Angelo in Formis (Morisani, *Affreschi*, pl. 53) and Monreale (Demus, *Mosaics*, pl. 74A) are quite close to the Salerno rendering.

Christ Appears at Bethany: New York, Morgan Library, cod. 692, fol. 11r (eleventh-century lectionary; photograph in the Department of Art and Archaeology, Princeton University). The sequence of *Bethany-Ascension* may be seen in Cambridge, Eng., St. John's College Library, cod. K21, fol. 61, a miscellany of thirteenth-fourteenth-century date (photograph in the Index of Christian Art, Princeton University).

Testament cycle that I have shown to derive in whole or in part from post-Iconoclastic Byzantine prototypes (*Presentation, Baptism, Transfiguration, Resurrection of Lazarus, Entry into Jerusalem, Last Supper, Washing of the Feet, Crucifixion*) represent events that in the Byzantine church formed part of the liturgical cycle of the Great Feasts. Although these feasts are generally considered to be twelve in number, spread over the course of the year, in fact the exact number and even the identity of the events commemorated was somewhat flexible. In Middle Byzantine times, this liturgical structure often determined which episodes from Christ's life would be depicted in representational contexts of various kinds. Cycles of Christ's life assumed the shape of the liturgical festival sequence; a hieratic organization replaced the more simple narrative approach used elsewhere. Such feast pictures, usually rendered hieratically, were disseminated, if not invented, as part of the illustration of the Gospel lectionary, the most important liturgical book in the Byzantine church, in which the Gospel text itself was subjected to a process of selection and rearrangement in accordance with the sequence in which the Gospels were read in the course of the year.[113] There is no doubt that this liturgically inspired Middle Byzantine Christological imagery—already recognized by modern scholarship as influential in early medieval European art—had a significant impact on the Salerno ivories' New Testament cycle.[114]

THE ITALIAN ELEMENT

A number of New Testament iconographic types in the ivories do not appear in either the Grado Chair ivories or post-Iconoclastic Byzantine art but do occur in works executed in Italy. Regardless of the ultimate origins of these types, their appearance in the Salerno series indicates that the carvers at least glanced back at an earlier Italian tradition in creating their New Testament iconography.

Entombment (Fig. 31)

In the *Entombment* the enshrouded body of the dead Christ is lowered into a sarcophagus by Nicodemus and Joseph of Arimathea. The sarcophagus, its front decorated with a strigilated motif, is placed beneath a baldachinlike structure. Although two figures bearing the body of Christ in a manner similar to that in the Salerno ivory are found in mid-Byzantine *Entombments* such as the tenth-century lectionary miniature in Leningrad,[115] these examples invariably show Christ being pushed into a cave, not lowered into a sarcophagus. The sarcophagus was a traditional feature in Western *Entombments*; it is found, for instance, in the tenth-century Codex Egberti (Fig. 119),[116] where the two bearers face each other at either end of Christ's body. But

113. The extent of the impact of the Great Feast cycle on Byzantine imagery is yet to be thoroughly assessed. See Millet, *Récherches*, pp. 15–30; O. Demus, *Byzantine Mosaic Decoration* (Boston, 1955), pp. 22–26; M. Restle, "Dodekaorton," in *Reallexikon zur byzantinischen Kunst*, 1:col. 1207–1214; E. Lucchesi-Palli, "Festbildzyklus," in *Lexikon der christlichen Ikonographie*, 2:cols. 26–31; L. Ouspensky and V. Lossky, *The Meaning of Icons* (Boston, 1969), pp. 147–215; Weitzmann, "Narrative and Liturgical," pp. 248–270; idem, "The Constantinopolitan Lectionary Morgan 639," in *Studies in Art and Literature for Belle da Costa Greene*, ed. D. Miner (Princeton, 1954), pp. 354–373; idem, "Eleventh-Century," pp. 289–312; idem, "Tenth-Century Lectionary," passim.

114. H. Buchthal, "Byzantium and Reichenau," *Byzantine Art: An European Art: Lectures* (Athens, 1966), pp. 45–60; K. Weitzmann, "Various Aspects of Byzantine Influence on the Latin Countries from the Sixth to the Twelfth Century," *Dumbarton Oaks Papers* 20 (1966):15–17; O. Demus, *Byzantine Art and the West* (New York, 1970), pp. 93–95.

115. Leningrad, Public Library, cod. gr. 21, fol. 8v (Millet, *Récherches*, fig. 485; C. R. Morey, "Notes on East Christian Miniatures," *Art Bulletin* 11 [1929]:fig. 100).

116. Trier, Stadtsbibliothek, cod. 24, fol. 85v (H. Schiel, *Codex Egberti*, facsimile ed., fol. 85v).

two elements of the Salerno version are notably lacking in this Ottonian manuscript—the strigillata on the sarcophagus and the baldachin over it—and it is exactly in these details that the composition of the ivory appears to be specifically Italian.[117] This very combination of elements appears, for example, in the *Entombment* scene in Sant'Angelo in Formis (Fig. 120) and in the illustration for the chapter *De sepulchro* from the Hrabanus Maurus manuscript illuminated at Monte Cassino in 1023 (Fig. 121).[118] The strigillata motif (also found in the *Marys at the Tomb*) is, of course, a classical one found on countless Roman sarcophagi. The preservation or revival of this element seems understandable in southern Italy, where classical monuments were preserved in great numbers during the Middle Ages.[119]

Anastasis (Fig. 32)

Byzantine representations of the *Anastasis* assumed several forms. Motifs such as the personification of Hades and the doors of Hell were sometimes included and sometimes not. Scholars have made distinctions between earlier and later types: certain examples show Christ reaching down in front of him and pulling Adam up from Hell, while others show him reaching behind and dragging Adam up. The second type is generally considered to be later, an invention of the Macedonian Renaissance of the tenth century, during which it was developed under the impact of the classical model of *Heracles Dragging Cerberus from Hell.*[120]

The fully developed mid-Byzantine versions of the *Anastasis* generally showed other figures besides the main protagonists.[121] The more simplified iconography of the ivory was popular in Italy, appearing, for example, in the frescoes of San Clemente in Rome,[122] Cimitile (Fig. 122),[123] and Santa Maria Antiqua.[124] Most characteristic of the Salerno version are the three-quarter-length enshrouded corpses that appear in the upper right corner of the composition. A similar feature appears in a group of eighth- or ninth-century Palestinian works, but in these examples the small figures are only two in number and definitely represent David and Solomon, who are mentioned in the Nicodemus text.[125] In the ivory the figures in the upper part clearly represent the masses of the dead awaiting the general resurrection. The same meaning is conveyed by differently rendered figures in the *Anastasis* on a mid-Byzantine ivory casket in Stuttgart[126] and in the fresco from the church of St. Barbara at Soghanli in Cappadocia.[127] The actual motif of the wrapped corpses at Salerno is paralleled in very few works, among which are the frescoes of Cimitile (Fig. 122)[128] and a

117. For this *Entombment* type see O. Pächt, C. R. Dodwell, and F. Wormald, *The St. Alban's Psalter* (London, 1960), pp. 71–73. Here the possible influence of the liturgical drama is also considered.

118. Morisani, *Affreschi*, fig. 48. For the Hrabanus manuscript, Monte Cassino, Monastery Library, cod. 132, p. 367, see A. Amelli, *Miniature sacre e profane illustranti l'enciclopedia medioevale di Rabano Mauro* (Monte Cassino, 1896), pl. 98.

119. This type of Roman sarcophagus may be found all over southern Italy and Sicily; see, for example, V. Tusa, *I sarcophagi romani in Sicilia* (Palermo, 1957), figs. 155, 158.

120. K. Weitzmann, "Das Evangelion im Skevophylakion zu Lawra," *Seminarium Kondakovianum* 8 (1938):88. This view has recently been disputed by E. Schwartz ("A New Source for the Byzantine Anastasis," *Marsyas* 16 [1972–1973]:32–33), who suggests a source for the iconography in imperial imagery and an origin of the type in pre-Iconoclastic times.

121. See R. Lange, *The Resurrection* (Recklinghausen, 1957), passim.

122. Wilpert, *Mosaiken und Malereien*, 4: pl. 209, 3.

123. Belting, *Cimitile*, fig. 31.

124. Wilpert, *Mosaiken und Malereien*, 4:pl. 168, 2; Nordhagen, *The Frescoes of John VII*, pp. 81–82, pl. C(b).

125. See E. Lucchesi-Palli, "Der syrisch-palästinische Darstellungs-typus der Höllenfahrt Christi," *Römische Quartalschrift*, 56/57 (1961–1962):250–267.

126. Goldschmidt and Weitzmann, *Elfenbeinskulpturen*, 2:30–31, no. 24, pl. 7.

127. Restle, *Byzantine Wall Painting*, 3:fig. 440.

128. Belting, *Cimitile*, fig. 31.

south Italian Exultet Roll now in the Vatican.[129] These examples—both of which also display sarcophagi with strigils—suggest that the shrouded figures were part of an Italian iconographical tradition that had wide impact from the tenth through the twelfth century.[130]

Incredulity of Thomas (Fig. 34)

The *Incredulity of Thomas* in the Salerno ivories is similar to the usual mid-Byzantine version in showing Christ and Thomas in the center of the composition and the Apostles in two roughly equal groups on either side. Thomas approaches Christ from the left and thrusts his finger toward the wound that Christ has uncovered by pulling back his mantle. These elements are present in the versions at Daphni and Hosios Lukas,[131] where, as in the ivory (and in accordance with the text), only eleven Apostles are shown. But the ivory depicts another element that is never found in the mid-Byzantine examples of the scene: the figures are shown slightly more than half-length, the lower halves of their bodies hidden by a wall in the foreground. At the center of this wall a pair of doors is prominently displayed. These doors, specifically required by the text, are included in the canonical Byzantine versions cited above, but there they are always relegated

to a position in the rear of the scene and often form a backdrop for the figure of Christ. Although the origin of the Salerno type remains obscure—it may ultimately go back to early Palestinian sources[132]—it was undoubtedly popular in Italy during the tenth, eleventh, and twelfth centuries. The wall is found at the front of the *Incredulity* in the frescoes at Cimitile,[133] at Sant'Angelo in Formis (Fig. 123),[134] and in the twelfth-century Exultet Roll in Troia.[135] The last two examples show the doors in the center of the wall, held together with the same type of elaborate lock found in the ivory. The appearance of a related composition in two works of probable north Italian origin—the ivory from the Magdeburg antependium[136] and the miniature from the Ivrea lectionary of c. 1000[137]—suggests either an influence from the south or dependence on a common model.

The scenes described above clearly are associated with an Italian tradition current at the time the Salerno ivories were made. Possibly other New Testament scenes in the Salerno series were also derived from this source, but the evidence is scanty. The unusual composition of the *Christ at Emmaus* plaque (Fig. 36), with Christ placed at the extreme left of the table and the two Apostles to the right, is paralleled in the Troia Exultet Roll,[138] which suggests that this

129. Avery, *Exultet Rolls*, pl. 142.

130. In the upper left corner of the fresco at Santa Maria Antiqua (see note 124 above) are fragments of two figures dressed in white. Wilpert (*Mosaiken und Malereien*, 2:891) identified them as angels, while Belting (*Cimitile*, p. 75) maintained that they were a mummy group like those seen at Salerno and Cimitile. I am inclined to agree with Belting on the basis of the relative size and location of the fragments. Nordhagen (*Frescoes of John VII*, p. 82) mentions the conflicting opinions but renders no judgment.

131. Diez and Demus, *Byzantine Mosaics*, figs. 10–11 (Hosios Lukas), 103–104 (Daphni).

132. The doors also appear in front of the figures in the cross-shaped metal container of Paschal I in the Vatican. The Thomas episode is shown here in two stages: (1) the appearance of Christ before the group; (2) Thomas thrusting his finger into the wound. See Cecchelli, "Tesoro," fig. on p. 159, for the first scene.

133. Belting, *Cimitile*, fig. 43. I do not agree with Belting's attribution of the motif of the doors in front to a Carolingian prototype on the basis of the appearance of city walls in Carolingian examples of the scene. These three-dimensional abbreviated cityscapes are very different from the flat walls of the Italian tradition.

134. Morisani, *Affreschi*, fig. 54.

135. Avery, *Exultet Rolls*, pl. 172.

136. Goldschmidt, *Elfenbeinskulpturen*, 3:52, no. 301, pl. 60.

137. Ivrea, Biblioteca Capitolare, cod. 86, fol. 71r (L. Magnani, *Le miniature del sacramentario d'Ivrea*, Vatican City, 1934, pl. 20).

138. Avery, *Exultet Rolls*, pl. 171.

scene, too, was taken from an Italian tradition. Further evidence of native Italian iconographical elements has not come to light.

One further indication of the influence of a native Italian tradition on the New Testament cycle is evident in the size of the *Crucifixion* and *Ascension* scenes. The carvers gave these scenes special emphasis by enlarging them to twice the size of the other scenes. There is precedent for this in other Italian works: in the frescoes of Old St. Peter's (Fig. 47)[139] the *Crucifixion* was enlarged, as it later was in the late twelfth-century fresco cycle in San Giovanni a Porta Latina;[140] and at Sant'Angelo in Formis, as in the ivories, both the *Crucifixion* and the *Ascension* are enlarged.[141]

CONCLUSIONS

Clearly, the carvers of the Salerno ivories employed two basic sources for their Christological scenes, deriving individual scenes from these sources on a selective basis and sometimes combining elements from both. The specific models were, of course, the Grado Chair ivories—including a number of panels from the series that are now lost—and a Middle Byzantine cycle. The latter probably was a manuscript because its content is so strikingly discursive, most likely a lectionary or a Gospel book influenced by the lectionary. In a few cases a third source embodying a more traditional Italian iconography was introduced, or at least Western (Italian?) details were introduced to the compositions.

The Grado Chair ivories served directly as models but the Middle Byzantine iconographic types may not have been derived directly from a Greek source. They may have been filtered through the intermediary of an earlier Italian cycle—perhaps from Monte Cassino—that also contained the Italian iconographical traits described above. Whether or not the *immediate* model for scenes based on these types was Greek or Latin, however, the ultimate source for their iconography was a Middle Byzantine cycle.

In combining these sources, the designer of the cycle aimed at creating a narrative account of Christ's life that followed the chronology of the Gospels as closely as possible. Within this general framework, however, he chose to emphasize aspects of the life that would convey important messages to the faithful. For example, there is a marked emphasis on the miracles of healing and resurrection. No fewer than seven individuals are saved from various afflictions, and considering the size of the cycle (and the fact that other such scenes might be lost), that is a substantial number. There is also a liturgical undercurrent in the cycle as a result of the numerous scenes that allude to the Eucharist. The *Miracle at Cana, Feeding of the Multitude, Last Supper,* and *Supper at Emmaus* are all types for the sacrament of the Eucharist. The wheat sprigs and grapes in the *Ascension* make the meaning even more explicit. Many scenes involve water, that vital agent of Christian renewal. Water is turned to wine in the *Cana* scene, Christ is baptized in it in the *Baptism,* the Apostles sail on it in the *Calling,* the Samaritan woman draws it from the well, Christ washes the Apostles' feet in it, the blind man washes his eyes with it, and Peter swims in it in the Tiberius scene. Another prominent theme is Christ's return after his resurrection. No fewer than eight different appearances are shown in the ivories, and perhaps more were in-

139. Waetzoldt, *Kopien,* fig. 485.
140. Wilpert, *Mosaiken und Malereien,* 4:pl. 255.
141. Morisani, *Affreschi,* p. 84 and diagram at back.

cluded among lost plaques. This is a high number for such a cycle. Christ's ability to heal and resuscitate the afflicted and dead was amply represented in the earlier panels. The scenes that complete the cycle stress the idea that Christ, having already risen once after his crucifixion, would come a second time, offering further miracles of healing and resurrection.

3. STYLE, DATE, AND PLACE OF ORIGIN

A TRULY COMPREHENSIVE ANALY-SIS of the style of the Salerno ivories is a complex undertaking because the ivories' style, while reflecting the impact of a number of sources, remains unique. Outside of the small circle of directly related ivories included in the Catalogue there exist virtually no works that are fully comparable. Nevertheless, stylistic interpretation yields a meaningful pattern of associations that, among other things, allows one to suggest where and when the ivories were made.

THE QUESTION OF HANDS

Before analyzing the style of the ivories, it is helpful to consider the artists who made them. Ferdinando Bologna has proposed that sufficient stylistic divergence exists among the ivories to indicate the participation of three distinct artistic personalities.[1] The first of these was responsible for the Old Testament cycle, which Bologna says is characterized by a certain "archaism," perhaps as the result of Ottonian influence. This artist was marginally influenced by Byzantine works and used some Arabic ornament. In his intense plasticity, however, he re-vealed himself as a Romanesque artist whose panels are related to the sculptures of St. Sernin at Toulouse, the Cathedral of Modena, and San Nicola in Bari. Bologna's second carver executed the Infancy cycle and a few other related plaques in the New Testament group. He was more expressionistic than the Old Testament artist and employed a greater number of naturalistic elements. Although displaying marked Islamic characteristics, the second carver's style, Bologna says, is characterized mainly by a tendency toward inflation of the figures (I assume Bologna is here referring to the very rounded faces of the Infancy scenes); this aspect of his work relates his style to the second school of Toulouse, as reflected in the Porte Miègeville at St. Sernin and the Puerta de las Platerías at Santiago de Compostela. The third artist would have carved the remainder of the New Testament series. His scenes are flatter and more sharply cut than the others, and he tended to execute more explicitly descriptive scenes. In these ways, according to Bologna, the third artist's style is related to that of the sculpture of the school of León.

Although it is indeed probable that more

1. *Opere d'arte nel salernitano del XII al XVIII secolo*, exhibition catalogue (Naples, 1955), pp. 14–16.

than one artist executed the Salerno series, the differences that Bologna cites might not have resulted from the participation of different artists. The sections ascribed to different hands by Bologna correspond roughly to those that derive from different iconographical sources. This suggests that the differences Bologna describes may be due to the influence on the ivory carver of the style of his models, or, at least, to the interaction of the models' style with the workshop's own.[2]

Even though the ivories display variations in compositional principles, figural proportions, and facial types, among other things, in general the panels have a high degree of stylistic unity. These works were made either simultaneously or consecutively in the same workshop, an atelier that had access to and used different iconographic and stylistic sources. Although the conventions of the carvers' or workshop's approach were strong enough to create a group cast in a generally consistent style, they were not so potent that they completely obliterated all distinguishing characteristics of the contributor styles. The analysis of stylistic sources yields conclusions that, in general, confirm observations concerning iconographic models.

STYLISTIC SOURCES

Too often the attempt to isolate stylistic sources or components degenerates into a mere cataloguing of individual motifs. It is necessary to pinpoint specific elements derived from the sources, but one should keep in mind that the sum of the individual elements frequently does not equal the total style. The style of a work, whatever the stylistic sources, may constitute a whole new approach to form, one that permeates the work and results in a unique rendering of the subject. Stylistic influences may also manifest themselves in ways difficult to quantify. Indeed, the most profound stylistic influences are frequently not to be found in specific elements easily isolated in a work of art. Instead, they are absorbed during the far less tangible artistic "education" that takes place before or during the creation of the work.

THE GRADO CHAIR IVORIES

The stylistic influence of the Grado Chair series on the Salerno group was less profound than its iconographic influence, but was important nonetheless. The carvers of the Salerno panels derived their architectural types from the Grado Chair ivories, but this does not mean that in every scene where such architectural forms appear in the Salerno reliefs the carver copied these forms from a scene in the earlier group. The fact that such architectural forms occur in Old Testament scenes (such as Fig. 13) never contained in the Grado Chair group testifies to the great impact of these architectural backgrounds: they could even be introduced into scenes in the Salerno ivories that were otherwise derived from different sources.

Despite its obviously derivative nature, the architecture in the Salerno ivories differs significantly from its prototype. For instance, in the Grado Chair *Nativity* (Fig. 98) there is a cityscape in which three buildings are convincingly depicted within a clearly three-dimensional wall. In the Salerno panel (Fig. 23), not only are the buildings flattened out—in the Grado Chair plaque they had been markedly rounded—but the wall itself has lost its organic, three-dimensional quality. It no longer encircles the city but

2. I suggested in Chapter 1 that the Salerno Old Testament cycle relates to a tradition extending back to early Christian Rome (fifth century). In terms of style, however, I can find little direct impact of this early tradition. Perhaps the tendency toward slightly stouter proportions in the Old Testament scenes can be attributed to this source. This lack of influence is understandable if, as I suspect, the Old Testament iconography was not transmitted directly from the early Christian source but was filtered through one or more intermediary medieval stages.

instead stands in front of it. As noted earlier, the shrine with the hanging lamp that appears in front of the cityscape in the earlier plaque is similarly placed in the Salerno *Nativity,* but is there devoid of all rationale, its function obscured. The altar-manger of the earlier version seems to hover in mid-air in the Salerno plaque.

In general, the architecture in the Salerno series reflects a marked devaluation of structural coherence when compared with that in the Grado Chair panels. Not only are the buildings flattened out in the later works, but the backgrounds show abrupt changes in scale (as in Fig. 27). Obvious anomalies, such as the appearance of buildings beneath arches (Fig. 32), occur that are notably absent in the Grado Chair cycle. The ultimate degeneration of background unity is represented by the *Flight into Egypt* (Fig. 23). At the right appears a strange conglomeration: a domed building forms the base above which rises a decorated arch, then an aedicula with a tree growing out of it, and, finally, on top, a slender cylindrical structure. The background is filled with buildings executed on a completely different scale. By comparison, the architecture of the Grado Chair backgrounds maintains a high degree of unity and coherence. The architecture in the Salerno panels is also distinctly more ornamental than that in the earlier group. The decoration of the doorway in the *Healing of the Widow's Son at Nain* (Fig. 27), with its intarsia work and rosettes, or of the archway in the *Healing of the Paralytic at Bethesda* (Fig. 32), is more elaborate than anything in the Grado Chair group.

Also derived from the Grado Chair series were a number of costume types, and their appearance in the Salerno ivories parallels the devaluation of function seen in the rendering of architectural forms. Chief among these costumes are the fringed ornamental draperies worn by a number of women in the New Testament cycle (see Figs. 20 and 23). The delicate *clavi* that characterize the drapery of the main female figure in the *Resurrection of Lazarus* from the earlier series (Fig. 100) have become thick and detached in the Salerno panels (see Fig. 20), although their identity is beyond question. The costumes of the servants in the Salerno version of the *Miracle at Cana* (Fig. 25) provide instructive examples when juxtaposed with the fragment of the same scene associated with the Grado Chair group (Fig. 102). Here again the tunics with *clavi* extending from shoulder to waist are derived from the earlier example. But, as suggested earlier, the Italian artist has misunderstood how the *clavi* function; he has made them into elements unconnected to the tunic, worn almost as one would wear a pair of suspenders. A similar misunderstanding occurs in the treatment of the vessel held by the middle servant: in the earlier panel it follows perfectly the form of the ancient device used for extracting liquids; in the Salerno panel the form is so vaguely comprehended that it becomes a mixing rod inserted into a large container.[3] To return once more to costume, consider the difference between the boots worn by the first figure in the *Pentapolis* scene of the early group (Fig. 104) and the boots worn by the son of Joseph leading the ass in the Salerno version of the *Journey to Bethlehem* (Fig. 22). In the latter, typically, the boots are given the overall grill pattern used in the Salerno panels for everything from decorating walls to rendering material, while in the Grado Chair example a more naturalistic texture is maintained.

Virtually no scholar who has dealt at any

3. This type of wine-lifter was discovered in Egyptian grave sites. See M. Longhurst, *Victoria and Albert Museum, Catalogue of Carvings in Ivory* (London, 1927), p. 33; Weitzmann, "Grado Chair," p. 61.

length with the style of the Salerno ivories has failed to mention the influence of Islamic art on the panels.[4] One author has gone so far as to propose the intervention of an Islamic artist in the execution of certain plaques.[5] In fact, the role played by Islamic forms is limited, and the transmission of Islamic influences to the south Italian works was indirect. For the most part the Islamic aspects are confined to the background architectural motifs, and these, as noted above, came to the Salerno carvers not through direct contact with Islamic art but through the intermediary of the Grado Chair ivories. Furthermore, the basic architectural forms shown are not contemporary with the Salerno panels but reflect Islamic architecture of the seventh and eighth centuries, the time when the Grado Chair ivories were executed.[6]

Another aspect of the ivories' style often spoken of in terms of Islamic influence is the wide, rounded facial type found many times in the Salerno New Testament cycle, particularly in the Infancy section (for example, Figs. 20 and 24). Like the architectural forms, these pudgy faces, though possibly derived ultimately from Islamic sources, were probably transmitted through the Grado Chair series; similar types may be seen in the *Marriage at Cana* fragment (Fig. 102) and in the figure of the angel on the plaque depicting *Peter Dictating the Gospel to Mark* (Fig. 124). It should also be kept in mind here that the Infancy cycle was heavily dependent for its iconography on the Grado Chair group.[7]

MIDDLE BYZANTINE ART

The significant impact of post-Iconoclastic Byzantine art on the style of the Salerno ivories has been pointed out many times in the past, but, aside from Weitzmann, scholars have always rested their views on vague generalities, never stopping to define more precisely the nature of the Byzantine influence.[8]

It is true that the Salerno panels could never be mistaken for Byzantine works, but it is equally indisputable that the stately, classically inspired approach of much Middle Byzantine art has contributed significantly to the general tone of the ivories. Whether one considers entire compositions such as the *Transfiguration* (Fig. 26), or looks at types of single figures, such as Christ on the cross (Fig. 31) or in the *Baptism* (Fig. 26), one sees Byzantine-derived formulas. This influence is especially marked where the canons of mid-Byzantine iconography have held sway.

The single most characteristic element of the Salerno style is the method of rendering drapery. By this I mean in particular the almost omnipresent use of box pleats and flattened trumpet-folds in the delineation of the hanging portions of drapery (generally the part covering the legs). The figure of Christ in the *Feeding of the Multitude* (Fig. 30) offers a particularly clear illustration of these elements. Although such devices are by no means unique, the rendering of these seemingly three-dimensional motifs virtually in a single plane is most peculiar, producing a flat relief profile in exactly the place

4. For example, Goldschmidt, *Elfenbeinskulpturen*, 4:3; and P. Toesca, *Storia dell'arte italiana: il medioevo*, vol. 2 (Turin, 1927), p. 1096.

5. L. Becherucci, "Gli avori di Salerno," *Rassegna storica salernitana* 2 (1938):82.

6. Weitzmann, "Grado Chair," pp. 57–58.

7. Goldschmidt (*Elfenbeinskulpturen*, 4:3) emphasized, as evidence of the influence of an early Egyptian source, the unusual coiffure with three cascading locks of hair that appears on numer-

ous figures of angels, Magi, and shepherds in the Salerno panels (see Figs. 20, 21, and 24). As noted earlier, this motif was probably derived by the carvers of the Salerno reliefs from the Grado Chair ivories.

8. See, for instance, A. Venturi, *Storia dell'arte italiana*, vol. 2 (Milan, 1902), pp. 625–630; Bertaux, *Italie méridionale*, p. 434; and Goldschmidt, *Elfenbeinskulpturen*, 4:3. Weitzmann's more precise analysis is in "Grado Chair," pp. 62–63.

where one expects to find the most markedly three-dimensional surface. Although perfectly in tune with a general tendency in the ivories toward compression, this anomaly does suggest that elements of a foreign style are being assimilated, or at least emulated, by the workshop.

One need not search far for the origins of this foreign style. These characteristic drapery motifs derive from Middle Byzantine prototypes, as simple comparison of the Christ figure from the *Feeding of the Multitude* with one on a Byzantine plaque in Würzburg (Fig. 125) shows.[9] Here, in a work that is a true descendant of the classical tradition, those same folds that in the Salerno panels have become planar and two-dimensional have a relatively robust, modeled character. Comparison of the Christ figures in the Salerno panel of *Christ Appears in Jerusalem* (Fig. 39) and on a plaque of tenth-century Byzantine workmanship depicting a similar composition (Fig. 126)[10] reveals not only similar drapery types but also profound correspondences in the deep-cut incisions used to delineate the vertical folds and the peculiar V-shaped stylization between the legs. The dramatic poses of the Apostles in the Salerno scene, however, are a markedly non-Byzantine feature, and indicate that the carver of the ivory could introduce significant elements of his own invention into a panel whose style is predominantly derived from one of his sources.[11]

Consider for a moment one little drapery detail that is symptomatic of the relationship of the Salerno ivories' style to that of the Byzantine sources. The Salerno *Crucifixion* scene (Fig. 31) is, in general type, clearly derived from a Byzantine prototype, and the particular poses of the Virgin and St. John can be paralleled in numerous Byzantine examples.[12] In depicting St. John's sorrowful gesture of raising his right hand to support his inclined head, the Salerno artist had considerable difficulty in rendering the resultant fall of drapery. Specifically, the problem arises at the juncture between the bunched-up drapery at the elbow, which occurs as a result of the bending and raising of the arm, and the beltlike portion of the garment that appears at the waist. An arrangement results in which the sleeve of the mantle is brought around and under the arm and is then tucked into the waistband, a less than logical solution at best. It seems fair to conclude that the carver of the south Italian plaque would have had as his model some work in which this drapery motif was handled with a greater degree of consistency. Numerous Byzantine panels might be adduced as examples of such a type, as for instance the St. John on a tenth-century *Crucifixion* ivory (Fig. 127), where the two elements of waistband and sleeve coexist in a natural and logical way.[13]

The indication of drapery folds by the use of a few relatively short incisions on the surface, evident in many of the Salerno plaques (for instance, Figs. 33 and 34), is the hallmark of a particular group of mid-Byzantine ivory carvings, the Triptych Group (see Fig. 128).[14] Weitzmann has emphasized the importance of this group in accounting for the Salerno ivories' style, citing, in addition to the characteristic

9. Goldschmidt and Weitzmann, *Byz. Elfenbeinskulpturen,* 2:42, no. 56, pl. 23.

10. Ibid., p. 55, no. 100, pl. 38.

11. Such exaggerated poses of veneration occur a number of times in the Salerno series (for example, Figs. 11, 13, and 27). They are common in south Italian art of the period and should probably be seen as an emphatic gesture of the Italian artist. Compare, for example, the angels who adore Christ in the Exultet Rolls at Monte Cassino or in Pisa: M. Avery, *The Exultet Rolls of South Italy* (Princeton, 1936), pls. 66, 84.

12. Goldschmidt and Weitzmann, *Byz. Elfenbeinskulpturen,* 2:nos. 101–102, pl. 39.

13. Ibid., p. 55, no. 102, pl. 39.

14. Ibid., p. 70, no. 174, pl. 59.

STYLE, DATE, AND PLACE OF ORIGIN

method of rendering drapery, the soft, wavy hair styles found in various figures in the Infancy cycle and the lively expression around the eyes (created by rendering the eyes with two lines above but only one below the punch) as related to this or other groups of Byzantine ivories.[15]

Another Byzantine convention was adapted at Salerno to depict hair; the effect in the Salerno panels is one almost of a cap composed of several rounded sections, each consisting of a number of incised lines used to indicate separate waves (Fig. 36). The motif occurs in tenth-century Byzantine ivories of the Nicephorus Group, such as the beautiful *Crucifixion* plaque in Paris (Fig. 129).[16] The Salerno carvers understood this motif relatively well, but in adapting it to their work they lost some of the organic quality of the Byzantine prototype.

Another very specific Byzantine element in the Salerno ivories is the type of nimbus used for the Christ figures. In almost every case the carvers used the cross-nimbed variety, with a pearl border running around its periphery and with rows of pearls extending down the center of each cross-arm. Generally, the arms of the cross become wider as they approach the outer rim of the halo. This precise type of nimbus, although not easy to find within the corpus of Byzantine ivories, is present in three tenth-century Triptych Group plaques representing the *Dormition of the Virgin* (see Fig. 128).[17]

The Byzantine ivories used for comparison with the Salerno panels belong to the Nicephorus and Triptych groups. Apparently, it is with these two groups of Byzantine ivories, particularly the latter, that the Italian carvers found their greatest affinities—or at least to

which they had most exposure. It is well known that the Triptych Group ivories, often coarser than products of the other workshop traditions, tended to be made for export.[18] Whether or not the Italian carvers learned their "Byzantine lessons" solely through contact with imported models from these schools of carving (and from the painted models from which they derived much of their New Testament iconography), or whether they had more direct contact with and training under Byzantine artists who worked in these styles is difficult to say. But one thing is certain: Byzantium was the single most important source for the Salerno style, and the south Italian carvers, despite the impact of other sources and the exercise of their own creativity, cast their series in an obviously Byzantine mode.

THE ITALIAN COMPONENT

Earlier Regional Traditions The impact of the stylistic sources discussed above becomes clearer when they are evaluated in the context of the indigenous formal tradition available to the carvers of the Salerno panels. The Salerno ivories did not emerge from a vacuum. In my opinion, they represent the mature stage in the development of an ivory workshop whose earlier stage is represented by only a small body of extant works. Chief among these is the so-called Farfa Casket of c. 1060 (Figs. 152-155; see Catalogue no. B1). The somewhat awkward figures in the Farfa version of the *Dormition of the Virgin* (Fig. 152) are stylistically less "classical" and more rigid than the figures in the Salerno series. Indeed, one senses that the carvers of the casket were inexperienced in rep-

15. "Grado Chair," p. 63.
16. Goldschmidt and Weitzmann, *Byz. Elfenbeinskulpturen,* 2:pl. 38.
17. Ibid., p. 70, nos. 174, 175, 176, pl. 59.

18. Ibid., p. 18; K. Weitzmann, "Ivories," in *Byzantine Art: An European Art,* Catalogue of the Ninth Exhibition of the Council of Europe (Athens, 1964), p. 147; and idem, "Grado Chair," p. 63.

resenting the human figure. The angels in the sky, for instance, are formed of almost independent horizontal and vertical portions joined at almost a right angle. A basically flat and rigid form predominates, and the surface of the figures is defined by a host of parallel or semiparallel lines. The long, vertical drapery sections, stiff and repetitive, that define the lower portions of the Apostles' tunics in the *Dormition* are very similar to those in the fresco of St. John the Evangelist from the Grotto of the Saints near Calvi (Fig. 130), an important Campanian site.[19] Although the fresco may date as late as the 1070s, it maintains older stylistic traditions native to the region. The simplified planes of the faces, general stiffness of form, and overall sense of proportion, all relate the fresco's style to the style of the Farfa *Dormition* scene.

On the casket this style is limited to the *Dormition* and one or two other small scenes. Virtually all the other figures, for example those in the *Crucifixion* (Fig. 154), have stockier proportions and drapery of a very different type. In contrast to the garments of the Apostles in the *Dormition,* the drapery here is far more simply articulated, executed with a sparing use of line. This second style may be seen as well, and perhaps to even better advantage, on the two related *Crucifixion* ivories in New York and Berlin (Figs. 156 and 158; see Catalogue nos. B2 and B3). The style of all these pieces shows remarkable affinities with earlier south Italian works. The general outline of the Berlin panel and the

smooth, symmetrical torso of Christ seen in all three *Crucifixions* are foreshadowed in the corresponding scene from the late tenth-century *Benedictio fontis* manuscript recently attributed to a Beneventan scriptorium (Fig. 131).[20] Like the ivory panels, the miniature shows Christ's loincloth disposed symmetrically around a prominent central knot. The figures of Longinus and Stephaton in the miniature are not unlike their counterparts in the Farfa and Berlin panels. Particularly striking is the flatness of the drapery in all three versions, created in the miniature by a few dark lines, some parallel, and in the ivories by a few incisions. This approach is typical of Campanian art of the period; the Cimitile frescoes, for example, are closely related in style (Fig. 122).[21] For these, as well as other reasons, it is fair to assert that the Farfa Casket and its relatives have close connections with the earlier artistic traditions of southern Italy.

Although the style of the Salerno ivories departs from many of the formal canons incorporated in the Farfa Casket, a significant relationship between the styles of the two works does exist. Some of the uncertainty that characterizes the execution of the figures on the casket lingers in the Salerno series, especially where a figure is represented in a complex pose. The contorted images of the "ruler of the feast" in the *Miracle at Cana* (Fig. 25) or of Salome in the *Nativity* (Fig. 23) bear this out. Many of the figures in the Farfa Casket are generically con-

19. H. Belting, *Studien zur beneventanischen Malerei* (Wiesbaden, 1968), pp. 105–111, figs. 120–122.

20. For the *Benedictio fontis* manuscript see Avery, *Exultet Rolls,* pp. 28–29, pls. 110–117 (here attributed to San Vincenzo al Volturno); and Belting, *Beneventanischen Malerei,* pp. 153–166, 230–249, figs. 191–200.

21. For a more detailed characterization of this style—and its further manifestations in both Greek and Latin manuscripts attributed to south Italian scriptoria—see Belting, *Cimitile,* pp. 127–130; idem, *Beneventanischen Malerei,* pp. 230–249; and

idem, "Byzantine Art among the Greeks and Latins in Southern Italy," *Dumbarton Oaks Papers* 28 (1974):3–29.

In my article of 1974, "Ivory Carving in Amalfi," I emphasized the relationship between the style of this group of ivories and that of much earlier Italian works in the Lombard north and "Carolingian" Rome. Although stylistic connections do exist among these works, I now prefer to see an intervening south Italian tradition (here represented by the frescoes and manuscripts) forming a link between the earlier style and the Salerno ivories.

nected with their counterparts in the Salerno series by the vivid and expressive gestures they use to communicate with each other and with the observer. There are correspondences in drapery motifs between the two works, especially in the incised, closely spaced vertical lines that delineate the major folds of the tunics in the Farfa Casket *Dormition* and in the Salerno version of *Christ Adored by the Angels* (Fig. 27). Similar types of capitals appear in the casket's architectural backgrounds and in the columns separating the Old Testament scenes in the Salerno cycle. The carvers of both works used the concentric circle punch for the eyes of the sheep in the two versions of the *Annunciation to the Shepherds* (Figs. 24 and 155). Finally, but far from least important, there is a profound similarity in certain paleographical details of the inscriptions in the two works that undeniably points to reliance on a common tradition. In particular, the characteristic short and steeply angled right leg of the *R* is found in both places, as is the tendency to make the *O* smaller than the other letters so that it seems to hover in the middle of the line (compare Figs. 31 and 154).

Evidently, then, the style of the Salerno ivories has affinities with the style of the earlier productions of the workshop. But it is clear that these stylistic similarities did not dictate the overall conception of the Salerno series. Under the impact of foreign sources, particularly Byzantine models, the Salerno carvers diverged fundamentally from the earlier native approach.

The Cassinese Connection The style of works produced at Monte Cassino during the abbacy of Desiderius in many respects parallels that of the Salerno ivories. This fact is particularly important given the almost total absence of works of art conceived in a significantly related style. Unfortunately, Cassinese sculpture has virtually disappeared, and so one must compare the Salerno reliefs with painted works. The ivories and Cassinese works share a number of specific architectural motifs. For instance, columns are used to separate the scenes in the frescoes of Sant'Angelo in Formis in much the same way that they are employed in the Old Testament cycle in the ivories.[22] The spirally fluted column shown in a number of the ivories, a rather characteristic form, has a counterpart in certain of the architectural backgrounds in the miniatures of the Vatican Library, cod. lat. 1202, the most sumptuous of the preserved Desiderian manuscripts.[23] Furthermore, the classically fluted well in the scene of *Christ and the Samaritan Woman* (Fig. 29) appears both in the corresponding scene at Sant'Angelo in Formis[24] and in one of the episodes from the life of St. Benedict illustrated in Vat. lat. 1202.[25]

Despite an accumulation of such parallels, in the end it appears that one must rely on the broadest of correspondences to demonstrate the affiliation. Both the Salerno ivories and works emanating from Desiderian Monte Cassino appear to reflect syntheses of similar ingredients. In both cases there is a common stylistic determinant: the art of Byzantium. The Byzantine element, a very strong influence on the ivories, is at least as powerful an influence in Cassinese works, such as the *Annunciation* miniature from cod. 99 in the Monte Cassino library (Fig.

22. Morisani, *Affreschi*, fig. 12.

23. D. M. Inguanez and M. Avery, *Miniature cassinese del secolo XI illustranti la vita di S. Benedetto* (Monte Cassino, 1934), pl. 8, nos. 1 and 2.

24. Morisani, *Affreschi*, fig. 19.

25. Inguanez and Avery, *Miniature cassinese*, pl. 16, no. 2.

132).[26] Otto Demus has compared the angel of the *Annunciation* with a nearly contemporary Byzantine one in a mosaic in the Vatopedi monastery on Mt. Athos and has concluded that the Cassinese artist learned his Byzantine lessons well, and produced a figure embodying the basic Byzantine canons of form, which derived ultimately from the antique.[27] Nowhere in the Salerno panels can one find such a perfect evocation of Byzantine values, which emphasized weight, substance, and definition; native tendencies consistently compromised their expression. But there can be no doubt that common goals were set by the artist of cod. 99 and the carver of the Christ figure in the Salerno panel *Healing of the Blind Man at Siloam* (Fig. 33). Especially in his drapery, the figure of Christ in the ivory reveals an attempt to create a robust, three-dimensional type similar to the Cassinese angel. Particularly striking in both works are the panellike segments in the lower portions of the tunic, asserting their plasticity as pleats ostensibly billowing out from the leg. This effect is convincingly rendered in the miniature, but in the ivory, as I mentioned earlier, these pleats ultimately flatten out, thus contradicting their spatial meaning.

I have chosen this comparison because it typifies the relationship between the Salerno ivories and Cassinese style, a relationship characterized by shared intentions but markedly different realizations. The gap between intent and execution may have to do with the relative abilities of the manuscript illuminators on the one hand and the ivory carvers on the other, but I hesitate to account for the differences in so facile a manner. However, this is not to suggest that there is no qualitative difference, for there is: the manuscripts are clearly the creations of masters more adept in the manipulation and exploitation of their medium. But a historical issue is involved here that goes beyond an assessment of the artists' abilities per se. Manuscript illumination had been practiced at Monte Cassino for centuries by the time the illuminators of cod. 99 or Vat. lat. 1202 set to work. Even adaptation of Byzantine models had a long-standing tradition, going back to the tentative efforts of miniaturists active during the abbacy of Theobald (1022–1036).[28] By contrast, figurative carving in ivory—in fact, figurative carving in any material—was a new endeavor for south Italian artists of the late eleventh century. As indicated above, their pioneer efforts (such as the Farfa Casket) were closely linked to earlier Italian stylistic traditions, a stage through which the illuminators of Monte Cassino passed in the late tenth century.[29] When the carvers of the Salerno ivories set out to create a series of narrative reliefs with hundreds of figures, they were, so to speak, starting from scratch. They absorbed much from their figurative exemplars, both ivories and manuscript illuminations. But to carve such an extensive series of narrative sculptures was unprecedented in their region; to do so in a perfectly fluent "bilingual" fashion was not possible.[30]

The relationship between the Salerno

26. For cod. 99 see P. Baldass, "Disegni della scuola cassinese del tempo di Desiderio," *Bollettino d'arte* 37 (1952):102–114, fig. 15; C. R. Dodwell, *Painting in Europe, 800–1200* (Baltimore, 1971), p. 137, pl. 151.

27. *Byzantine Art and the West* (New York, 1970), p. 27, figs. 27–28.

28. As exemplified in the miniatures of Monte Cassino, Monastery Library, cod. 73, which Hans Belting ("Der Codex 73 in Monte Cassino und die cassinesische Kunst vor Desiderius,"

Zeitschrift für Kunstgeschichte 25 (1962):198–201) has shown was influenced by Byzantine painting c. 1000.

29. This phase is represented by Monte Cassino, Monastery Library, cod. 175 (Belting, *Beneventanischen Malerei*, pp. 133–136, figs. 177–178).

30. A comparison of many of the earlier frescoes in Belting's *Beneventanischen Malerei* with those of Sant'Angelo in Formis suggests a development in Campanian painting similar to that seen in manuscript illumination and ivory carving.

ivories and works produced in Desiderian Monte Cassino becomes even more evident when one keeps in mind the earlier stage of the ivory workshop represented by the Farfa Casket. The carvers' assimilation of a fundamentally new and Byzantine style was a radical departure from the prior dependence of the workshop's artists on native stylistic canons. What motivated such a shift of stylistic allegiance? It cannot be accidental that precisely those years intervening between the carving of the Farfa Casket (c. 1060) and the creation of the Salerno ivories (c. 1084) witnessed the great wave of Byzantine influence fostered by Desiderius at Monte Cassino, realized through the importation of Byzantine artists as well as Byzantine works of art. Directly or indirectly, this event, perhaps more accurately described as an inundation than a wave, must have been a significant factor in the shift of stylistic orientation in the workshop that produced the Salerno ivories. At the outset of this chapter I indicated how difficult it is to discover works of art stylistically akin to the Salerno panels. In fact, the Cassinese manuscripts illuminated under Desiderius are their closest relatives.

THE FUSION: TOWARD ROMANESQUE

The style of the Salerno ivories is clearly more than simply a layering of the various influences discussed above, but the carvers of the Salerno cycles did not transform the contributions of their stylistic sources beyond recognition. One can pick out elements that derive from the fundamentally nonfigurative native sculptural heritage and from the robust figurative traditions represented by the Grado Chair ivories and mid-Byzantine art. But there is yet another ingredient added to the mix: the first tentative steps toward the Romanesque style. The Salerno panels were executed at a transitional point in the history of art, a time leading up to the new aesthetic of the Romanesque. Hesitantly and sparingly, the carvers of the ivories introduced the new aesthetic principles into their compositions, partially transforming the elements gleaned from their sources into the rudiments of a new style. In particular, two characteristics of the Salerno series indicate the carvers' contact with the emerging Romanesque style.[31] One concerns composition and the other has to do with the depiction of drapery.

Lack of three-dimensional spatial organization is typical of medieval art in general, and particularly characteristic of Romanesque is the trend toward substituting for organic, irregular figural groupings arrangements characterized by the repetition or multiplication of similar elements. Individual figures lose their unique identities and become members of a set of closely related figures. Often this is the result of the adaptation of a group to a specific architectural setting in monumental sculpture, as in the famous reliefs of the twelfth century at Silos (Fig. 133),[32] but the effect may occur even in the absence of physical restraints. In the Salerno ivories this tendency is evident in numerous instances, especially in the rows of Apostles who appear in the *Last Supper* (Fig. 30), the *Incredu-*

31. The classic publications leading toward a definition of Romanesque style are still: H. Focillon, *L'art des sculpteurs romans* (Paris, 1931); idem, *The Art of the West*, vol. 1 (New York, 1963); J. Baltrusaitis, *La stylistique ornamentale dans la sculpture romane* (Paris, 1931); M. Schapiro, "The Romanesque Sculpture of Moissac," *Art Bulletin* 13 (1931):239–350, 464–531; idem, "From Mozarabic to Romanesque in Silos," *Art Bulletin* 21 (1939):313–374; and idem, "The Sculptures of Souilac," in *Medi-*

aeval Studies in Memory of Arthur Kingsley Porter, Jr., vol. 2, ed. W. Koehler (Cambridge, Mass., 1939), pp. 359–387 (these last three studies, along with several other of Schapiro's important writings on Romanesque art, are now reprinted in his *Romanesque Art*, New York, 1977).
32. See Schapiro, "Mozarabic to Romanesque," passim, and A. K. Porter, *Romanesque Sculpture of the Pilgrimmage Roads*, vol. 1 (Boston, 1923), pp. 44–58.

lity of Thomas (Fig. 34), the *Ascension* (Fig. 39), *The Marys Announce the Resurrection to the Apostles* (Fig. 35), and *Christ Appears at Bethany* (Fig. 37). The repetitious quality of the figures is further emphasized in these instances by the isocephalic nature of the figural groups. The effect is enhanced in more subtle ways as well. In the *Creation of the Firmament* (Fig. 2), for instance, the six outstretched arms of the angels form a regularized pattern extending across the panel's surface. Similarly, the figures of Noah and his sons bowing before the Creator in the scene of the *Covenant* (Fig. 11) appear to unfold backward into the plaque, a series of slightly receding identical postures.

The fundamentally nonorganic, nonnaturalistic Romanesque approach has also influenced the rendering of drapery in the Salerno ivories. One of the hallmarks of Romanesque drapery style is the use of a system of double parallel lines to delineate folds. A classic early specimen of the type may be seen in the impressive *Christ in Majesty* relief (Fig. 134) now in the ambulatory of St. Sernin in Toulouse (c. 1100),[33] especially in the drapery that covers the upper torso. In the "double-fold" system, the decorative aspect of form has become more important than the imitation of the natural folds of drapery. The double fold is not consistently applied in the Salerno ivories, but it appears, among other places, in the drapery of the Creator in *God Closes the Door of the Ark* (Fig. 9) and in the drapery of Moses in the *Miracle of the Withered Hand* (Fig. 18).

Despite this use of the double fold, the drapery in the ivories is fundamentally different from the drapery in "true" Romanesque works. In the ivories, fold lines persist that are unique and are not part of any greater pattern group. A comparison of the seated Christ in *Christ at Emmaus* (Fig. 36) with the Toulouse relief cited above is instructive here. Within an essentially similar figural framework the disposition of drapery in the two works differs markedly. The lines in the St. Sernin Christ adhere strictly to an overall system; series of lines or folds are shown in parallel or multiple sequences that have a consistant rhythm. In the Salerno panel, the lines are repetitious enough not to depict the irregular folds of real drapery, but they are not so systematized as the lines in the St. Sernin relief. The incisions on the portion of Christ's tunic covering his upper torso, for example, while roughly parallel, are not absolutely identical in direction, depth, or thickness. The several lines incised on the cuff of the tunic's right sleeve are short strokes without "relatives"; that is, they are unique in size, shape, and direction, and fall outside the scope of any larger pattern system. From the Christ of Toulouse to the Christ of the central tympanum of Chartres' *Porte royale*, the more fluid drapery still evident in the Salerno ivories is suppressed in favor of the more rigid systematization of the Romanesque style.

Should the Salerno ivories, then, be classified as Romanesque? The use in the ivories of stylistic elements characteristic of Romanesque art is not pervasive enough to justify such an assertion. These elements are introduced tentatively and are in no way systematically applied; they do not define a consistent aesthetic point of view. The Salerno ivories do embody certain proto-Romanesque qualities, but they never become full participants in the Romanesque style. The reason is very simple: the mitigating forces of the various sources used by the carvers —particularly the ultimately classically in-

33. Porter, *Romanesque Sculpture,* 1:207–210; P. Deschamps, *French Sculpture of the Romanesque Period* (New York, n.d.), pp. 19–21; and, most recently, B. Rupprecht, *Romanische* *Skulptur in Frankreich* (Munich, 1975), pp. 78–80, pl. 1, figs. 12–15.

spired mid-Byzantine and Grado Chair group models—in other words, the eclectic nature of the Salerno style constrained it from becoming more fully Romanesque.

The style of the Salerno ivories remains enigmatic and difficult to categorize: neither Byzantine nor Romanesque, neither wholly Italian nor Syro-Palestinian, but a complex amalgam of them all.[34] In the end it remains unique, truly a reflection of the cultural ambience from which it issued.

DATE

Scholarship is about equally divided in assigning either a late eleventh- or an early twelfth-century date to the Salerno reliefs.[35] However, many of the criteria employed by critics in assessing the ivories' style in order to fix their date have been at best arbitrary. I hope to introduce more reliable standards.

If one begins by trying to establish a *terminus ante quem*, it is immediately clear that the Salerno panels are not part of the classicizing movement that characterized Campanian and Sicilian sculpture in the second half of the twelfth century, as represented by the figures supporting the lectern on the great mosaic pulpit at Salerno (Fig. 135).[36] There is no correspondence between the soft and supple draperies clinging to the figure in the marble sculpture and the comparatively rigid drapery types in the ivories.

By far the most important evidence for the dating of the Salerno panels—evidence that strongly supports an attribution to the end of the eleventh century—is the date of the Farfa Casket. The Latin inscription that runs around the sides of the figurative portions identifies the donor of the casket as a certain Maurus, a well-known merchant of Amalfi.[37] Maurus, active as a patron of the arts in the third quarter of the eleventh century, took his vows in 1071 and entered the monastery at Monte Cassino. The casket has often been associated with that occasion

34. The remains of the ornamental borders also indicate multiple sources. Three distinct motifs are used:

1. *Inhabited vine scroll* (Fig. 42). This is an ancient motif taken over in various regions during early Christian times. The characteristic aspect of the bird pecking at the berries is paralleled in numerous early examples (see E. Kitzinger, "Anglo-Saxon Vine-Scroll Ornament," *Antiquity* 19 [1936]:61–71) and, closer to the ivories in time and place, in the marble frame of the main portal of Amalfi Cathedral, which has been dated in the late eleventh century (see A. Schiavo, *Monumenti della costa di Amalfi*, Milan, 1946, fig. 212; and G. Matthiae, *Le porte bronzee bizantine in Italia*, Rome, 1971, fig. 1). Although the exact source from which the Salerno carvers derived the motif remains unknown, it was not Middle Byzantine because the type cannot be found in such works. The motif may have been inherited directly from an early source.

2. *Foliate vine scroll with leaves, berry clusters, and rosettes* (Fig. 43). This is perhaps the most stylized of the ornamental types; the vine is partially transformed into a series of trumpet-like shapes that curl around to frame the central berry cluster, leaf, or rosette. This type is closely related to various "Lombard" ornamental marbles from previous centuries, such as the tenth-century examples from Cimitile (Belting, *Cimitile*, figs. 71, 82–84).

3. *Cornucopia frieze* (Fig. 44). A series of arching cornucopias with pearl decorations at their open ends forms a more flowing pattern than the previous types. From the open end of each horn sprouts a vine tendril from which leaves and/or berries grow. The source of this motif seems secure: the identical element appears on at least two Middle Byzantine ivory caskets (Goldschmidt and Weitzmann, *Byz. Elfenbeinskulpturen*, 1:50, no. 69, pl. 50; p. 52, no. 84, pl. 52).

35. Goldschmidt (*Elfenbeinskulpturen*, 4:38); W. F. Volbach ("Gli avori della Cattedra di San Marco," in *Arte del primo millenio*, ed. E. Arslan, Vislongo, 1950, p. 136) and H. Fillitz (*Zwei Elfenbeinskulpturen aus Süditalien*, Bern, 1967, p. 14), among others, support a date in the late eleventh century. Venturi (*Storia dell'arte italiana*, 2:621), Becherucci ("Avori," p. 69), and Carucci (*Avori*, p. 12) prefer the twelfth century. Toesca (*Storia dell'arte italiana*, 2:1096) cautiously suggests a date between the late eleventh century and 1161. D. Gaborit-Chopin (*Ivoires du Moyen Age*, Paris, 1978, pp. 122–125, 202–203), the most recent scholar to write about the ivories, appears to accept the eleventh-century date.

36. C. Shepphard, "A Chronology of Romanesque Sculpture in Campania," *Art Bulletin* 32 (1950):319–326; see also D. Glass, "The Archivolt Sculpture at Sessa Aurunca," *Art Bulletin* 52 (1970):119–131, and idem, "Romanesque Sculpture in Campania and Sicily: A Problem of Method," *Art Bulletin* 56 (1974):315–324.

37. For this inscription see Catalogue no. B1.

and that center because one of the lines of the inscription—"Iure vocor Maurus quoniam sum nigra secutus"—has been interpreted to refer to Maurus' donning the "black garb" of the Benedictines. Herbert Bloch, in his brilliant early study on Monte Cassino,[38] accepted this then-current theory, but has since discovered that the crucial phrase had not assumed that meaning in the eleventh century; it was first so used by the followers of St. Bernard in the following century, as a pejorative reference to their Benedictine rivals. In the present context *sum nigra secutus* has nothing to do with Benedictinism but is simply an admission that Maurus was a sinner, that is, that he followed sin.[39] This discovery severs the traditional connection between the casket and Monte Cassino and also renders the year 1071 practically meaningless for the purpose of dating the casket. Because one of Maurus' sons was killed in battle in 1072 and all six of his offspring are mentioned in the inscription, we can at least be sure of that date as a *terminus ante quem.* Traditionally, the casket belonged to the abbey of Farfa, probably the most important Cluniac foundation in Italy in the eleventh century.[40] Because the box was clearly a gift (this is evident from the inscription), it seems quite possible that it was offered originally to that abbey rather than to Monte Cassino. A suitable occasion for such a dona-

tion was the dedication of the monastery's new basilica in 1060, a grand event attended by the pope and many of the nobility.[41] The emphasis on the Virgin in the casket's iconography is particularly fitting for Farfa because she was held in special veneration there. A fresco of the *Dormition,* in a fragmentary state, may still be seen at the monastery.[42]

That the Farfa Casket and the Salerno panels belong to the same carving tradition has already been established. Indeed, Pietro Toesca has gone as far as describing one figure on the Farfa Casket as a "sketch" for a similar type in the Salerno series.[43] This is an exaggeration, but it does indicate how intimate are the ties between the two works. However, I have already indicated that a significant artistic event, a new wave of Byzantine influence, intervened between the Farfa Casket and the Salerno ivories. This new influx is easily explained by historical circumstances, for in Leo of Ostia's chronicle of Monte Cassino we have an ample description of the coming of Byzantine artists to Monte Cassino in the years before the dedication of the great new basilica in 1071. At that time Desiderius saw to it that the most promising among his own monastic craftsmen were instructed in the execution of works of art in various media, among which carving in ivory is explicitly mentioned.[44] It is possible that the carvers of the Sa-

38. H. Bloch, "Monte Cassino, Byzantium, and the West in the Earlier Middle Ages," *Dumbarton Oaks Papers* 3 (1946):207–212.

39. I am indebted to Professor Bloch for sharing this information with me before its publication in his long-awaited book on Monte Cassino in the Middle Ages.

40. It is recorded as being seen among the possession of the abbey about 1800 by the abbot Giuseppe di Costanzo (P. Toesca, "Un cimelio amalfitano," *Bollettino d'arte* 27 [1934]:537).

41. I. Schuster, *L'Imperiale abbazia di Farfa* (Rome, 1921), p. 197.

42. A. B. Schuchart, "Eine unbekannte Elfenbeinkassette aus dem 11. Jahrhundert," *Römische Quartalschrift* 40 (1932):pl. 5.

43. Toesca, "Cimelio," p. 541.

44. Leo of Ostia, *Chronica monasterii Casinensis,* III, 27 (Migne, *PL,* 173:749): "Legatos interea Constantinopolim ad locandos artifices destinat, peritos utique in arte musiaria et quadrataria, ex quibus videlicet alii absidem et arcum atque vestibulum maioris basilicae musivo comerent, alii vero totius ecclesiae pavimentum diversorum lapidum vauetate consternerent . . . Non tamen de his tantum sed et de omnibus artificius quaecumquae ex auro vel argento, aere, ferro, vitro, ebore, ligno, gipso, vel lapide patrari possunt, studiosissimos prorsus artifices de suis sibi paravit." For an English translation see E. Holt, *Literary Sources of Art History* (Princeton, 1947), p. 8. For some unexplained reason this translation omitted gold (*auro*) from the list of metals to be worked. Henry Willard has suggested that *gipso* might be translated as stucco rather than alabaster.

lerno panels received instruction from these Byzantine masters, or perhaps they were trained by students of the Greek artists. We will never know for certain. But given the testimony of Leo of Ostia's chronicle, combined with the stylistic and iconographic parallels between the ivories and Cassinese works, it seems sensible to place the Salerno panels within the orbit of the Cassinese revival of the arts in the second half of the eleventh century. The date of the Farfa Casket, c. 1060, and the comparatively advanced style of the Salerno ivories make a date around the time of the consecration of the new Duomo at Salerno in 1084 most probable for the execution of the Salerno reliefs.[45]

Further corroboration of the eleventh-century date comes from an unexpected source—Spain. Goldschmidt noted that Spanish ivories of the eleventh century have connections with the Salerno group without going into further detail.[46] His idea was picked up and elaborated upon by Becherucci and Bologna.[47] These scholars may have gone too far in drawing the parallels but, allowing for the obvious differences brought about by their Spanish origin, it is remarkable how similar in spirit many of the panels decorating the shrine of St. Aemilianus at San Millan de la Cogolla (c. 1070)[48] are to the Salerno ivories (see Fig. 136). They manifest the same liveliness of gesture that energizes the Salerno figures and show, as well, the use of the flattened trumpet-folds ultimately derived from Byzantine sources. The coiffure with the sections of hair decorated with spare single lines is found here also, as is the use of the punch for the eye. Although more schematized in terms of the application of linear decoration, the St. Aemilianus ivories are, like the Salerno panels, proto-Romanesque.

Yet another group of ivories can assist in dating the Salerno plaques, the oliphants.[49] Of the many ivory horns surviving in the museums and church treasuries of the West, only a small number are relevant to this discussion. Central among this group is a magnificent specimen in Boston's Museum of Fine Arts (Fig.

45. Although the approximate time of the consecration (1084 or early in 1085) is relatively secure, the question of when the cathedral was begun has provoked a good deal of controversy. In a famous letter of 1080 (A. Carucci, *S. Gregorio VII e Salerno,* Salerno, 1954, pp. 57–58, provides an Italian translation), Pope Gregory VII urged Archbishop Alfanus to convince Duke Robert Guiscard to honor the recently rediscovered relics of St. Matthew. One has little difficulty accepting the idea that his letter provided the initial impetus for the rebuilding of the Duomo. That the project had not yet gotten under way in 1078 seems assured by the silence of Amatus of Monte Cassino, whose chronicle ends in that year. Had the duke initiated such an ambitious project by that time, the vigorously pro-Norman Amatus would have mentioned it. (This is also the reasoning of A. Schiavo, "Monte Cassino e Salerno: affinità stilistiche tra la chiesa cassinese di Desiderio e quella salernitana di Alfano I," in *Atti del II convegno nazionale di storia dell'architettura,* Rome, 1939, p. 179). However, in 1948 an inscription containing the date 1078 and bearing the name of Alfanus was found near the atrium of the Duomo (see Carucci, *S. Gregorio VII,* p. 54n1). Some scholars (e.g., A. Pantoni, "La basilica di Monte Cassino e quella di Salerno ai tempi di San Gregorio VII," *Benedictina* 10[1956]:36) accepted this as the new date for the beginning of the cathedral's construction, but the inscription was soon shown by A. Balducci ("Una lapide di Alfano I del 1078 e la data d'inizio della costruzione del Duomo di Salerno," *Rassegna storica salernitana* 17 [1957]:157) to belong to another church, San Fortunato, and to have no bearing on the cathedral's date.

46. Goldschmidt, *Elfenbeinskulpturen,* 4:3.

47. Becherucci, "Avori," p. 79; and Bologna, *Opere d'arte nel salernitano,* pp. 13–14.

48. Goldschmidt, *Elfenbeinskulpturen,* 4:26–27, no. 84, pls. 25–27; and P. de Palol and M. Hirmer, *Early Medieval Art in Spain* (New York, 1966), pp. 94, 479–80, figs. 80–81 (here dated 1053–1067).

49. The first systematic attempt to deal with the oliphants was that of O. von Falke ("Elfenbeinhörner," *Pantheon* 4[1929]: 511–517, 5 [1930]:39–44), who separated the horns into four groups with distinctly separate origins in Fatamid Egypt, Italy, a second (non-Italian) European center, and Byzantium. These categories were radically revised by E. Kühnel ("Die sarazenischen Olifanthörner," *Jahrbuch der Berliner Museen* 1 [1959]:33–50; see now idem, *Die islamischen Elfenbeinskulpturen,* Berlin, 1971, pp. 6–19), who assigned the first three of Falke's groups an origin in Amalfi, while omitting any treatment of the "Byzantine" examples.

137).[50] Although figures are occasionally represented on these horns, their decoration consists primarily of plant and animal motifs. Correspondences may be found between the foliate vine with berries and leaves and the quadrupeds shown in these oliphants and in the Salerno panels (compare Figs. 40 and 137).

Originally, Falke proposed Byzantium as the place of origin of this group of oliphants,[51] but Swarzenski, while refining and limiting the group, convincingly reattributed them to a south Italian center, presumably the same one that produced the Salerno ivories.[52] On the basis of documentary evidence for one member of the group, the Horn of Ulph in York Minster,[53] the whole series was dated around the second quarter of the eleventh century. Recently, however, the validity of this evidence has been called into question and a new date late in the eleventh century proposed.[54] Given the close relationship of the flora and fauna in the oliphants and the Salerno panels, a common time of creation is suggested. A date in the 1080s appears to agree well with the evidence.

PLACE OF ORIGIN

Given the various clearly Campanian details discernible in the ivories' iconography—for example, the types of the *Anastasis* and *Entombment*—and their stylistic affiliations, it is virtually certain the panels were carved somewhere in Campania. A more specific attribution

to a particular center has not been possible until now, although scholars have always recognized that only the cities of Salerno and Amalfi were vital and cosmopolitan enough to have supported a major ivory workshop and to have produced such a complex series of images.

Unfortunately, for neither of these centers do written documents exist attesting the presence of a workshop of ivory carvers during the late eleventh century. Any argument suggesting an origin for the ivories in Salerno naturally rests on the fact that this is the place for which they seem to have been originally destined and in which they have always remained. However, although there is no *a priori* reason to eliminate Salerno from the realm of possibility, no further evidence supporting such an attribution can be called forth.

In the case of Amalfi the situation is quite different. Among all the active commerical republics of medieval Italy only Amalfi always remained on good terms with the Arabs, the source of ivory as well as of silk and spices.[55] The identification of Maurus as the donor of the Farfa Casket places Amalfi further in the forefront of consideration. While the casket was still associated with Maurus' entry into Monte Cassino in 1071, many thought that he had had the work made there. However, with the separation of the casket from any connection with that abbey, it became more likely that Maurus would have had his donation made at home, in Amalfi, and taken to its destination, perhaps

50. The other members of this small group are in: (1) Paris, Cabinet des Medailles (from the Chartreuse des Portes); (2) York Minster (the Horn of Ulph); (3) Vienna, Kunsthistorisches Museum (from Muri Abbey); (4) Toulouse, St. Sernin; and (5) Saragossa Cathedral. This is the group isolated by Swarzenski (as in note 52, below). See, most recently, David Ebitz, "Two Schools of Ivory Carving in Italy and the Mediterranean Context of the Eleventh and Twelfth Centuries," Ph.D. thesis, Harvard University, 1979.

51. "Elfenbeinhörner" (1930), p. 39.

52. "Two Oliphants in the Museum," *Bulletin of the Museum of Fine Arts, Boston* 60 (1962):42.

53. T. D. Kendrick, "The Horn of Ulph," *Antiquity* 11 (1937):278–282.

54. This is the theory proposed by Ebitz in the thesis referred to in note 50. He emphasizes, and justifiably so, the relationship between the ornament in the Salerno panels and that in this group of horns.

55. The political and commercial situation of Amalfi is treated in some detail in Chapter 5. Gaborit-Chopin, *Ivoires du Moyen Age*, pp. 122–125, without committing herself, appears to favor the attribution to Amalfi.

Farfa, at the appropriate moment. That ivory carving was practiced in Amalfi around this time is suggested by an unusual object in the Metropolitan Museum of Art, a cylindrical casket for writing instruments (Fig. 138) decorated with animals of the type found on numerous Islamic works that have been attributed to southern Italy. Ernst Kühnel, who first published the piece, ascribed this whole group of Islamic ivories to Amalfi.[56] On the ends of the casket are the letters of an inscription, an abbreviated form of TAURUS FILIUS MANSONIS. Can it be coincidental that the Mansone family, along with that of Maurus himself, was among the most prominent noble families of Amalfi in the tenth and eleventh centuries? I think not.

The Salerno ivories themselves offer additional evidence corroborating an Amalfitan origin. Among the Grado Chair ivories, which we saw being copied by the Salerno carvers, the only panel for which there is any hint of a provenance is that in the British Museum showing the *Resurrection of Lazarus* (Fig. 100). There is eighteenth-century testimony to the effect that it had come from the "Chiesa di Sant'Andrea" (that is, the Duomo) at Amalfi.[57] It should be remembered that the only place in Campania that a parallel can be found for the particular inhabited vine scroll ornament in the Salerno ivories' border is in the sculptural frame surrounding the central doorway of the Duomo at Amalfi.[58] Furthermore, it is worth noting that in representations of the Apostles in the Salerno series only one man besides Peter and Paul is singled out by the inclusion of an attribute: Andrew, patron saint of Amalfi. He is shown holding the cross both in the series of Apostle busts (Fig. 40b), and in the *Pentecost* scene (Fig. 39). It is in just such a small way that the carvers of these panels destined for the Duomo at Salerno may have chosen to leave some mark indicative of their Amalfitan origin.[59]

56. "Die sarazenischen Olifanthörner," pp. 48–49; idem, *Die islamischen Elfenbeinskulpturen*, p. 67, no. 86, pl. 91.

57. A. F. Gori, *Thesaurus veterum diptychorum*, vol. 3 (Florence, 1759), p. 110. Reference to Gori was made by O. Dalton, *British Museum, Catalogue of Ivory Carvings of the Christian Era* (London, 1909), p. 27; E. Maclagen, "An Early Christian Ivory Relief of the Miracle at Cana," *Burlington Magazine* 38 (1921):193; and Weitzmann, "Grado Chair," p. 89.

58. See above, note 35.

59. Of the four Apostles on the wings of the triptych in the Louvre (Catalogue no. B21, Fig. 182) that came from the workshop of the Salerno ivories only St. Andrew is identified by his attribute. Although Andrew's body was not brought to Amalfi until 1208, the special veneration he received there in the eleventh century is attested by his inclusion, along with Christ, the Virgin, and St. Peter, in the decoration of the Duomo's bronze doors (see Matthiae, *Porte bronzee*, fig. 3). The cathedral was probably dedicated to him by that time.

4. RECONSTRUCTION

THE EARLIEST DOCUMENTS pertaining to the Salerno ivories date in the sixteenth century and suggest that by that time at least some of the panels had been inserted into a wooden framework mounted on the front of the altar in the Treasury of Salerno Cathedral.[1] A similar arrangement (Fig. 139), perhaps dating from the eighteenth century, remained until the dismantling and restoration of the panels in 1960. A replica of this antependium, with plaster casts replacing the ivories, is now kept in an anteroom of the Museo del Duomo.

A number of earlier writers simply assumed that the long-standing disposition of the plaques represented the original arrangement,[2] but modern scholars agree that this cannot be the case. Examination of the old paliotto reveals a lack of coherence in the succession of biblical episodes, and the certainty that the various displaced plaques, in Salerno and elsewhere, must originally have been integrated into the complex (there is no space for them on the antependium) confirms the view that the pre-1960 mounting of the panels was a reworking of the original arrangement.

Assuming the clearly corrupt character of the antependium arrangement, scholars in this century have sought to discover the original disposition of the plaques and the type of object they adorned. I have already, in the chapters on iconography, dealt with the sequence of the scenes. The strictly chronological system followed there seems secure. In Chapter 2 I also discussed the grouping of the plaques, particularly the New Testament panels, in rows or series; I will consider this problem in more detail in the following assessment of the several reconstructions of the panels that have been proposed. Finally, I will present my own reconstruction of the sequence.

ANTEPENDIUM

Although the former disposition of the ivories on the front of the altar in the Treasury was clearly not the original arrangement, a

1. A transcription of these documents, checked against the original, is in the Appendix. See A. Capone, *II Duomo di Salerno*, vol. 1 (Salerno, 1927), p. 390; Carucci, *Avori*, pp. 9–12. See also A. Rotundo, "L'Archivescovo Federico Fregoso nella storia delle diocesi di Salerno e la Santa Visita del 1510–1511," *Rassegna storica salernitana* 15 (1954):151–181; A. Balducci, "Prima visita pastorale dell'archiv. Marsili Colonna della chiesa di Salerno," *Rassegna storica salernitana* 24/25 (1963–1964):103–136.

2. For example, C. Rohault de Fleury, *La messe*, vol. 1 (Paris, 1883), p. 199; G. Guglielmi, *Monumenti figurati del Duomo di Salerno* (Salerno, 1885), p. 51.

number of scholars, most notably Bertaux,[3] Toesca,[4] and Volbach,[5] accepted the idea that even in the eleventh century the plaques decorated an antependium. Since no substantive arguments are ever presented in defense of this thesis, one is inclined to believe that it developed primarily from the ivories' traditional association with the Treasury altar.

Arguments can be adduced to counter this hypothesis. Most important, as Goldschmidt was the first to point out,[6] the traditional format of early medieval antependia did not consist of a sequence of similarly sized plaques arranged in series; the invariable arrangement placed symmetrically organized secondary sections around a major central component. The famous ninth-century paliotto of Sant'Ambrogio in Milan[7] or the twelfth-century altar frontal in Città di Castello (Fig. 140)[8] are excellent examples of the type. From the evidence at hand there is no reason to believe that the Salerno panels were ever arranged in such a manner.

It is significant that the two antependia mentioned above are made not of ivory but of gold and silver. That altar frontals in gold and silver were in vogue in southern Italy at the time the Salerno ivories were carved is made clear by Leo of Ostia's testimony that Desiderius of Monte Cassino sent to Constantinople in the 1070s for an antependium of gold and silver decorated with gems and enamels that displayed scenes from the lives of Christ and St. Benedict.[9] Indeed, in the 1150s King Roger II donated a silver antependium for the high altar at Salerno. Goldschmidt thought that the donation of this luxurious object made the existence of a sumptuous ivory antependium just fifty to sixty years old highly unlikely.[10] He did not then realize that King Roger's gift was specifically designated for the *back* of the altar.[11] But we also know that in 1161 Symon Senescalcus donated some type of decoration in precious metal for the face (front) of the high altar.[12] If the altar had had a monumental ivory antependium dating from the time of Alfanus, this gift would surely have been superfluous.

DOSSAL

Luisa Becherucci proposed that instead of being placed in front of the altar, the ivories were raised over and behind it to create a dramatic backdrop for the performance of the ritual at the high altar.[13] She maintained that in the eleventh century monumental dossals had already come into existence, but cited only the

3. Bertaux, *Italie méridionale*, p. 430.

4. P. Toesca, *Storia dell'arte italiana: il medioevo*, vol. 2 (Turin, 1927), p. 1096.

5. W. F. Volbach, "Gli avori della cattedra di San Marco," in *Arte del primo millenio*, ed. E. Arslan (Vislongo, 1950), p. 126.

6. Goldschmidt, *Elfenbeinskulpturen*, 4:38.

7. J. Braun, *Der christliche Altar*, vol. 1 (Munich, 1924), pp. 111–113, pl. 101; G. Tatum, "The Paliotto of Sant'Ambrogio at Milan," *Art Bulletin* 26 (1944):25–47; V. Elbern, *Der karolingische Goldaltar von Mailand* (Bonn, 1952).

8. Braun, *Altar*, 2:101, pl. 132; C. Rosini, *Città di Castello* (Città di Castello, 1961), pp. 56–57.

9. *Chronica monasterii Casinensis*, III, 32 (Migne, *PL*, 173:col. 756). For an English translation, see E. Holt, *Literary Sources of Art History* (Princeton, 1947), p. 9.

10. Goldschmidt, *Elfenbeinskulpturen*, 4:38.

11. Romualdi Salernitani, *Chronicon*, ed. C. A. Garufi (Città di Castello, 1925), p. 236 (Muratori, *Rerum italicarum scriptores*, 7:pt. 1): "Hic etiam ad memoriam hominis sui expensis factam,

ante altare beati Mathei fecit apponi, et quotiens Salernum a Sicilia ueniebat, de more Salernitane ecclesie unum nel duo pallio offerebat." The editor of the *Chronicon*, noting that this donation was made during the last years of Roger's life, suggests (p. 402) that it might have been motivated by the death of his wife, Sibilla, in 1150. See also A. Schiavo, "L'artchitettura negli avori salernitani e ipostesi sulle loro origine," *Rassegna storica salernitana* 19 (1958):80n2.

12. A. Carucci, in "Un Ipotesi sull'originaria destinazione degli avori di Salerno," *Apollo* (Bolletino dei musei provinciali del salernitano) 3/4 (1963–64):134, and Goldschmidt, *Elfenbeinskulpturen*, 4:38, both cite this entry in the *Liber confratum* that included the obituary. See *Necrologio del Liber confratrum di S. Matteo di Salerno*, ed. C. A. Garufi (Rome, 1922), p. 68: ". . . dominus Symon Senescalcus ob. qui faciem altaris deauravit e plura alia ornamenta huic ecclesie optulit."

13. L. Becherucci, "Gli avori di Salerno," *Rassegna storica salernitana* 2 (1938):69.

much later examples at Pavia[14] and in the Louvre[15] as evidence of a tradition in ivory. In addition, she maintained that the Salerno plaques are simply too numerous to have formed a paliotto.

This last assertion concerning the number of panels is at best arbitrary and, although both Bologna[16] and Pantoni[17] accepted the idea of the dossal (and lately Volbach too),[18] no supporting evidence or precedent for such an object can be found. The tradition current at the time of the ivories' creation did not include monumental dossals, and, moreover, the liturgical requirements of the cathedral indicate that in the eleventh century a dossal could certainly not have been placed on its high altar. Given the fact that the bishop's throne is located in the apse, the presence of a dossal on the altar (and certainly one of the necessary size) would have made the occupant of the chair invisible to the congregation, clearly an awkward arrangement. More important, in cathedrals in which the cathedra was placed in the center of the apse, it was the custom for the bishop to celebrate the mass *versus populum*—facing the congregation.[19] Obviously this makes the inclusion of a sizable dossal on the altar an impossibility.

THRONE

EPISCOPAL CATHEDRA

Goldschmidt was the first to propose that the ivories originally decorated a throne. He suggested that they adorned an episcopal cathedra that was located in the cathedral's apse.[20] There is a precedent for such an ivory cathedra: the famous sixth-century chair of Maximianus in Ravenna (Fig. 147),[21] and it was the physical and iconographical parallels between the panels of the Ravenna throne and those in Salerno that prompted Goldschmidt's suggestion. Both groups contain vertically oriented panels illustrating New Testament scenes and horizontally oriented panels depicting events from the Old Testament. In addition, Goldschmidt recognized correspondences in the appearance of bust-length figures and decorative bands of foliate ornament in both places. He pointed to the fact that thrones of the Maximianus type, that is, those with recessed backs, are actually represented in the Salerno carvings, as, for instance, in the scene of *Abraham and Sarah before Pharoah* (Fig. 14).

The theory of an episcopal cathedra is no longer tenable. During the restoration of Salerno Cathedral in 1931–32, the original marble cathedra, built into the wall of the apse, was rediscovered behind the wooden choir stalls that had obscured it for more than a century.[22] The nature of this throne, known as the cathedra of Gregory VII, does not allow for the inclusion of any decoration consisting of ivory panels.

There is, however, a second, more complex component to Goldschmidt's theory, for he introduced the relationship between the Grado Chair ivories and the Salerno panels into his

14. Braun, *Altar*, 2:300, pl. 205.

15. Ibid., p. 301.

16. F. Bologna, *Opere d'arte nel salernitano dal XII al XVIII secolo*, exhibition catalogue (Naples, 1955), p. 23.

17. A. Pantoni, "Opinioni, valutazioni critiche e dati di fatto sull'arte benedettina in Italia," *Benedictina* 12(1959):157n200.

18. Volbach retracted his published opinion and announced that he favored a dossal in a lecture at Salerno during the Convegno internazionale di studi sulle antichità cristiane della Campania, which took place in April 1970. The papers of this conference have yet to be published.

19. S. Jungmann, *The Mass of the Roman Rite*, vol. 1, trans. F. Brunner (New York, 1951), p. 255n13.

20. Goldschmidt, *Elfenbeinskulpturen*, 4:38.

21. C. Cecchelli, *La cattedra di Massimiano e altri avori romano-orientali* (Rome, 1936–1944); G. Morath, *Die Maximianskathedra in Ravenna* (Freiburg, 1940).

22. M. de Angelis, "La sedia di Gregorio VII ed i mosaici del transetto nel Duomo di Salerno," *Archivio storico per la provincia di Salerno* 2 (1934):103–136; G. Chierici, "Il Duomo di Salerno e la chiesa di Monte Cassino," *Rassegna storica salernitana* 1 (1937):104–105.

discussion.[23] Following the theory of Hans Graeven,[24] Goldschmidt asserted that the Grado Chair panels are the remains of the decoration of a throne, the cathedra sancti Marci, made in Alexandria in the late sixth century, sent to Constantinople, and finally given, c. 600, by the Emperor Heraclius to the Cathedral of Grado. Recognizing that certain of the Salerno ivories were based on corresponding compositions in the Grado Chair series[25]—a fact supported by the iconographic analysis in Chapter 2—Goldschmidt went on to conclude that an early Christian throne such as that from Grado served as a model for the proposed Salerno cathedra. If the Salerno ivories were based on models associated with an early Christian throne, there would still be some foundation for proposing that the Salerno panels were originally used to decorate a throne. But is the association of the Grado Chair ivories with the cathedra sancti Marci secure?

It was the subject of these carvings— scenes from the life of St. Mark as well as New Testament episodes—that led Graeven to associate them with the throne of St. Mark. The existence of the throne was attested in the sixteenth century by G. Candido, who wrote that in the Cathedral of Grado, "Vidimus illam cathdram S. Marci alexandrinum in sacrario Gradensi, laceram, ebore consertam."[26] The ivory throne was also mentioned in the *Passio sancti Marci*,[27] of unknown date, and was again seen in Grado in the seventeenth century, although stripped of its ivories, by E. Palladio de Olivas.[28] However, Otto Demus and Kurt Weitzmann

have shown that all of these identifications of an ivory throne of St. Mark are erroneous.[29] It is well documented that early in the seventh century Heraclius donated to Grado Cathedral a stone cathedra of St. Mark (the one now in the Treasury of San Marco in Venice). According to Johannes Diaconus,[30] along with this throne another was also given, the cathedra sancti Hermagorae, made of wood and ivory. There is not reason to identify the Grado Chair plaques— showing scenes from St. Mark's life but none from the story of St. Hermagorus—as belonging to this second throne. The *Passio sancti Marci* confused the two chairs and spoke of the ivory throne as the cathedra sancti Marci. From here the error was repeated through the centuries. Stylistic analysis supports the separation of the Grado Chair ivories from the throne given by Heraclius: parallels with Islamic art of the seventh and eighth centuries have been recognized in the Grado Chair group,[31] and these would obviously not be possible in a throne created c. 600.

Both parts of Goldschmidt's theory, then, must in the end be rejected: the Salerno ivories were not originally mounted on an episcopal cathedra, nor did the earlier ivories that served as models for some of them ever decorate the cathedra sancti Marci in Grado.

SEDES ROMANA

Having seen that the original cathedra was still extant in the apse of the Duomo, Armando Schiavo proposed that the Salerno ivories deco-

23. This relationship had been seriously discussed several years earlier by E. Maclagan, "An Early Christian Ivory Relief of the Miracle at Cana," *Burlington Magazine* 38 (1921):178–195.

24. H. Graeven, "Die heilige Markus in Rom und in der Pentapolis," *Römische Quartalschrift* 13 (1899):109–126.

25. Goldschmidt, *Elfenbeinskulpturen,* 4:3.

26. G. Candido, *Commentarior. Aquilensium libri octo,* (Venice, 1521), fol. 136. See Graeven, "Heilige Markus," p. 126, and Cecchelli, *Cattedra,* p. 40n35.

27. *Acta sanctorum,* April 3, p. 347.

28. E. Palladio de Olivas, *Rerum foro-Juliensium libri undicem* (Utini, 1659), p. 98. See Graeven, "Heilige Markus," p. 126, and Cecchelli, *Cattedra,* p. 40n35.

29. O. Demus, *The Church of San Marco in Venice* (Washington, D.C., 1960), p. 10n27; Weitzmann, "Grado Chair," pp. 51–53. Almost all of the information cited in the text is derived from Demus' rich note.

30. Ibid.

31. See the stylistic analysis and dating discussed above, Chapter 2, pp. 55–56, and Chapter 3, pp. 77–79.

rated a second throne in the cathedral, perhaps portable, whose existence is attested by the fragments of the oldest Salernitan liturgy, dating from the end of the twelfth century.[32] According to Schiavo, this document prescribes that the archbishop, after having stood at the altar to recite the Confiteor, should not return to his throne in the apse but should proceed to a second chair, the sedes Romana, located near the southern pilaster of the triumphal arch. Schiavo believes that this throne, donated by Guglielmus II, was decorated with the ivories somewhat in the manner of the cathedra Petri in the Vatican (Fig. 142).[33] Since the panels give no indication that they were ever mounted on a concave surface such as would have been required by a throne of the Maximianus type, Schiavo proposes the throne of St. Peter as a prototype with flat surfaces, despite the fact that the program of its decoration in no way relates to the Salerno panels. He finds inspiration from this source quite appropriate for a sedes Romana. ·

Schiavo cites the same similarities with the Maximianus throne as did Goldschmidt, and further supports his claim that the ivories once decorated a chair by asserting that certain of the decorative friezes are too long to have fit on any other type of object. This last idea, concerning the kind of object that might accommodate the long decorative borders, as I shall later show, is clearly not correct.

Schiavo's hypothesis is open to criticism on a number of levels, the most important of which revolves around the date that he proposes for the ivories—during the archbishopric of Guglielmo da Ravenna, 1137–1152. According to my stylistic analysis, the ivories are firmly rooted in the late eleventh century, and were executed during the reign of Alfanus I, probably about the time of the cathedral's consecration in 1084 (see p. 89). With this established, one must ask whether the sedes Romana would have been in use by the late eleventh century. It must be remembered that the liturgical document mentioned above refers only to the late twelfth century. Is there any reason for such a throne to have existed then but not a century earlier, at the time of the Duomo's consecration? In fact, simple logic argues that there is such a reason. It was certainly not traditional in the Middle Ages to include two thrones in the church's ritual, and therefore the use of a second throne during the ritual of the late twelfth century at Salerno is an extraordinary requirement, one that must have differed from the requirements of the procedure in use at the time of the cathedral's consecration. At that time what must have been called for was an apsidal cathedra; otherwise the throne would not have been placed in the apse. Moreover, during the twelfth century there are two times at which events and circumstances arose which might explain the necessity of introducing this second throne. First, Archbishop Romualdus II (1153–1181) built a new choir in the cathedral,[34] per-

32. Schiavo, "Architettura," p. 82.

33. P. E. Schramm (Herrschaftszeichen und Staatessymbolik, vol. 3, Stuttgart, 1956, pp. 694–707) maintained that the throne was made by the same Carolingian workshop that produced the Bible of San Paolo fuori le mura and that along with this Bible it was given as a gift to the pope either by Charles the Bald in 875 or Louis the Stammerer in 878. Recently, the ivory throne was removed from the cathedra of Bernini, in which it had been enclosed since the seventeenth century. A papal commission has completed its study of the throne and its report supports

Schramm's conclusions: see La Cattedra lignea di S. Pietro in Vaticano. Atti della Pontificia Accademia Romana di archeologia: Memorie, 3rd ser., Vol. 10 (Vatican City, 1971). The decoration of the throne consists of incised and inlaid panels showing the Labors of Hercules, constellations, and inhabited borders featuring animals, constellations, and various other configurations. The border displays a portrait of Charles the Bald in a prominent position.

34. A. Balducci, "L'altare maggiore del Duomo di Salerno," Rassegna storica salernitana 14 (1953):196.

haps pushing the nave of the church, and thus the congregation, farther away from the apse and the archbishop's throne than had originally been the case. The archbishop, seated in the apse, would have been less audible and visible than previously. Placing a second chair at the level of the triumphal arch could have been an attempt to alleviate this problem. Second, the necessity for the new throne might have arisen as the result of Guglielmus da Ravenna's construction of the still extant marble enclosure around the altar.[35] The enclosed altar precinct thus delimited seems to have had no opening at the back, indicating that the bishop could no longer walk directly from his apsidal throne to his position behind the altar, but instead had to walk around to the front of the altar, enter the enclosure, and then walk around again to the back. The new seat, placed in front of the marble wall, would enable the celebrant to advance to the altar far more directly and gracefully. Either of these two changes in the church's interior would have provided adequate motivation for the introduction of a new throne into the ritual.

Having provided a rationale for the appearance of the sedes Romana only in the later twelfth century and having demonstrated earlier a date for the ivories in the late eleventh century, I think it is safe to say that the Salerno carvings did not decorate such a chair.

ETIMASIA

In December 1960, a team from the Soprintendenza in Naples began to disassemble the ivory antependium that for centuries had adorned the front of the altar in the Treasury of Salerno Cathedral. When, in March 1962, the panels were returned to the Duomo, they no longer formed an altar frontal but were arranged instead (in their new showcase in the Duomo's museum) as the decoration of the sides and back of a throne in accordance with the theories of H. L. Hempel of Mainz (Fig. 1).[36] Hempel maintained that the panels had originally adorned a votive cathedra, a monumental representation of the Etimasia, the throne on which God would take his place at the end of time, according to the Book of the Apocalypse.

Owing to the premature death of Professor Hempel, the arguments in support of this hypothesis were never published. However, since the present arrangement of the plaques is based on his research and was executed under his supervision, at least the conclusions of his investigation are preserved. I have been fortunate in gaining access to the typescript of a lecture delivered by Professor Hempel in Salerno on the occasion of the return of the ivories to the cathedral.[37] Although this lecture, prepared for a somewhat general audience, provides only the most general account of the reasons behind Hemple's reconstruction, it does outline his approach. Since the lecture has not been published, I present here as full an account of it as possible.

The arrangement was arrived at by employing a number of criteria: markings on the individual plaques, differences in measurements, vestiges of mountings, and the iconographic-theological program. The first thing that emerged was that the Old Testament plaques form two groups, the first of which extends

35. Ibid., p. 187; G. Crisci and A. Campagna, *Salerno sacra* (Salerno, 1962), p. 121.

36. Crisci and Campagna, *Salerno sacra*, pp. 127–128; B. W., "Il restauro Italo-Tedesco di una 'etimasia' eburnea monumentale," *L'osservatore romano*, April 6, 1962, p. 6; A. Pantoni, "Il ciclo eburneo di Salerno," *L'osservatore romano*, Oct. 3, 1965, p. 7.

37. Hempel's notes for this lecture were lent to me by Professor Gunther Urban of Aachen, formerly of the Biblioteca Hertziana, to whom I would like to express my thanks.

from the first day of Creation through Noah's Sacrifice. Hempel mentions that the cleaning of the rear sides of the panels revealed a marking system of scratched letters and that this, along with consideration of plaques that had been separated from the main group, demonstrated that this first section of Old Testament scenes was originally ordered in five rows of two plaques each. Naturally, a corresponding arrangement is required for the second group of Old Testament scenes, which narrate the events from God's sign to Noah after the Flood through Moses receiving the Law on Mt. Sinai. Hemple implies that the break in the middle of the Noah cycle, and thus the content of both Old Testament groups, were determined by theological considerations: certain Genesis interpretations recognize a substantive break at the point of Noah's convenant with God.[38]

Similar criteria were used to determine the order of the New Testament panels. The cycle must have begun with the *Annunciation*, followed by the extant *Visitation* plaque. According to Hempel, traces of nails in this panel and the succeeding four correspond perfectly and thus produce a first row of six plaques, from the *Annunciation* through the *Massacre of the Innocents*. He goes on to say that on the basis of corresponding scratch marks (*ritzzeichen*), on the backs and sides of the remaining panels, the next three rows must originally have contained only five panels each. He felt that this arrangement was confirmed by the size of the ornamental borders, which he placed on the sides of the last three rows. The width of these lateral frames corresponds to the difference in width between the top row of six panels and the remaining ones with only five (see Fig. 1).

In Hempel's reconstruction the *Ascension* plaque is placed in the center of the bottom row

and is flanked by two pairs of columns. The left column-pair, according to Hempel, has three bore holes on its left side, which he explains as connecting points for a hinge, indicating that this middle piece in the bottom row was originally capable of being swung open. If so, it must have been used as a reliquary container.

Within the New Testament group Hempel points to the profound theological importance of the central axis of the bottom three rows: *Baptism, Transfiguration, Crucifixation,* and *Ascension.* He sees here "testimony of the doctrine of Christ as Son of God, the sealing of his work of redemption on the cross, and the majestic appearance of the Son of God at the end of days."

For the reconstruction of the gable, Hempel relied on the following four observations: (1) The two round medallions are worn down and were originally square like the others. (2) Four of the bust figures can definitely be identified: Christ, though without attribute, gestures in a manner peculiar only to him (Fig. 41c); Peter and Andrew (Figs. 40b, 41a), carry the usual keys and cross; Paul (Fig. 40d) is identifiable by his characteristic facial type and hair. (3) Three figures display totally different drapery and lack nimbi (Figs. 41e, f, and g). (4) Two of the nimbed figures (Figs. 40c and f) by their shifting axes and the remnants of their nail-holes, are revealed to have been corner pieces. Putting all this together, Hempel suggested that the nimbed figures represent Christ and the twelve Apostles (three Apostles lost), while the unnimbed figures, which Hempel arranged vertically beneath the bust of Christ, are the four major prophets of the Old Testament (one lost). He added: "In the three lateral corner places of the gable, which are today empty, are to go the four Evangelist symbols, two of which—

38. Medieval exegesis of Genesis does not define a fundamental break at this point in the narrative.

Matthew and John—are to be found in the Hermitage in Leningrad."

Hempel concluded his lecture by pointing out that the ivories were probably carved in the area around Salerno and Amalfi. He believed, however, that the Etimasia was not originally intended for Salerno Cathedral (St. Matthew, to whom it was dedicated, plays no special role in the scenes), but was a gift of Pope Urban II to the basilica of Santa Trinità in the nearby cloister of Cava dei Tirreni, which the pope consecrated on September 5, 1092.[39] Hempel found the theological program of the throne appropriate for a church dedicated to the Trinity and "whole bishop and abbot in the fourteenth century carried a holy stool in their seal."

Although Hempel's theory was convincing enough to persuade the authorities in charge of the ivories to reconstruct them in the form of his proposed votive cathedra, a thorough examination of his reconstruction reveals numerous difficulties. First, no precedent exists for a structure even remotely resembling Hempel's proposed Etimasia. In fact, Hempel's only reference point for a previous Etimasia is the fifth-century mosaic at the summit of the triumphal arch in Santa Maria Maggiore in Rome,[40] hardly evidence for a tradition of monumental, free-standing examples of the type (particularly in ivory). Furthermore, the assertion that this throne was made for the church at the Cava monastery at the request of Pope Urban II is, as far as I am able to ascertain, wholly without foundation.

Objections may also be raised to more specific aspects of the reconstruction. The order of

the Old Testament panels appears sensible and correct, although, as will be seen, I would alter the manner in which they are mounted. The same is not true for the New Testament, however, and here I question Hempel's results. The various physical factors—lettering, holes, and scratches—that he used as a guide are very misleading because none of them was present on the panels in their original state. They date from later reorganizations of the plaques. This is clear from the lack of consistency in disposition of the marks and holes, for surely they would have occurred consistently if they were part of the original mounting of the ivories. The consecutive lettering of the panels does not include lacunae where the missing plaques must be inserted and the holes found on some of the plaques are not found on all of them, which indicates that these are not remnants of the original mounting.

In my opinion, Hempel's ordering of the New Testament series in four rows with six panels in the topmost row and only five in the other three is clearly wrong. That there were four rows appears certain, but it is equally evident that each of the rows originally held an equal number of panels (some of which are now lost), and that this number was six. Evidence of this arrangement was provided in Chapter 2 in my discussion of the iconography of the New Testament.

It is difficult to discern any rationale for Hempel's arrangement of the bust portraits and decorative borders. I do not agree that Christ is recognizable among the bust portraits[41] and that the four nimbless orant figures represent the

39. P. Guillaume, *Essai historique sur l'abbaye de Cava* (Cava die Tirreni, 1877), pp. 61–62.

40. H. Karpp, *Die frühchristlichen und mittelalterlichen Mosaiken in Santa Maria Maggiore zu Rom* (Baden-Baden, 1966), fig. 1.

41. Nothing about the figure to which Hempel refers (the one placed at the summit of the gable) identifies him as Christ. Christ is consistently represented throughout the New Testament cycle as a bearded figure with a cross-nimbed halo, and it is therefore unlikely for him to be shown here beardless and with a plain halo.

Old Testament's major prophets.[42] I also fail to understand how Hempel could fit the symbols of the four Evangelists into what he called the three empty corners of the gable (three spaces hard to locate in his reconstruction).

Needless to say, this discussion emphasizes points in Hempel's research with which I find fault. This should not be taken to mean that his work contained little of value. In fact, much of his arrangement of the plaques differs very little from mine in its details, and his ordering of the Old Testament panels appears to be correct. Hempel's contributions, then, are major and lasting, although parts of his solution, which he himself described as tentative and requiring criticism and debate, can no longer be maintained.

RELIQUARY URN

The latest suggestion for the reconstruction of the ivories was offered in 1964 in an article by Canonico Arturo Carucci.[43] According to his theory, the panels originally decorated the four sides of a large rectangular reliquary container placed above the high altar and mounted on its dossal (Fig. 143). The creation of this reliquary would have been part of the program for the amplification of the altar and its surroundings undertaken in the 1150s at the order of Archbishop Guglielmus da Ravenna.

Basic to Carucci's thesis is the idea that the ivories were mounted on a four-sided object, a notion that arose from the entry in the inventory of Marsilio Colonna (see the Appendix) which mentions "dieci altri quadretti piccioli di due deta in quattro in circa puro de avolio con le figure del testamento vecchio." Carucci is un-

able to find these ten square plaques among the extant ivories and assumes that, along with the two square panels showing Old Testament scenes that still exist (Figs. 15, 19), these formed the fourth side of his reliquary. This fourth side would have been the back of the reliquary, with the New Testament panels on the front and the other, oblong, Old Testament plaques on the two lateral sides. Carucci further suggests that the relic contained within this ivory receptacle was the arm of St. Matthew, and finds theological justification for his entire proposal in the dictum of the *Admonitio synodalis* (probably of the ninth century) that prescribes the elevation of relics onto the altar, where they were to be displayed in a *capsa*.[44]

Carucci's proposal is indeed ingenious, but certain of the assumptions on which it rests may be seriously questioned. As with most of the proposed reconstructions, the problem of dating immediately arises. Carucci refers to an object made in the mid-twelfth and not in the late eleventh century, the date that I propose for the Salerno ivories. Furthermore, the reliquary urn he reconstructs would conflict with the ability of the archbishop to conduct the mass *versus populum*, as was the practice in the cathedral at that time. Besides these points, a number of objections might be raised concerning Carucci's interpretation of the literary sources.

First, the idea that whatever object the ivories decorated would have been four-sided raises a number of problems. Carucci's proof of this is that there still remain two square plaques with Old Testament scenes that would have formed part of the fourth side along with

42. Lack of scrolls and the unusual orant position argue against their identification as prophets. Their secular dress and submissive gestures might indicate that they were donors, but their identity cannot be firmly established.

43. "Ipotesi," passim.

44. The relevant passage of the *Admonitio synodalis* is in Migne, *PL*, 132:456.

the ten other square plaques mentioned in the Colonna inventory. The words used in Colonna's inventory are not in question, but what these words actually refer to is another matter. There is reason to believe that the paliotto on the altar of the Treasury in Colonna's time was an arrangement dating to the construction of this part of the building in 1563–1565. Carucci operates under the false assumption that the plaques on the altar frontal known since the nineteenth century are identical with those on Colonna's *tavola*. On the contrary, two facts suggest a reworking of the paliotto between the sixteenth and nineteenth centuries. First, Colonna's inventory lists seven oblong Old Testament panels aside from those then on the altar frontal. It is highly unlikely that there ever existed seven such plaques *in addition to* those mounted on the paliotto visible in the nineteenth century. The altar frontal in use during Colonna's time must have contained fewer Old Testament panels than its successor. Second, Matteo Pastore, in his description of the cathedral, written in 1700 (see the Appendix), described the paliotto as lacking many pieces, some of which were preserved elsewhere in the Treasury. The altar frontal visible until 1960, although not incorporating all extant ivory pieces in the Duomo, had very much the appearance of a unified work; it seems unlikely that it would elicit such a description from Pastore. We know that in 1730 a new altar was built in the Treasury and that the ivory paliotto was incorporated into this new structure. This might well have been the time of its reworking into the altar frontal that existed until 1960.[45]

Furthermore, Carucci's assertion that the ten additional square plaques were similar in character to the two preserved square Old Testament panels (which may be fragments of larger plaques) is contradicted by the text of the inventory. After listing the seven oblongs with Old Testament narratives, Colonna indicates the two square plaques with scenes of the same character ("con le medesime figure del testamento vecchio"). Then, in a separate entry, he lists the additional ten small squares, omitting the word "same" (*medesime*) from his description of their content. Colonna also gives the measurement of the ten squares as "due deta in quattro." Since the oblong plaques are given as a palm in length, and the two preserved squares do approximate half of this measurement, it stands to reason that the ten other squares, in Carucci's system, should also measure half a palm. In Renaissance measurements a palm is divided into twelve *once* or *dita*. If the little squares were truly the size of the two preserved squares, they would measure six *dita* (*deta*); they would be three times the size of the squares in Colonna's list. Thus, in both content and size the ten little squares of Colonna's inventory differ from the two preserved Old Testament squares. I suspect that the ten little squares are actually to be identified with the ten Apostle busts, which might easily have been mistaken for figures of prophets.

As a liturgical basis for his reliquary Carucci cites the *Admonitio synodalis* and its prescription for the raising of the relics onto the altar. As far as I know, this generally resulted in the placing of some small memento in a modest jar or urn small enough to be placed *on* the altar.[46] I know of no instance where a reliquary

45. Capone, *Duomo*, 1:391–392.
46. E. Bishop, *Liturgia historica* (Oxford, 1918), p. 27, and C. E. Pocknee, *The Christian Altar* (London, 1963), p. 84 point out that raising the relics above the altar is justified by the existence of the entire body of the saint or martyr in the reliquary. This could not have been the case at Salerno because the body of St. Matthew had been interred in the crypt since its translation in 954. See N. Acocella, *La traslazione di San Matteo* (Salerno, 1954), p. 56.

was mounted in the manner here proposed. All in all, then, one has to conclude that the reliquary theory, while ingenious, does not provide an acceptable reconstruction of the Salerno ivories.

A NEW HYPOTHESIS

Having examined the various reconstruction proposals, and found them all unsatisfactory, I decided to approach the problem by looking at what the content and form of the ivories themselves suggest as their original vehicle. The Old and New Testament program of the ivories in itself suggests a previously unmentioned reconstruction possibility, for in several instances precisely this subject matter was selected for the decoration of *doors.*

Doors naturally present a very tempting large, flat surface for the decoratively minded, and since early Christian times artists have embellished them with suitable adornments, either figurative or solely ornamental. Among the former type (which are of most interest here), two examples from the early Christian period survive: the wooden doors of Sant'Ambrogio in Milan (fourth century)[47] and Santa Sabina in Rome (fifth century; Fig. 144).[48] Both of these doors, although in different manners, present decorative schemes in which plaques longer than they are wide alternate with plaques that are square or nearly square.

Doors with figurative decoration did not fall out of favor in Italy during the course of the Middle Ages. This is amply demonstrated by an entry in the *Liber pontificalis* that describes Pope Leo IV (847–855) as renewing the doors given to St. Peter's by Honorius (625–638), the decoration of which had been stolen in 846 by the Saracens. The description of these doors, attached to the central portal of the basilica, includes the following: "multisque argenteis tabulis lucifluis salutiferisque historis sculptis decoravit."[49] The editor of the *Liber pontificalis* mentions that inscriptions on the doors indicate that the decoration included central panels of Saints Peter and Paul.[50] The words used in the text quoted above imply that narrative scenes were included as well.

At the time of the creation of the Salerno ivories doors were still receiving a great deal of attention in ecclesiastical-artistic circles: historiated doors in different materials were made throughout eleventh-century Europe in places as far apart as Le Puy (wood),[51] Hildesheim (bronze; Fig. 145),[52] Cologne (wood),[53] and Verona (bronze; Fig. 152).[54] More important, southern Italy at this time displayed what may be described as an almost fanatic interest in decorated doors of bronze. The most important of the doors created during this period is the series commissioned by the family of Pantaleone of Amalfi and made in Constantinople during the second half of the eleventh century for the cathedral at Amalfi, for Monte Cassino, San Paolo fuori le mura in Rome, and the church at Monte

47. A. Goldschmidt, *Die Kirchentür des heiligen Ambrosius in Mailand* (Strasbourg, 1902).

48. J. Berthier, *La porte de Sainte-Sabine à Rome* (Freiburg, 1892); J. Weigand, *Das altchrisliche Hauptportal an der Kirche des hl. Sabina* (Trier, 1900).

49. L. Duchesne, *Le liber pontificalis,* vol. 1 (Paris, 1955), p. 323; 2:127.

50. Ibid., 1:324n2.

51. A. Fikry, *L'Art roman du Puy et les influences islamiques* (Paris, 1934), pp. 171–184, fig. 231; M. Götz, "Die Bildprogramme der Kirchentüren des 11. und 12. Jahrhunderts," Ph.D.

thesis, University of Tübingen, 1971. See, most recently, W. Cahn, *The Romanesque Wooden Doors of Auvergne* (New York, 1974).

52. R. Wesenberg, *Bernwardische Plastik* (Berlin, 1955), pp. 65–116, figs. 157–255; Götz, *Bildprogramme,* pp. 102–116.

53. R. Hamann, *Die Holztür de Pfarrkirche zu St. Maria im Kapitol* (Marburg, 1926); Götz, *Bildprogramme,* pp. 58–68.

54. A. Boeckler, *Die Bronzetür von Verona* (Marburg, 1931); P. Gazzola, *La porta bronzea di S. Zeno a Verona* (Milan, 1965); Götz, *Bildprogramme,* pp. 117–134.

Sant'Angelo in Apulia.[55] In 1099, under the auspices of another group of donors, Salerno Cathedral received what is commonly considered to be the last in this great series of bronze doors imported from the East,[56] and in the following century a series of doors in bronze were made by the Italian sculptors Barisanus of Trani (for Ravello, Trani, and Monreale) and Bonanus of Pisa (for Pisa and Monreale).[57]

Clearly, historiated doors were popular in the West throughout the Middle Ages, particularly in southern Italy during the later eleventh and twelfth centuries. But what of the decoration of these doors in relation to the Salerno plaques? No fewer than four of the doors previously cited have as their decoration juxtaposed cycles of episodes from the two Testaments: Santa Sabina, Hildesheim, Verona, and Bonanus' doors at Monreale. None of these shows the same narrative breadth as the Salerno program; Santa Sabina (Fig. 144) and Hildesheim (Fig. 145) are considerably more restricted in the number of scenes represented and are more specifically organized around typological expositions of events. The history of the Verona doors (Fig. 146) is quite complex. As presently constituted they include two stylistically distinct groups of panels that originally decorated two different doors, and at least one of these sets of panels illustrated scenes from both the Old and New Testaments. The Monreale program (Fig. 147) comes closest to that of the Salerno ivories in that it includes

scenes of Adam and Eve, Cain and Abel, Noah, Abraham, and Moses, as well as a comprehensive cycle of the life of Christ. These examples make one thing certain: the association of the general iconographic program of the Salerno ivories with a place on doors is well founded in the artistic tradition of the Middle Ages, especially in Italy.

The general subject matter of the Salerno series can be paralleled in doors of bronze and wood, but no extant example of an ivory door with scenes from the Old and New Testaments can be cited as a precedent for my proposed reconstruction. However, I have shown that doors with the thematic content of the ivories exist, and, if I can also show that ivory was employed in the decoration of doors during the Middle Ages, might not these two facts be combined to form a foundation for the proposal that the Salerno panels were originally mounted on doors?

Extant ivory doors of any kind are very rare, but they do exist. In the church of El'Adra, part of the monastery Der es Surian in Egypt's Wadi 'N Natrun region, there are two pairs of doors composed of panels of ebony and inlaid ivory. These works are securely dated by inscription in the early tenth century and, although their ornamentation is mainly of a decorative nature, it does include a number of single figures (Fig. 148). The doors illustrated in Fig. 148 are those that separate the nave from the choir; the second pair are placed between the choir and sanctuary (*haikal*).[58]

55. On the south Italian doors in general, see T. Preston, *The Bronze Doors of Monte Cassino and San Paolo fuori le mura* (Princeton, 1915); A. Schiavo, *Monumenti della costa di Amalfi* (Rome, 1941), pp. 202–241; G. Matthiae, *Le porte bronzee bizantine in Italia* (Rome, 1971); Götz, *Bildprogramme*, pp. 190–213; M. Frazer, "Church Doors and Gates of Paradise: Byzantine Bronze Doors in Italy," *Dumbarton Oaks Papers* 27 (1973):145–162.

56. Most authors (for example, Capone, *Duomo*, 1:66, and Crisci and Campagna, *Salerno sacra*, p. 121) repeat the traditional 1099 date for the doors. However, H. Hahnloser, ("Magistra latinitas und perita greca," *Festschrift für Herbert von Einem*, Berlin,

1965, p. 81) mentions only that the door must postdate 1084, by implication suggesting an earlier date than 1099. M. Frazer ("Church Doors and Gates of Paradise," p. 160) proposes a date in the first half of the twelfth century on the basis of style. See also Götz, *Bildprogramme*, pp. 212–216.

57. A. Boeckler, *Die Bronzetüren des Bonanus von Pisa und des Barisanus von Trani* (Berlin, 1953); Götz, *Bildprogramme*, pp. 147–168.

58. H. G. E. White, *The Monasteries of the Wadi 'N Natrun*, vol. 3 (New York, 1933), pp. 187–189, pl. 58 and fig. 198 (choir doors); pl. 64 (*haikal* door).

Two further pairs of ivory, or bone, doors bear mention here. Both are on Mt. Athos and date from the thirteenth or fourteenth century. Those in the monastery of Chilandari are decorated primarily with intarsia work, but ivory rosette borders provide frames for what must have been several rectangular ivory plaques.[59] The other doors, in Karyes, also show the characteristically late medieval intarsia work and decorative borders (here of floral and animal motifs) but also preserve one ivory relief with the figure of a saint.[60] In both examples earlier ivories have been incorporated into a later intarsia framework. Both pairs of doors served a similar function: they formed the centerpiece of choir screens that separated the sanctuary of a church from the naos.

It was not only in various corners of the monastic world that ivory was employed in the decoration of doors. Nor was such use of the material in the Middle Ages without a long and distinguished history, as numerous literary sources attest. Doors of ivory were made in the ancient Near East as early as c. 3000 B.C. Among the Romans, aside from appearing as a literary topos derived from the Greeks,[61] such works were found as part of the embellishment of important temples. For instance, Cicero, in one of the Verrine orations, speaks of the Temple of Minerva in Syracuse, whose doors displayed "various scenes carved in ivory with the utmost care and perfection."[62] Undoubtedly, the most prominent ivory doors of Roman antiquity were those through which one passed to enter the Temple of Apollo on the Palatine. Propertius tells us: "the doors were of Libyan ivory, marvellously wrought. On one was the story of the Gauls hurled down from Parnassus' height; the other told the death of the daughter of Tantalus."[63] This ancient tradition was continued in early Christian times. St. Jerome complains in a letter of the overly sumptuous churches erected by some of his contemporaries: first he mentions the marble-encrusted interior walls, then the sculpted capitals on massive columns, the ivory and silver doors, and, finally, the altar of gold and precious stones.[64] According to a medieval description, Justinian's Hagia Sophia displayed no less than six pairs of ivory doors in the side portals leading from the inner narthex to the naos.[65] An entry in one of the Carolingian chronicles describes how, during a visit to Italy in 807, the archbishop of Grado, Fortunatus, presented the emperor with a gift of "beauti-

59. V. Han, "Chilandar Altar Door Adorned with Bone Intarsia," *Musej Primenjene Umetnosti* (Belgrade), *Zbornik* 2 (1956):24–25.

60. S. Pelekanides, "Byz. Bemotheron ex Hagiou Orous," *Archaiologikes Ephemerides*, 1957, pp. 50–65. K. Weitzmann ("Die byzantinischen Elfenbeine eines Bamberger Graduale und ihre ursprüngliche Verwendung," *Festschrift für Karl Hermann Usener*, Marburg, 1967, pp. 11–20; "An Ivory Diptych of the Romanos Group in the Hermitage," *Vizantijskij Vremennik* 32 [1972]:142–156) has proposed an even more extensive use of carvings in ivory on the Byzantine iconostasis.

61. For the ancient Near Eastern doors see R. Barnett, *The Nimrud Ivories* (London, 1957), pp. 112–113; for the ivory gates in Greek and Roman literature, particularly Virgil, see E. H. Highbarger, *The Gates of Dreams* (Baltimore, 1940), pp. 38–49.

62. *Contra Verres* 3.4, 56 (Cicero, *The Verrine Orations*, vol. 2, trans. L. Greenwood, Cambridge, Mass., 1935, pp. 432–435): "Confermare hoc liquido, iudices, possum, valvas magnificentiores, ex auro atque ebore perfectiones, nullus umquam ullo in templo fuisse . . . ex ebore diligentissime perfecta argumenta erant in valvis."

63. *Carmen* 31 (Sexti Properti, *Carmina*, ed. E. A. Barber, Oxford, 1953, p. 78): "Et valvae, Libyce nobile dentis opus;/altera deiectos Parnasi vertice Gallos,/altera maerebat funera Tatalidos," See the translation in D. R. Dudley, *Urbs Roma* (London, 1967), p. 155. For other ancient references to ivory doors see Pauly-Wissowa, *Real-Encyclopädie der classischen Altertumswissenschaft*, vol. 5, pt. 2 (Stuttgart, 1905), s.v. Elfenbein, esp. cols. 2354–2360; *Reallexikon für Antike und Christentum*, vol. 4, ed. T. Klauser (Stuttgart, 1957), s.v. Elfenbein, esp. col. 1106.

64. *Ad Demetriadem* (Sancti Hieronymi, *Epistulae*, vol. 3, ed. I. Hilberg, Vienna, 1918, p. 194): "Alii aedificent ecclesias, vestiant parietes marmorum crustis; columnarum moles advehant, earumque deaurent capita pretiosum ornatum non sentientia; ebore argentoque valvas, et gemmis aurata distinguant altaria."

65. *Narratio de S. Sophia*, chap. 18: C. Mango, *The Art of the Byzantine Empire, 312–1453* (Englewood Cliffs, N.J., 1972), pp. 99–100. I owe knowledge of another early Byzantine ivory door to Professor Ihor Ševčenko. This door was placed in the north entry to the chapel of St. James in the church at the monastery of St. Catherine's in Sinai. Although the door is no longer extant, it was

fully sculpted" ivory doors that he had obtained in Constantinople.[66] Finally, Abbot Suger, in his *De consecratione*, refers to an ivory door placed somewhere in the eastern end of St. Denis.[67] Although we have no idea of what the sculptural decoration of these or most of the previously cited doors included, testimony of their existence proves that a tradition of carved ivory doors existed before and during the Christian Middle Ages, both East and West.

The surface of doors provides a particularly suitable armature for the ivory panels because it allows for a realization of their inherent narrative and programmatic qualities. Although any number of specific reconstructions is possible, the arrangement that I think best fulfills both thematic and aesthetic criteria is shown on pp. 106–107. The configuration may be described as a pair of doors each valve of which contains twelve New Testament plaques and ten Old Testament ones. Integrated into the interstices between the New Testament panels are the bust figures of Apostles and donors. These fit neatly into the sixteen spaces between the panels. I have tentatively arranged the decorative borders so that they surround the figurative plaques on all sides. The wider borders (7 cm.) appear at the sides, the narrower ones (5 cm.) at top and bottom. Originally, the ivories would have been held in place on the wooden frame-

work by overlapping borders of wood. If only a minimal amount of this framework showed between the plaques, each valve would have measured about 194 cm. high and 81 cm. wide. The dimensions of the closed doors would have been approximately 194 cm. by 162 cm.[68]

This arrangement keeps the Old and New Testament cycles in close proximity, allowing the two halves of the program to be integrated into a single visual whole. Furthermore, both stories are allowed to unfold in a consistent and unbroken chronological fashion—from upper left to lower right—on the unified surface of the closed doors. This organization not only is ideally suited to the fundamentally narrative aspect of the program, but also accommodates the direct juxtaposition of certain Old and New Testament episodes that have a typological relationship (for example, *Pentecost* and *Moses Receiving the Law*).

If one assumes that the doors were made for the Duomo of Salerno around the time of its consecration in 1084, where in the church would they have been located? Given the relatively delicate material of which they are made it seems unlikely that they would have been mounted on an exterior doorway. Besides, as noted earlier, the central portal of the church still holds the bronze doors donated at the end of the eleventh century. If there were ivory

described in the seventeenth century by the learned abbot of the monastery, Nectarius (*Epitome tes ierokosmikes historias*, Venice, 1677, pp. 165–167). The literary style of the recorded inscriptions and their mention of a certain Bishop Job suggest a date in the sixth century. Aside from mentioning that the doors were made of ivory, Nectarius describes the subject of the decoration: scenes connected with the life of Moses on one side and episodes from Christ's life, centering on the Transfiguration, on the other.

66. *Monumenta germaniae historica, scriptores*, vol. 1 (Berlin, 1826), p. 191: "Venit quoque Fortunatus patriarca de Graecis afferens secum inter caetera dona duas portas eburnass [*sic*] mirificio opere sculptas." See also B. Simson, *Jahrbucher der frankischen Reichs unter Ludwig dem Frommen*, vol. 1 (Leipzig, 1874), p. 173. Cecchelli, *Cattedra*, p. 41n4, quoted this passage. I would like to thank Professor Carl Nordenfalk for first calling this reference to my attention.

67. See E. Panofsky, *Abbot Suger: On the Abbey Church of Saint Denis and Its Art Treasures* (Princeton, 1946), pp. 116–117, 229–230: "cum sanctorum corpora martyrum et confessorum de tentoriis palliatis, humeris et collis episcoporum et comitum et baronum, sanctissimo Dionysio sociisque eius ad eburneum ostium occurrerunt."

68. My reconstruction does not recognize the variation of two centimeters among the Old Testament plaques as a factor of any consequence. Such size differences could easily be compensated for by the wooden framework. Moreover, variations far greater than this are often found in medieval doors made up of many panels, as, for instance, in the wooden doors of Santa Maria in Cellis near Carsoli (Bertaux, *Italie méridionale*, fig. 253; Götz, *Bildprogramme*, pp. 71–77).

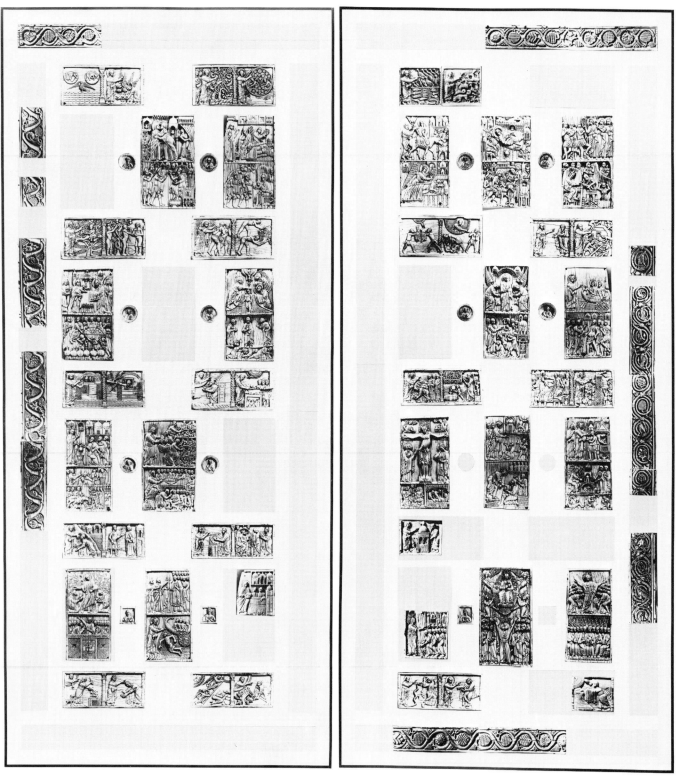

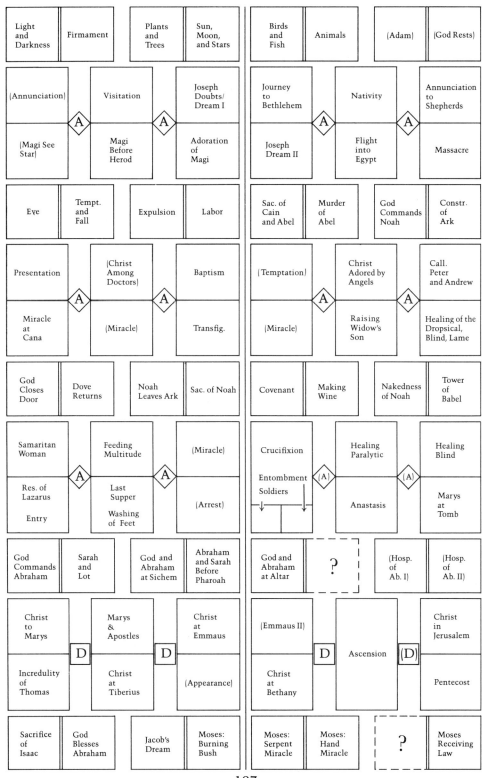

Reconstruction of the Salerno ivory doors: (left) photographic; (right) diagrammatic (A, Apostle; D, "donor")

107

doors at the Duomo, they must have been somewhere in the interior. The ivory doors of Hagia Sophia were placed in the openings between the inner narthex and the interior of the church proper. But such a space did not exist in the Duomo. More important is the placement of the doors at Der es Surian: one pair separating the choir from the nave, the other the sanctuary from the naos. The doors described in St. Jerome's letter and in Abbot Suger's treatise were also placed in the eastern portion of the church. I propose that the ivory doors at the Duomo of Salerno were similarly located. Although there is no direct evidence of a barrier between the sanctuary and the body of the Duomo in 1084, we do know that when the choir was remodeled around 1175 a monumental closure was placed between it and the nave.[69] It would have been unusual, to judge from the tradition of the time, had such a barrier not existed in the eleventh century, either in front of the choir or in front of the sanctuary proper. Chancel screens are found in Rome in the churches of Santa Sabina, San Clemente, and Santa Maria in Cosmedin, all probably dating from the ninth through the eleventh centuries.[70] In the church of Santa Maria in Valle

Porclaneta in the Abruzzi there is a fragment of a twelfth-century iconostasis made of stone and wood that probably comes closer to what the Salerno screen must have looked like.[71] Nearer Salerno, one finds in San Aspreno in Naples two decorated pilasters (probably ninth- or tenth-century) that have been identified as the remains of a choir screen.[72] Furthermore, Leo of Ostia describes an elaborate iconostasis in Desiderius' church at Monte Cassino.[73] It is not surprising to find what might be thought of as a Greek element in the Duomo at Salerno (and at Monte Cassino). In fact, at the turn of the eleventh-twelfth century, part of the liturgy was spoken in Greek at Salerno, indicating a profound ceremonial influence from the East.[74] The ivory doors that I have reconstructed, impressive and sumptuous, would have served admirably as the centerpiece of the chancel screen in the Cathedral of Salerno. If, in Byzantine fashion, they functioned as a veil behind which certain of the mysteries of the liturgy were concealed, at the same time, through the medium of their richly carved decorative program illustrating sacred history, they were a means of revelation to the faithful who stood before them.[75]

69. The arch of the central opening of this screen is still preserved, embedded in the masonry on the transept walls. It bears the date and the donor's name, Matthew Aiello: see Bertaux, *Italie méridionale*, p. 496, fig. 219; Capone, *Duomo*, 1:81–84.

70. For Santa Sabina and San Clemente, see E. Mâle, *The Early Churches of Rome*, trans. D. Buxton (London, 1960), figs. 29 and 75; for Santa Maria in Cosmedin, see G. Matthiae, *Le chiese di Roma dal IV al X secolo* (Rome, 1962), p. 252, figs. 129 and 148.

71. Bertaux, *Italie méridionale*, p. 56, figs. 251–252.

72. A. Venditti, *Architettura bizantina nell'Italia meridionale*, vol. 2 (Naples, 1967), p. 504, fig. 295.

73. *Chronica monasterii Casinensis*, chap. 32 (Migne, *PL*, 173:756–757; English translation in Holt, *Literary Sources*, p. 9).

74. On this point see A. Carucci, "Il ricordo di Alfano II nella liturgia greca," in *il contributo dell'archidiocesi di Capua alla vita religiosa e culturale del meridione* (Caserta, 1967), p. 88.

75. Margaret Frazer, in her discussion of the Byzantine bronze doors of southern Italy ("Church Doors and Gates of Paradise"), not only points to the general paradisiac symbolism of these doors but also demonstrates in convincing fashion that

their iconographic programs relate closely to those designed for the decoration of the iconostasis. In other words, Frazer recognizes profound connections in the thematic character of elements that mark the passage into discrete areas of the church. Entry into the church from the external world and entry into the sanctuary are accompanied by similar iconographic fanfare. This concept is germane to my reconstruction proposal because the Old Testament–New Testament doors that I suggest stood at the entrance to the sanctuary in Salerno Cathedral find their counterparts in several instances at the point of transition from exterior to interior. Just as Frazer discerned in the programs of the exterior bronze doors an iconographic communion with the passage into the sanctuary, so one can recognize a similar correspondence between the program of universal sacred history represented in the Salerno ivories and the doors of passage into the church from the exterior at Santa Sabina, Hildesheim, Verona, and Monreale. At San Zeno in Verona, the Old Testament–New Testament program is not restricted to the doors; in the early twelfth century it received even more monumental expression in the stone reliefs by the sculptor Niccolò spread across the entire facade.

5. ART IN CONTEXT

I HAVE ALREADY SUGGESTED that the Salerno ivories were carved during the last quarter of the eleventh century in the city of Amalfi. Earlier I adduced certain specific bits of evidence to support this attribution, but the most convincing argument has yet to be considered. This is the remarkable coincidence that exists between the various components that determined the character of the Salerno ivories, on the one hand, and, on the other, those that defined the fabric of political, economic, and cultural life in eleventh-century Amalfi. This chapter explores that relationship.

Gloriously situated on the slopes of the Lattari Mountains rising from the Gulf of Salerno, today's picturesque resort town retains little of the vitality of the medieval city. Old chronicles attest its founding by a group of wandering Romans in the early fourth century, but the earliest document that specifically mentions Amalfi by name is a letter written by Pope Gregory I in 596.[1] At this time, as part of the Duchy of Naples, Amalfi stood within the portion of the Italian peninsula controlled by the Byzantines. For details of its complex history, so full of glorious and ignominious moments, we must wait another two centuries. Between 781 and 786 Arechis I, duke of Benevento, laid siege to Amalfi. Although the city suffered considerable destruction, the army of its Neapolitan overlords ultimately routed the enemy. A nominal peace was then effected, but, even so, the late eighth and early ninth centuries appear to have been times of repeated wars between Amalfi and its Lombard neighbors. In 835 the Beneventans, now under the leadership of Duke Sicard, directed another futile attack against the Duchy of Naples, again followed by a treaty, this time calling for a five-year moratorium on hostilities. By 838, Sicard could hold himself in check no longer. He agains readied his forces, aiming them specifically at Amalfi. The cam-

1. Much of the literature on medieval Amalfi is outdated. The basic source remains M. Camera, *Memorie storico-diplomatiche dell'antica città e ducato di Amalfi*, 2 vols. (Salerno, 1876–1881). Other, more specific studies are referred to in the following notes. Fortunately, there has been a revival of Amalfitan studies in the last several years: B. Kreutz, "Amalfi and Salerno in the Early Middle Ages: A Regional Profile," Ph.D. thesis, University of Wisconsin, 1970; J. Mazzoleni et al., *Le pergamene degli archivi vescovili di Amalfi e Ravello*, 4 vols. (Naples, 1972–1979); *Amalfi nel medioevo* (papers from the Convegno internazionale, 1973) (Salerno, 1977); M. del Treppo and A. Leone, *Amalfi medioevale* (Naples, 1977); U. Schwarz, *Amalfi im frühen Mittelalter* (Tübingen, 1978). For the literature on Amalfi's commercial history, see notes 10 and 19, below. A. Citarella has compiled a useful bibliography of literature on Amalfi: "Saggio bibliografico per una storia di Amalfi nell'alto medioevo," *Archivio storico per le provincie napoletane* 3rd ser. 10 (1971):407–425.

paign was successful; Amalfi was taken. Sicard moved immediately to consolidate his victory by transferring part of the Amalfitan population to Salerno in an attempt to amalgamate the two peoples into a single "nationality." Although some of the Amalfitani acquiesced in Lombard domination, both in Amalfi and among the exiled populace in Salerno there was considerable resistance to the Lombards' rule. In fact, Lombard domination was to be short-lived. In July 839, Sicard was assassinated by a rival Lombard faction, and his supporters fell into disarray. The Amalfitans recognized the moment as a propitious one. Those in Salerno returned to their native city in August, and by the following month their independence was a fact. Amalfi stood free, not only from the Lombards but from her former Neapolitan overlords as well.

In declaring independence Amalfi proclaimed as its new leader a man named Peter, granting him the title of Prefect. Little is known about the history of Amalfi for the next hundred years, although it is recorded that from the time of Peter until 958 it was ruled by a succession of prefects. After 958 the Amalfitan leaders were known as dukes. An old chronicle preserves the names of these leaders, but unfortunately details of their reigns are scanty. Sporadic evidence suggests that the late ninth and tenth centuries were times of relative peace for the Amalfitans. Indeed, these years must have seen the development of the city's essential character; in 972 ibn-Hawqal, a merchant of Baghdad visiting Amalfi on business, described it as "the most prosperous city of Langobardia, the noblest, the most illustriously situated, the most commodious, the richest."[2] This enviable position could not have been attained without the political stability provided in the tenth century by the long and apparently prosperous reigns first of Prefect Mastalus I (914–952) and then of Duke Mansone I (966–981, 984–1004). These were the decades that saw Amalfi extend at least nominal control over the surrounding region, a position consolidated in 987 when, at the instigation of Duke Mansone, Amalfi was made an archbishopric, thus making the churches of its constituent communities subject to Amalfitan central control. By the beginning of the tenth century, Amalfi was more like a republic than a city, a loose federation of communities in the southern half of the Sorrentine peninsula.[3]

The decade 1028–1038 found the Amalfitans engaged in protracted bouts of civil strife. In 1039, during the tenure of the weak Duke John II, Prince Guaimar of Salerno, with the help of one of the Norman factions in southern Italy, took Amalfi. Instead of incorporating it into the Principate of Salerno, he wisely allowed it nominal independence, installing the former Duke Mansone II, now old and blind, as his puppet. This arrangement did not prevail for long; in 1052 the Amalfitans expelled Mansone and returned his brother, John II, to the throne.[4]

This newly restored freedom was doomed even before it had begun, for Amalfi's battle for independence was fought in the shadow of that inexorable force whose hegemony had already begun to be asserted in southern Italy—the Normans.[5] By 1073 the power of the Normans in the south was so great that when the Amalfi-

2. *The Book of Routes and Kingdoms.* The translation is from R. Lopez and I. Raymond, *Medieval Trade in the Mediterranean World* (New York, 1955), p. 54.

3. On these early centuries of Amalfitan history, see in particular A. Hofmeïster, "Zu Geschichte Amalfis in der byzantinischen Zeit," *Byzantinisch-neugreichische Jahrbücher* 1 (1920):94–127; M. Berza, "Un'autonomia perifica bizantina: Amalfi (secolo VI-X)," *Studi bizantini e neoellenici* 5 (1939):25–31.

4. See E. Pontieri, "La crisi di Amalfi medioevale," *Archivio storico per le provincie napoletane* 59 (1934):12. Leo of Ostia mentions the restitution of autonomy in the *Chronica monasterii Casinensis,* II, 83 (Migne, *PL,* 173:688).

5. On the Normans in southern Italy see particularly E. Pontieri, *Tra i normanni nell'Italia meridionale* (Naples, 1964).

tans were threatened again by their Salernitan arch-enemies, it was to the great Norman soldier, Robert Guiscard, that they turned for help. In fact, they literally gave themselves into Guiscard's hands for safekeeping, abandoning independence in a bloodless transfer of power and sovereignty to the Normans.[6] This event was to mark the beginning of the end of Amalfitan autonomy. But for Robert Guiscard it marked only a beginning. In 1076, using Amalfi as a base— and undoubtedly with the assistance of its ships—he attacked Salerno. After a long and bitter siege, the city was his.[7] It became the Norman capital of the region under Guiscard, a fact of no small importance for understanding the historical circumstances surrounding the creation of the Salerno ivories. The recurrent hostilities between Salerno and Amalfi outlined above would hardly have produced an atmosphere conducive to the commissioning in Amalfi of a major work for Salerno Cathedral. After 1076, however, the situation was considerably altered. Amalfi and Salerno were no longer independent entities at odds; they were confederates in a grander Norman whole. It is exactly the moment at which one might expect a significant interchange to occur.

This is not to say that the Amalfitans were content with Norman rule. On the contrary, they spent the next fifty years in an almost constant effort to shake loose from foreign domination. A rebellion in 1088 was quickly put down, but one in 1096 succeeded to the point where the Amalfitans created a new duke—Marino

Sebaste—who was able to rule for almost four years until the Normans again overwhelmed Amalfi in 1100. In the early years of the twelfth century the Amalfitani rose up once more, but when King Roger II ended their revolution in 1131 the strength of that remarkably enduring and persistent Amalfitan will to independence was finally broken for good. As if to throw salt on the wounds of Amalfi's lost autonomy, the Pisans attacked the city and its surroundings in 1135 and 1137, viciously sacking and wantonly burning the still splendid buildings of the once-proud republic. "An" Amalfi never ceased to exist; but the days of its independence and glory were never to be restored.[8]

The history of Amalfi in the Middle Ages is unusual in one respect. Unlike the history of many other medieval polities, it is not characterized by the recitation of successes and failures in the acquisition of land or the aggrandizement of sovereignty. The Amalfitans were not soldiers; they were merchants. They chose not to scale the mountains behind them in order to increase their territory; instead they turned toward the sea and toward the commercial brand of imperialism that its mastery could afford them. The neighboring forests provided ample timber for ship building, but it was Amalfitan organization and resourcefulness— and, one suspects, not a little measure of cunning and guile—that made the duchy, along with Venice, the leading Italian merchant republic of its day. Whether or not it is true that an Amalfitan is properly credited with the in-

6. This is attested by William of Apulia, *Gesta Roberti Wiscardi*, III, 58 (M. Mathieu, *Guillaume de Pouille, La Geste de Robert Guiscard*, Palermo, 1961, p. 190). Although the text appears to indicate that Guiscard reconquered Amalfi after taking Salerno, most scholars reject this as a confusion of events. See Camera, *Memorie*, 1:268. Amatus of Monte Cassino also describes the relationship (*L'Ystoire de li Normant*, VIII, 7: V. de Bartholomaeis, ed., *Storia de'Normanni di Amato di Montecassino*, Rome, 1935, p. 348).

7. On the siege of Salerno see M. Schipa, "Storia del principato longobardo di Salerno," *Archivio storico per le provincie napoletane* 12 (1887):575.

8. Camera, *Memorie*, 1:323–325; see also G. Rossi-Sabatini, "Relazioni fra Pisa e Amalfi nel medioevo," in *Studi sulla repubblica marinara di Amalfi* (Salerno, 1935), pp. 55–67.

vention of the compass,[9] it remains incontestable that the Amalfitani managed to navigate an ambitious course around the Mediterranean world, both Christian and Moslem, with remarkable assurance.

Even more than political stability, it was the commercial exploits of the Amalfitans that shaped the milieu in which the Salerno ivories were created. The Salerno series is a "crossroads" work of art—as is a Gandharan sculpture or an American cubist painting—reflecting the aggressive and profound crosscultural influences that permeated all Amalfitan experience in the eleventh century.

For many years the traditional view of the circumstances underlying the period of tremendous prosperity enjoyed by Amalfi in the tenth and eleventh centuries maintained that its chief cause was the favorable position held by the Amalfitans in the Byzantine Empire.[10] Indeed, they did occupy a special status through most of the Middle Ages. This was directly the result of the city's having originally formed part of the Duchy of Naples, a Byzantine dependency, and also of Amalfi's continuing recognition of at least nominal Byzantine suzerainty even after its "declaration of independence" in 839. Amalfitan political leaders and members of the nobility from the ninth through the eleventh centuries often had titles or dignities bestowed on

them by the Byzantine emperor, among which that of *Patricius* apparently ranked highest.[11]

In the tenth century the Amalfitans were already actively exploiting their Byzantine connections. Liutprand of Cremona, an Italian bishop, returning home from Constantinople in the middle of the century, complains when certain silks in his possession are confiscated by the Byzantine customs officials and declared illegal for export. There is little point to such enforcement of the law, Liutprand suggests, because one can easily obtain these items at home (Italy), from Amalfitans or Venetians.[12]

In the tenth and eleventh centuries the Amalfitans must have maintained quite an establishment in the Byzantine capital. Pantaleone, son of Maurus of Amalfi, whose name appears on the Farfa Casket along with those of his five brothers, had a very large house there where hospitality was offered to Gisulf of Salerno and his party during their visit in 1062.[13] The family of Maurus, as we shall see, was by far the most visible and active single group in Amalfi during this period. There were two Amalfitan monastic foundations in Constantinople ministering to the spiritual needs of what must have been a sizable merchant community. Both Santa Maria de Latina and St. Saviour were located in the region of the Golden Horn, in the midst of the traders' quarter.[14] Only after the conquest of Amalfi by the Normans, hated

9. For the legend that credits the Amalfitan Flavio Gioia with the invention of the compass see H. Winter, "Who Invented the Compass?" *The Mariner's Mirror* 33 (1937):95–102; A. D'Arrigo, "La bussola amalfitana," *Annali dell'Istituto Universitario Navale di Napoli* 27 (1957):247–272.

10. See, for example, W. Heyd, *Histoire du commerce du Levant au moyen-âge*, vol. 1 (Leipzig, 1885), pp. 98–108; G. Coniglio, "Amalfi e il suo commercio nel medioevo," *Nuova rivista storica* 18–19 (1944–1945);100–114.

11. See Camera, *Memorie*, 1:89; A. Hofmeister, "Die Übersetzer Johannes und das Geschlecht Comitis Mauronis in Amalfi," *Historische Vierteljahrschrift* 27 (1932):245–249.

12. For Liutprand's text, see Camera, *Memorie*, 1:194–195.

13. Amatus, *L'Ystoire*, VIII, 3 (de Batholomaeis, *Amato*, p. 342). See also Hofmeister, "Übersetzer Johannes," pp. 263–264.

14. On the Amalfitan monasteries in Constantinople see R. Janin, "Les sanctuaires des colonies latines a Constantinople," *Revue des Etudes Byzantines* 4 (1946):163–177; idem, *La géographie ecclesiastique de l'empire byzantine*, vol. 1 (Paris, 1953), pp. 582–583. Amalfi also maintained a considerable foundation on Mt. Athos, Santa Mari degli Amalfitani, for which see, most recently, A. Pertusi, "Monasteri e monaci italiani all'Athos nell'alto medioevo," *Le millenaire du Mount Athos 963–1963, études et mélanges*, vol. 1 (Chevetogne, 1963), pp. 217–251.

enemy of the Eastern empire, did the Amalfi-tans begin to lose their privileged position in Byzantium. This is borne out by the famous bull of Emperor Alexis I Commnenus issued in 1082 that demanded payment of an annual fee to the church of San Marco in Venice by Amal-fitans living in the Byzantine Empire.[15]

Liutprand's text suggests the nature of Amalfitan imports from Byzantium—luxury goods. The importation of Eastern silks must have continued to be an Amalfitan specialty be-cause in the following century one finds Desi-derius of Monte Cassino journeying to Amalfi (probably in 1065) in order to purchase a gift of "viginti pannos sericos quos triblattos appel-lant," in anticipation of a planned visit of Em-peror Henry IV.[16] The consistency of the refer-ence is striking; surely Desiderius' purchase was of purple silk similar to that confiscated from Liutprand by those vigilant Byzantine cus-toms officials.

The most famous Amalfitan imports from the Byzantine Empire, of course, were the bronze doors commissioned by members of Maurus' family and offered to the Duomo at Amalfi, Monte Cassino, San Paolo fuori le mura in Rome, and the sanctuary of San Michele at Monte Sant'Angelo in Apulia.[17] Leo of Ostia de-scribes yet another Amalfitan import from By-zantium. An unnamed Amalfitan merchant re-siding in Constantinople in 1078 during the sacking of Emperor Michael VII Ducas' imperial palace apparently joined in the looting. He took

away with him a jeweled *stauroteca* in gold and enamel that he brought home to Amalfi and eventually presented to St. Benedict upon his entry into the monastery of Monte Cassino.[18]

Although this evidence is less full than one might wish, it is nonetheless convincing in its suggestion of the nature of the commodities brought back to Amalfi by its traders in Con-stantinople. Ivory is not explicitly mentioned along with silk, bronze, and goldwork, but one can readily imagine the inclusion of Byzantine carvings in ivory—such as those often used for comparison in earlier chapters—among the treasures brought back to Amalfi.

Recently, our view of Amalfitan trade and prosperity has been radically transformed, most notably through the investigations of Armand Citarella.[19] Whereas before Byzantium was seen as Amalfi's great trading partner, it is now widely acknowledged that trade with Byzan-tium was a less important aspect of Amalfitan foreign commerce than trade with, first, Islamic north Africa and, later, Fatamid Egypt and Pal-estine. A close reading of the history of Amalfi reveals how careful its leaders were not to an-tagonize their Islamic friends. They sought al-ways to avoid participation in any of the "mini-crusades" organized by the Italian cities that had felt the sting of Moslem attack. It is a testi-mony to Amalfitan diplomacy—and also to a heightened sense of self-preservation—that vir-tually alone among the Italian coastal cities

15. For references to the bull of Alexis I see note 59 to Chapter 3.

16. Leo of Ostia, *Chronica monasterii Casinensis*, III, 18 (Migne, *PL*, 173:736).

17. The bronze doors are most conveniently published in G. Matthiae, *Le porte bronzee bizantine in Italia* (Rome, 1971).

18. *Chronica monasterii Casinensis*, III, 55 (Migne, *PL*, 173:792).

19. "The Relations of Amalfi with the Arab World before the Crusades," *Speculum* 42 (1967):299–312; "Patterns in Medieval Trade: The Commerce of Amalfi before the Crusades," *Journal of*

Economic History 28 (1968):531–555; "Scambi commerciali fra l'Egitto e Amalfi in un documento inedito della Geniza del Cairo," *Archivio storico per le provincie napoletane* 3rd ser. 9 (1970):141–149; "A Puzzling Question concerning the Relations between the Jewish Communities of Christian Europe and Those Represented in the Geniza Documents," *Journal of the American Oriental Society* 91 (1971):390–397; "Il declino del commercio marittimo di Amalfi," *Archivio storico per le provincie napole-tane* 3rd ser. 12 (1975):9–54; and, most recently, *Il commercio di Amalfi nel medioevo* (Salerno, 1977).

Amalfi remained unscathed by Arab raids.[20] The city's close relations with Islamic nations as well as Christian ones make Amalfi an almost classic example of a multiethnic, multireligious "Mediterranean society" of the earlier Middle Ages, an open-trade community that fostered the exchange of goods and ideas along the shores of the Mediterranean.[21] Its openness was based on a subtle blend of self-interest, tolerance, and ambition, a delicate compound that was destroyed forever by the spirit and fact of the Crusades. The glorious days of Amalfitan history soon disappeared in their wake.

There is one very practical point to be made immediately concerning the importance of Amalfitan-Islamic trade for the creation of the Salerno ivories. It was undoubtedly through the hands of middlemen in Fatamid Egypt that African ivory would have passed en route to the Mediterranean and, eventually, to Europe. Harvested in central Africa, the tusks would have been shipped down the Nile to an Egyptian port, probably Alexandria, for export. According to more than one contemporary source, the Amalfitan merchants were an established presence in Alexandria at least by the eleventh century, and probably even earlier.[22] Furthermore, documents attest to the presence of a significant number of Amalfitans further up the Nile at Fustat (Old Cairo). As early as 996 an incident occured indicating that a major Amalfitan colony must have been established there. When five ships of the Fatamid fleet being readied for action against Byzantium were burned, elements in the caliph's guard immediately ac-

cused the Amalfitans of the deed. They set out for revenge, killing more than one hundred Amalfitans and destroying a considerable amount of personal property. The caliph soon realized that the Amalfitans had been wrongly accused and sent envoys to make amends with the rest of the community, offering restitution of property and compensation for loss.[23] What is most significant to note here is the considerable size of the Amalfitan community and the importance attached to it by the Fatamid ruler of Egypt.

Perhaps the most famous establishment of the Amalfitans in Islamic territory was in Jerusalem. William of Tyre, writing in the twelfth century, recorded that the Amalfitan merchants residing in Egypt petitioned the caliph for permission to organize a hospice for their countrymen in the Holy City, then under the caliph's control. The request was granted and ample space was set aside in the Christian quarter. There the merchants built a monastery and hospice, very near the entrance of the Holy Sepulchre, and staffed it with an abbot and monks brought from Amalfi. The hospice was soon to become a center of refuge for all Christians visiting the Moslem-controlled city. Responding to the increased responsibility, the Amalfitans erected a convent and added a hospital to their complex. The citizens of Amalfi provided support for these foundations, sending money to the abbot "by the hands of those who were going to Jerusalem."[24]

Amatus of Monte Cassino added an important detail concerning the Amalfitan es-

20. Citarella, "Relations of Amalfi," pp. 303–305.

21. This conception of Amalfi was inspired by S. Goitein, *A Mediterranean Society: The Jewish Communities of the Arab World as Portrayed in the Documents of the Cairo Geniza 1: Economic Foundations* (Berkeley, 1967); see also the articles by Citarella listed in note 19.

22. Heyd, *Histoire du commerce,* 1:100. William of Apulia mentions Alexandria in his description of Amalfi (*Gesta Roberti Wiscardi*, III, 67: Mathieu, *La Geste*, p. 190).

23. The document is discussed in C. Cahen, "Un text peu connu relatif au commerce oriental d'Amalfi au Xᵉ siècle," *Archivio storico per le provincie napoletane* n.s. 73 (1955):61–66.

24. William of Tyre, *A History of Deeds Done beyond the Sea,* vol. 2, trans. and annotated by E. Babcock and A. Krey (New York, 1943), pp. 241–245.

tablishment in Jerusalem, missing in the account of William of Tyre: the builder and benefactor of the hospital complex was none other than Maurus of Amalfi.[25] That this benefaction occurred at just about the time of Maurus' activity elsewhere is proved by an entry in an Amalfitan chronicle describing a visit to the hospital by Archbishop John of Amalfi in 1080, at which time he was received *cum honore*.[26] Perhaps the archbishop brought to Jerusalem a portion of the annual subvention provided by his countrymen, and perhaps he, or Maurus, or some other Amalfitan visiting the Holy City—there must have been many—carried back with him to Amalfi the panels known as the Grado Chair ivories.

Jerusalem was not the only center in that part of the Near East to offer hospitality to an Amalfitan merchant colony. There is ninth-century evidence (of dubious validity) indicating that a relationship already existed at that time between Amalfi and the city of Antioch in Syria; eleventh and twelfth-century testimony proves that by then connections were definitely maintained.[27] In fact, Amatus claims that Maurus built another hospital in Antioch.[28] A document of 1161 issued by William, bishop of Acre in Palestine, granted the Amalfitans the right to establish their own cemetery in the city, indicating the substantial size and importance of their community.[29] Contemporary sources also record the existence of an Amalfitan colony in the Syrian coastal city of Tripoli.[30]

This description of Amalfitan trading establishments could be continued at considerable length. Aside from those already mentioned in the Byzantine Empire, Egypt, Syria, and Palestine, colonies existed in northern Africa, in the major cities of Sicily and Apulia, in Salerno, and, undoubtedly, at Rome. The Amalfitans conducted business regularly at the great market in the northern Italian city of Pavia, the Lombard capital.[31]

In short, the Amalfitani were ubiquitous, as William of Apulia described them, "Bearing away their merchandise to sell / And loving to carry back the wares they have bought."[32] It is precisely this combination of wide-ranging foreign experience and an acquisitive nature that made possible the synthesis of sources that we have seen accomplished by the carvers of the Salerno ivories.

Among Amalfi's broad-ranging relationships, perhaps most significant are its connections with the most important spiritual, cultural, and artistic center of southern Italy in the eleventh century: the abbey of Monte Cassino.[33] Only an extended

25. *L'Ystoire*, VIII, 3 (de Bartholomaeis, *Amato*, p. 342).

26. See the lines from the Amalfitan chronicle quoted in de Bartholomaeis, *Amato*, p. 342n2.

27. See Heyd, *Le colonie commerciali degli italiani in oriente nel medio evo*, vol. 1 (Venice, 1866), p. 270; idem, *Histoire du commerce* 1:104. William of Apulia also mentions Antioch in his description of Amalfi (*Gesta Roberti Wiscardi*, III, 67: Mathieu, *La Geste*, p. 190).

28. *L'Ystoire*, VIII, 3 (de Bartholomaeis, *Amato*, p. 342).

29. R. Brentano, "The Archepiscopal Archives at Amalfi," *Manuscripta* 4 (1960):104.

30. See Camera, *Memorie*, 1:203–204; Heyd, *Colonie commerciali*, p. 261.

31. A. Solmi, "Honorantie Civitatis Papie," in *L'amministrazione finanziaria del regno italico nell' alto medio evo* (Pavia, 1932), pp. 107–108.

32. *Gesta Roberti Wiscardi*, III, 67 (Mathieu, *La Gesta*, p. 190).

33. All students of Monte Cassino eagerly await the publication of Herbert Bloch's forthcoming *Monte Cassino in the Middle Ages*. In the meantime see H. Bloch, "Monte Cassino, Byzantium, and the West in the Earlier Middle Ages," *Dumbarton Oaks Papers* 3 (1946):165–224; L. Fabiani, *La terra di S. Benedetto*, 2 vols. (Monte Cassino, 1968). On the architectural character of the monastery, see H. M. Willard and K. Conant, "A Project for the Graphic Reconstruction of the Romanesque Abbey at Monte Cassino," *Speculum* 10 (1935):144–146; A. Pantoni, *Le vicende della basilica di Montecassino* (Monte Cassino, 1973); G. Urban, "Die Klosterakademie von Montecassino und der Neubau der Abteikirche im 11. Jahrhundert," *Römisches Jahrbuch für Kunstgeschichte* 15 (1975):11–23.

and close relationship between the two can account for the many specific points of comparison between the Salerno ivories and Cassinese works revealed in the chapters on style and iconography. In Chapter 1 I suggested that the entire program of universal sacred history represented in the Salerno cycles had been conveyed to the ivory carvers through the intermediary of the frescoes painted in the atrium of Desiderius' new basilica at Monte Cassino around 1070. That a monumental cycle did intervene in the design of the Salerno series is suggested by the enlargement of the *Crucifixion* and *Ascension* scenes (Figs. 31, 38). As noted earlier, these very same episodes were given greater prominence than the others on the walls of Sant'Angelo in Formis and, by inference, probably in the Monte Cassino series itself.[34] Significantly, the *Crucifixion* had already been emphasized by an increase in scale in the early Christian decoration of Old St. Peter's in Rome (Fig. 47).[35]

This last observation introduces a particularly important aspect of the relationship between the ivories and the art of Monte Cassino. As I pointed out in Chapter 1, the program of the ivories did not simply parallel the frescoes at Monte Cassino; along with the Cassinese example and others, it was the fruit of a revival of an early Christian artistic program that had its origin in fifth-century Rome. Was the revival of this program an isolated phenomenon or was it part of a broader artistic and cultural movement? Overwhelming evidence indicates that it was part of a pervasive movement. Reviving the spirit and glories of early Christian Rome was a central theme in the cultural consciousness of Monte Cassino during Desiderian times. Alfanus of Salerno, the greatest poet to emerge from the circle of the monastery (and archbishop of Salerno at the time of the creation of the ivories), wrote that Rome was "urbis Apostolicae, totius orbis adhuc dominae."[36] Elsewhere he displayed his regard for old Rome and his view that Rome in the Apostolic age was even greater than the Rome of the Caesars.[37] Both Amatus of Monte Cassino and an anonymous south Italian poet of the eleventh or twelfth century sing the praises of the ancient city in elegies devoted to Peter and Paul.[38]

The reverence for Roman architectural exemplars is equally clear. In *Versus de situ, constructione et renovatione Casinensis coenobi*, composed to honor the dedication of the new basilica at Monte Cassino in 1071, Alfanus wrote:

> Tanta decoris in hoc rutilat
> gloria, Roma quod ipsa sua
> pluris, ut aetimo, non faciat:
> sic quoque vota Desiderii
> convaluere benigna patria.[39]

This passage clearly indicates Desiderius' desire to rival the monuments of Rome, and we know a good deal about how he realized his goals. It is abundantly clear that the general plan of the new church of St. Benedict, with its monumental stairway, propylaea, atrium, and basilica with continuous transept—as well as the Old

34. See the plan of the nave wall of Sant'Angelo in Formis in Morisani, *Affreschi*, after p. 293.

35. For the decoration of the nave of Old St. Peter's see the Introduction.

36. Alfano di Salerno, *Il carme per Monte Cassino*, ed. N. Acocella (Salerno, 1963), p. 20.

37. F. J. E. Raby, *A History of Secular Latin Poetry in the Middle Ages*, vol. 1, 2nd ed. (Oxford, 1957), p. 381: *Ode to Hildebrand*.

38. Ibid., p. 377. For the anonymous poet, see F. J. E. Raby, *A History of Christian-Latin Poetry from the Beginnings to the Close of the Middle Ages* (Oxford, 1927), pp. 233–234. The Roman origins of Desiderius' revival are suggested by F. Heer, *Europäische Geistesgeschichte* (Stuttgart, 1953), pp. 41–42.

39. *Carme*, p. 26.

Testament–New Testament fresco program in the atrium—was based on the early Christian layout of Old St. Peter's. But these were not the only connections between Desiderius' church and the great Roman basilica. For his triumphal arch Desiderius selected a dedicatory inscription that paraphrased the one placed by Constantine on the great arch of the Vatican basilica. Desiderius' inscription read:

Ut duce te patria iustis potiatur adepta
Hinc Desiderius pater hanc tibi condidit aulam.

At Old St. Peter's Desiderius could have read the following:

Quod duce te mundus surrexit in astra triumphans
Hanc Constantinus Victor tibi condidit aulum.

The relationship between the two inscriptions is obvious, and further indicates Desiderius' determination to associate himself and his works with the venerated monuments of ancient Christian Rome.[40]

With regard to the figurative arts one might cite extant evidence that is equally convincing. Bertaux cites a number of eleventh- and twelfth-century apse compositions in and around Rome that revert to the early Christian Roman type of Saints Cosmas and Damian.[41] One of these is a fresco in the church of San Sebastiano al Palatino, a foundation that was from 1065 a possession of Monte Cassino, in fact the only one in the city of Rome.[42] Furthermore, this revival of early Christian Roman iconographical schemes is attested by the fragmentary mosaic preserved on the apsidal arch of the Duomo in Salerno (Fig. 149).[43] Enough pieces survive to indicate that the composition originally showed the four symbols of the Evangelists arranged horizontally near the top and sides of the arch's opening and flanking a medallion at the center that contained either a bust of Christ or a Christological symbol. Similar compositions may be found in fifth- and sixth-century Roman mosaics at San Paolo fuori le mura and Saints Cosmas and Damian.[44] Even the decorative motif on the soffit of the arch at Salerno—a garland around which wind twisted ribbons—relates to models in early Christian Rome, such as those at Sant'Agnese fuori le mura or San Lorenzo fuori le mura.[45] The Salerno arch, which surely was created within the orbit of Monte Cassino, offers an interesting parallel to the ivories in that it reproduces an early Christian program derived from a Roman source but uses very up-to-date Byzantine stylistic devices. The specific drapery motif on the symbol of St. Matthew, where the drapery falls down the back of the figure and then loops into

40. The inscription at Monte Cassino is recorded in Leo of Ostia, *Chronica monasterii Casinensis*, III, 27 (Migne, *PL*, 173:749). The one from Old St. Peter's is discussed in L. Duchesne, *Le liber pontificalis*, vol. 1 (Paris, 1898), p. 193. For the relationship of the two, see Bloch, "Monte Cassino, Byzantium, and the West," p. 199, and N. Acocella, *La decorazione pittorica di Monte Cassino dalle didascalie di Alfano I (sec. XI)* (Salerno, 1966), pp. 31–42.

41. *Italie méridionale*, p. 186.

42. Ibid., pp. 187–188; P. Fedele, "Una chiesa del Palatino: S. Maria in Pallara," *Archivio storico della società romana di storia patria* 26 (1903):343–380. C. R. Dodwell (*Painting in Europe, 800–1200*, Baltimore, 1971, p. 120, pl. 135) and G. Matthiae (*La pittura romana*, vol. 1, Rome, 1966, pp. 242–243, figs. 168, 170–

171) offer recent summary treatments of this intriguing fresco, a thorough study of which I am preparing.

43. The earlier literature on the subject has been superseded by E. Kitzinger, "The First Mosaic Decoration of Salerno Cathedral," *Jahrbuch der österreichischen Byzantinistik* 21 (1972): 149–162. The older bibliography may be found here.

44. M. van Berchem and E. Clouzot, *Mosaiques chrétiennes du IVme au Xme siècle* (Geneva, 1924), fig. 139 (SS. Cosmas and Damian); W. Oakeshott, *The Mosaics of Rome* (New York, 1967), fig. 185 (San Paolo).

45. G. Matthiae, *Mosaici medioevale delle chiese di Roma*, vol. 2 (Rome, 1967), pls. 90 (St. Agnese) and 101–102 (San Lorenzo); Oakeshott, *Mosaics*, pls. 75–76 (San Lorenzo) and 85 (St. Agnese).

the belt at the waist, is a contemporary Byzantine device that may also be found in late eleventh-century Cassinese manuscripts.[46]

The many artistic associations connecting the Salerno ivories with Cassinese art of the late eleventh century are inextricably linked to the matrix of historical and cultural relationships between Amalfi and Monte Cassino. Some of these, particularly those concerning the acquisition of works of art at Amalfi, have already been mentioned, but it should also be recognized that when Desiderius embarked upon his building program at Monte Cassino he imported artisans from Amalfi to assist in the construction of the new church.[47] When the basilica was dedicated on October 1, 1071, important members of the Amalfitan community were, of course, present.[48]

All of this evidence confirms the existence of a significant artistic dialogue between Amalfi and Monte Cassino. With the recent publication of Henry Willard's study concerning the relations of Amalfi and the great abbey during the Desiderian era, the broader climate in which this dialogue flourished has for the first time been systematically described.[49] Not only did Amalfi contribute works of art and artisans to the Cassinese community but, in more than one case, Amalfitans took vows to become members of the monastery. Furthermore, the Amalfitani established one of their numerous trading colonies at San Germano, the town at the foot of Monte Cassino. Here, laymen from Amalfi must have come into continuous contact with the Cassinese population.

In his treatment of the Cassinese presence in Amalfi, Willard makes use of significant new material that he unearthed from the archives of the abbey. No less than four churches in Amalfi, along with their attached monasteries, were possessions of Monte Cassino and, in addition, by 1085 Monte Cassino owned a *fundicus*, or port facility, in the harbor of Amalfi.[50] Clearly, Amalfitan-Cassinese relations were reciprocal. If at first glance this alliance of the spiritual-monastic capital of southern Italy with the seemingly worldly-secular outpost of Amalfi strikes one as unusual, upon reflection it emerges as a highly successful symbiosis. As Amalfi provided objects *de luxe* or artisans for the great monastery, so Monte Cassino offered theological underpinnings, iconographical models, and even, perhaps, stylistic inspiration for works of art produced at Amalfi, among which the Salerno ivories rank as the most significant.

I hope that these paragraphs on the character and history of medieval Amalfi provide a meaningful framework for the ideas concerning the character and genesis of the Salerno ivories offered in the earlier chapters. These carvings now stand revealed as the prod-

46. Kitzinger, "First Mosaic," pp. 155–156.

47. Leo of Ostia, *Chronica monasterii Casinensis*, III, 26 (Migne, *PL*, 173:747n4332). H. Willard (*Abbot Desiderius and the Ties between Monte Cassino and Amalfi in the Eleventh Century*, Monte Cassino, 1973, p. 46) points out that the manuscript of the *Chronicon* containing this notice is one of the most reliable. It has been suggested that the Amalfitan builders were responsible for introducing the pointed arch into Monte Cassino (from where it spread into northern Romanesque architecture via Cluny); see K. Conant and H. Willard, "Early Examples of Pointed Arch and Vault in Romanesque Architecture," *Viator* 2 (1971):203–209. Presumably, the Amalfitan architects would have assimilated the form from Islamic sources.

48. Leo of Ostia, *Chronica monasterii Casinensis*, III, 29 (Migne, *PL*, 173:751) mentions the presence of the archbishop of Amalfi, while Amatus (VIII, 3:de Bartholomaeis, *Amato*, pp. 341–346) says that Maurus also participated in the dedication.

49. Willard, *Abbot Desiderius*.

50. Ibid., pp. 13–30. The churches were San Nicola, Santa Croce, Santa Maria, and San Biagio, located in various sections of the city. For the *fundicus* see ibid., p. 31, and idem, "The Fundicus: A Port Facility of Monte Cassino in Medieval Amalfi," *Benedictina* 26 (1972):253–261.

uct of a creative impulse arising from a web of cultural, political, and commercial circumstances. One strand that remains elusive and dangling is that of the Normans. Robert Guiscard was, in fact, the patron of the new cathedral of Salerno for which the ivories presumably were made. Furthermore, as we have seen, it was at the hands of Guiscard's army that during the 1070s and 1080s Amalfi and Salerno were united in a Norman principate. A political situation was precipitated that provided the setting for the creation in Amalfi of ivories destined for the Duomo of Salerno. But could the Normans have been yet more intimately associated with the commission? That Robert Guiscard chose to present works of art in ivory as gifts to favored religious institutions is proved by an entry in Leo of Ostia's chronicle, where a *scrinium eburneum magnum* is catalogued among a series of precious objects offered to Monte Cassino by Guiscard, presumably in 1085.[51] This casket would probably have been made within the Norman domain, perhaps even at Amalfi. If the Salerno ivories were also a Norman donation, it could be that in the little squares representing figures *en buste* dressed in simple tunics and lacking halos (Fig. 41) one sees images of three Norman overlords of the region—perhaps one is Guiscard himself—who sponsored the work. If this were so—and it remains wholly conjectural—the carvings would be connected with yet another of the critical impulses of their time and region. But even if the "donors" must remain anonymous for now, this subtracts little from our new vision of the Salerno ivories as the most significant extant creation of the rich cultural and artistic milieu shaped during Amalfi's golden age.

51. *Chronica monasterii Casinensis*, III, 58 (Migne, *PL*, 173:795).

CATALOGUE OF CHRISTIAN IVORIES OF THE AMALFITAN SCHOOL

THIS CATALOGUE INCLUDES all known ivories of Christian subjects made in the Amalfitan workshop that produced the Salerno series. It is divided into two major sections. The first lists each extant piece in the Salerno group itself (Cat. nos. A1-A44), appending notes on size and condition and references to prior illustrations in the works of Goldschmidt and Carucci. For those few panels that are in museums outside Salerno I have included information on provenance and additional specific references. The second section contains entries on ivories from the workshop that are not part of the Salerno group proper. These entries are considerably more detailed than those in the first part, and include descriptions of and commentaries on each piece.

The ivories in this corpus are not cast in a homogeneous style but fall, more or less, into three related but distinct groups. The first, represented by the Farfa Casket and its relatives (Cat. nos. B1-B5), was characterized above in the chapter on style. The style of these pieces shows a great dependence on the aesthetic approach of native pre-Romanesque art and, as I tried to demonstrate in "Ivory Carving in Amalfi," displays a reliance on mixed but fundamentally Western iconographic sources. The second group is the Salerno ivories themselves. By this stage in its existence, the workshop had modified many of its traditional impulses under the impact of Middle Byzantine stylistic and iconographic sources and through the influence of the Grado Chair ivories. The third, relatively large group of works (Cat. nos. B6-B23) represents what was apparently the final phase of the Amalfi school. For the most part the iconography of these panels is derived directly from the Salerno group. These latest ivories are not wholly unified in their style; they reflect a gradual departure from the style of the Salerno series; for example, the *Ascension* triptych (Cat. no. B21, Fig. 176) is still relatively similar to the version in the Salerno ivories, at least in its middle section. Finally, a new style emerges, based on that of the Salerno panels but marked by a distinct trend toward symmetry, simplification, and schematization. Once again one must look to native traditions for correspondences, this time not to a tradition of the past but to the emerging Romanesque style of the period beginning c. 1100. Although figurative sculpture of this period is difficult to find in southern Italy, the figure of a prophet from the Cathedral of Modena in the north (Fig. 150), executed c. 1100 (see R. Salvini, *Wiligelmo e le*

origini della scultura romanica, Milan, 1956, pp. 66–68), offers compressed and repetitious drapery patterns similar to the patterns that appear time and again in these ivories; for instance, in the figure of St. John on the *Crucifixion* plaque in the Metropolitan Museum of Art (Cat. no. B20, Fig. 175). In both, the parallel-line method of rendering certain details of the mantle is clearly in evidence. In Chapter 3 I pointed out correspondences between the works produced in the first two stages in the development of the Amalfitan workshop and manuscripts illuminated at Monte Cassino. The same is true for this latest phase, whose rigidity of form and strict repetition of line is strikingly echoed in the *Crucifixion* miniature from a psalter (Vat. Lib., cod. Urb. lat. 585, fol. 257v: Fig. 151) produced at the great abbey c. 1100 (see E. A. Loew, *The Beneventan Script,* Oxford, 1914, pl. 30; H. Toubert, "Le Breviaire d'Oderisius et les influences byzantines au Mont-Cassin," *Mélanges de l'Ecole Française de Rome* 83 [1971]:193–261). Following this third phase of creativity the activity of the workshop apparently ceased.

It is worth noting the uses to which the ivories produced in Amalfi were put. Besides the doors at Salerno, there is evidence of two caskets, six triptychs, a diptych(?), and a multi-paneled object whose character remains unclear. It is significant that among these works triptychs predominate. This was among the most popular forms in the Middle Byzantine repertoire of ivory objects.

Arturo Carucci (*Avori,* pp. 9, 13–14, 160, 196) has speculated on what the large group of ivories (Cat. nos. B6-B17) produced after the Salerno series originally decorated. He points out that only New Testament scenes are illustrated on these ivories, and, assuming that the plaques must have come from Salerno Cathedral, he suggests that they can only have formed part of a *cona* with the arms of the Piscicelli family mentioned in an inventory of 1575 (for the text, see the Appendix). This object is described in the inventory as containing only New Testament scenes; and it was probably some sort of triptych because a *serratura bellissima* is mentioned as part of it. Carucci says that the only members of the Piscicelli family who might have donated the triptych were the two archbishops of the family (both named Niccolò), who held the episcopate around the middle of the fifteenth century. According to Carucci, one of these men was responsible for commissioning this ivory triptych decorated with plaques that had then been in the Duomo for some 350 years. This reconstruction is not impossible, but it seems unlikely. No physical evidence may be adduced to support it. Furthermore, there is no reason to associate the panels with Salerno Cathedral in the first place because they were probably made in Amalfi. None of them indicates in its provenance any connection with Salerno. In any case, Carucci's proposal does not explain the original use of the plaques because his *cona* represents a fifteenth-century remounting. For now, the question of their original function must remain open.

The production of the Amalfitan workshop might not have been restricted to works of strictly Christian content. As noted in the text, a group of ivory oliphants probably was produced in Amalfi at this time. In addition, a group of chess pieces that manifest close parallels with the latest group of Christian ivories (especially Cat. nos. B6-B17) may have been produced in the same or a related Amalfitan workshop (see Goldschmidt, *Elfenbeinskulpturen,* 4:46–48, nos. 161-173, pls. 59-62; S. Wichmann, *Schach,* Munich, 1960, pp. 287–288, nos. 23-29, figs. 23-28, 33).

A. THE SALERNO IVORIES

1. *The Spirit over the Waters* and *The Separation of Light and Darkness—Creation of the Firmament* (Fig. 2)
22 × 10.2 cm.

Condition Excellent; small crack at upper right. Four holes in corners.
Bibliography Goldschmidt, *Elfenbeinskulpturen*, 4:pl. 42, no. 3; Carucci, *Avori*, p. 49.

2. *Creation of Plants and Trees—Creation of the Sun, Moon, and Stars* (Fig. 3)
21.8 × 10.2 cm.

Condition Excellent; right edge slightly shaved. Four holes in corners.
Bibliography Goldschmidt, *Elfenbeinskulpturen*, 4:pl. 42, no. 4; Carucci, *Avori*, p. 55.

3. a. *Creation of Birds and Fish* (Budapest, Museum of Fine Arts); b. *Creation of Animals* (New York, Metropolitan Museum of Art, acq. no. 17.190.156) (Figs. 4a and 4b)
21 × 10.2 cm. (together)

Condition Although cut in half, the two fragments are in excellent condition. The Budapest piece has some breaks on the right border. No holes in either half.
Provenance Budapest: The plaque was in Budapest by 1867. There was an inscription on the back said to have been written by a Hungarian soldier garrisoned in Salerno who appropriated the plaque as a souvenir: "Le 23 Septembre 1820 dans l'église de Salerne, la ville la plus ancienne après Naples." New York: The plaque was acquired as part of the J. P. Morgan bequest in 1917. On the back of the panel there appeared a small piece of parchment (now in the museum's files) relating that the piece was found in Pisa, among the works of the Pisan sculptor Buschetto (said to have been the architect of Pisa Cathedral). The inscription, dated April 10, 1759, further describes the transference of the ivory from its owner, Ignacius Soria, to the "Curator of the Rarities of Pisa," Count Sciammane.
Bibliography Budapest: Goldschmidt, *Elfenbeinskulpturen*, 4:pl. 42, no. 5; Carucci, *Avori*, p. 305; F. Bock, "Das ungarische National-almuseum in Pest," *Mitteilungen der KK. Central Commission* 12 (1867):117 (here the subject is misidentified as *St. Francis Preaching to the Birds and Fish*); H. Semper, "Ivoires au Musée national de Buda-Pesth," *Revue de l'Art Chrétien* 4th ser. 8 (1897):492–495; E. Stevenson, "Scoperta di un avorio spettante al paliotto di Salerno," *Nuovo bullettino di archeologia cristiana* 3 (1897):322–324; J. Balogh, *Katalog der ausländischen Bildwerke des Museums der bildenden Kunste in Budapest* (Budapest, 1975), pp. 32–34, cat. no. 6. New York: Goldschmidt, *Elfenbeinskulpturen*, 4:pl. 42, no. 6; Carucci, *Avori*, p. 305.

4. *Creation of Eve—Temptation and Fall* (Fig. 5)
21.8 × 10.9 cm.

Condition Good; three large horizontal cracks in the right half and some breaks in the right border. Four holes in corners.
Bibliography Goldschmidt, *Elfenbeinskulpturen*, 4:pl. 42, no. 7; Carucci, *Avori*, p. 64.

5. *Expulsion—Adam and Eve at Labor* (Fig. 6)
21.8 × 11 cm.

Condition Excellent; no holes.
Bibliography Goldschmidt, *Elfenbeinskulpturen*, 4:pl. 42, no. 8; Carucci, *Avori*, p. 72.

6. *Sacrifice of Cain and Abel—Murder of Abel* and *Condemnation of Cain* (Paris, Louvre) (Fig. 7)
21.8 × 11 cm.

Condition Excellent. No holes.
Provenance Unknown.
Bibliography Goldschmidt, *Elfenbein-skulpturen*, 4:pl. 43, no. 9; Carucci, *Avori*, p. 307; E. Molinier, "Quelques ivoires récemment acquis par le Louvre," *Gazette des Beaux Arts* 20 (1898):484–485; E. Stevenson, "Di un altro avorio spettante al paliotto di Salerno," *Nuovo bullettino di archeologia cristiana* 4 (1898):97.

7. *God Commands Noah to Construct the Ark—Construction of the Ark* (Fig. 8)
22 × 10 cm.

Condition Good; one large crack at upper left; shaved at bottom edge. Four holes in corners.
Bibliography Goldschmidt, *Elfenbein-skulpturen*, 4:pl. 43, no. 10; Carucci, *Avori*, p. 77.

8. *God Closes the Door of the Ark—The Dove Returns to the Ark* (Fig. 9)
22.3 × 11 cm.

Condition Good; one large crack at center right; some breaks on top right border. Four holes in corners.
Bibliography Goldschmidt, *Elfenbein-skulpturen*, 4:pl. 43, no. 11; Carucci, *Avori*, p. 83.

9. *God Orders Noah to Leave the Ark—Sacrifice of Noah* (Fig. 10)
21.8 × 10.3 cm.

Condition Good, except for major damage at right center, where there is an indented slot with a single hole intruding through the border into the figural portion of the plaque (perhaps this notch originally accommodated some sort of mount). One hole in upper left corner.
Bibliography Goldschmidt, *Elfenbein-skulpturen*, 4:pl. 43, no. 12; Carucci, *Avori*, p. 89

10. *God and Noah Establish the Covenant—Making of Wine* (Fig. 11)
24.2 × 10.5 cm.

Condition Excellent; no holes.
Bibliography Goldschmidt, *Elfenbein-skulpturen*, 4:pl. 42, no. 13; Carucci, *Avori*, p. 95.

11. *Nakedness of Noah—The Tower of Babel* (Fig. 12)
24 × 10.7 cm.

Condition Excellent; four holes in corners, one in top center, just to the right of the dividing column.
Bibliography Goldschmidt, *Elfenbein-skulpturen*, 4:pl. 43, no. 14; Carucci, *Avori*, p. 101.

12. *God Commands Abraham to Leave Haran—Sarah and Lot in Abraham's House* (Fig. 13)
24.2 × 9.9 cm.

Condition Excellent; no holes.
Bibliography Goldschmidt, *Elfenbein-skulpturen*, 4:pl. 44, no. 18; Carucci, *Avori*, p. 113.

13. *God and Abraham at Sichem—Abraham and Sarah before Pharoah* (Fig. 14)
24.2 × 9.9 cm.

Condition Excellent; several nicks on the left border; no holes.

Bibliography Goldschmidt, *Elfenbein-skulpturen*, 4:pl. 44, no. 16; Carucci, *Avori*, p. 107.

14. *God and Abraham at an Altar* (Fig. 15)
Berlin-Dahlem, Staatliche Museen, Preussischer Kulturbesitz, inv. no. 5952
12 × 9 cm.

Condition Fair; top sheared off; some dark stains. Holes in top center and top right. Perhaps a fragment of a larger plaque.
Provenance The plaque was acquired by the museum in Berlin in 1919.
Bibliography Goldschmidt, *Elfenbein-skulpturen*, 4:pl. 42, no. 15; Carucci, *Avori*, p. 311; W. F. Volbach, *Die Elfenbeinbildwerke*, Staatliche Museen zu Berlin: Die Bildwerke des deutschen Museen, 1 (Berlin, 1923), p. 31 no. 5952.

15. *Sacrifice of Isaac—God Blesses Abraham* (Fig. 16)
24.1 × 10.2 cm.

Condition Excellent; no holes.
Bibliography Goldschmidt, *Elfenbein-skulpturen*, 4:pl. 44, no. 18; Carucci, *Avori*, p. 119.

16. *Jacob's Dream—Moses at the Burning Bush* (Fig. 17)
24.1 × 10.2 cm.

Condition Excellent; no holes.
Bibliography Goldschmidt, *Elfenbein-skulpturen*, 4:pl. 44, no. 19; Carucci, *Avori*, p. 125.

17. *Moses: Miracle of the Serpent—Moses: Miracle of the Withered Hand* (Fig. 18)
24.1 × 9.8 cm.

Condition Excellent; perhaps slightly sheared at the top; no holes.
Bibliography Goldschmidt, *Elfenbein-skulpturen*, 4:pl. 44, no. 20; Carucci, *Avori*, p. 129.

18. *Moses Receiving the Law* (Fig. 19)
11.5 × 9 cm.

Condition Fair; top and bottom borders cut; nicks on left and right borders; no holes. Perhaps a fragment of a larger plaque.
Bibliography Goldschmidt, *Elfenbein-skulpturen*, 4:pl. 43, no. 21; Carucci, *Avori*, p. 135.

19. *Visitation—Magi before Herod* (Fig. 20)
14.4 × 24.5 cm.

Condition Good; one large crack in upper left; shaved at left and right; one hole at top center; two holes in bottom corners; indentations on right and left borders.
Bibliography Goldschmidt, *Elfenbein-skulpturen*, 4:pl. 45, no. 25; Carucci, *Avori*, p. 141.

20. *Joseph Doubts Mary* and *Joseph's First Dream—Adoration of the Magi* (Fig. 21) 13.1 × 24.5 cm.

Condition Good; broken at upper left; crack at upper right; one hole visible in lower right corner; indentations on left and right borders.
Bibliography Goldschmidt, *Elfenbein-skulpturen*, 4:pl. 45, no. 26; Carucci, *Avori*, p. 149.

21. *Journey to Bethlehem—Joseph's Second Dream* (Fig. 22)
12.8 × 24.2 cm.

Condition Good; broken at top left; one hole in top right corner; two holes in bottom corners; indentations on left and right borders.
Bibliography Goldschmidt, *Elfenbein-skulpturen,* 4:pl. 45, no. 27; Carucci, *Avori,* p. 155.

22. *Nativity—Flight into Egypt* (Fig. 23)
 13.1 × 24.5 cm.

Condition Excellent; some nicks in borders; four holes near corners.
Bibliography Goldschmidt, *Elfenbein-skulpturen,* 4:pl. 45, no. 28; Carucci, *Avori,* p. 165.

23. *Annunciation to the Shepherds—Massacre of the Innocents* (Fig. 24)
 13.1 × 23.8 cm.

Condition Excellent; one small crack at lower right; small break at top right; five holes near corners (two in lower right).
Bibliography Goldschmidt, *Elfenbein-skulpturen,* 4:pl. 45, no. 29; Carucci, *Avori,* p. 173.

24. *Presentation—Miracle at Cana* (Fig. 25)
 13.4 × 24.4 cm.

Condition Fair; some loss on left side; major vertical crack at left top and smaller one at right top; evidence of eight holes, two in each corner.
Bibliography Goldschmidt, *Elfenbein-skulpturen,* 4:pl. 45, no. 30; Carucci, *Avori,* p. 181.

25. *Baptism—Transfiguration* (Fig. 26)
 13.2 × 24.6 cm.

Condition Excellent; four holes at corners.
Bibliography Goldschmidt, *Elfenbein-skulpturen,* 4:pl. 46, no. 31; Carucci, *Avori,* p. 190.

26. *Christ Adored by the Angels—Raising of the Widow's Son at Nain* (Fig. 27)
 11.7 × 23.8 cm.

Condition Good, some loss at lower right corner; two holes behind angels in the upper half; two toward the corners of the lower half.
Bibliography Goldschmidt, *Elfenbein-skulpturen,* 4:pl. 46, no. 32; Carucci, *Avori,* p. 203.

27. *Calling of Peter and Andrew—Healing of the Dropsical, Blind, and Lame* (Fig. 28)
 11.2 × 23.9 cm.

Condition Good; some loss at upper right corner; nicks in left and lower borders; three plugged holes in corners (none in lower left); one plugged hole in the center of top half; one just above the lower border in the center of the bottom half.
Bibliography Goldschmidt, *Elfenbein-skulpturen,* 4:pl. 46, no. 34; Carucci, *Avori,* p. 209.

28. *Christ and the Samaritan Woman—Resurrection of Lazarus* and *Entry into Jerusalem* (Fig. 29)
 12.5 × 24.4 cm.

Condition Excellent; some nicks on borders; small break at lower right corner; slight damage to surface beneath ass in lowest scene; four holes in corners.

Bibliography Goldschmidt, *Elfenbein-skulpturen*, 4:pl. 46, no. 35; Carucci, *Avori*, p. 215.

29. *Feeding of the Multitude—Last Supper* and *Washing of the Feet* (Fig. 30)
14.3 × 24.1 cm.

Condition Good; one major vertical crack on right side of lower half; three holes in corners (none in lower left).
Bibliography Goldschmidt, *Elfenbein-skulpturen*, 4:pl. 46, no. 36; Carucci, *Avori*, p. 225.

30. *Crucifixion—Soldiers Gambling—Entombment* (Fig. 31)
12.8 × 24.1 cm.

Condition Excellent; some shaving of left and right borders; four holes in corners.
Bibliography Goldschmidt, *Elfenbein-skulpturen*, 4:pl. 47, no. 37; Carucci, *Avori*, p. 233.

31. *Healing of the Paralytic at Bethesda—Anastasis* (Fig. 32)
11.4 × 24.6 cm.

Condition Excellent; bottom border shaved; four holes in corners.
Bibliography Goldschmidt, *Elfenbein-skulpturen*, 4:pl. 47, no. 39; Carucci, *Avori*, p. 242.

32. *Healing of the Blind Man at Siloam—The Marys at the Tomb* (Fig. 33)
12.4 × 24.6 cm.

Condition Excellent; some breaks in top border; four holes at corners.
Bibliography Goldschmidt, *Elfenbein-*skulpturen*, 4:pl. 47, no. 38; Carucci, *Avori*, p. 249.

33. *Christ Appears to the Marys—Incredulity of Thomas* (Fig. 34)
11.7 × 23.6 cm.

Condition Excellent; two nicks in left border; four holes in corners.
Bibliography Goldschmidt, *Elfenbein-skulpturen*, 4:pl. 47, no. 40; Carucci, *Avori*, p. 257.

34. *The Marys Announce the Resurrection to the Apostles—Christ Appears at Lake Tiberius* (Fig. 35)
12.1 × 23.9 cm.

Condition Excellent; some nicks in right border; holes in two lower and upper left borders.
Bibliography Goldschmidt, *Elfenbein-skulpturen*, 4:pl. 46, no. 33; Carucci, *Avori*, p. 203.

35. *Christ at Emmaus* (fragment) (Fig. 36)
Berlin-Dahlem, Staatliche Museen, Preussischer Kulturbesitz, inv. no. J510
10.1 × 12.1 cm.

Condition Fair; lower half of plaque missing, some loss at left side; nicks in right border; hole in upper right border.
Provenance The plaque was acquired from a Naples dealer in 1844.
Bibliography Goldschmidt, *Elfenbein-skulpturen*, 4:pl. 47, no. 41; Carucci, *Avori*, p. 313; W. Vöge, *Die Elfenbeinbildwerke*, Köngliche Museen zu Berlin, Beschreibung der Bildwerke der christlichen Epochen (Berlin, 1900), p. 41, no. 69; Volbach, *Elfenbeinbildwerke*, p. 31, no. J510.

36. *Christ Appears at Bethany* (fragment) (Fig. 37)
(Christ figure in Kunstgewerbe Museum, Hamburg)
11 × 11.8 cm.

Condition Poor; top half of plaque missing; figure of Christ severed; breaks in top border, nicks in lower border; two holes in lower corners.
Bibliography Goldschmidt, *Elfenbeinskulpturen*, 4:pls. 47, no. 42, 48, no. 126 bis; Carucci, *Avori*, pp. 268, 271; for the Christ figure, see M. Longhurst, "A Fragment of the Ivory Paliotto at Salerno," *Burlington Magazine* 49 (1926):43–44.

37. *Ascension* (Fig. 38)
12.4 × 23.2 cm.

Condition Excellent; some nicks in left border; three holes in upper corners and lower left corner; one at bottom center.
Bibliography Goldschmidt, *Elfenbeinskulpturen*, 4:pl. 47, no. 43; Carucci, *Avori*, p. 281.

38. *Christ Appears in Jerusalem—Pentecost* (Fig. 39)
11.6 × 23.9 cm.

Condition Excellent; indentations on left and right borders; four holes in corners.
Bibliography Goldschmidt, *Elfenbeinskulpturen*, 4:pl. 47, no. 44; Carucci, *Avori*, p. 273.

39a–j. Ten Apostle Busts (Figs. 40-41)
Peter (Fig. 41a) holds the keys, Andrew (Fig. 40b) holds the cross, and Paul (Fig. 40d) is identifiable by his bald pate; the others remain unidentified
Approximately 6 cm. square.

Condition Good, one panel is cracked through; two have been trimmed into medallion form; most have two holes, but two have four holes.
Bibliography Goldschmidt, *Elfenbeinskulpturen*, 4:pl. 42, nos. 1 and 2 (only eight are shown); Carucci, *Avori*, pp. 291–300.

40a–c. Three "Donor" Portraits (Figs. 41e-g) Approximately 5.5 × 6 cm.

Condition Good; some cracks; each has two holes in corners.
Bibliography Carucci, *Avori*, pp. 301–303.

41a–e. Five Fragments of Border: Inhabited Vine Scroll (Figs. 42a-e)
a. 7 × 22 cm.
b. 7 × 23.8 cm.
c. 6.9 × 25.4 cm.
d. 7 × 6.5 cm.
e. 6.9 × 7.5 cm.

Condition Good; holes in wider border.
Bibliography Goldschmidt, *Elfenbeinskulpturen*, 4:pl. 42, no. 1; Carucci, *Avori*, pp. 13, 21, 25, 37.

42a–e. Five Fragments of Border: Vine Scroll with Berries and Leaves (Figs. 43a-e)
a. 5.4 × 18.8 cm.
b. 5.4 × 19 cm.
c. 5.3 × 19 cm.
d. 5.4 × 18.9 cm.
e. 5.4 × 20.4 cm.

Condition Good; some rubbing; holes in borders.
Bibliography Goldschmidt, *Elfenbeinskulpturen*, 4:pl. 42, no. 2; Carucci, *Avori*, pp. 17, 39, 41.

43a–g. Five Fragments of Border: Cornucopia Frieze and Two Pairs of Colonnettes (Figs. 44a-g)
a. 7 × 21.1 cm.
b. 6.9 × 22.1 cm.
c. 7.1 × 24 cm.
d. 7.2 × 7.5 cm.
e. 7.2 × 12.6 cm.
f. 1.7 × 23.4 cm.
g. 2.1 × 23.5 cm.

Condition a-e: good; some rubbing; holes in border; f: damage at base; g: crack at top.

Bibliography Goldschmidt, *Elfenbeinskulpturen,* 4:pl. 44, nos. 22 and 23; Carucci, *Avori,* pp. 11, 15, 31, 34, 41, 42.

B. RELATED AMALFITAN IVORIES

These ivories fall into two broad groups: nos. B1-B5, which predate the Salerno group, and nos. B6-B23, which postdate it.

1. Casket: Scenes of Christ's Infancy and Passion (Figs. 152–155)
Farfa, Abbey Treasury
21(h) × 33.5(l) × 7(w) cm. (with top)

Condition The casket is in excellent condition, with only one small replacement piece added by restorers (at the very top left of the *Anastasis* and including part of the inscription above it) in the place where originally there must have been a lock. On the top, toward the center, are holes indicating the presence at one time of a handle. Inside is a nineteenth-century wooden armature covered with parchment. Fragments of red and blue still cling to certain of the incised letters of the inscription, indicating that originally at least this part of the casket was polychromed.

Inscription

SUSCIPE VAS MODICUM DIVINIS CULTIB
[US] APTUM
AC TIBI DIRECTUM DEVOTA MENTE
TUORUM
NOMINA NOSTRA TIBI QUESUMUS SINT
COGNITA PASSIM
HAEC TAMEN HIC SCRIBI VOLUIT CAU-
TELA SALUBRIS

IURE VOCOR MAURUS QUONIAM SUM
NIGRA SECUTUS
ME SEQUITUR PROLES CUM PANTALEONE
IOHANNES
SERGIUS ET MANSO MAURUS FRATER
QUOQUE PARDO
DA SCELERUM VENIAM CAELESTEM
PREBE CORONAM

(Receive this modest box fit for a divine cult / And given devoutly by your servants. / We beseech that our names be known by you always. / Nevertheless, a healthy sense of caution made us have them written here. / I am rightly called Maurus because I have followed sin. / My sons follow me, John with Pantaleone, / Sergius and Manso, Maurus and also their brother Pardo. / Give pardon for the crimes and offer the crown of heaven.)

Provenance From the end of the nineteenth century the casket was kept in the library of San Paolo fuori le mura in Rome, to which it had come from the abbey of Farfa. It was returned to Farfa in the spring of 1969.

Bibliography M. Foloci-Pulignani, "L'Odeporico dell'abbate Don Giuseppe di Costanzo," *Archivio storico per le Marche e per l'Umbria* 2 (1885):682–683; P. Toesca, "Un frammento dell'antica porta di San Paolo fuori le mura ed un cimelio farfense ora smarito," *L'arte* 7 (1904):509–510; T. Preston, *The Bronze Doors*

of Monte Cassino and San Paolo fuori le Mura (Princeton, 1915), p. 11n22; A. Schuchárt, "Eine unbekannte Elfenbeinkassette aus dem 11. Jahrhundert," *Römische Quartalschrift* 40 (1932): 1–11; idem, "Zur Elfenbeinkassette von Farfa," *Römische Quartalschrift* 41 (1933):162–165; A. Hofmeister, "Maurus von Amalfi und die Elfenbeinkassette von Farfa aus dem 11. Jahrhundert," *Quellen und Forschungen aus italienischen Archiven und Bibliotheken* 24 (1932–33):278–283; E. Weigand, "Review of Schuchart (1932)," *Byzantinische Zeitschrift* 33 (1933):226–227; idem, "Review of Schuchart (1933) and Hofmeister," *Byzantinische Zeitschrift* 34 (1934):240–241; P. Toesca, "Un cimelio amalfitano," *Bollettino d'arte* 27 (1934):537–543; Bloch, "Monte Cassino, Byzantium, and the West," pp. 207–212; L. Mortari, *Opere d'arte in Sabina* (Rome, 1957), pp. 63–64; *Bullettino dell'Istituto centrale del restauro* 34–35 (1958):121, figs. 92-98; E. Kühnel, "Die sarazenischen Olifanthörner," *Jahrbuch der Berliner Museen* 1 (1959):47–48; Barcelona, Palacio nacional, *L'art roman*, Catalogue of the Eighth Council of Europe Exhibition (Barcelona, 1961), pp. 246–247, no. 285; Kessler, "Eleventh-Century Ivory," pp. 72–73; Bergman, "Ivory Carving in Amalfi," pp. 163–171; *Tesori d'arte sacra di Roma e dell'Lazio*, exhibition catalogue (Rome, 1976), p. 7, no. 7; D. Gaborit-Chopin, *Ivoires du moyen-âge* (Paris, 1978), pp. 121, 202, no. 179.

Commentary The general form of the casket—a rectangular body with pyramidal lid—is common in Middle Byzantine ivory carving (see the plates in Goldschmidt and Weitzmann, *Byz. Elfenbeinskulpturen*, vol. 1). Byzantine caskets, however, usually have panels affixed to a wooden core; the Farfa Casket is solid ivory, a construction more common in Islamic or Carolingian caskets (see E. Kühnel, *Die islamische*

Elfenbeinskulpturen, Berlin, 1971, pp. 63–67, nos. 80–85, pls. 82–90; Goldschmidt, *Elfenbeinskulpturen*, 1:52–53, nos. 95–96, pls. 41–45). No Byzantine casket displays a narrative cycle of Christ's life. Such cycles appear to be a strictly Western phenomenon, shown, for instance, on caskets from the Carolingian Metz school of the late ninth century (see Goldschmidt, as above).

The scenes of Christ's Infancy shown on the lid are: (1) *Annunciation*, (2) *Visitation*, (3) *Nativity*, (4) *Annunciation to the Shepherds*, (5) *Adoration of the Magi*, (6) *Presentation*, (7) *Flight into Egypt*, (8) *Baptism*. On the body of the casket are represented: (9) *Washing of the Feet*, (10) *Crucifixion*, (11) *Anastasis*, (12) *Ascension*, (13) *Pentecost*, (14) *Dormition of the Virgin*.

The style is far from homogenous, and there is little question that more than one carver worked on the casket. Toesca assigns to one artist the *Dormition, Adoration of the Magi, Presentation,* and *Flight into Egypt;* to a second the *Crucifixion, Anastasis, Ascension, Visitation, Nativity,* and *Pentecost.* A follower of this second master, Toesca says, executed the *Washing of the Feet,* while "lesser artists" carved the *Annunciation to the Shepherds* and the *Baptism.* In general I agree with Toesca's attributions, but I think that only two artists were involved: the *Annunciation to the Shepherds* appears to be by the *Dormition* Master, the *Washing of the Feet* and the *Baptism* by the *Crucifixion* Master. It is unlikely that more than two carvers worked on such a relatively small commission. For a detailed analysis of the style of the Farfa Casket, and of its historical importance, see above, Chapter 3, and Bergman, "Ivory Carving in Amalfi," pp. 167–171.

The sources for the casket's iconography are mixed but appear to be primarily Western.

This is true, for instance, of both the *Nativity* and *Ascension* scenes, which differ from mid-Byzantine iconographic traditions. The *Dormition of the Virgin*, however, does reflect a Middle Byzantine model. I am presently preparing a study of the iconography of the Farfa Casket. In the meantime see Bergman, "Ivory Carving in Amalfi," p. 167.

2. Plaque: *Crucifixion* and Genesis Scenes (Figs. 156-157)
Berlin-Dahlem, Staatliche Museen, Preussicher Kulturbesitz (inv. no. J589)
27 × 12 cm.

Condition A crack is visible in the bottom center of the plaque on the *Crucifixion* side, and signs of wear are evident in the corners. There are no holes.
Inscriptions On the *Crucifixion:* LUNA SOL (letters inverted) I [ES]Ū[S] N̄AS [A]R̄E [nus] LONGĪN[US] STEFĀ [TON] ECLESIA ANGELO (*sic*) SINAḠO[GA]. On the Genesis side: LUX TEN [EBRAE].
Provenance The museum obtained the panel from the Wallerstein Collection in 1856.
Bibliography J. Westwood, *Fictile Ivories in the South Kensington Museum* (London, 1876), pp. 54, 58–59, nos. 124, 132; H. Semper, "Ivoires au Musée nationale du Buda-Pesth," *Revue de l'Art Chrétien* 46 (1897):493; Vöge, *Elfenbeinbildwerke*, pp. 37–39, no. 65; G. Savoner, "La Bible," *Revue de l'Art Chrétien* 59 (1909):160; Volbach, *Elfenbeinbildwerke*, pp. 32–33, no. J589; Goldschmidt, *Elfenbeinskulpturen*, 4:42–43, no. 146, pl. 52; P. Toesca, *Storia dell'arte italiana: il medioevo*, vol. 2 (Turin, 1927), p. 1142n49; idem, "Cimelio," p. 542; Demus, *Mosaics*, p. 233; E. Kitzinger, *The Mosaics of Monreale* (Palermo, 1960), p. 129n87; E. B. Garrison, in *Studies in the History of Medie-*

val Painting 4 (1961):207; J. Thoby, *Le crucifix* (Paris, 1959), p. 87; Berlin, Staatliche Museen, *Bildwerke der christlichen Epochen*, exhibition catalogue, ed. P. Metz (Munich, 1960), no. 222; Kessler, "Eleventh-Century Ivory Plaque," passim.

Commentary The plaque is carved on both surfaces. On one side the *Crucifixion* shows Christ on the cross at the center flanked by Longinus on his right and Stephaton on his left. A chalice sits at Stephaton's feet. Above the arms of the cross are two angels gesturing in astonishment. The discs of the sun and moon are also shown above the cross. On the hillock at the base of the cross is the head of Adam. Beneath the *Crucifixion*, separated from it by a thin border, an angel welcomes Ecclesia at the left and another expels Synagogue at the right. On the other side of the plaque are ten scenes illustrating the first chapters of Genesis: (1) *The Creation of Light and Darkness*, (2) *Creation of the Firmament*, (3) *Creation of Plants and Trees*, (4) *Creation of the Sun and Moon*, (5) *Creation of Birds and Fish*, (6) *Creation of Adam*, (7) *Creation of Eve*, (8) *Fall of Man*, (9) *God Admonishes Adam and Eve*, (10) *Expulsion*. These scenes are surrounded by decorative borders.

Goldschmidt suggested that the Genesis side was the first to be begun. In the course of carving work was broken off after completion of the first three Creation panels but after all the frames had been generally blocked out. Surely in the original scheme, the *Creation of the Animals* and the *Labors of Adam and Eve* were intended to be included in the cycle. At a later time, the plaque was taken and used on the other side for the *Crucifixion* composition. Since the back would apparently be visible, the Genesis cycle was then completed.

The iconography of the Genesis cycle is al-

luded to throughout Chapter 1 above, because it is similar to the iconography of the Salerno ivories. The *Crucifixion* side of the plaque, according to Kessler, derives from a number of sources. For example, the presence of the chalice at Stephaton's feet is rare in south Italian art but is common in Carolingian and Ottonian Crucifixions. The figures of Ecclesia and Synagoga, by contrast, seem to relate most closely to works from provincial Eastern centers. In general, the *Crucifixion* proper is similar to others in section B of the Catalogue, particularly the Farfa Casket version.

Kessler finds the stylistic sources as varied as the sources for the iconography. Besides the connections with Lombard art (for example, the Rambona Diptych), he points to parallels between Ecclesia and the figure of a Byzantine Empress on the Byzantine casket, probably of provincial origin, now in the Palazzo Venezia in Rome (Goldschmidt and Weitzmann, *Byz. Elfenbeinskulpturen,* 1:63–64, no. 123, pl. 70). Kessler is undoubtedly correct in recognizing a distinct stylistic break in the Genesis cycle between the first three frames and the rest of the scenes. He compares the drapery style of the early scenes to that of the Veroli Casket in the Victoria and Albert Museum (ibid., pp. 30–32, no. 21, pl. 9), another tenth-century Byzantine casket. The later Genesis scenes were executed in the more simplified manner of the *Crucifixion.*

The *Crucifixion*-Genesis plaque is intimately related to the Farfa Casket, as a comparison of the two *Crucifixions* shows. Christ on the cross in the Berlin plaque is very similar to the Christ of the Farfa *Crucifixion* Master, while the figures of the angels below, especially the rendering of their drapery, are closer to the style of the *Dormition* Master.

3. Plaque: *Crucifixion* (Fig. 158)
New York, The Metropolitan Museum of Art (inv. no. 17.190.37)
12.9 × 8.7 cm.

Condition There is some damage to the left border and a severe crack in the bottom right corner. The panel shows signs of wear, and the upper part of the figure of John the Evangelist is damaged. There are two large holes in both top and bottom borders. The panel has a very light brownish patina on the front and a rather darker brown patina on the rear.

Provenance Goldschmidt notes that in 1899 the plaque was in the hands of a dealer in Munich. By 1914 it was in the collection of J. P. Morgan, in whose bequest it came to the Metropolitan Museum in 1917.

Bibliography Goldschmidt, *Elfenbeinskulpturen,* 4:42, no. 144, pl. 51; J. Breck, *The Metropolitan Museum of Art: The Morgan Wing* (New York, 1929), p. 49; Toesca, "Cimelio," p. 542; Kessler, "Eleventh-Century Ivory Plaque," p. 70; Bergman, "Ivory Carving in Amalfi," pp. 169–170.

Commentary Christ appears on the cross in the center of the panel. To his right stands the Virgin, raising both veiled hands toward her son; on his other side stands John the Evangelist with his right hand raised toward Christ and his left holding a book. Above the arms of the cross are two half-length angels who face toward the center and raise their hands in astonishment.

The basic composition is like that of countless Middle Byzantine ivories (for example, see Goldschmidt and Weitzmann, *Byz. Elfenbeinskulpturen,* 2:nos. 158–165, pls. 55–56), and the specific gestures of the Virgin and St. John may also be found in Byzantine ivory plaques (ibid., nos. 42, 72, pls. 18, 28). The figure of

Christ is very close to those found on the Farfa Casket and the Berlin *Crucifixion*-Genesis plaque (Cat. nos. B1 and B2), while the figures of the Virgin and St. John find their counterparts in the *Crucifixion* plaque in Berlin (Cat. no. B17).

The style of this plaque is so close to that of the *Crucifixion* Master of the Farfa Casket that one is tempted to suggest that the same hand is at work.

That the panel originally formed the center of a triptych is clear from the holes in its top and bottom borders. Such holes served as fastening points for decorative ledges, and these in turn provided support for the dowels used to attach the wings. The remains of such a ledge may still be seen in Cat. no. B21 and in numerous Byzantine triptychs (for example, ibid., nos. 155–156, pl. 54). These examples also indicate that the *Crucifixion* was particularly popular as a central composition for Byzantine triptychs of the tenth and eleventh centuries.

4. Plaque: *Saints Philip and Jacob* (Fig. 159)
New York, Rabenou Collection
5 × 8.7 cm.

Condition The left and top sides are intact and preserve their original limits; the right and bottom sides have obviously been cut. Otherwise, the fragment is in excellent condition except for a small repair to the left of Philip's head.

Inscriptions Left: S̄ P̄H̄I[LIPPUS]; right: S̄ ĪĀ[COBUS].

Provenance The Rabenou family has owned the piece since about 1950. Its whereabouts before then are unknown.

Bibliography Unpublished.

Commentary The saints appear beneath arches supported by spirally fluted columns and with birds in their spandrels. The figures are preserved from their heads down to a point slightly above their waists. The saints are very similar: both have nimbi, beards, and short hair, carry a scroll in the left hand, and gesture with the right. Each has an indentation in the center of his forehead.

The decorative border of stylized palmettes running along the top edge of the piece indicates that originally the top was exposed to view. This is an important clue to the type of object the fragment decorated. Even more important is the existence of an identation on the panel's rear side, slightly below the top and running the entire width of the plaque. This identation, about a quarter-inch across, clearly would have continued on the remainder of the piece now broken off. From the condition of the inner surfaces of this ridge, it is evident that some wear has occurred as a result of continued contact with another surface. Its function is obvious. The fragment originally formed part of the decoration of the side of a casket with a sliding top; the indentation is the place where the sliding top would ride. Many Byzantine caskets had such sliding tops and ridged sides (see, for example, Goldschmidt and Weitzmann, *Byz. Elfenbeinskulpturen*, 1:nos. 28, 68, pls. 14, 49). Most of the Byzantine examples have panels set onto a wooden core; the casket to which this fragment belonged was solid ivory, so that the lid would have ridden directly on the rear of an ivory piece rather than on a wooden core.

Probably the decoration of the casket included figures of the rest of the Apostles. It may well have had four figures on the long sides and two on each of the short sides, as does the Byzantine casket with busts of the Apostles now in the Metropolitan Museum of Art (Gold-

schmidt and Weitzmann, *Byz. Elfenbeinskulp-turen*, 1:no. 100, pl. 60). No examples of Byzantine caskets with full-length figures of the Apostles are extant, but that such figures decorated this casket is proven by the existence of the related piece, Cat. no. B5. An interesting parallel to this casket is provided by a silver one preserved in the Treasury of the Cathedral at Cividale, a Lombard work of the ninth or tenth century (G. Fogolari, *Cividale del Friuli*, Bergamo, 1906, fig. opp. p. 52). On the sides of this casket appear full-length figures of the Apostles, along with Christ and the Virgin, all beneath arches. Perhaps the design of such a casket influenced the format of the casket to which the fragment was attached.

A number of factors indicate that this piece originated in the same circle and at the same time as Cat. nos. B1, B2, and B3. The best comparisons are with the *Dormition* of the Farfa Casket. There the same drapery types appear, characterized by an excessive use of small parallel lines to decorate the surface, as well as the same strange formula for rendering the eye with the socket placed at a slight diagonal, the eyeball protruding, and a small deep hole punched for the iris. The hair and beard types are also paralleled, as is the trapezoidal neck on the garment of St. Philip. Elsewhere on the Farfa Casket similar conventions are used for the halos (*Pentecost*), capitals (any of the scenes on the lid), and for the eyes of the birds punched with concentric circles (the lambs in the *Annunciation to the Shepherds*).

This piece and Cat. no. B5 obviously come from the same object.

5. Plaque: *Two Saints* (fragment) (Fig. 160)
 Formerly in New York, Demotte Collection, present location unknown
 3 × 5 cm. (approx.)

Condition The piece has been cut at the top and both sides, but the bottom border seems intact. There is a hole between the feet of the saint on the left.

Provenance All that is known about the plaque is that in the 1930s (according to Goldschmidt's notes) it was in the Demotte Collection.

Bibliography Unpublished.

Commentary Two saints are preserved from slightly above the waist downwards; the right side of the saint at the right has been cut off. The figures are separated by a spirally fluted column on a base. The figure on the left carries a book in his left hand and holds his right hand close to his body just above his waist.

For general stylistic considerations, cf. Cat. no. B4. The drapery motifs in this piece are strikingly similar to those in the Apostles in the Farfa Casket *Dormition* and in the angels below the *Crucifixion* in Cat. no. B2.

This fragment must have formed part of the same casket as Cat. no. B4. This casket must have been destroyed rather soon after it was made because on the reverse of the fragment there is carving of apparently twelfth-century date, executed after the saints were broken in half. This new carving formed part of a larger *Crucifixion* composition.

6. Plaque: *Annunciation* (Fig. 161)
 Formerly in Mannheim, Engelhorn Collection, present location unknown
 16.2 × 14.2 cm.

Condition The bottom border is almost entirely cut off, and there are small cracks in the top border. There is one hole at the top center, below the border. From the photograph it would appear that the panel has a brownish patina.

Provenance In 1927 the plaque was in a private collection in Switzerland. According to Goldschmidt's notes, it was in the possession of Mrs. Marie Engelhorn in 1935.

Bibliography Toesca, *Storia*, p. 1097, fig. 787; idem, "Cimelio," p. 541.

Commentary The archangel Gabriel stands at the left facing toward the right, his right hand extended, his left holding a long staff. At the right, the Virgin holds a spindle in her upraised left hand and the yarn in her right. She stands before a structure that appears to be a confused combination of a throne and a stylized colonnette. Above rise two domical buildings flanking a central structure with a gable reminiscent of the architecture found in the Grado Chair group. At the Virgin's feet sits a woman who looks up at the angel and, like the Virgin, works the spindle.

As noted above, the *Annunciation* surely would have been included among the Salerno ivories. The existence of this plaque in a group of ivories strongly influenced by the Salerno panels supports this view. Furthermore, the present plaque probably reflects the iconography of the lost Salerno version in important respects. The unusual locks of hair that hang down to Gabriel's shoulders in this plaque appear in several of the Salerno panels, and were, as noted earlier, derived from the Grado Chair ivories. The maidservant seated between the Virgin and Gabriel is an iconographical detail derived from an apocryphal text. Such apocryphal details, as noted in Chapter 2, are abundant in the Salerno ivories' Infancy cycle.

On stylistic grounds (and because of similarities in measurements) this plaque belongs with the ten panels that follow (Cat. nos. B7-B17). Goldschmidt brought these plaques together in his corpus, except for Cat. nos. B6, B12, and B14, which were not known to him at the time. Probably these panels are by a number of different hands: the *Annunciation* seems to be closest in style to Cat. nos. B7, B9, and B10.

7. Plaque: *Visitation* (Fig. 162)
Leningrad, Hermitage (inv. no. 104)
16.5 × 10.7 cm.

Condition The plaque has been mounted in modern times on the cover of a tenth-century Franco-Saxon manuscript. There is a hole in the center of the top border. There is a brownish patina on the piece.

Provenance The plaque was formerly in the Basilewsky Collction in Leningrad (no. 41).

Bibliography *Collection Basilewsky: catalogue raisonné* (Paris, 1874), p. 52, no. 41; Goldschmidt, *Elfenbeinskulpturen*, 4:40, no. 129, pl. 49; Leningrad, Hermitage, *Reznaia Kost* (Leningrad, 1925), pp. 27–28, no. 27, pl. 3; Leningrad, Hermitage, *Les arts appliqués de l'Europe occidentale XIIᵉ-XVIIIᵉ siècles* (Leningrad, 1974), p. 71, no. 3, pl. 3.

Commentary The Virgin and Elizabeth embrace at the center of the panel. On either side of them, and executed on a smaller scale, are two maidservants who push back hanging drapes and peer into the scene. The drapes hang from two little domical buildings with windows. Above the domes, on either side of and level with the women's heads, are two small arcades, each supporting two more small domes. Above them, an architrave runs across the width of the plaque, rising in a horseshoe arch at the center. This central arch encloses a rosette; on either side are domical structures whose base is formed by the architrave. The architecture is like that the Salerno carvers derived from their Grado Chair models.

The composition is similar to the Salerno ivory version (Fig. 20), save that the maidser-

vant has been given a companion in order to make the scene symmetrical. The symmetrically disposed maidservants are found numerous times in various religious and secular contexts. They appear time and again on chesspieces perhaps made in the same workshop as the plaque (see, for example, Goldschmidt, *Elfenbeinskulpturen*, 4:nos. 161–165). The draperies on the two women are much simpler than the elaborate types in the Salerno ivory version, and the figures are more static. The cluttered, almost haphazard disposition of the interior furniture in the Salerno plaque has given way to a rigidly symmetrical arrangement that develops vertically in three steps from the lesser to the more monumental.

The plaque is closest in style to Cat. nos. B6, B8, and B10.

8. Plaque: *Joseph's Dream* (Fig. 163)
Rouen, Musée des antiquités (inv. no. 721)
15.5 × 11.8 cm.

Condition There are a number of breaks in the top border and a little chip in the right side of the lower border. There is a hole in the top center below the border.

Provenance The plaque was acquired by the museum in 1852 from the Paris dealer Delange. It was exhibited at the Universal Expositions in Paris in 1878 and 1900.

Bibliography Westwood, *Fictile Ivories*, p. 418; M. Marcou, "Exposition retrospective de l'art français," *Gazette des Beaux Arts*, 1900, p. 484; W. Lethaby, in *Proceedings of the Society of Antiquaries of London* 2nd ser. 22 (1907–08):236; M. Longhurst, *Victoria and Albert Museum, Catalogue of Carvings in Ivory* (London, 1927), p. 92; Volbach, *Elfenbeinbildwerke*, p.

31; Goldschmidt, *Elfenbeinskulpturen*, 4:40, no. 132, pl. 49.

Commentary In the foreground, on a bed extending the width of the panel, Joseph lies asleep, his head resting in his left hand. Above him and to the left of the bed is an angel who looks down toward Joseph, gesturing with his right hand and holding a staff in his left. To the right of the angel a pedestallike structure composed of four columns supports an arch topped by a ball. This device seems to be perched atop a wall segment that rises from behind the pillow on the bed.

The composition is basically derived from *Joseph's First Dream* in the Salerno ivories (Fig. 21); the figures of Joseph and the angel compare well with their counterparts there. From the Salerno scene of *Joseph's Second Dream* (Fig. 22) the carver took the staff held by the angel and the basic form of the architectural background. The Rouen plaque is more schematic than the Salerno ivory version of the scene; the rigid folds of the bed cover are more abstract than the folds in the Salerno piece.

The artist who executed this plaque appears not to have carved any of the other extant panels in this group.

9. Plaque: *Journey to Bethlehem* (Fig. 164)
Cleveland, Cleveland Museum of Art
16.5 × 11.4 cm.

Condition There are breaks in the left and bottom borders and a chip in the right border. The lower right-hand corner of the panel is broken away. Two holes appear in the center of the top border.

Provenance From at least 1871 to 1928 the plaque was in the possession of the Fürstlich Hohenzollernsches Museum in Sigmaringen. The museum sold the piece in 1928

through a Frankfurt dealer, from whom it was obtained by Baron Robert von Hirsch. It was sold at Sotheby Park-Bernet, London, on June 22, 1978, to the present owner.

Bibliography F. A. Lehner, *Fürstlich Hohenzollern'sches Museum zu Sigmaringen: Verzeichnissen der Schutzwerke* (Sigmaringen, 1871), p. 82, no. 314; H. Sprinz and O. Lossen, *Die Bildwerke der Fürstlich Hohenzollernschen Sammlung Sigmaringen* (Stuttgart, 1925), no. 1; Longhurst, *Catalogue*, p. 92; Goldschmidt, *Elfenbeinskulpturen*, 4:40, no. 130, pl. 49; Toesca, *Storia* 2:1097 (the plaque is illustrated in fig. 788 but wrongly labeled Bologna, Museo Civico); *Verzeichnis der Verseigerung der Sigmaringer Sammlungen* (Frankfort, 1928), no. 258; H. Swarzenski, "Two Oliphants in the Museum," *Bulletin of the Boston Museum of Fine Arts* 60 (1962):44; H. Fillitz, *Zwei Elfenbeinskulpturen aus Süditalien* (Bern, 1967), p. 14; Sotheby Park-Bernet (London), *The Robert von Hirsch Collection*, vol. 2 (sale catalogue: June 22, 1978), no. 277, pp. 104–105 (color plate); W. Wixom, "Eleven Additions to the Medieval Collection," *Bulletin of the Cleveland Museum of Art* 66 (1979):87–89.

Commentary In the foreground the Virgin is shown seated on the ass, balancing herself by placing her left hand on the beast's neck. At the left, behind the animal, is Joseph, one hand on the ass's hind quarters, the other holding a short staff. In front of the ass stands Joseph's son, looking back toward the Virgin. He holds the animal's reins in his left hand, and in his right he carries a short staff from which hangs a water container. In the background is an elaborate architectural setting comprised of a series of four coupled columns supporting two horseshoe arches containing rosettes. Between the arches appear parts of a flat architrave, and from these rise three stylized buildings, the one in the center domical and those at the sides gabled, all related to types in the Salerno panels and the Grado Chair group.

The elements of the composition are clearly drawn from two of the Salerno panels: the *Journey to Bethlehem* (Fig. 22) and the *Flight into Egypt* (Fig. 23). From the former comes the figure of Joseph's son with the water jug held on his staff and the type of heavy-set, sleepy animal. The figures of the Virgin, with her hand on the ass's neck, and Joseph, with one hand on the animal's rump and a staff in the other come from the *Flight into Egypt*. The architrave with its horseshoe arches and rosettes is similar to that in the *Visitation* (Cat. no. B7), as is the decoration on the dome in the center.

The plaque is similar to Cat. nos. B6, B7, and B10.

10. Plaque: *Joseph's Dream* (Fig. 165)
London, Victoria and Albert Museum
(inv. no. 701-1884)
16.5 × 12 cm.

Condition The panel has some severe damage, mainly from a crack that extends from the center of the top border to the middle of the plaque. In addition, there is a great deal of wear at the bottom and some wear on both of the side borders. There was probably a hole at the top center just under the border, where now the widest part of the crack appears. There is also an indentation in the upper part of the right border that has resulted from the use of another mounting system. The panel has a brownish patina.

Provenance The plaque was obtained by the museum from the Castellani Collection in 1884.

Bibliography Westwood, *Fictile Ivories*, p. 364; H. Graeven, *Frühchristliche und mittel-*

alterliche Elfenbeinbildwerke in photographischen Nachbildung, vol. 1 (Rome, 1898), no. 57; Lethaby, in *Proceedings*, p. 236: Goldschmidt, *Elfenbeinskulpturen*, 4:41, no. 134, pl. 49; Longhurst, *Catalogue*, p. 92; Toesca, *Storia*, 2:909n76; Carucci, *Avori*, p. 159.

Commentary Joseph lies asleep on a bed in the foreground, his head resting on his left hand. Behind the bed to the left is an angel holding a staff in his left hand and gesturing with his right. In the background on the right is a domed building behind a crenellated wall enclosure penetrated by two windows.

The angel is very similar to the one in the Rouen plaque, Cat. no. B8, but Joseph, instead of facing up as in that plaque, here lies with his face to the side and his eyes closed. The sleeping figure also lies on his side in *Joseph's Second Dream* in the Salerno series (Fig. 22). The architecture in the background is very much like that in the *Nakedness of Noah* in the Salerno ivories (Fig. 12).

Goldschmidt identified this scene as the *Second Dream*, probably because the main figure is similar to the Joseph in that episode in the Salerno cycle.

11. Plaque: *Flight into Egypt* (Fig. 166)
Bologna, Museo Civico
16.4 × 11.5 cm.

Condition There is a crack at the bottom left of the panel and some damage to the top and bottom borders. One hole appears in the top center.

Provenance Unknown.

Bibliography Westwood, *Fictile Ivories*, p. 364; Graeven, *Elfenbeinbildwerke* 1, no. 5; Goldschmidt, *Elfenbeinskulpturen*, 4:41. no. 133, pl. 49; Toesca, *Storia*, 2:1095–1096; Ravenna, Archepiscopal Museum, *Avori dell'alto*

medioevo, exhibition catalogue, ed. G. Bovini and L. Ottolenghi (Ravenna, 1956), p. 115, no. 117; Bologna, Museo Civico, *Lavori in osso e avorio*, exhibition catalogue (Bologna, 1959), p. 41, no. 92; Barcelona Catalogue, pp. 249–250, no. 391; Bergman, "Ivory Carving in Amalfi," p. 183.

Commentary The Virgin sits astride the ass at the center of the composition, the Christ child on her lap. Joseph follows behind with one hand on the animal's rump and the other grasping a short staff. Joseph's son leads the group. He holds a short staff over his right shoulder and turns to look at the others. Above him is a half-length female figure wearing a crown who personifies Egypt. A cornucopia slung over her shoulder, she leans down to offer the contents of a dish to the Virgin and child. All the figures are enclosed by a semicircular element that extends the width of the panel. Within the semicircle, behind the figure of Joseph, is a door with a gable. Above, and presumably behind, the semicircle, decorated tympana supported by pairs of columns appear to the left and right. Between these two structures, at the center of the panel, is a baldachin supported on columns.

The figure of Joseph and the personification of Egypt who offers the paten are derived from the Salerno version of the *Flight* (Fig. 23), and the son of Joseph at the front is similar to the corresponding figure in the *Journey to Bethlehem* plaques in the Salerno ivories Fig. 22) and in the Cleveland Museum (Cat. no. B9, Fig. 164). in the Salerno *Flight* scene an angel, not a boy, leads the group, and the Virgin has one hand on the animal's neck, while here the Virgin holds the child with both hands. The pearl-studded fittings with which the beast is provided on both chest and hindquarters in the Salerno scene appear only in the rear here. Unlike the haphazardly arranged architectural and

floral elements of the Salerno *Flight,* the architectural motifs here, except for the door behind Joseph, are symmetrically disposed. The baldachin at the center appears directly over the Virgin's head, emphasizing her centrality.

The presence of the son, rather than an angel in this scene is common in Byzantine and Italian art, as, for example, in the eleventh-century Byzantine psalter, British Library, cod. add. 19.352 (S. der Nersessian, *L'illustration des psautiers grecs du moyen age, 2 (Londres, Add. 19.352),* Paris, 1970, fig. 200); in the mostly destroyed fresco of the eighth century in Santa Maria Antiqua (W. de Grüneisen, *Sainte Marie Antique,* Rome, 1911, p. 300 and fig. 102); and on the plaque the Farfa Casket (Cat. no. B1).

The style of the plaque is closest to that of Cat. nos. B12 and B14-17.

12. Plaque: *Adoration of the Magi* (Fig. 167)
Frederikssund, Denmark, J. F. Willumsens Museum
16.5 × 14.2 cm.

Condition Except for breaks in the top border the panel is in nearly perfect condition. There is one hole in the top center beneath the border (cropped in the photograph in Fig. 167).
Provenance Unknown.
Bibliography E. V. Philippowich, *Elfenbein* (Braunschweig, 1961), p. 54.

Commentary At the right sits the Virgin on a throne with a high, rounded back. The child sits on her lap facing to our left. He holds a scroll in his left hand and with his right gestures toward the three figures of the Magi approaching from the left. The first two of the Magi are bearded; the third is clean-shaven. All offer gifts in veiled hands and wear tunics, leggings, and high boots.

The relationship to the Salerno ivories' version (Fig. 21) is striking. The facial types of the Magi and their elaborate dress of tunic, chlamys, and tiara, leggings and high boots are clearly derived from the Salerno scene. The guiding angel and the figure of Joseph seen in the Salerno ivory *Adoration* have been omitted. The Virgin and child in the Willumsens panel differ from the Salerno ivory types: here the Virgin sits frontally and the child turns in her lap; in the Salerno ivory both mother and son face to the left. The throne in the Salerno *Adoration* seems to have been rejected by the carver of this plaque and replaced by the simpler type found in the Salerno ivory *Massacre of the Innocents* (Fig. 24).

The panel is closest in style to Cat. nos. B11 and B14-17.

13. Plaque: *Presentation* (Fig. 168)
London, Victoria and Albert Museum (inv. no. 238-1867)
16.5 × 10.5 cm.

Condition The top border is seriously chipped. The piece is very white in color.
Provenance The museum obtained the panel in 1867 from the Webb Collection in London.
Bibliography W. Maskell, *Ivories Ancient and Medieval in the South Kensington Museum* (London, 1872), p. 92; Westwood, *Fictile Ivories,* p. 59, no. 133; Bertaux, *Italie méridionale,* p. 437; Longhurst, *Catalogue,* p. 93; Goldschmidt, *Elfenbeinskulpturen,* 4:40, no. 131, pl. 49.

Commentary At the extreme right stands the prophetess Anna, her right hand raised as she looks upward. At the left stands Joseph, holding two birds in his veiled hands. In the left center stands the Virgin. The Christ child ap-

pears to be held partially by her and partially by the veiled hands of Simeon, who stands at the right.

The four figures are close to their counterparts in the Salerno series (Fig. 25) except that there all the figures have halos and Joseph's hands are not veiled. In the London plaque the child is almost in the arms of the priest, but this should not be interpreted as a difference in iconography: it is merely the result of moving the figures of the Virgin and Simeon closer to each other in the narrower compositional field. In fact, the postures and relative positions of these three figures are virtually identical to those in the Salerno ivory. The simple, nondetailed architecture in the background—a central pillar from which canopies spring—has no counterpart in the Salerno group.

This plaque is cruder in style and simpler in conception than the rest of the ivories in this group. I am inclined to attribute it to an artist less gifted than the carvers of the other plaques, but it is also possible that this plaque was never finished.

14. Plaque: *Baptism* (Fig. 169)
Lugano, Collection Thyssen-Bornemisza
16 × 13.4 cm.

Condition There are some small breaks in the top and bottom borders. A large hole appears in the top center beneath the border.

Provenance In the 1950s the plaque was in the possession of Thomas Fischer, a Lucerne dealer. From there it came to the Kofler Collection in Lucerne. It was sold to the present owner in about 1970.

Bibliography J. Baum, "Avori sconosciuti in Svizzera," in *Arte del primo millenio,* ed. E. Arslan (Vislongo, 1953), pp. 139–140; Ravenna Catalogue, pp. 112–113, no. 114; Cologne, Schnütgen Museum, *Grosse Kunst des Mittelalters aus Privatbesitz,* exhibition catalogue (Cologne, 1960), no. 10; H. Schnitzler, W. Volbach, and P. Bloch, *Skulpturen Sammlung E. und M. Kofler-Truniger, Luzern* (Lucerne, 1964), no. 15; P. Lasko, "A Notable Private Collection," *Apollo* 79 (1964):464–473, esp. fig. 6; Zurich, Kunsthaus, *Sammlung E. und M. Kofler-Truniger, Luzern,* exhibition catalogue (Zurich, 1964), pp. 71–72, no. 678; Carucci, *Avori,* p. 195.

Commentary John the Baptist is at the left, and behind him are Peter and Andrew. John steps upward, raising his left hand and looking up to the arc of heaven above. A hand of God and a dove carrying a wreath or crown in its beak issue from the arc. John's right hand extends to touch the head of Christ, who, shorthaired and unbearded, stands in the center of the scene. He is visible only from the shoulders upward; the rest of his body is obscured by horizontal wavy segments representing the river. To the right of the river are two angels holding Christ's garments. Their hands are veiled and they stand behind a parapet decorated with a diamond pattern.

The carver clearly took from the Salerno ivories' *Baptism* the unusual element of the crown or wreath held by the dove (see above, Chapter 2), but in many ways he diverged from the earlier version: Christ is beardless in this plaque, he is covered by water to his shoulders, and the cross is omitted. The beardless Christ is common in early Christian examples of the scene (for example, the ivory in W. F. Volbach, *Elfenbeinarbeiten der Spätantike und des frühen Mittelalters,* 3rd ed., Mainz, 1975, p. 70, no. 141), and he is often shown without a nimbus, as in this ivory. The motif of the water covering Christ was employed in the mid-Byzan-

tine psalters (see J. Strzygowski, *Ikonographie der Taufe Christi*, Munich, 1885, pl. 7: nos. 1, 2, and 6); but closer still to the ivory's rendering of the water are the versions of the motif on the late twelfth-century bronze doors at Pisa and Monreale (see A. Boeckler, *Die Bronzetüren des Bonanus von Pisa und des Barisanus of Trani*, Berlin, 1953, pls. 13 and 26). Peter and Andrew, who appear in the rear of the Lugano plaque, are omitted in the Salerno panel. These figures appear in the *Baptism* on the Monreale door, probably as the result of Byzantine influence. They may be found in numerous Byzantine examples, such as the Menologium of Basil II (Strzygowski, *Taufe Christi*, pl. 2, no. 11). That they were included in the scene also in pre-Iconoclastic times is proven by their appearance on the painted wooden cover of a sixth- or seventh-century reliquary box from the Sancta Sanctorum treasure that has been attributed to a Palestinian source (see C. R. Morey, "The Painted Panel from the Sancta Sanctorum," *Festschrift Paul Clemen*, Bonn, 1926, passim). Regardless of the precise source of these motifs found in the Lugano ivory, it is evident that the carver was combining elements derived from the *Baptism* in the Salerno series with elements derived from other sources.

The panel is closest in style to Cat. nos. B11, B12, and B15-B17.

15. Plaque: *Healing of the Dropsical, Blind, and Lame* (Fig. 170)
Boston, Museum of Fine Arts (inv. no. 49.258)
15.7 × 11 cm.

Condition The plaque has evidently been cut at the left and right so that neither lateral border remains. There is damage in three of the corners and the lower border is severely

chipped. A hole appears in the center at the base of the upper border. The plaque has a brownish patina.

Provenance In 1886 the piece was in the collection of Charles Stein, Paris, and in 1900 it was in the Paris Exposition Universelle. By 1926 its location was unknown. The Boston Museum acquired the plaque from the Brummer Collection in New York in 1949.

Bibliography Goldschmidt, *Elfenbeinskulpturen*, 4:41, no. 135, pl. 49; *Boston Museum of Fine Arts Bulletin* 55 (1957):96.

Commentary Christ, followed by two Disciples, stands at the left, gesturing toward a group of men at the right. The first man, dressed only in a loincloth, holds his right hand out to Christ; with his left he grasps the loincloth at his waist. His stomach is distended. Behind him is a man in a short tunic and behind this man appears a third one who gestures with his right hand while with his left he holds a crutch cradling his maimed and bent right knee. Two other figures—only their heads are visible—appear behind these three men.

This scene is fundamentally derived from the corresponding representation in the Salerno series (Fig. 28). There, too, Christ, although carrying a staff instead of the scroll seen here, appears with two figures behind him; the three figures at the right are almost identical. In the Salerno ivory the figure in the center of these three has his hand on the shoulder of the man in front of him, identifying his affliction as blindness. In the Boston ivory this gesture is omitted. Identical in both places are the gesture of the dropsical man (whose stomach is more distinctly enlarged in the Salerno scene), and the type and application of the crutch used by the lame man. The Boston plaque adds two figures behind this group of the afflicted, perhaps to balance Christ's followers. The background ar-

chitecture of the Salerno version is missing here.

The style is closest to that of Cat. nos. B11, B12, B14, and B17.

16. Plaque: *Arrest of Christ* (fragment) (Fig. 171)
Berlin-Dahlem, Staatliche Museen, Preussicher Kulturbesitz (inv. no. J587)
8 × 11.6 cm.

Condition The bottom half of the plaque has been cut away entirely and there are some breaks in the top border. The piece is also rubbed in places.

Provenance The museum acquired the panel in 1886 from the Trotti-Trivulzi Collection in Milan.

Bibliography *Archivio storico dell'arte* 1 (1888):233; Bertaux, *Italie méridionale*, p. 437; Vöge, *Elfenbeinbildwerke*, p. 40, no. 68; Volbach, *Elfenbeinbildwerke*, p. 32, no. J587; Goldschmidt, *Elfenbeinskulpturen*, 4:41, no. 136, pl. 49; Toesca, *Storia*, 2:1142n39; Essen, Villa Hügel, *Europäische Bildwerke des Spätantike bis zum Rokoko*, exhibition catalogue, ed. P. Metz (Munich, 1957), p. 25, no. 73; *Bildwerke der christlichen Epochen*, p. 56, no. 220.

Commentary Christ stands at the center. He looks down toward the lower left corner of the plaque, where Peter is cutting off Malchus' ear (only the top of Peter's head and body is preserved). One soldier, accompanied by two others, grabs Christ's arm and pulls him off to the right. A second group of seven soldiers appears behind Christ, one of whom pushes Christ forward. The shafts of the soldiers' spears rise in the background.

This scene is now missing in the Salerno series, but the existence of this fragment in the closely related group of ivories strongly suggests that the scene was originally incorporated into the Salerno cycle.

The iconography here is highly unusual in one respect: Judas is omitted from the scene. As a rule, the action of Judas betraying Christ with his kiss is conflated with the scene of the arrest, conveyance to Caiaphas, and the episode of Peter and Malchus. In this plaque, however, the *Betrayal* proper is not represented; only the ensuing conveyance of Christ to Caiaphus and the Peter episode are depicted. This may be because the illustration was derived from the text of St. John rather than the Synoptic Gospels. In John 18:1–11 no mention is made of the kiss of Judas; only the arrest itself is described. The specific sources of the iconography remain largely obscure. The figures who pull Christ at the front and push him from the rear also appear in the Monreale mosaic of the scene (Demus, *Mosaics*, fig. 70). But I can find no parallel for the scene lacking the Judas figure, and the episode of Peter and Malchus is too common to be helpful in determining specific iconographical sources.

The panel is closest in style to Cat. nos. B11, B12, B14, B15, and B17. It is possible that the carving was not completed.

17. Plaque: *Crucifixion* (Fig. 172)
Berlin-Dahlem, Staatliche Museen, Preussischer Kulturbesitz (inv. no. J588)
16 × 12.9 cm.

Condition The bottom border is mostly broken off and there is one hole in the center of the top border. The plaque has a brownish patina.

Provenance The museum acquired the panel in 1887 from the collection of Professor aus'm Weerth.

Bibliography Archivio storico dell'arte 1 (1888):233; Vöge, *Elfenbeinbildwerke,* p. 40, no. 67; Volbach, *Elfenbeinbildwerke,* p. 32, no. J588; Bertaux, *Italie méridionale,* p. 437; Goldschmidt, *Elfenbeinskulpturen,* 4:41, no. 137, pl. 49; Toesca, *Storia,* 2:1142n39; *Europäische Bildwerke,* p. 25, no. 74; *Bildwerke der christlichen Epochen,* p. 56, no. 221.

Commentary The crucified Christ, with a cross-nimbus, appears at the center, but the cross has been omitted. Above, two angels gesture vigorously in astonishment. Below, the Virgin and Longinus (with the spear) stand to the left and John the Evangelist and Stephaton (with the sponge) stand to the right. Longinus and Stephaton stand on platforms that are raised to the height of Christ's *suppedaneum.*

The composition differs greatly from the one at Salerno (Fig. 31), but one detail indicates that the Salerno version was known to the carver: in both scenes a piece of Christ's loincloth to the left of center is pulled up and through a looped portion under the belt, and a piece of the cloth at the right is drawn up underneath the belt so that it hangs down over the belt on the top of the thigh. This is a very rare motif, found only in the south Italian group (see Cat. nos. B18 and B20). The motif retains an organic quality only in the Salerno panel; in the derivatives it becomes stiff and unnatural. The placement of Longinus and Stephaton on platforms is a feature of other south Italian examples, and this motif, too, seems to be peculiar to the region. The two figures themselves often appear in mid-Byzantine ivories, but never on platforms; one finds them in the tenth-century triptych in Berlin (Goldschmidt and Weitzmann, *Byz. Elfenbeinskulpturen,* 2:no. 72, pl. 28), where the positions and gestures of the Virgin and St. John are also perfectly paralleled. These two figures are also close to their

counterparts in the earlier Amalfitan *Crucifixion,* Cat. no. B3. The angels above the cross, although an element common in Byzantine Crucifixions, are closest in style to those on the related panels, Cat. nos. B2, B3, B18, and B20. The decoration of the *suppedaneum* is identical to that in Cat. no. B3.

The plaque is closest in style to Cat. nos. B11, B12, and B14-16. It is possible that the carving was not completed.

18. Plaque: *Crucifixion* and *The Marys at the Tomb* (Fig. 173)
Paris, Louvre
32.5 × 12 cm.

Condition There is a crack in the upper right section and the lower right corner is broken. The lateral borders are completely gone. There are two holes in the top border and two on the lower border. The plaque has a brownish patina.

Provenance The piece was acquired from the Spitzer Collection when it was sold in 1893, and was given to the Louvre in 1906 by Mr. F. Doistau.

Bibliography Catalogue of the Spitzer Collection (Paris, 1890), p. 35, no. 16; *La collection Spitzer,* sales catalogue (Paris, 1893), no. 51; M. Molinier, *Histoire générale des arts appliqués à l'industrie,* vol. 1 (Paris, 1896), p. 140; Bertaux, *Italie méridionale,* pp. 436–437; Toesca, *Storia* 2:1142n39; Goldschmidt, *Elfenbeinskulpturen,* 4:42, no. 142, pl. 51; Thoby, *Le crucifix,* pp. 87–88.

Commentary The upper two-thirds of the plaque is taken up with a *Crucifixion* similar to that in Cat. no. B17. Here, however, the cross is shown on a base decorated with stylized floral patterns. The Virgin gestures toward her son with only one hand, instead of both, and Stephaton holds a bowl rather than a sponge. Oth-

erwise, the elements of the composition are the same in both examples. Beneath the *Crucifixion* runs a narrow border decorated with a stylized bead and reel motif. Below the border is depicted *The Marys at the Tomb*. The two women appear at the right, swinging censers and holding pyxides. In the center a domical tomb rises over an open sarcophagus, and at the left sits an angel-guardian holding a staff in his left hand and gesturing toward the women with his right.

The plaque is, for the most part, based on the corresponding scenes in the Salerno group (Fig. 31). Its general layout, with the large *Crucifixion* at the top and the smaller scene at the bottom, is like the layout of the *Crucifixion* panel in the Salerno ivories, where the *Entombment* and the *Soldiers Gambling* appear at the bottom. Very similar in both examples are the type of loincloth, the posture of the Virgin, and the rendition of Christ—with the slightly sagging arms, head turned to his right, and hair falling in locks on his shoulders. There are, however, two major differences. In the Paris plaque, Longinus and Stephaton are added to the scene; and the Evangelist, as in Cat. nos. B3, B17, and B20, raises his right arm toward Christ while holding a book in his left, whereas in the Salerno panel, John's left hand is empty and his right is held to his face. The carver of the Paris plaque clearly reverted to another model for the Evangelist, probably one ultimately derived from a mid-Byzantine source.

Except for a change in the gesture and posture of the angel, the architectural details of the tomb, and the omission of the sleeping soldiers, the iconography of *The Marys at the Tomb* is very close to that in the Salerno version (Fig. 32). One detail of the architecture, however, does not appear in the Salerno ivory: the intersecting semicircular arches below the cupola on the tomb. This feature is characteristic of twelfth-century architecture in southern Italy, including Amalfi. For example, the exteriors of the apses of Sant'Eustachio in Pontone, just above Amalfi, are decorated with very similar intersecting arches (A. Schiavo, *Monumenti della costa di Amalfi*, Rome, 1941, pp. 141–147, figs. 151-154). The absence of this detail in the Salerno panels lends support to the eleventh-century dating of the group.

That the plaque originally formed the center of a triptych is demonstrated by the placement of the holes, which, as in Cat. no. B3, would have served as the mounting points for decorative ledges on which to hang the wings (see the discussion of Cat. no. B3). The recessed area cut into the plaque below *The Marys at the Tomb* was intended to receive a relic, probably of the True Cross; a similar niche appears in Cat. no. B20. A glass or crystal was placed over the indentation to protect the relic. Clearly, then, this panel was originally part of a reliquary triptych.

The style is much more refined than that of Cat. nos. B6-17; there is a greater feeling for the plasticity of the forms, even if certain of the gestures are rather stiff. No other pieces in the group appear to be by the same artist.

19. Plaque: *Saints Paul and Bartholomew*
(Fig. 174)
Paris, Louvre
30 × 8.5 cm.

Condition The surface is very rubbed and there are signs of wear in the bottom right section. There is a hole in the center of the top border. Holes also appear at the top and bottom of the left edge. The plaque has a brownish patina.

Inscriptions Upper: S̄ P̄AU[LUS]. Lower: S̄ BARTHO[LOMAEUS].

Provenance The plaque was bequeathed

to the Louvre in 1919 by Count Lair. At that time it had been in his collection for thirty years.

Bibliography *Les accroisements des Musées nationaux français, 3: le Musée du Louvre en 1920* (Paris, 1921), pl. 41; Goldschmidt, *Elfenbeinskulpturen*, 4:39, no. 127, pl. 48; K. Weitzmann, "Ivory Sculpture of the Macedonian Renaissance," *Kolloquium über spätantike und frühmittelalterliche Skulptur*, vol. 2 (Mainz, 1970), p. 9.

Commentary The plaque is divided in half by a horizontal border decorated with a bead and reel motif. Above stands a nimbed saint turning his head to the left. In his left hand he holds a book (at his waist), and he draws his right arm across his chest. The nimbed saint below faces forward. His left hand holds a scroll to the center of his body; the right hand is broken off (probably it was originally in the center of his chest).

It is clear that the panel originally formed the right wing of a triptych. The holes at the top and bottom of the left edge received the pin used to affix the wings to the decorative ledges at the top and bottom of the central panel (cf. Cat. no. B21). The identation about 1 cm. wide that runs along the length of the plaque on the back of the right side must have interlocked with an overlapping piece from the left wing (which would have shown two other saints), as in numerous Byzantine examples. The direction in which St. Paul faces in itself indicates that something appeared to the left. Figures of standing saints are not uncommon in Byzantine triptychs (for example, Goldschmidt and Weitzmann, *Byz. Elfenbeinskulpturen*, 2:nos. 138, 195, pls. 50, 54; even superimposed full-length saints may be found—nos. 31, 32, pls. 10, 11).

Although there are some connections between the style of this plaque and that of Cat.

no. B18, the style in this piece is more refined, and the forms are more fluid and graceful. The carver of this ivory is the most accomplished artist of this phase of the Amalfi workshop. His model was surely a Byzantine ivory of the Romanus group (see Weitzmann, "Ivory Sculpture of the Macedonian Renaissance," p. 9).

20. Plaque: *Crucifixion* and *Entombment* (Fig. 175)
New York, Metropolitan Museum of Art (inv. no. 17.190.43)
23 × 10.4 cm.

Condition There are cuts in the bottom and top borders. Otherwise the plaque is in excellent condition. There are two holes in the top border and two in the bottom. The plaque has a brownish patina.

Provenance J. P. Morgan purchased the plaque in Paris from the dealer Amedeo Canessa in April 1911. The plaque came to the museum in 1917 as part of Morgan's bequest.

Bibliography Goldschmidt, *Elfenbeinskulpturen*, 4:42, no. 143, pl. 51; Kessler, "Eleventh-Century Ivory Plaque," p. 76; Bergman, "Ivory Carving in Amalfi," pp. 183–184.

Commentary The composition of the *Crucifixion* is almost exactly like that of Cat. no. B18 except that Christ's nimbus lacks a cross and Longinus and Stephaton do not stand on a wall and thus seem to hover in mid-air. In the bottom section of the panel, instead of the scene of *The Marys at the Tomb* seen in Cat. no. B18, is the *Entombment*, with Christ being lowered into the sarcophagus by Nicodemus and Joseph of Arimathea. The underpart of the sarcophagus is hollowed out to receive a relic.

The relationship of the *Crucifixion* iconography to the iconography of the Salerno version of the scene was discussed under Cat. no.

B18. The *Entombment* is equally dependent on its counterpart in the Salerno group (Fig. 31) where it also appears at the bottom of the *Crucifixion* panel. Owing to lack of space in the Metropolitan panel the baldachin had to be eliminated; the columns that flank the sarcophagus are probably remnants of this structure. The capitals and bases on these columns are similar to those found on the columns in the Old Testament plaques in the Salerno ivories.

That the plaque was originally the center of a triptych is revealed by the two holes in both the top and bottom borders that held the decorative ledges.

The plaque is stylistically related to Cat. nos. B6-17. It must be considered among the least refined of the group.

21. Triptych: *Ascension* and Four Saints
(Fig. 176)
Paris, Louvre
21 × 12 cm. (center), 18.3 × 5.5 (left),
18.3 × 6.3 (right)

Condition The decorative ledge at the top of the central panel is broken in half and there are some chips at the bottom left of the panel. A severe crack runs the length of the left wing on its left side and there is another crack in the bottom left section of the right wing. Modern metal supports hold the triptych together; the left wing is also connected to the decorative ledge at the top by means of a pin that is inserted in its hollowed-out right edge. This method, if not the pin itself, is the original means of mounting the wing. There are holes as follows: center: three in the top border, two in the bottom border (the one at the right holds the remains of a nail); left: two in the corners at the top; right: four small ones on the right border. The triptych has a light brown patina.

Provenance The piece was donated to the Louvre in 1909 by a Mr. Ratzersderfer.

Bibliography Goldschmidt, *Elfenbeinskulpturen*, 4: 41, no. 138, pl. 50; Toesca, *Storia*, 2:1142 n 39.

Commentary The central panel is directly derived from the *Ascension* in the Salerno group (Fig. 38). The figures of Christ, the Virgin, and the angels that support the mandorla are virtually identical in both. The Apostles in the triptych differ from those in the Salerno scene, however, and other departures from that version are the undecorated mandorla, the uncrossed nimbus around Christ's head, and the omission of the wheat and grapes that appear beneath the mandorla in the Salerno scene. The cross in the nimbus and the stars in the mandorla might have been planned but not executed.

The saints on the wings were not derived from the Salerno series; no such standing single figures appear there. But the drapery types used —for example, the sling for the right arm, the diagonal fall of the mantle across the legs, the mantle hung over left arm—are found throughout the Salerno ivories. Furthermore, the same three saints who are identifiable here by type or attribute are those identified in the *Pentecost* and among the bust figures of the Salerno group: Peter, Paul, and Andrew. The facial type of Paul is very close in both plaques, although the others differ.

The rinceau pattern in the decorative ledge at the top of the triptych is not unlike that in the Virgin's throne in the Salerno ivories *Adoration of the Magi* (Fig. 21). The bead and reel appears here again, separating the saints in each wing and decorating the arch in the bottom section of the left wing. The other arches are decorated with a simplified palmette frieze, a motif identical to that found on chesspieces probably

produced by this workship (see, for example, Goldschmidt, *Elfenbeinskulpturen*, 4:no. 163, pl. 60).

The *Ascension* was often used as the central scene for triptychs in Byzantium; at least two examples of the type are extant (Goldschmidt and Weitzmann, *Byz. Elfenbeinskulpturen*, 2:nos. 114, 115, pl. 42). That superimposed figures of saints separated by a decorative border were used on triptych wings is demonstrated by Cat. no. 19 as well as by a host of Byzantine examples.

The Paris triptych is extremely well executed, although the central panel is a bit stiff owing to its close adherence in parts to its model. Of all the ivories in the Catalogue only this one and Cat. nos. B22-23 have the large hole for the iris of the eye (perhaps to receive an agate inlay) found in the Salerno group. Significantly different from the figures in the Salerno ivories, though, are the stout proportions and large heads of the figures here, particularly the saints on the wings. This change might reflect the influence of early Romanesque art in Italy, as it was developing at Modena and other northern Italian centers and moving south.

Toesca hesitated to attribute this triptych to the Amalfitan workshop, but I think the analysis above dispels any doubt that the piece was executed by carvers in that workshop.

22. Plaque: *Symbol of St. Matthew* (Fig. 177)
Leningrad, Hermitage (inv. no. 3189)
4.7 × 6 cm.

Condition Except for little cuts at the upper right and lower left borders the condition is excellent. It appears from the photograph that there is one hole in the right border and one in the left. The piece is cut at the bottom.

Provenance The plaque was purchased in Paris in 1882 for the Kunstgewerbe Museum in Leningrad.

Bibliography Goldschmidt, *Elfenbeinskulpturen*, 4:41, no. 140, pl. 50.

Commentary A winged, nimbed angel, bust-length and holding a book in his hands, is shown facing toward the right. The remnants of a decorative border may be seen at the bottom. The oversized hands and the coiffure relate the figure to the Salerno panels (see the figure of Lot in Fig. 13). Hempel thought that this piece and Cat. no. B23 were fragments of the Salerno group; this is impossible, because they were definitely parts of a triptych. Goldschmidt mentions a blue glass in the hole of the right eye. From the available photographs, it is difficult to tell whether it is still there.

The hole for a pin in the upper corner of the right edge, like the hole in Cat. no. B21, shows that the fragment was originally part of the upper left wing of a triptych. The decorative border indicates that the plaque has been cut at the bottom; originally it resembled the type of triptych wing with half-length saints common in Byzantine art (see, for example, Goldschmidt and Weitzmann, *Byz. Elfenbeinskulpturen*, 2:nos. 182–186, pl. 61). Cat. no. B23 was originally part of the same triptych. Goldschmidt suggests that the other two Evangelist symbols were also included.

23. *Symbol of St. John* (Fig. 178)
Leningrad, Hermitage (inv. no. 3190)
4.7 × 5.8 cm.

Condition The plaque is in excellent condition. It appears from the photograph that there is a hole in the left border.

Provenance The plaque was purchased together with Cat. no. B22 in Paris in 1882.

Bibliography Goldschmidt, *Elfenbein-skulpturen*, 4:42, no. 141, pl. 50.

Commentary A half-length figure of an unnimbed eagle, a book in his claws, faces toward the left.

The eagle is very much like those in the Salerno panels, especially in the conventions used to depict the feathers. Here, though, the eye hole is of the type used in human figures in the Salerno panels; the eyes of birds in the Salerno plaques were usually rendered with a concentric punch.

This piece formed the top of the right wing of a triptych. The same type of hole for a pin appears in its upper left edge as exists in Cat. no. B22. There was originally a decorative border at the bottom of the fragment which has broken off.

This fragment was part of the same triptych as Cat. no. B22.

DOCUMENTS PERTAINING TO THE SALERNO IVORIES

SALERNO, ARCHIVIO DIOCESIANO

Sancta Visita alla Cattedrale di Archivescovo Federico Fregoso, 1510, fasc. 1 (Inventarium Reliquiarium, etc.), fol. 12:

Item cona una de ebore magna.

Sancta Visita alla Cattedrale di Archivescovo Marco Antonio Marsili Colonna, 1575, fasc. 2 (Inventario della Cattedrale di Salerno):

Fol. 13r: Item sette tavolette de avolio de longhezza un terzo de palmo intagliato dove sono scolpite le figure del testamento vecchio.

Item due altre tavolette de avolio picciole in quatro con le medesime figure del testamento vecchio.

Item dieci Altri Quadretti picciloi di due deta in quattro in circa puro de avolio con le figure del testamento vecchio.

Item nove altre pezze de avolio laborate con certe fogliaggi.

Fol. 13v: Item una cona dove ci sono intagliate le figure del testamento novo etiam de avolio ad serratura bellissima con l'arme de piscicello.

Item una cascetta d'avolio con certe figure intagliate in la quale mancano alcuni pezzi d'avolio di lunghezza palmi due, die larghezza uno palmo e mezzo, e cosi l'altezza, infoderata da dentro di taffeta verde.

Fol. 26v: Item una tavola la quale sta in faccia dell'altare del reliquiario dove ci è intagliato l'istoria del testamento vecchio et novo ornata de cornice de ligno de vainello nel mezzo e nel torno.

MATTEO PASTORE, *PLATEA DELLA CHIESA SALERNITANA*, 1700:

P. 145: Nella sagrestia . . . vi è un'altra porta che corrisponde in altra camera, che si dice il Reliquiario o Tesoro, dove si conservano le cose più preziose che tiene la Chiesa; e primieramente nel prospetto di detta camera vi è un altare con suo Paliotto di legname, in cui con quadretti insculpiti in avolio, vi è effigiato il Testamento vecchio e nuovo; e sopra di detto altare vi è un credenzone grande con sue porte apritore; e dentro, in varii spartimenti, si conservano le Sacre Reliquie.

P. 154: Vi è un quadro pendente, d'avolio, historiato, manchante in molti pezzi, et alcuni sono conservati nel stipo collaterale della porta.

SELECTED BIBLIOGRAPHY

This bibliography includes only those works that deal exten-sively with the Salerno ivories.

AVENA, A. *Monumenti dell'Italia meridionale.* Rome, 1902.

BECHERUCCI, L. "Gli avori di Salerno." *Rassegna storica salernitana* 2 (1938):62–85.

BERGMAN, R. P. "A School of Romanesque Ivory Carving in Amalfi." *Metropolitan Museum of Art Journal* 9 (1974):163–185.

BERTAUX, E. *L'art dans l'Italie méridionale.* Paris, 1904.

BOLOGNA, F. *Opere d'arte nel salernitano dal XII al XVIII secolo.* Naples, 1955.

BOCK, F. "Das ungarische National-Museum in Pest." *Mitteilungen der KK. Central-Commission* 12 (1867):117.

CAPONE, A. *Il Duomo di Salerno.* 2 vols. Salerno, 1927–1929.

CARUCCI, A. *Gli avori salernitani del sec. XII.* 2nd ed. Salerno, 1972.

———— "Un' ipotesi sull'originaria destinazione degli avori di Salerno." *Apollo* (Bolletino dei musei provinciali del salernitano), 3–4 (1963–64):125–142.

———— *Il paliotto di avorio di Salerno.* Salerno, 1950.

———— *La "parousia" negli avori salernitani.* Salerno, 1965.

CRISCI, G., and A. CAMPAGNA. *Salerno sacra.* Salerno, 1962.

CRICHTON, G. H. *Romanesque Sculpture in Italy.* London, 1938.

DE ANGELIS, M. *Nuova guida del Duomo di Salerno.* Salerno, 1937.

GABORIT-CHOPIN, D. *Ivoires du moyen âge.* Paris, 1978.

GOLDSCHMIDT, A. *Die Elfenbeinskulpturen.* Vol. 4. Berlin, 1926.

GUGLIELMI, G. *Monumenti figurati del Duomo di Salerno.* Salerno, 1885.

KESSLER, H. "An Eleventh-Century Ivory Plaque from South Italy and the Cassinese Revival." *Jahrbuch der Berliner Museen* 8 (1966):67–95.

LONGHURST, M. "A Fragment of the Ivory Paliotto at Salerno." *Burlington Magazine* 49 (1926):43–44.

MACLAGAN, E. "An Early Christian Ivory Relief of the Miracle at Cana." *Burlington Magazine* 38 (1921):178–195.

MOLINIER, E. "Quelques ivoires récemment acquis par le Louvre," *Gazette des Beaux Arts* 29 (1898):484–485.

PANTONI, A. "Il ciclo eburneo di Salerno." *L'osservatore romano,* Oct. 3, 1965, p. 7.

"Il restauro italo-tedesco di una 'etimasia' eburnea

monumentale." *L'osservatore romano*, April 6, 1962, p. 6.

ROHAULT DE FLEURY, C. *La messe, études archéologiques sur les monuments*. Vol. 1. Paris, 1883.

SALAZARO, D. *Studi sui monumenti dell'Italia meridionale*. Vol. 1. Naples, 1871.

SCHIAVO, A. "L'architettura negli avori di Salerno e ipotesi sulle loro origini." *Rassegna storica salernitana* 19 (1958):75–86.

SCHULZ, H. *Denkmäler der Kunst des Mittelalters in Unteritalien*. Vol. 2. Dresden, 1860.

SEMPER, H. "Ivoires au musée national de Buda-Pesth." *Revue de l'Art Chrétien* 4th ser. 8 (1897):492–495.

STEVENSON, E. "Di un altro avorio spettante al paliotto di Salerno." *Nuovo bullettino di archeologia cristiana* 4 (1898):97.

——— "Scoperta di un avorio spettante al paliotto di Salerno." *Nuovo bullettino di archeologia cristiana* 3 (1897):322–324.

TOESCA, P. "Un cimelio amalfitano." *Bollettino d'arte* 27 (1934):537–543.

——— *Storia dell'arte italiana: il medioevo*. Vol. 1. Turin, 1927.

TURCO, M. *Il Duomo di Salerno: i mosaici e gli avori*. Salerno, 1938.

VENTURI, A. *Storia dell'arte italiana*. Vol. 2. Milan, 1902.

VÖGE, W. *Die Elfenbeinbildwerke (Köngliche Museen zu Berlin: Beschreibung der Bildwerke der christlichen Epochen)*. Berlin, 1900.

VOLBACH, W. F. *Die Elfenbeinbildwerke (Staatliche Museen zu Berlin: Die Bildwerke des deutschen Museums)*. Vol. 1. Berlin, 1923.

WEITZMANN, K. "The Ivories of the So-Called Grado Chair." *Dumbarton Oaks Papers* 26 (1972):45–91.

——— "Observations on the Cotton Genesis Fragments." In *Late Classical and Medieval Studies in Honor of Albert Mathias Friend, Jr.*, ed. K. Weitzmann, pp. 112–131. Princeton, 1955.

WILPERT, G. *Die römischen Mosaiken und Malereien der kirchlichen Bauten von IV bis XIII Jahrhunderts*. Vol. 2. Freiburg, 1917.

ILLUSTRATIONS

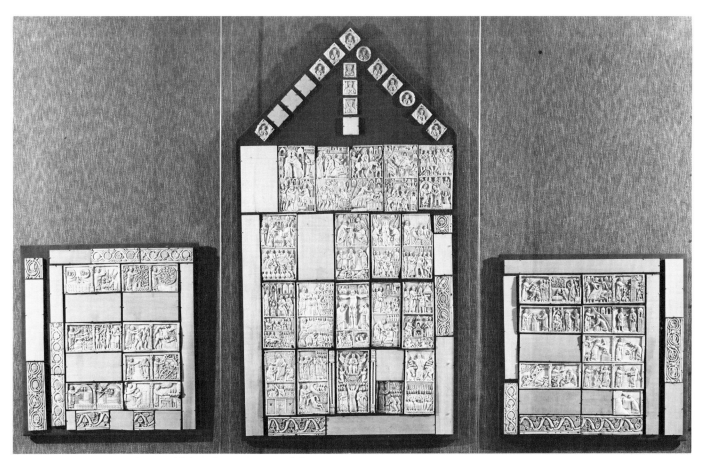

1. The Salerno ivories (ensemble), Salerno, Museo del Duomo

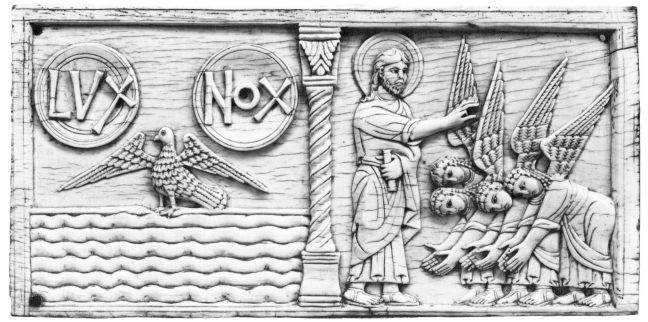

2. *The Spirit over the Waters* and *The Separation of Light and Darkness—Creation of the Firmament*, the Salerno ivories

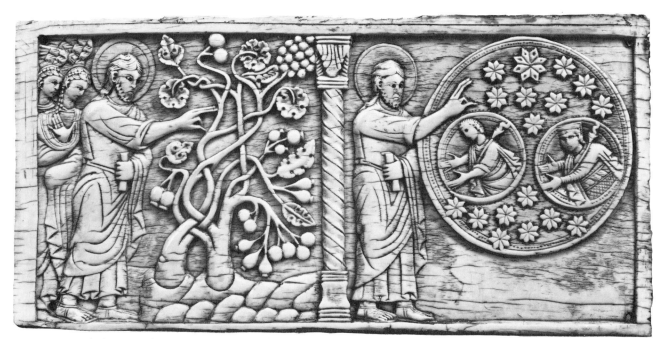

3. *Creation of Plants and Trees—Creation of the Sun, Moon, and Stars*, the Salerno ivories

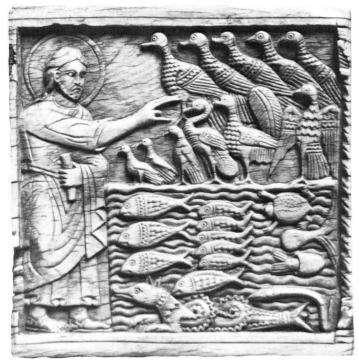

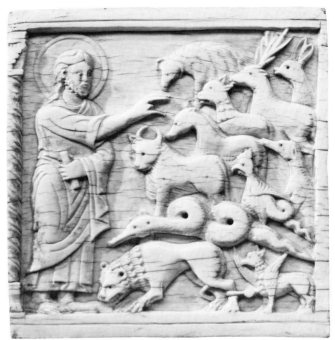

4a. *Creation of Birds and Fish,* the Salerno ivories (now in Budapest, Museum of Fine Arts)

4b. *Creation of Animals,* the Salerno ivories (now in New York, The Metropolitan Museum of Art)

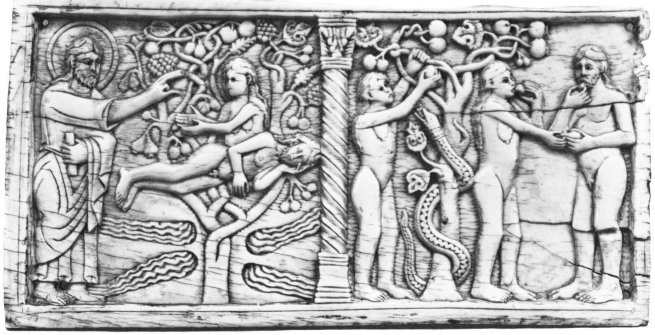

5. *Creation of Eve—Temptation and Fall,* the Salerno ivories

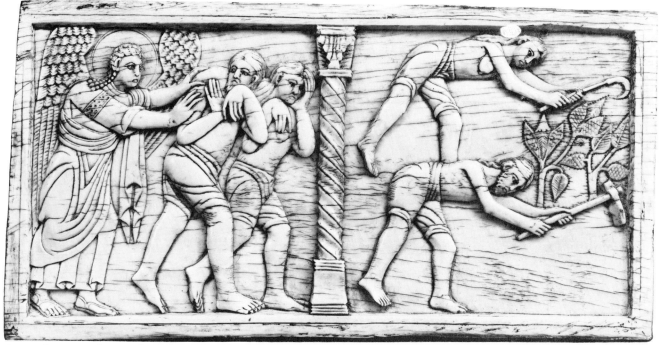

6. *Expulsion—Adam and Eve at Labor,* the Salerno ivories

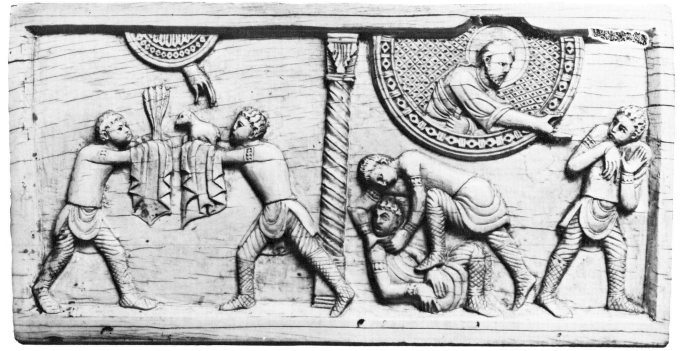

7. *Sacrifice of Cain and Abel—Murder of Abel* and *Condemnation of Cain,* the Salerno ivories (now in Paris, Louvre)

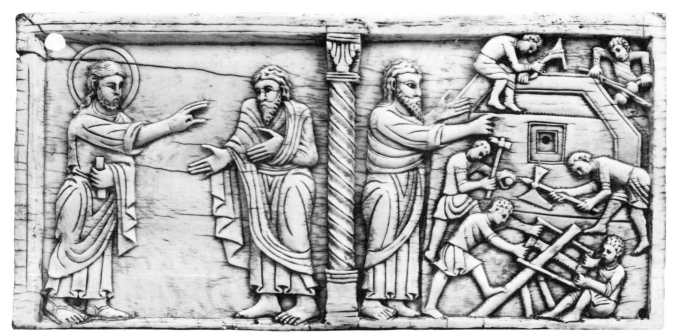

8. *God Commands Noah to Construct the Ark—Construction of the Ark,* the Salerno ivories

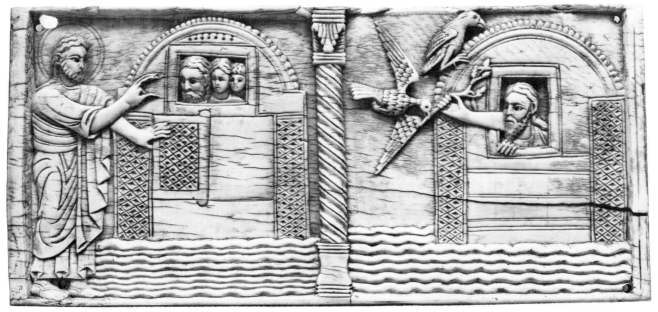

9. *God Closes the Door of the Ark—The Dove Returns to the Ark,* the Salerno ivories

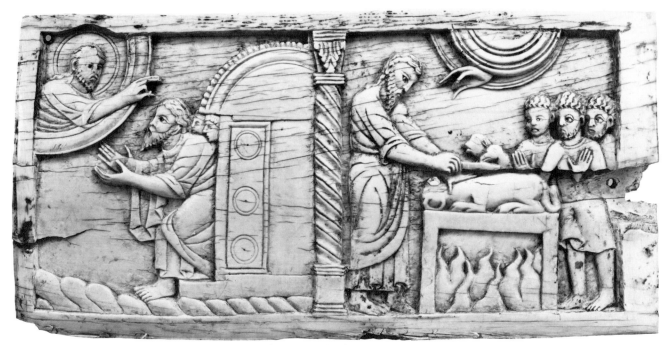

10. *God Orders Noah to Leave the Ark—Sacrifice of Noah,* the Salerno ivories

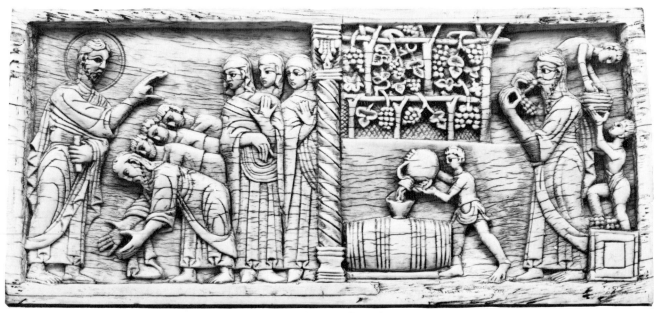

11. *God and Noah Establish the Covenant—Making of Wine,* the Salerno ivories

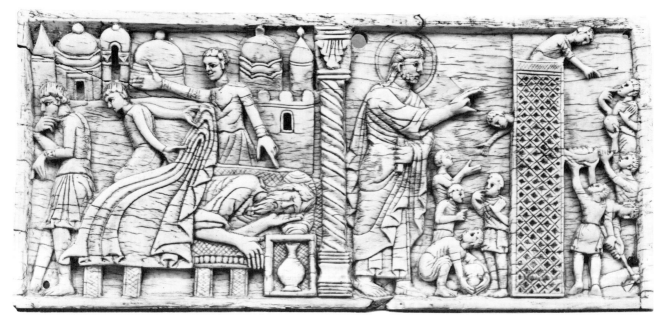

12. *Nakedness of Noah—The Tower of Babel,* the Salerno ivories

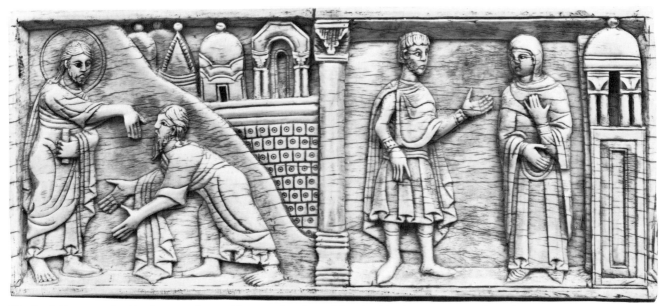

13. *God Commands Abraham to Leave Haran—Sarah and Lot in Abraham's House,* the Salerno ivories

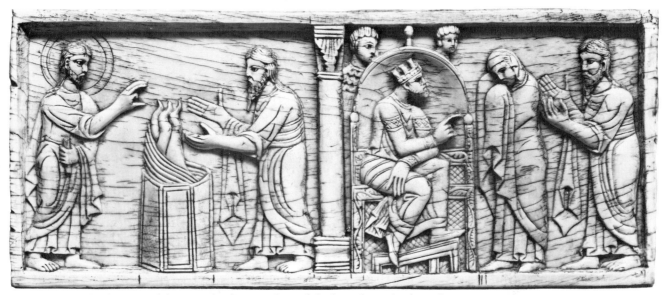

14. *God and Abraham at Sichem—Abraham and Sarah before Pharaoh,* the Salerno ivories

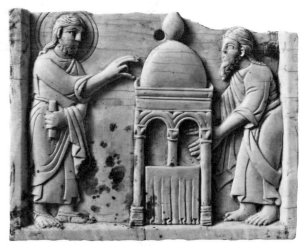

15. *God and Abraham at an Altar,* the Salerno ivories (now in Berlin-Dahlem, Staatliche Museen, Preussischer Kulturbesitz)

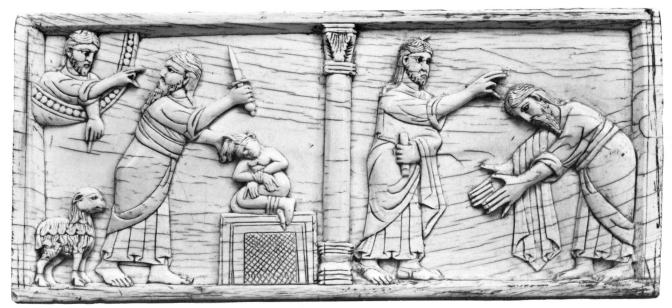

16. *Sacrifice of Issac—God Blesses Abraham,* the Salerno ivories

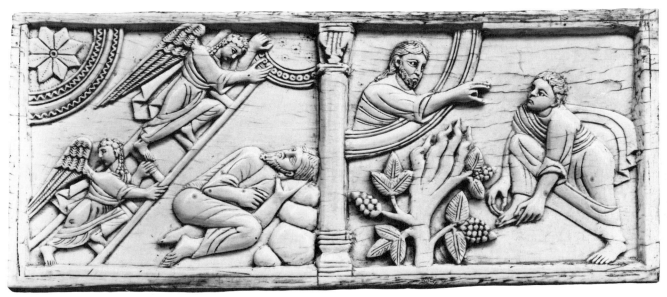

17. *Jacob's Dream—Moses at the Burning Bush,* the Salerno ivories

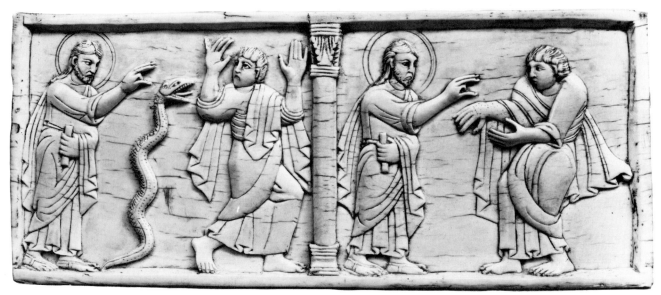

18. *Moses: Miracle of the Serpent — Moses: Miracle of the Withered Hand,* the Salerno ivories

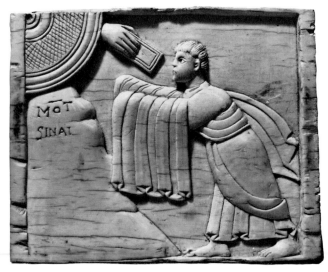

19. *Moses Receiving the Law,* the Salerno ivories

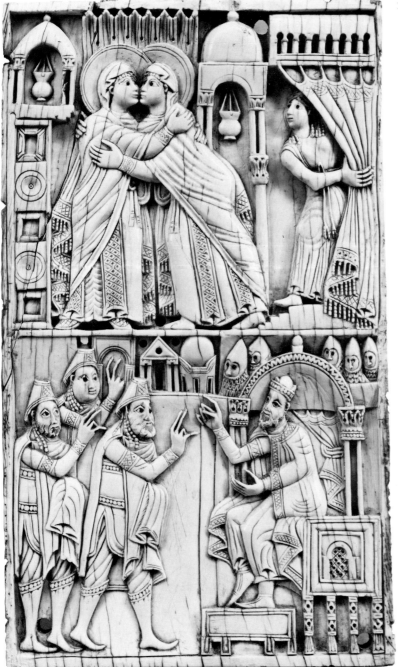

20. *Visitation—Magi before Herod,* the Salerno ivories

21. *Joseph Doubts Mary* and *Joseph's First Dream—Adoration of the Magi,* the Salerno ivories

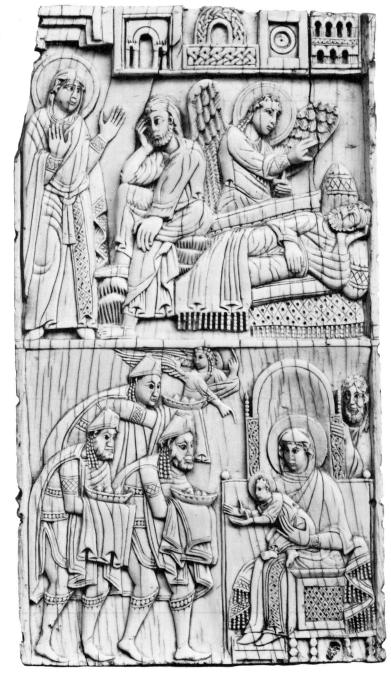

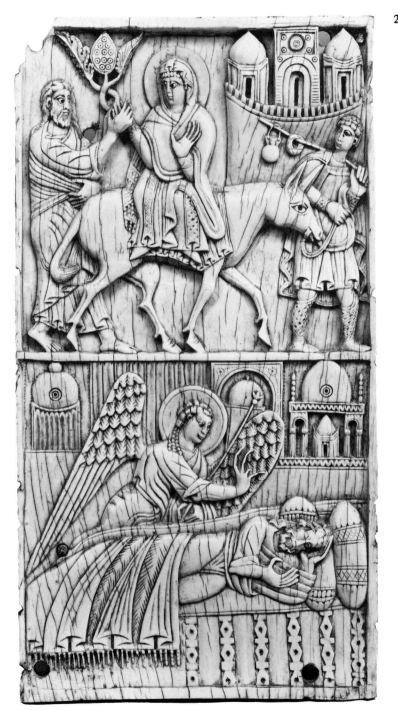

22. *Journey to Bethlehem—Joseph's Second Dream,* the Salerno ivories

23. *Nativity—Flight into Egypt,* the Salerno ivories

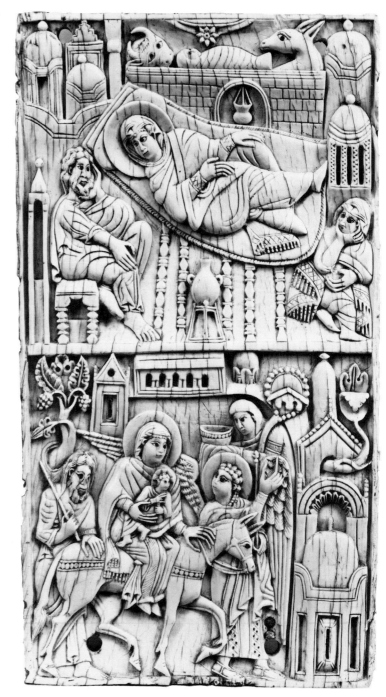

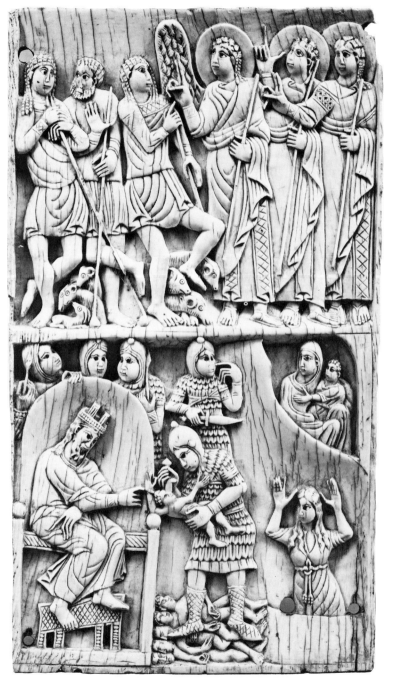

24. *Annunciation to the Shepherds—Massacre of the Innocents,* the Salerno ivories

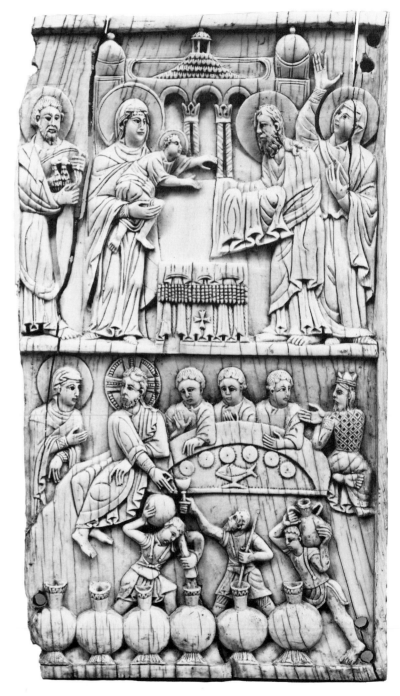

25. *Presentation—Miracle at Cana,* the Salerno ivories

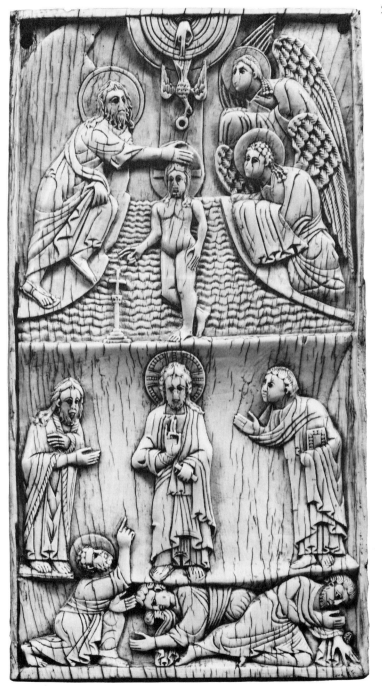

26. *Baptism—Trans-figuration,* the Salerno ivories

27. *Christ Adored by the Angels—Raising of the Widow's Son at Nain,* the Salerno ivories

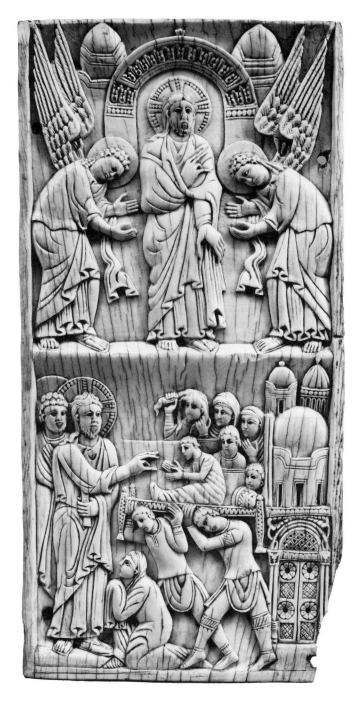

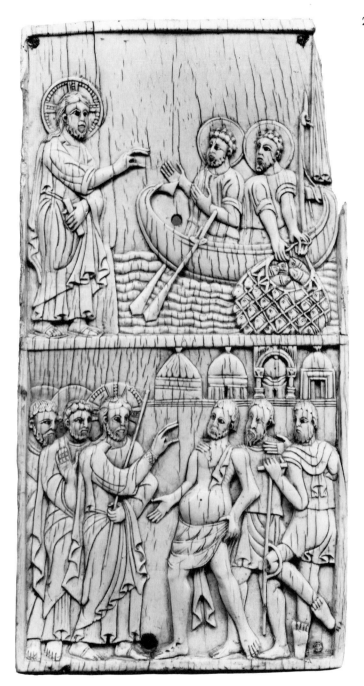

28. *Calling of Peter and Andrew—Healing of the Dropsical, Blind, and Lame,* the Salerno ivories

29. *Christit and the Samaritan Woman— Resurrection of Lazarus* and *Entry into Jerusalem,* the Salerno ivories

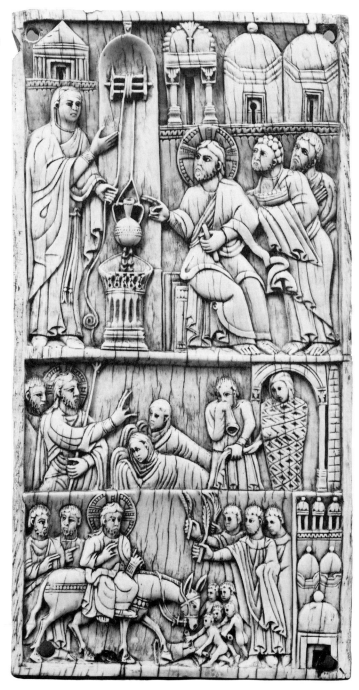

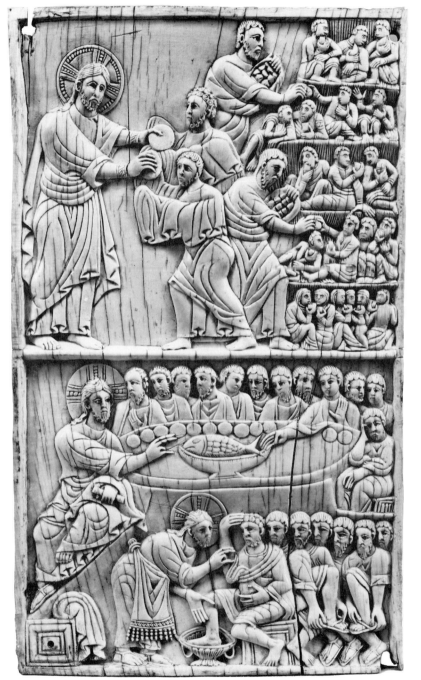

30. *Feeding of the Multitude—Last Supper* and *Washing of the Feet,* the Salerno ivories

31. *Crucifixion—Soldiers Gambling— Entombment,* the Salerno ivories

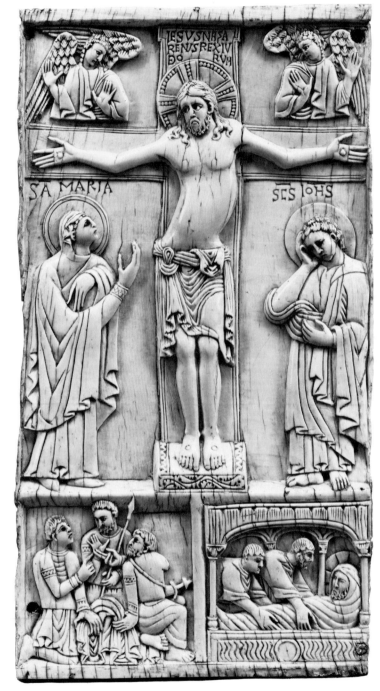

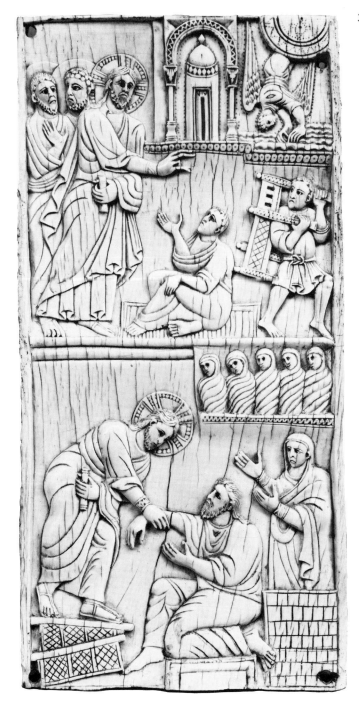

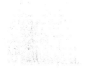

32. *Healing of the Paralytic at Bethesda—Anastasis,* the Salerno ivories

33. *Healing of the Blind Man at Siloam—The Marys at the Tomb,* the Salerno ivories

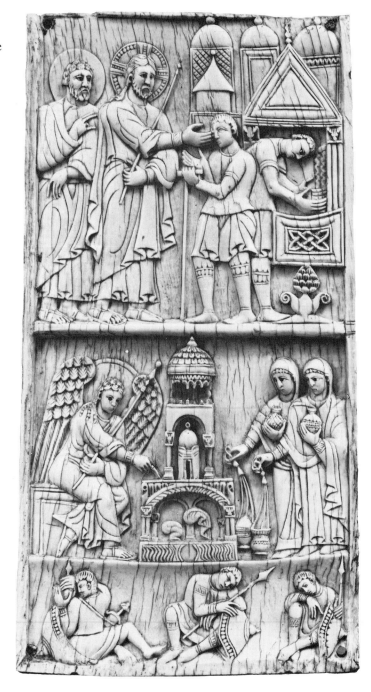

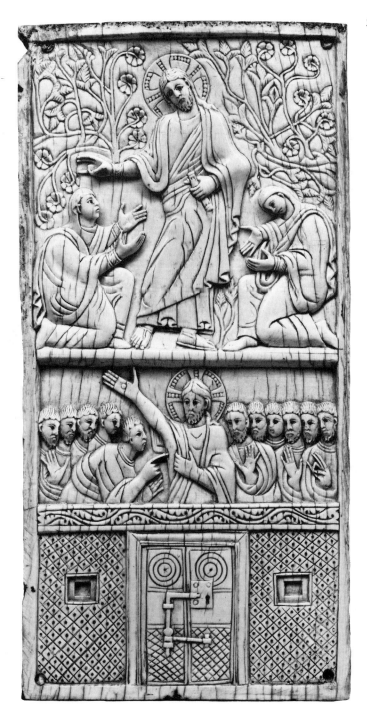

34. *Christ Appears to the Marys—Incredulity of Thomas,* the Salerno ivories

35. *The Marys Announce the Resurrection to the Apostles—Christ Appears at Lake Tiberius,* the Salerno ivories

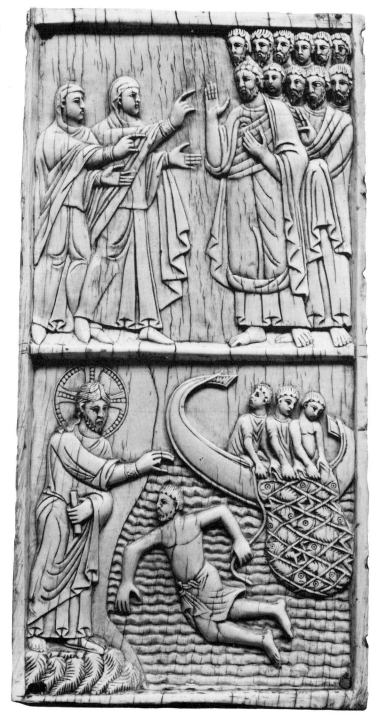

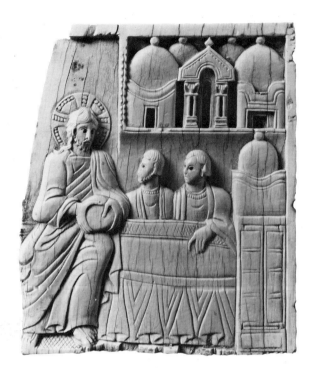

36. *Christ at Emmaus,* the Salerno ivories (now in Berlin-Dahlem, Staatliche Museen, Preussischer Kulturbesitz)

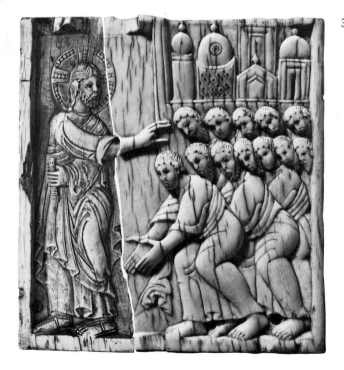

37. *Christ Appears at Bethany,* the Salerno ivories (Christ figure now in Hamburg, Kunstgewerbe Museum)

38. *Ascension,* the Salerno ivories

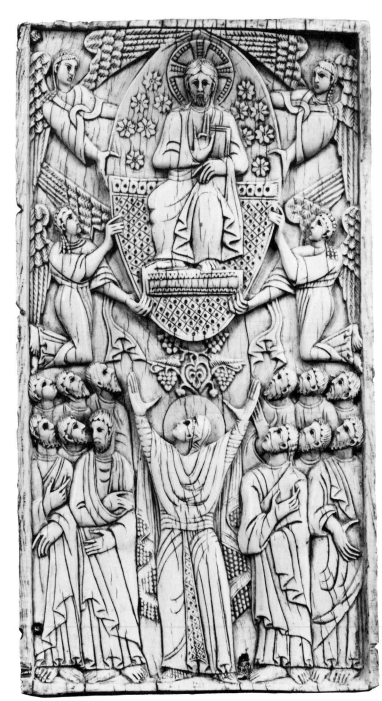

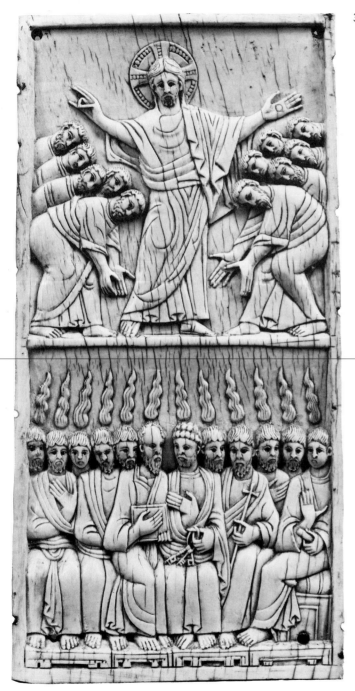

39. *Christ Appears in Jerusalem—Pentecost,* the Salerno ivories

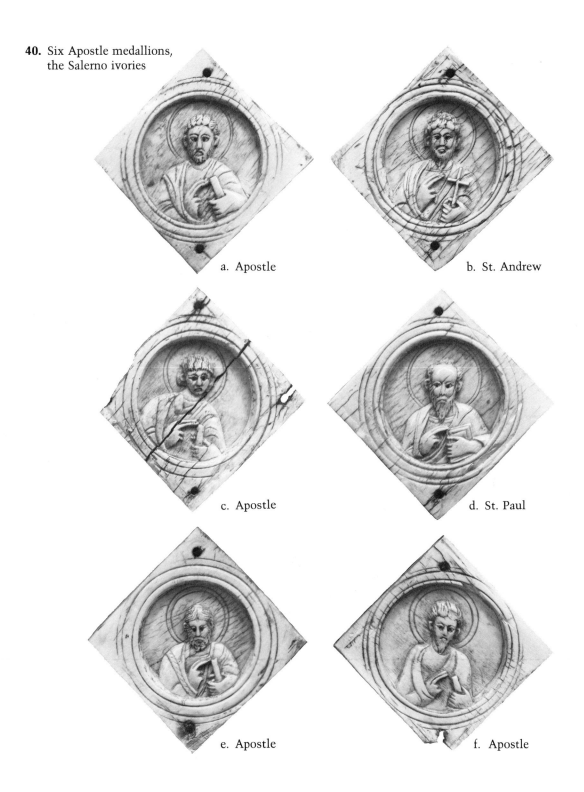

40. Six Apostle medallions,
the Salerno ivories

a. Apostle

b. St. Andrew

c. Apostle

d. St. Paul

e. Apostle

f. Apostle

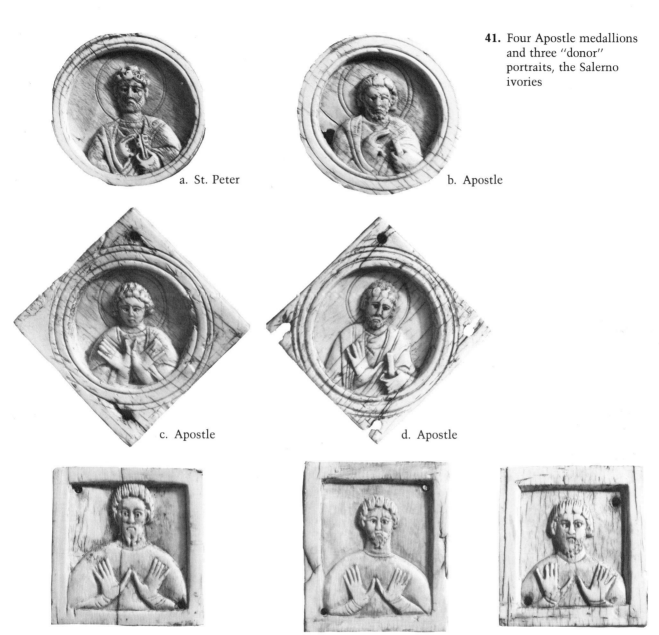

41. Four Apostle medallions and three "donor" portraits, the Salerno ivories

a. St. Peter

b. Apostle

c. Apostle

d. Apostle

e. Donor

f. Donor

g. Donor

42. Ornamental borders
(inhabited vine scroll),
the Salerno ivories

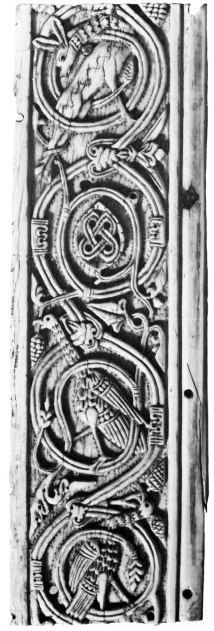

a.

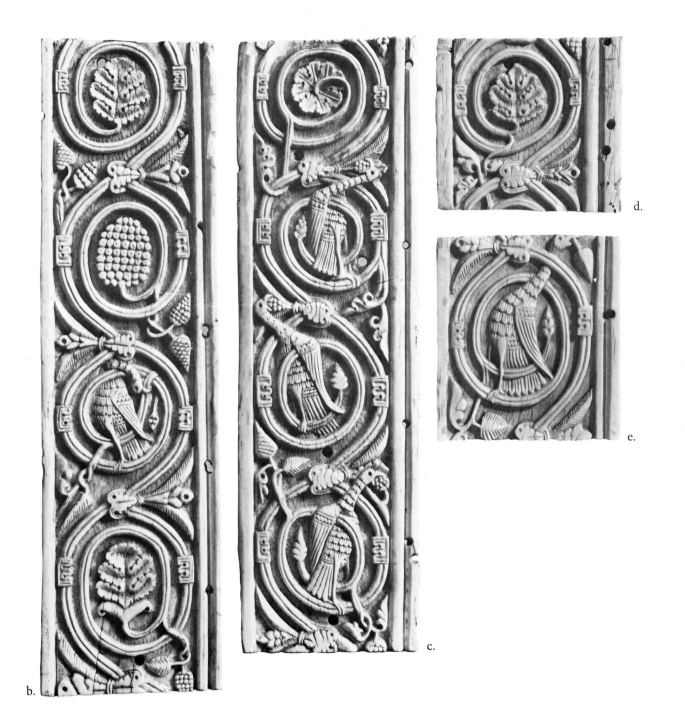

b.

c.

d.

e.

43. Ornamental borders (foliate vine scroll), the Salerno ivories

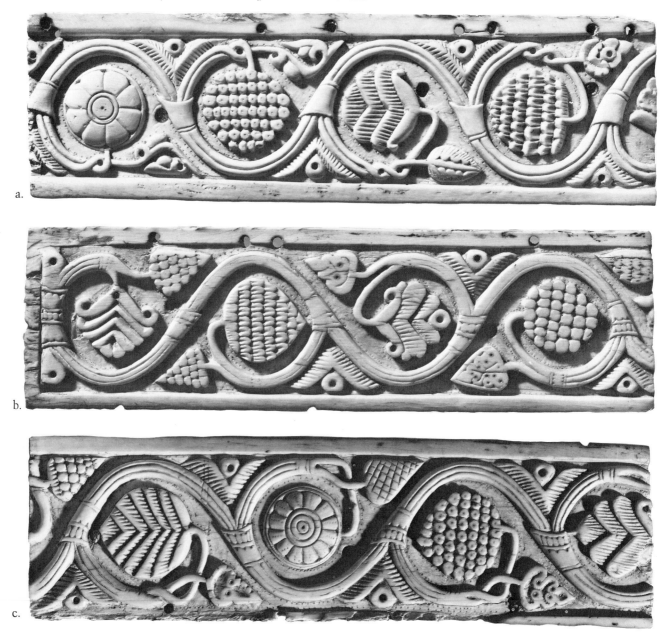

a.

b.

c.

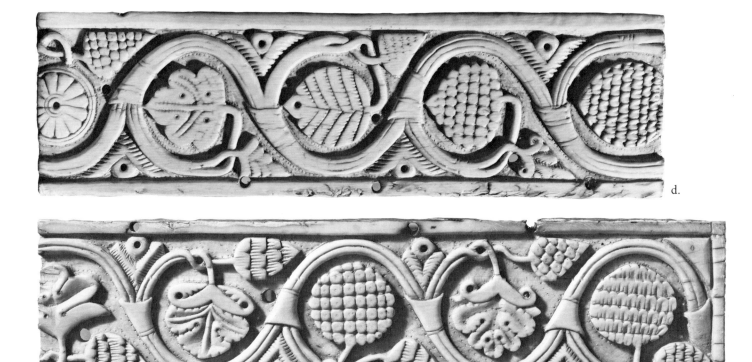

d.

e.

44. Ornamental borders
(cornucopia frieze) and
colonnettes, the Salerno
ivories

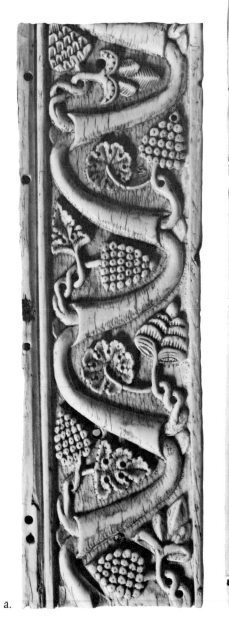

a.

b.

c.

d.

e.

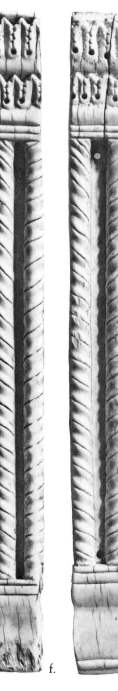

f.

g.

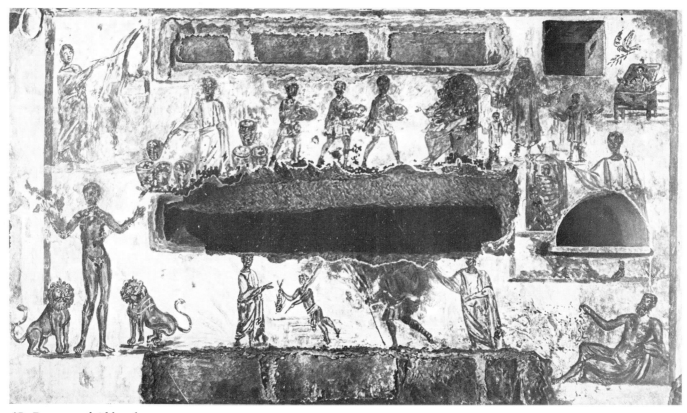

45. Frescoes of Old and New Testament episodes, Rome, Catacomb of the Vigna Massimo

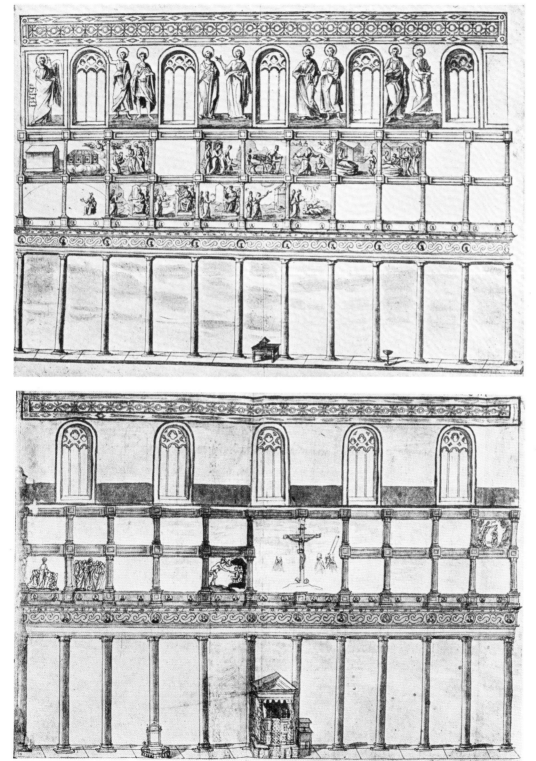

46. Drawing of the Old Testament nave wall of Old St. Peter's, Archivio San Pietro, Album, fol. 13

47. Drawing of the New Testament nave wall of Old St. Peter's, Vatican Library, cod. Barb. lat. 2733, fol. 15

48. *Spirit Hovering over the Waters, Separation of Light and Darkness,* mosaic, Venice, San Marco

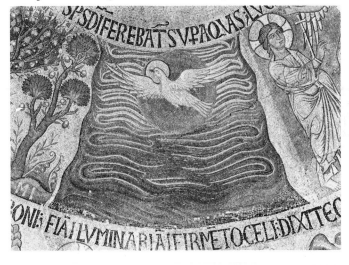

49. *Creation of Light,* mosaic, Monreale, Cathedral

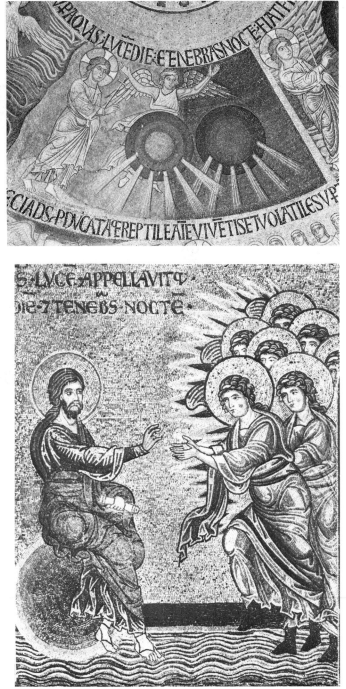

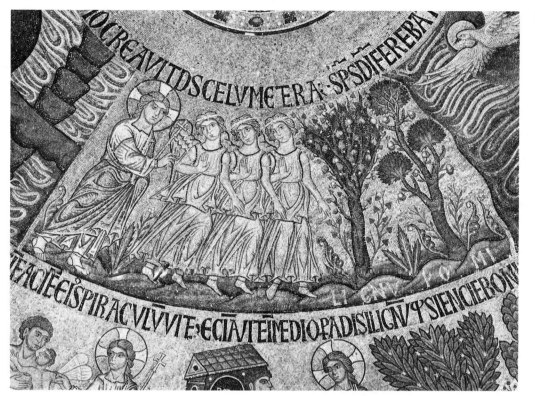

50. *Creation of Plants and Trees*, mosaic, Venice, San Marco

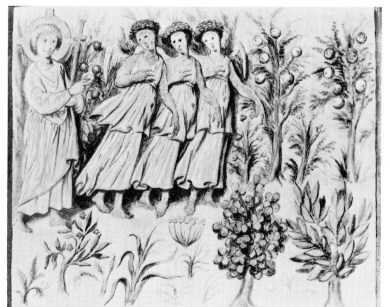

51. *Creation of Plants and Trees*, Paris, Bibliothèque nationale, cod. fr. 9530, fol. 32

52. *Creation of the Sun, Moon, and Stars,* mosaic, Venice, San Marco

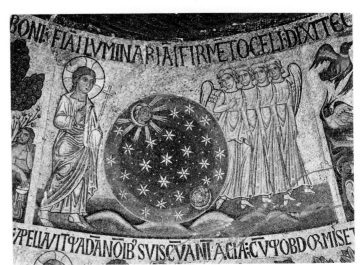

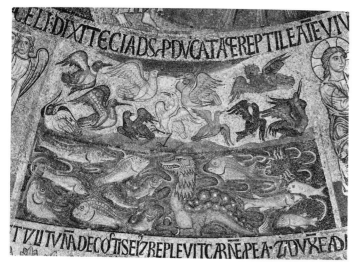

53. *Creation of Birds and Fish,* mosaic, Venice, San Marco

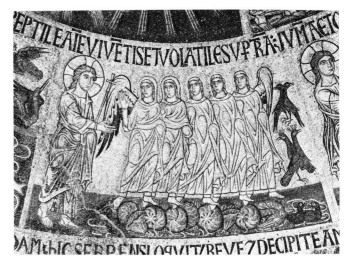

54. *Creation of Animals,* mosaic, Venice, San Marco

55. *Creation of Adam, God Resting,* mosaic, Palermo, Cappella Palatina

56. *Creation of Eve* (left), mosaic, Venice, San Marco

57. *Creation of Eve* (right), Vatican Library, cod. gr. 746, fol. 37r

58. *Temptation and Fall,*
mosaic, Venice, San
Marco

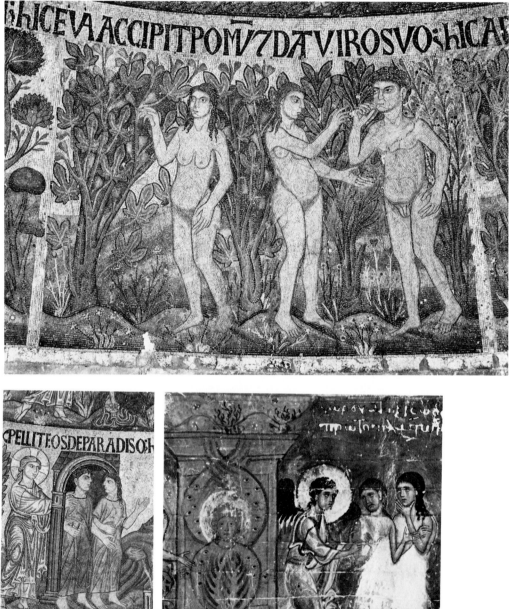

59. *Expulsion,* mosaic,
Venice, San Marco

60. *Expulsion,* Vatican Library, cod.
gr. 746, fol. 44r

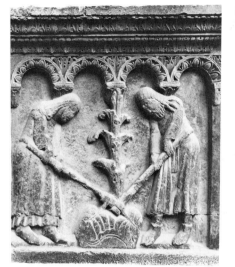

61. *Adam and Eve at Labor*, relief, Modena, Cathedral (façade)

62. *Sacrifice of Cain and Abel*, mosaic, Venice, San Marco

63. *Sacrifice of Cain and Abel*, Vatican Library, cod. gr. 746, fol. 45r

64. *Condemnation of Cain*, mosaic, Venice, San Marco

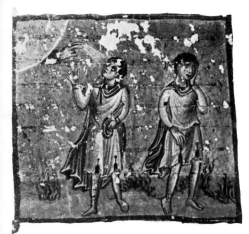

65. *Condemnation of Cain,*
Vatican Library, cod. gr.
746, fol. 46r

66. *God Commands Noah
to Construct the Ark,*
Vatican Library, cod. gr.
746, fol. 52r

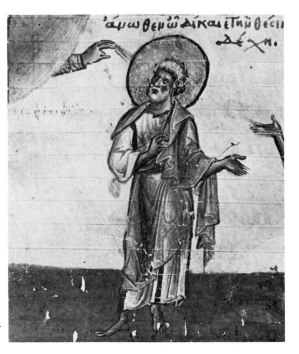

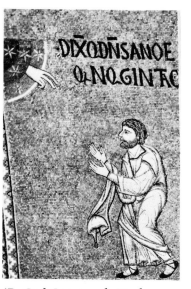

67. *God Commands Noah
to Construct the Ark,*
mosaic, Venice, San
Marco

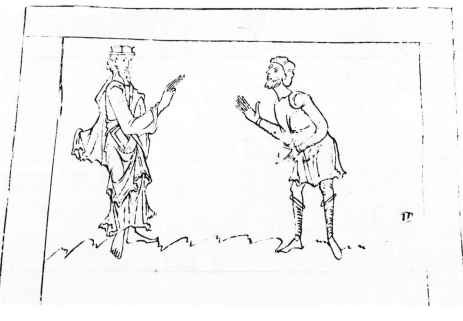

68. *God Commands Noah
to Construct the Ark,*
Oxford, Bodlcian
Library, cod. Junius 11,
p. 65

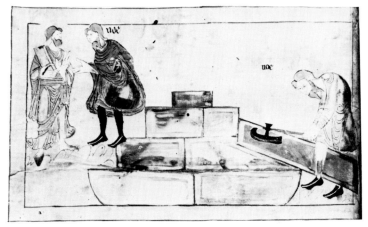

69. *God Commands Noah to Construct the Ark* and *Construction of the Ark*, London, British Library, cod. Cotton Claudius B VI, fol. 13v

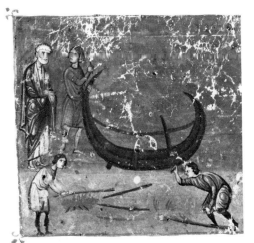

70. *Construction of the Ark*, Vatican Library, cod. gr. 746, fol. 53v

71. *Construction of the Ark*, mosaic, Venice, San Marco

72. *God Closes the Door of the Ark,* Oxford, Bodleian Library, cod. Junius 11, p. 66

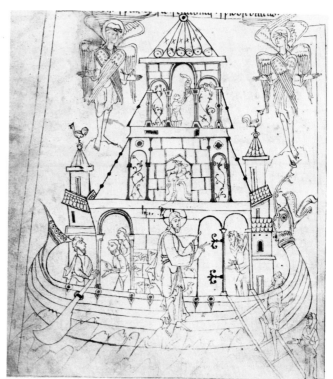

73. *De diluviis,* Monte Cassino, Monastery Library, ms. 132, p. 292

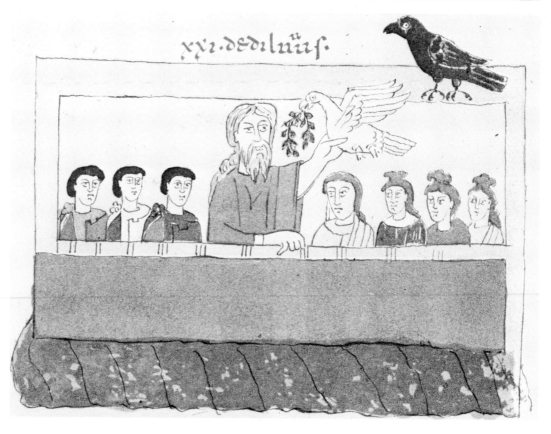

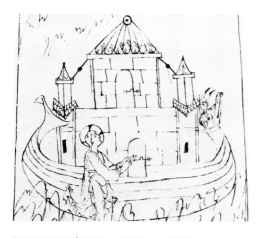

74. *God Opens the Door of the Ark*, Oxford, Bodleian Library, cod. Junius 11, p. 68

75. *Noah Leaves the Ark*, Oxford, Bodleian Library, cod. Junius 11, p. 73

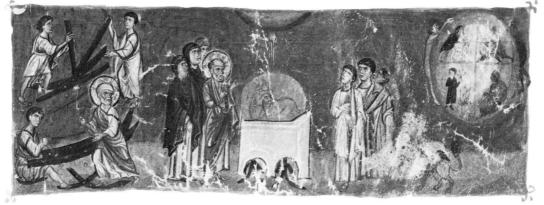

76. *Sacrifice of Noah* (center), Vatican Library, cod. gr. 746, fol. 57r

77. *God and Noah Establish the Covenant,* London, British Library, cod. Cotton Claudius B VI, fol. 16v

Noe soðlice ða ða he awoc ofdam slæpe. he oþ awoc
hwæt his suna him dydon· ða cwæð he awyrged is cha
naan· and byð ðeowena ðeowa his gebroðrum· And he cwæð
gebletsod is drihten semes god· beo chanaan his ðeowa
gemiclie fylde god iapheð· And he wunie onsemes geteldum·
and beo chanaan his ðeowa·

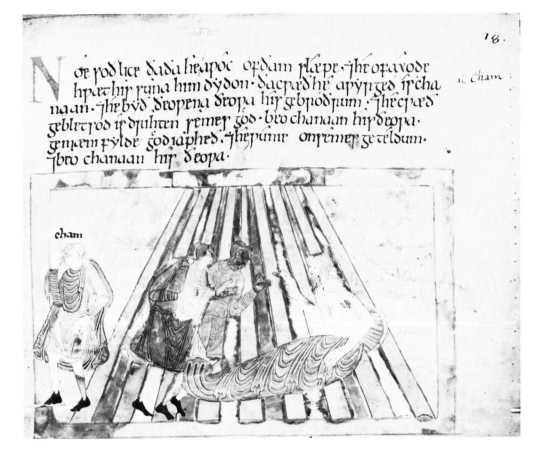

cham

80. *Tower of Babel,* mosaic,
Venice, San Marco

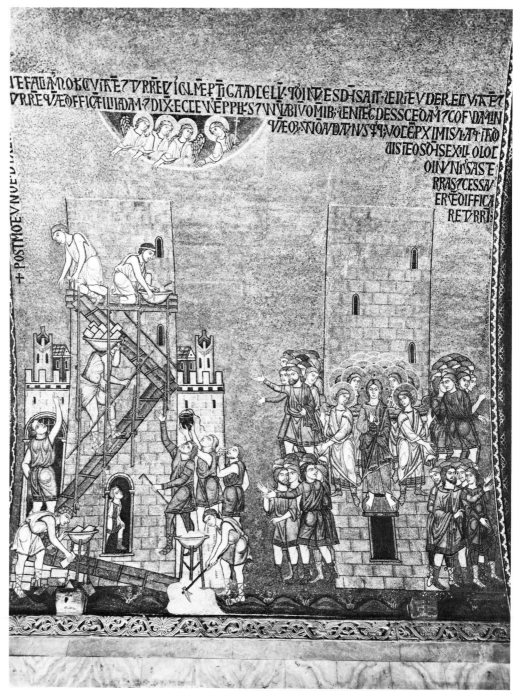

81. *Tower of Babel, Vetusta monumenta Britannicae,* Vol. 1, pl. 67, no. 5 (engraving after the Cotton Genesis manuscript)

82. *Tower of Babel,* Oxford, Bodleian Library, cod. Junius 11, p. 82

83. *God Commands Abraham to Leave Haran, Sarah and Lot in Abraham's House,* Oxford, Bodleian Library, cod. Junius 11, p. 84

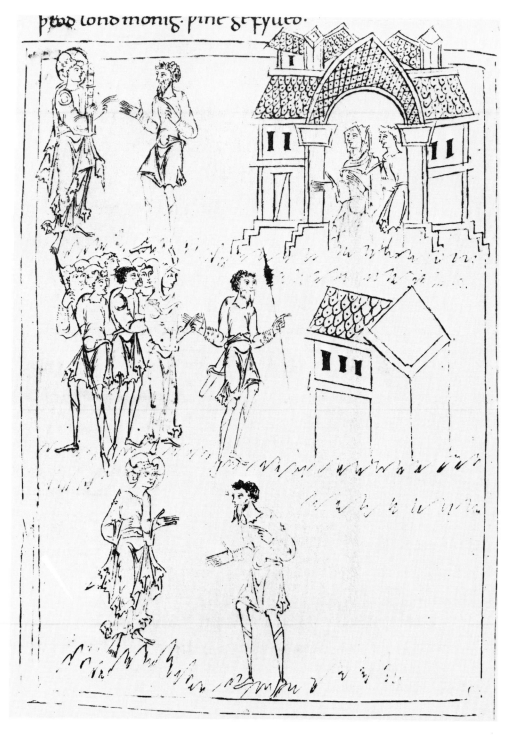

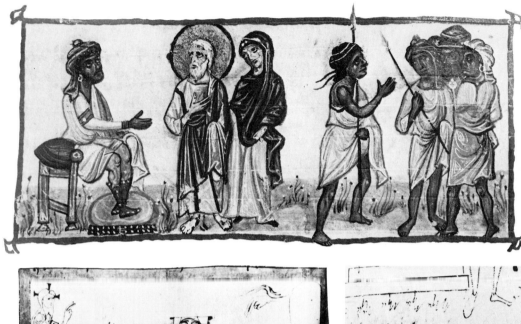

84. *Abraham and Sarah before Pharaoh,* Vatican Library, cod. gr. 746, fol. 65v

85. *God and Abraham at an Altar,* London, British Library, cod. Cotton Claudius B VI, fol. 24r

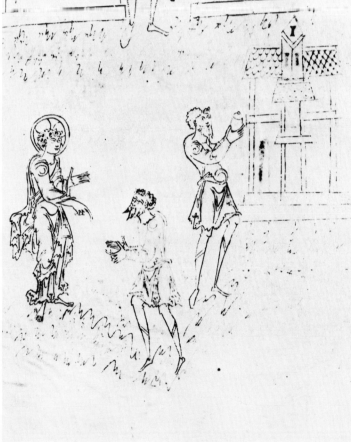

86. *God and Abraham at an Altar,* Oxford, Bodleian Library, cod. Junius 11, p. 87

87. *Hospitality of Abraham,* mosaic, Monreale, Cathedral

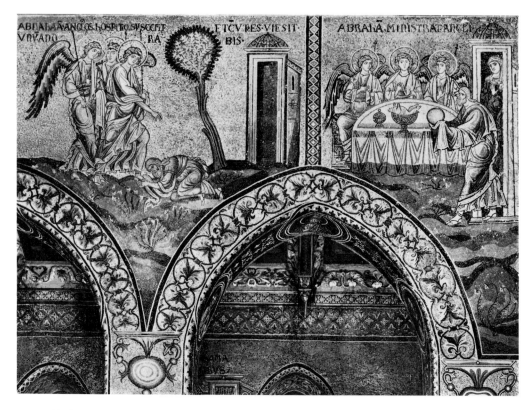

88. *Sacrifice of Isaac,* Klagenfurt, Museum, cod. VI, 19, fol. 29r

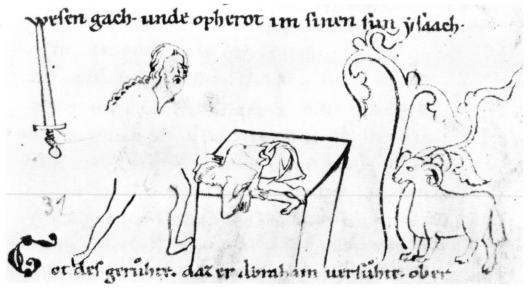

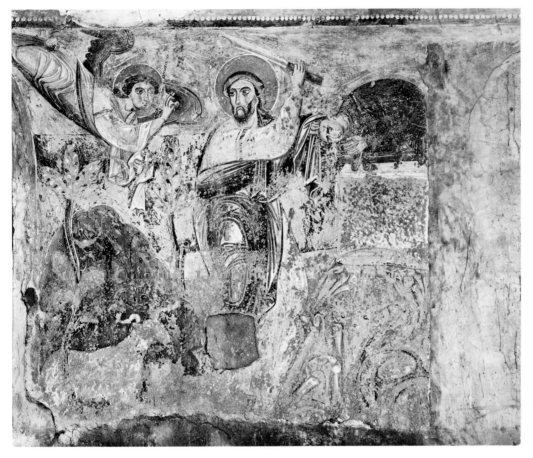

89. *Sacrifice of Isaac,* fresco, Sant'Angelo in Formis

der leitir stendit. dir engil ōf, nidir gende.

90. *Jacob's Dream,* Klagenfurt, Museum, cod. VI, 19, fol. 37v

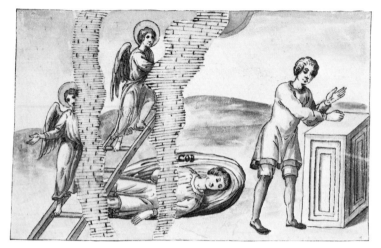

91. *Jacob's Dream*, Vatican
Library, cod. Barb. lat.
4406, fol. 42r

92. *Jacob's Dream*, London,
British Library, cod.
Cotton Claudius B VI,
fol. 43v

93. *Moses at the Burning
Bush*, Vatican Library,
cod. gr. 746, fol. 157r

94. Moses Miracles, London, British Library, cod. Add. 15277, fols. 3r, 3v

95. *Moses: Miracle of the Serpent*, Vatican Library, cod. Barb. lat. 4406, fol. 53r

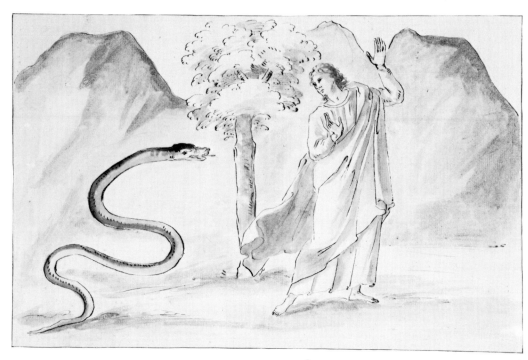

96. Moses Miracles, Vatican Library, cod. gr. 746, fol. 162v

97. *Moses Receiving the Law*, Vatican Library, cod. gr. 746, fol. 247r

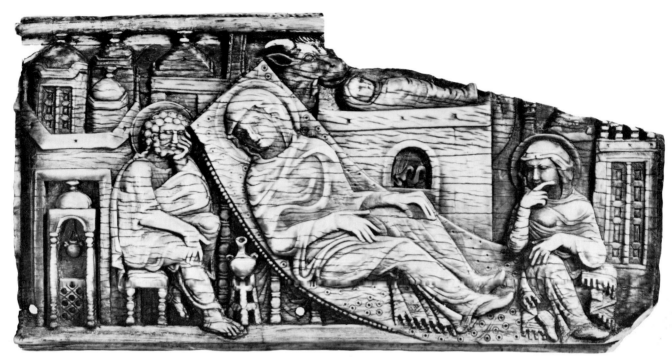

98. *Nativity,* ivory plaque, Washington, D.C., Dumbarton Oaks

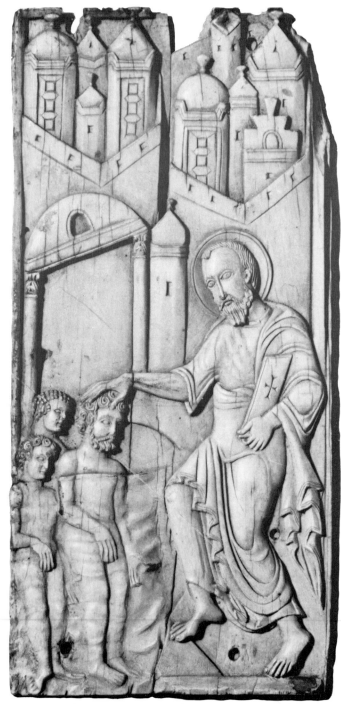

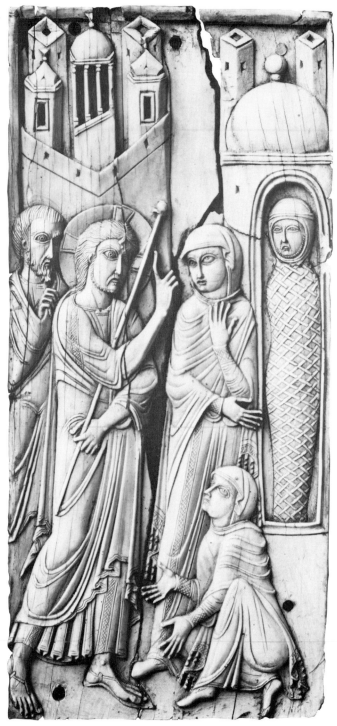

99. *St. Mark Baptizing,* ivory plaque, Milan, Castello Sforzesco

100. *Resurrection of Lazarus,* ivory plaque, London, British Museum

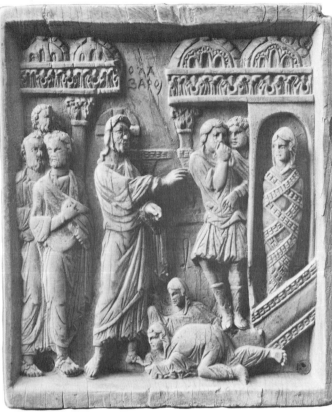

101. *Resurrection of Lazarus*, ivory plaque, Berlin-Dahlem, Staatliche Museen, Preussischer Kulturbesitz

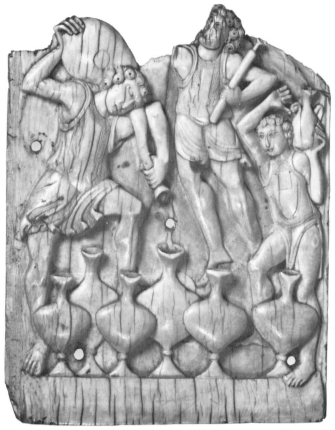

102. *Miracle at Cana*, ivory plaque (fragment), London, Victoria and Albert Museum

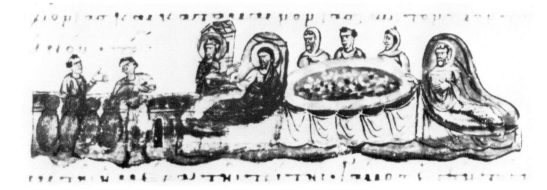

103. *Miracle at Cana*, Florence, Laurentian Library, cod. Plut. VI, 23, fol. 17v

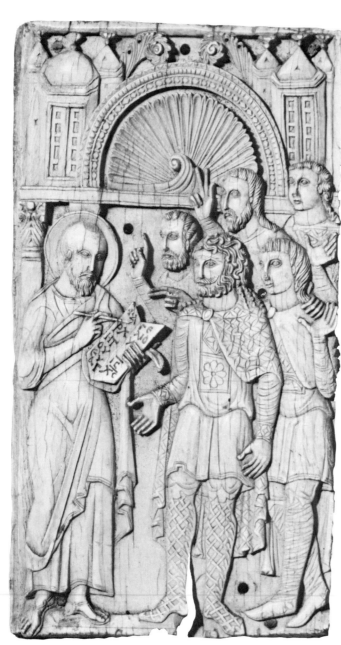

104. *St. Mark in Tripoli,* ivory plaque, Milan, Castello Sforzesco

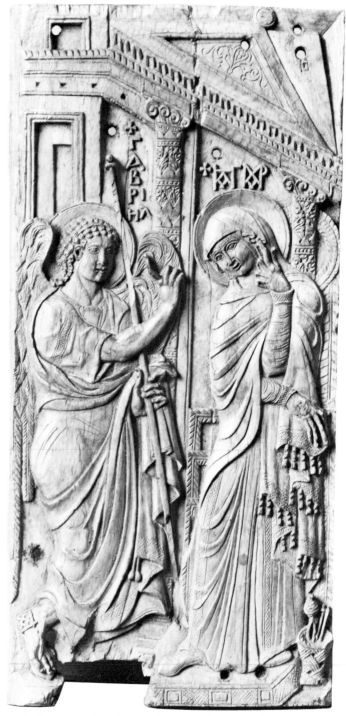

105. *Annunciation,* ivory plaque, Milan, Castello Sforzesco

106. *Flight of Elizabeth,* fresco, Deir Abu Hennis

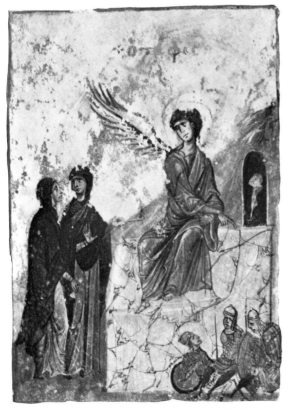

107. *The Marys at the Tomb,* Parma, Palatine
Library, cod. palat. 5, fol. 90r

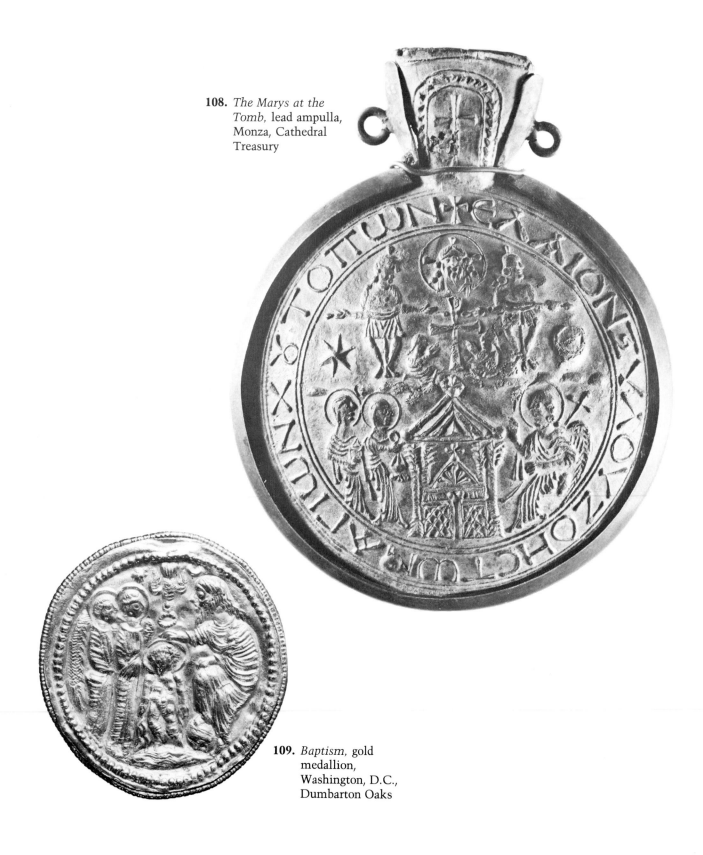

108. *The Marys at the Tomb,* lead ampulla, Monza, Cathedral Treasury

109. *Baptism,* gold medallion, Washington, D.C., Dumbarton Oaks

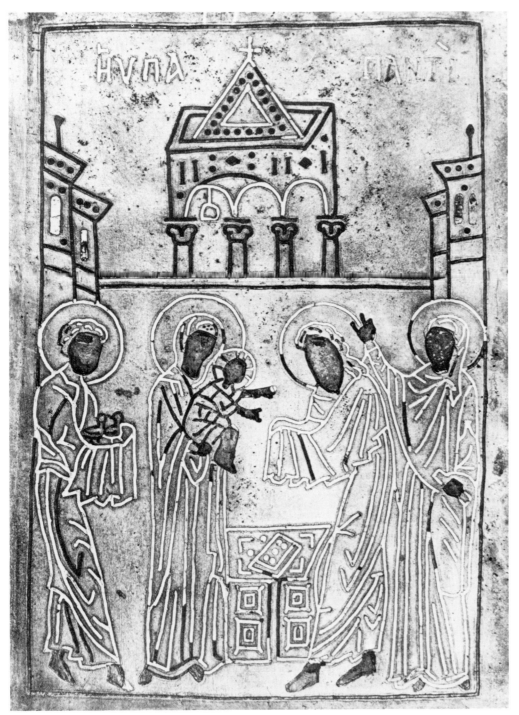

110. *Presentation of Christ*, bronze door panel, Rome, San Paolo fuori le mura

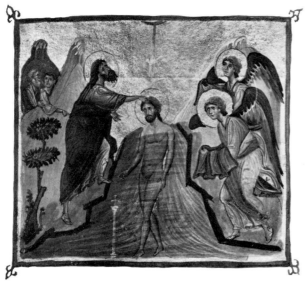

111. *Baptism,* Mt. Athos, Dionysiou monastery, cod. 587, fol. 141v

112. *Calling of Peter and Andrew,* Venice, San Giorgio dei Greci, Gospel lectionary, fol. 63r

113. *Transfiguration,* Mt. Athos, Dionysiou monastery, cod. 587, fol. 161v

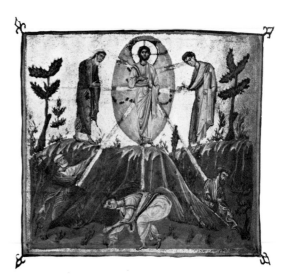

114. *Feeding of the Multitude,* Vienna, National Library, cod. theol. gr. 154, fol. 238r

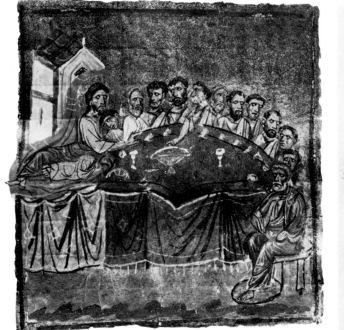

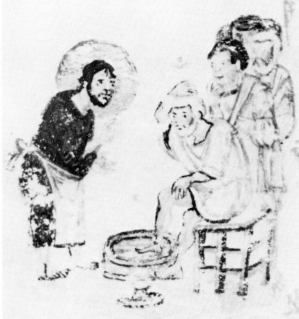

115. *Last Supper,* Athens, National Library, cod. 93, fol. 135r

116. *Washing of the Feet,* Moscow, Historical Museum, cod. add. gr. 129, fol. 40v

117. *Crucifixion,* mosaic, Hosios Lukas

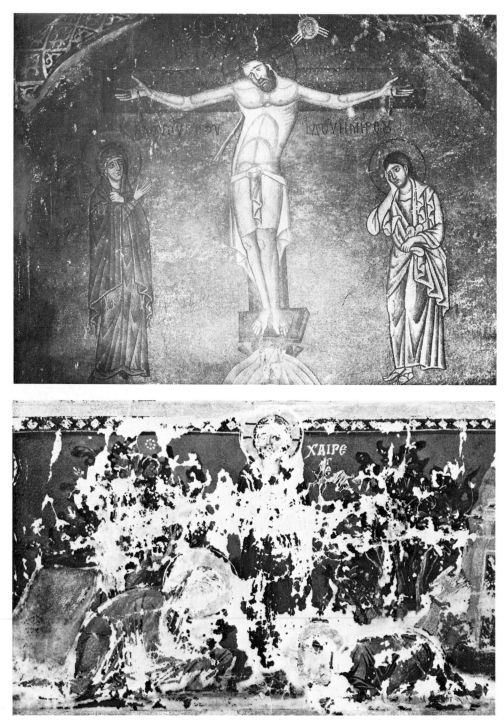

118. *Christ Appears to the Two Marys,* Paris, Bibliothèque nationale, cod. gr. 510, fol. 30v

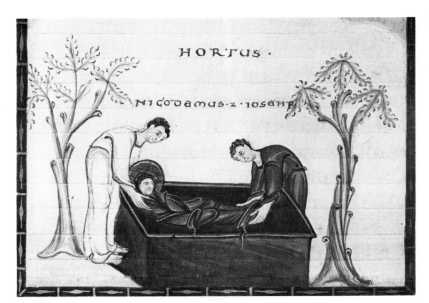

119. *Entombment*, Trier, Stadtbibliothek, cod. 24, fol. 30v

120. *Entombment*, fresco, Sant'Angelo in Formis

121. *De sepulchro,* Monte
Cassino, Monastery
Library, cod. 132, p.
367

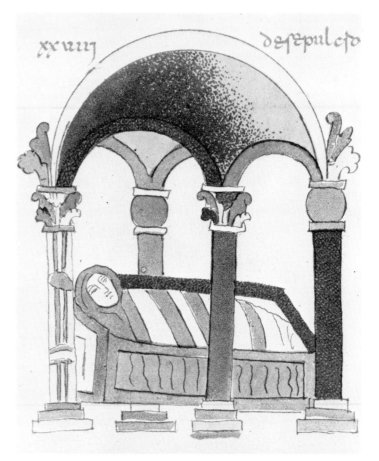

122. *Anastasis,* fresco,
Cimitile, Santi
Martiri

123. *Incredulity of Thomas,* fresco, Sant'Angelo in Formis

124. *Peter Dictating the Gospel to Mark,* ivory plaque, London, Victoria and Albert Museum

125. *Deesis,* ivory plaque,
Würzburg, University
Library

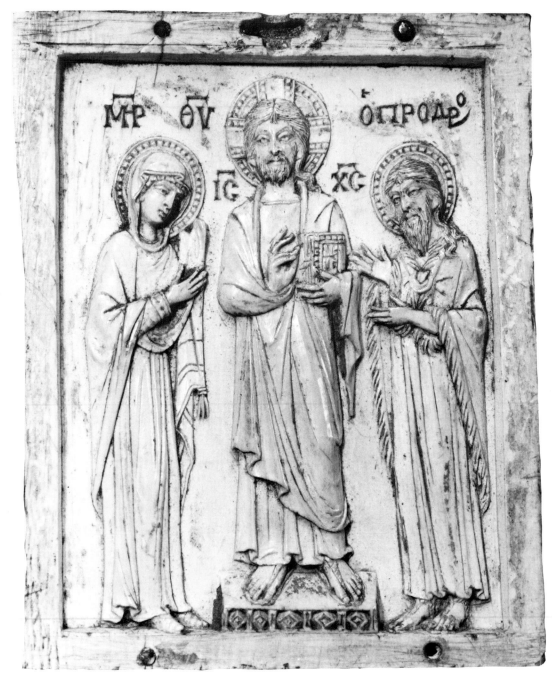

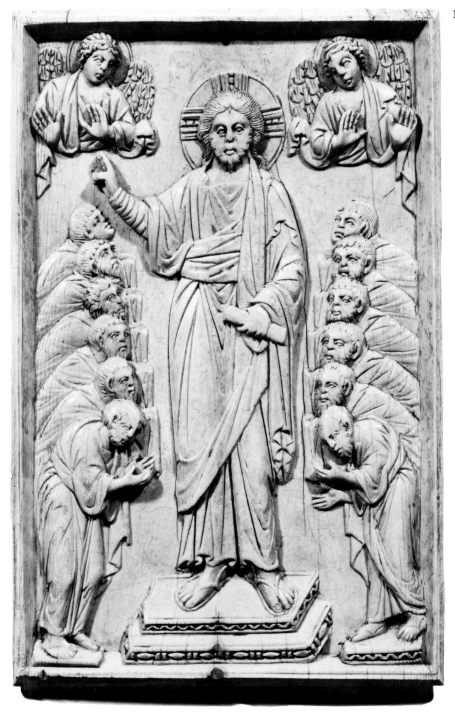

126. *Mission of the Apostles,* ivory plaque, Paris, Louvre

127. *Crucifixion,* ivory plaque, Berlin-Dahlem, Staatliche Museen, Preussischer Kulturbesitz

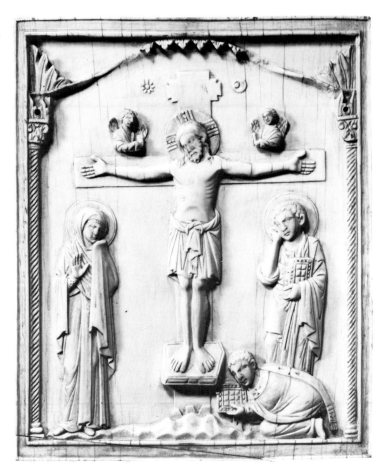

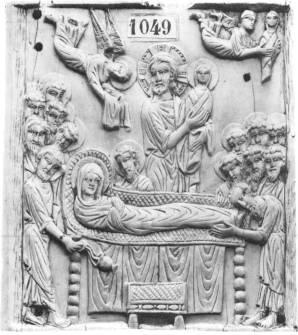

128. *Dormition of the Virgin,* ivory plaque, Paris, Musée Cluny

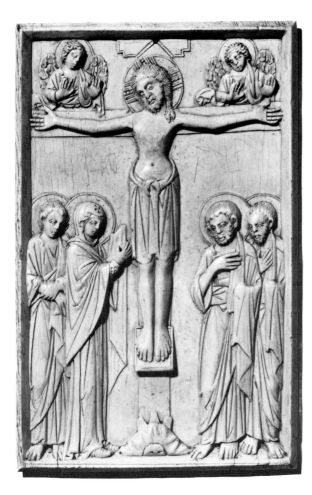

129. *Crucifixion,* ivory plaque, Paris, Louvre

130. *St. John the Baptist,* fresco, Calvi Risorta, Grotta dei Santi

131. *Crucifixion*, Rome,
Biblioteca Casanatense,
Benedictio fontis,
picture 9

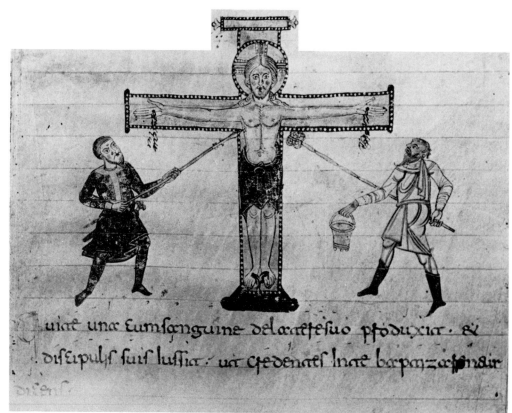

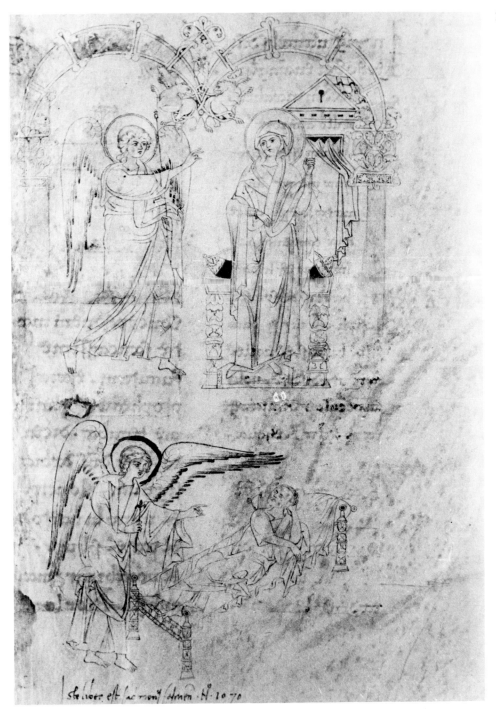

132. *Annunciation*, Monte Cassino, Monastery Library, cod. 99, p. 5

133. *Incredulity of Thomas,* relief, Silos, Santo Domingo (cloister)

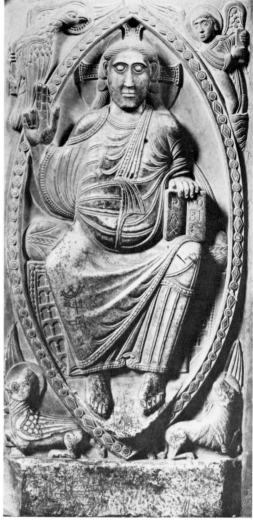

134. *Christ in Majesty,* relief, Toulouse, St. Sernin (ambulatory)

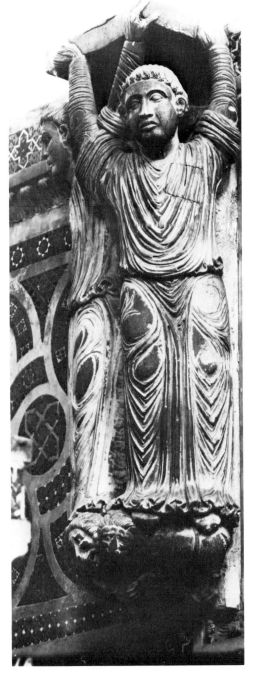

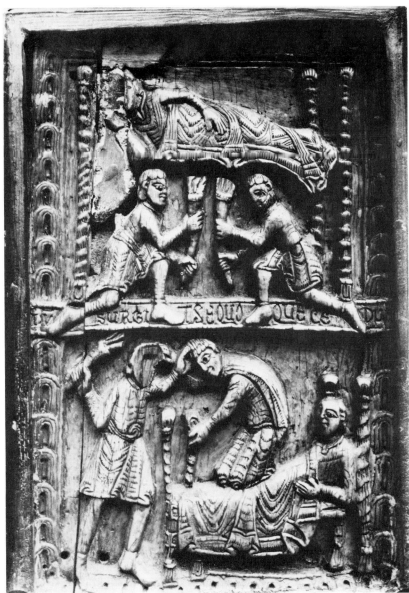

135. Evangelist figure, from the large pulpit, Salerno, Cathedral

136. Scenes from the life of St. Aemilianus, ivory plaque, San Millan de la Cogolla (Shrine of St. Aemilianus)

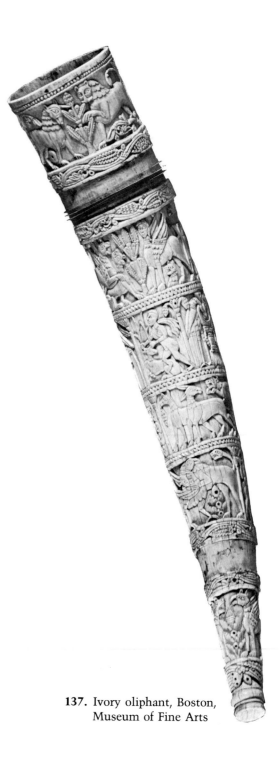

137. Ivory oliphant, Boston, Museum of Fine Arts

138. Islamic ivory casket (side and end views), New York, Metropolitan Museum of Art

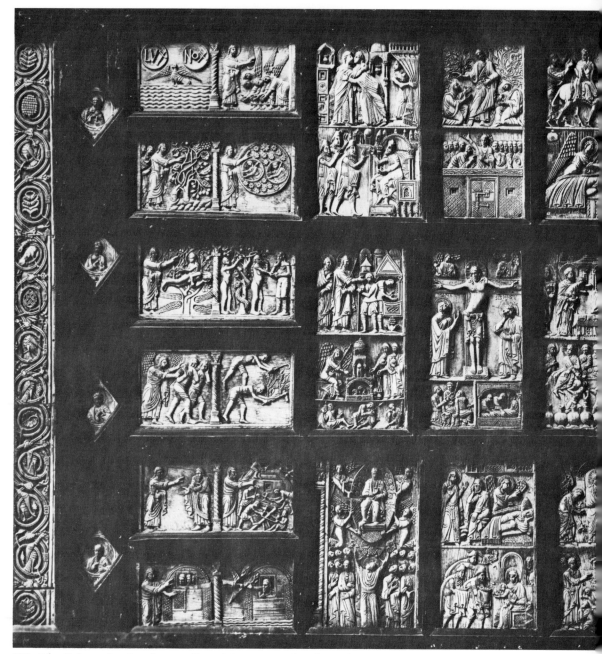

139. The Salerno ivories, former disposition on an altar frontal

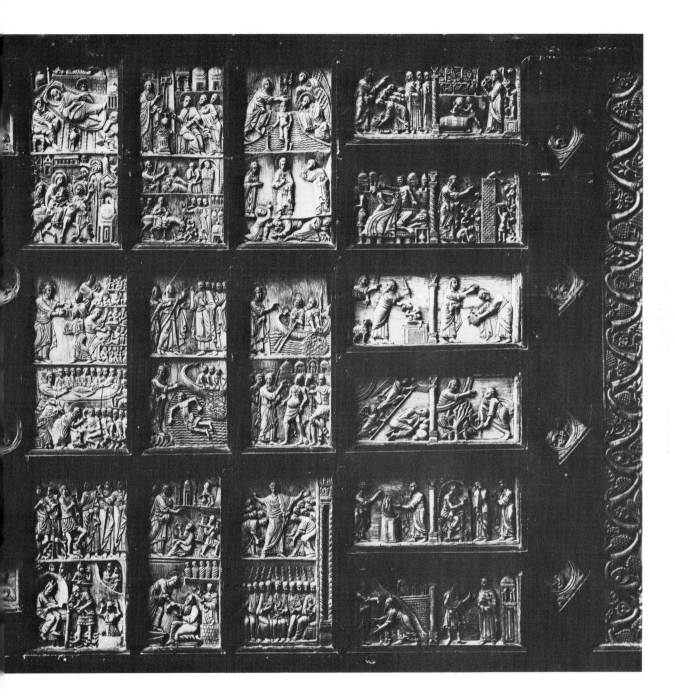

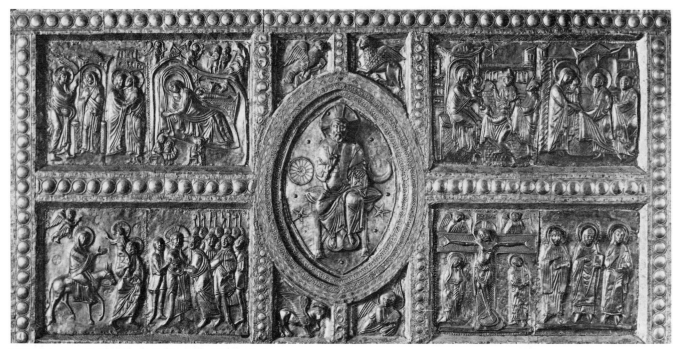

140. Antependium, Cittá di Castello, Cathedral

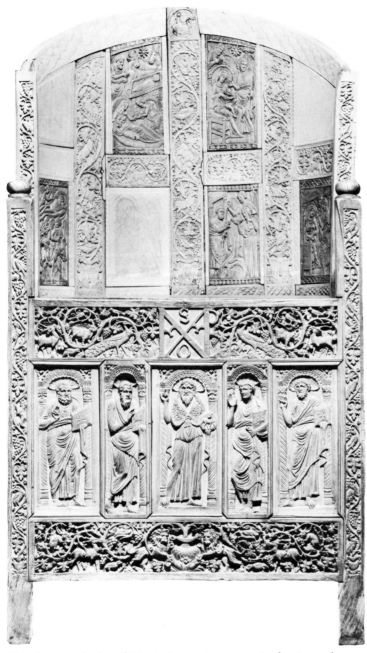

141. Ivory cathedra of Maximianus, Ravenna, Archepiscopal Museum

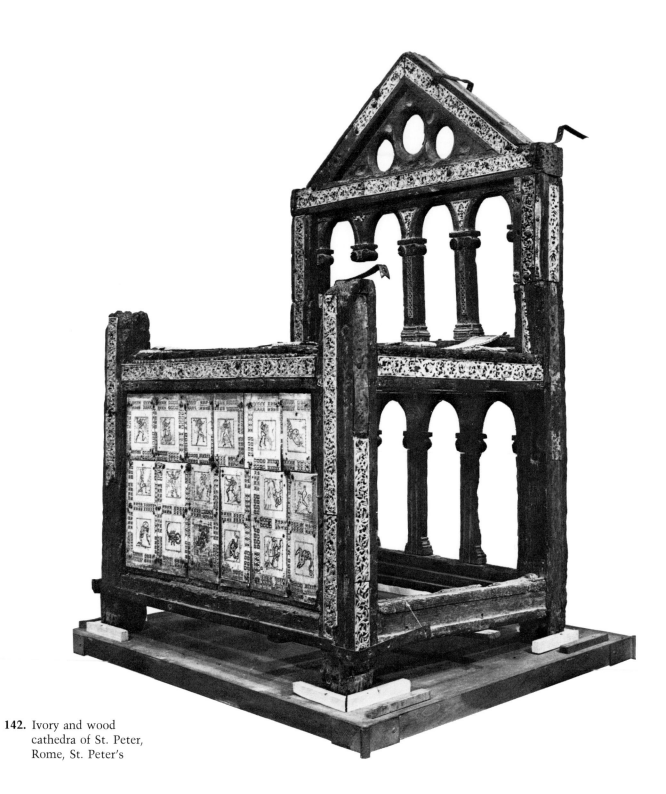

142. Ivory and wood
cathedra of St. Peter,
Rome, St. Peter's

143. Ivory reliquary urn, reconstruction proposal of A. Carucci (panels with an X are in museums outside Salerno; those with two X's are assumed lost)

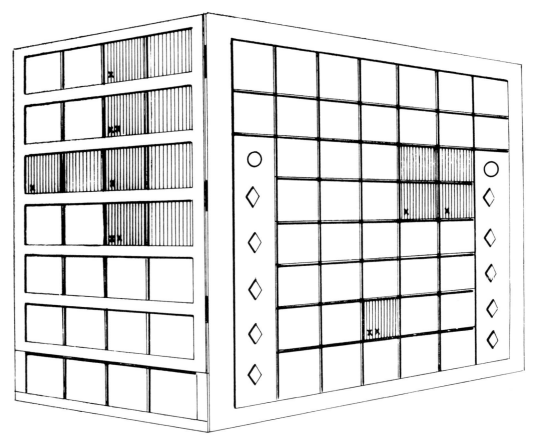

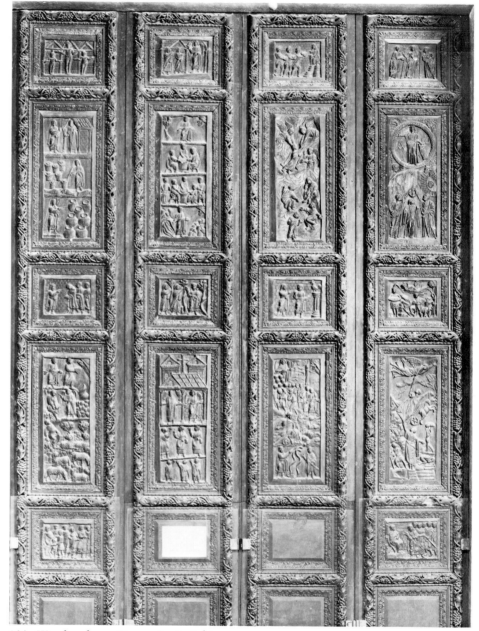

144. Wooden doors, Rome, Santa Sabina

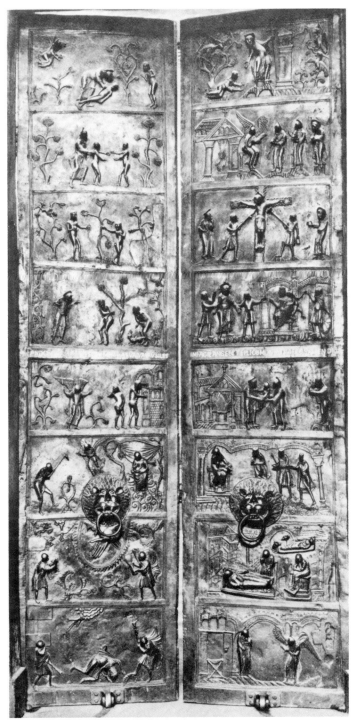

145. Bronze doors, Hildesheim, St. Michael's

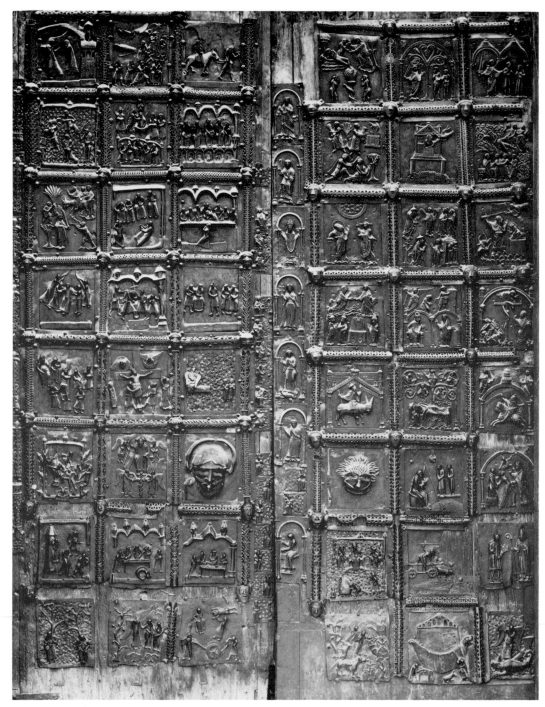

146. Bronze doors, Verona, San Zeno

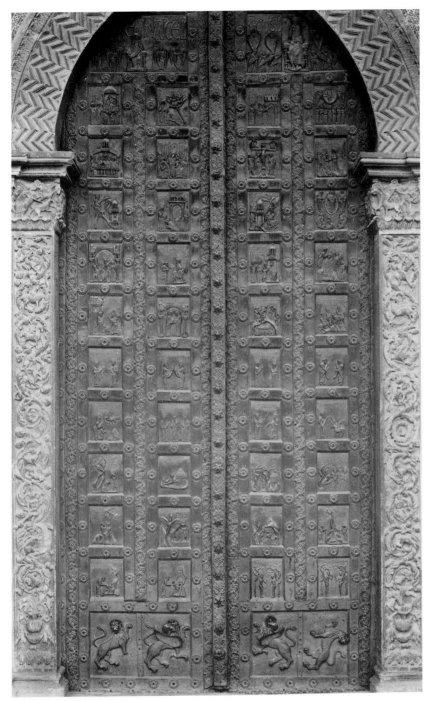

147. Bronze doors, Monreale, Cathedral

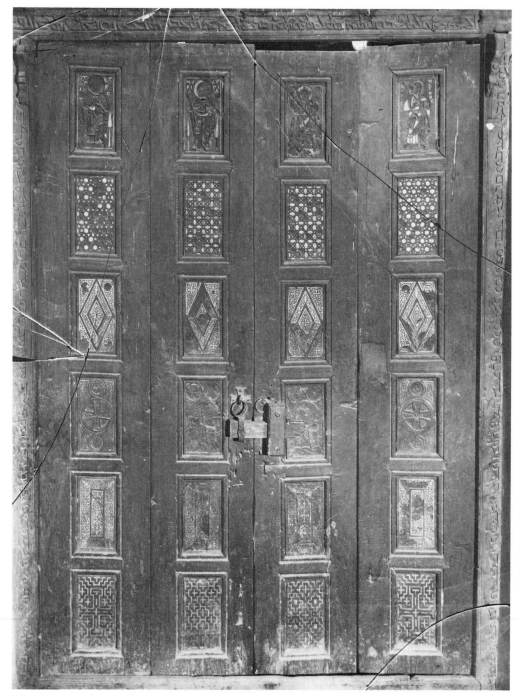

148. Ebony and ivory doors, Der es Suryan, Church of El 'Adra

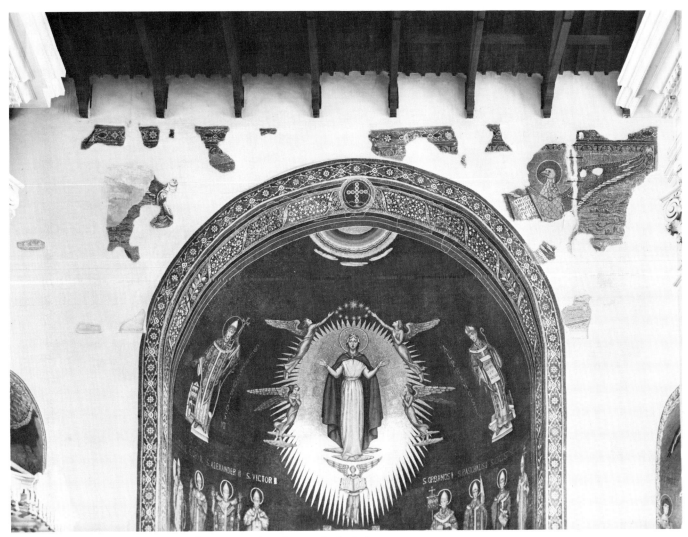

149. Evangelist symbols, mosaic (fragmentary), Salerno, Cathedral

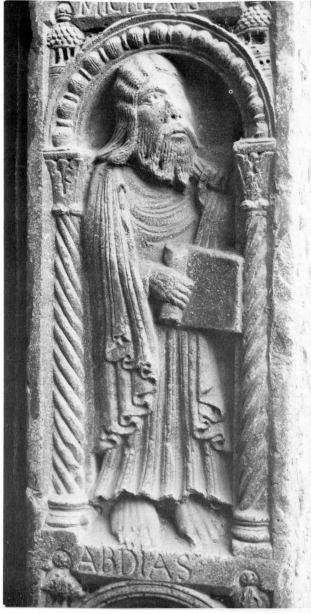

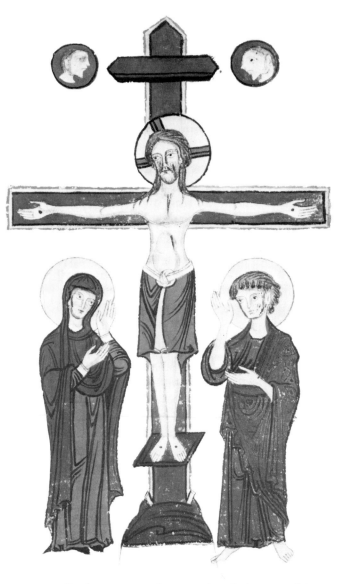

151. *Crucifixion*, Vatican Library, cod. Urb. lat. 585, fol. 257v

150. *The Prophet Micah*, relief, Modena, Cathedral (façade)

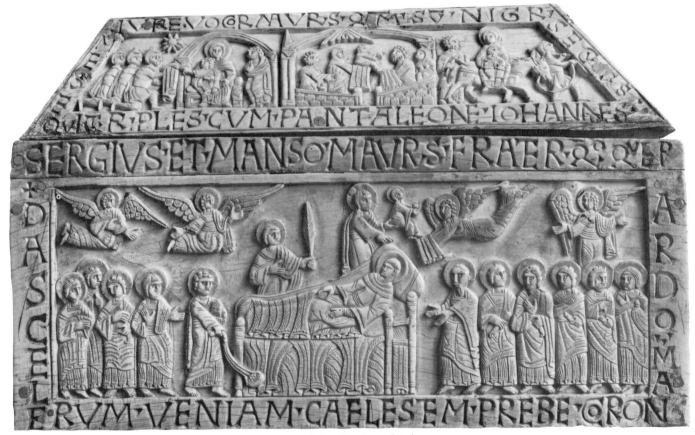

152. Ivory casket, Farfa, Abbey Treasury: *Dormition of the Virgin* and Infancy scenes

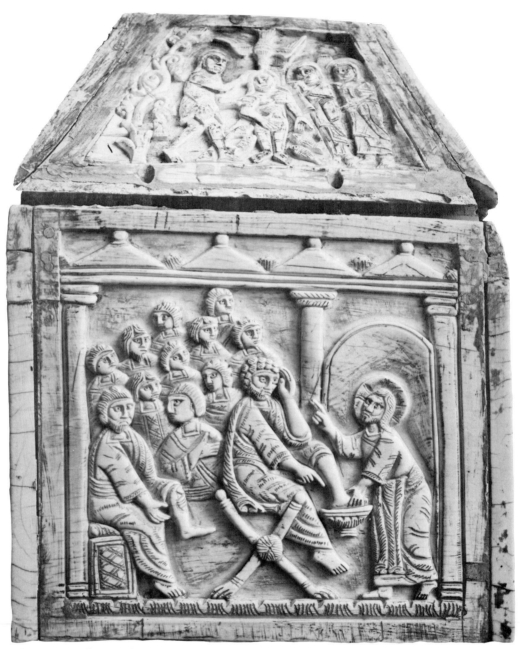

153. Ivory casket, Farfa, Abbey Treasury: *Washing of the Feet* and *Baptism*

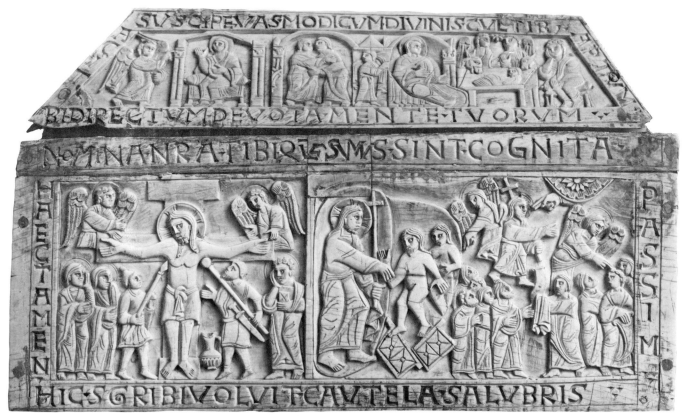

154. Ivory casket, Farfa, Abbey Treasury: Passion and Infancy scenes

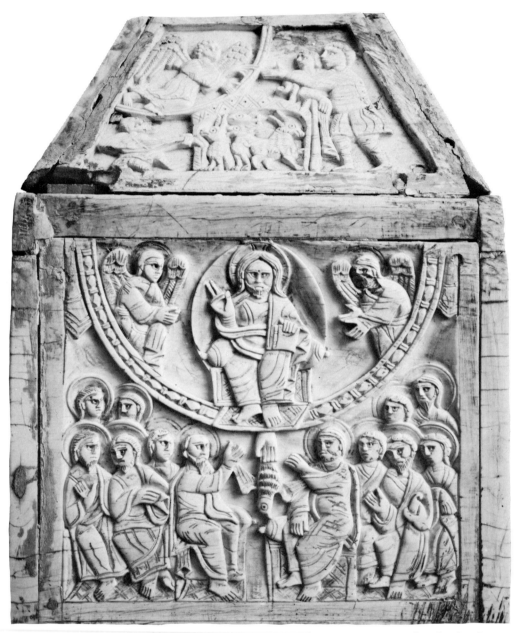

155. Ivory casket, Farfa, Abbey Treasury: *Pentecost* and *Annunciation to the Shepherds*

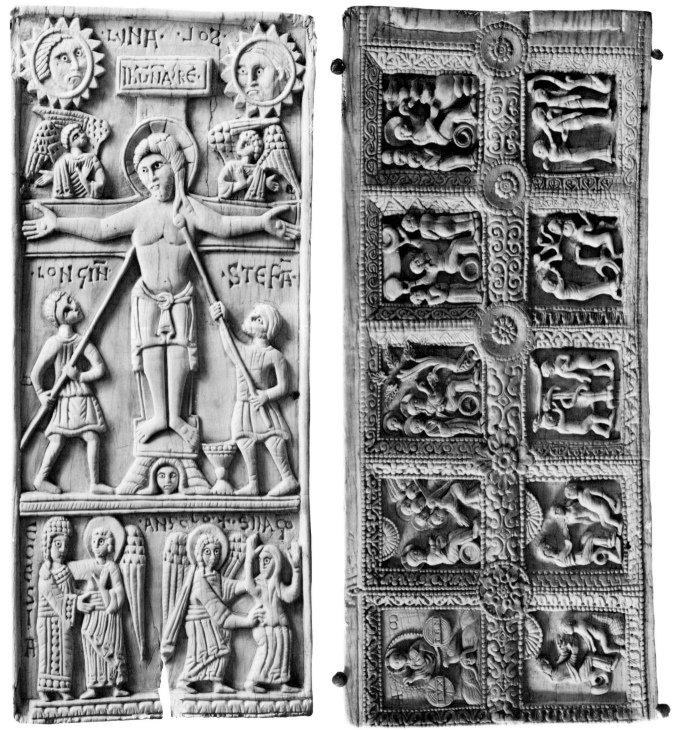

156. *Crucifixion*, ivory plaque (front), Berlin-Dahlem, Staatliche Museen, Preussischer Kulturbesitz

157. Genesis scenes, ivory plaque (rear), Berlin-Dahlem, Staatliche Museen, Preussischer Kulturbesitz

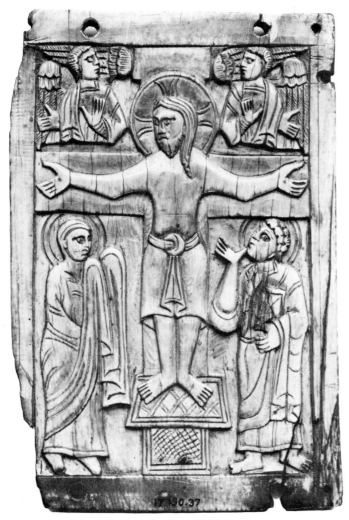

158. *Crucifixion*, ivory plaque, New York, Metropolitan Museum of Art

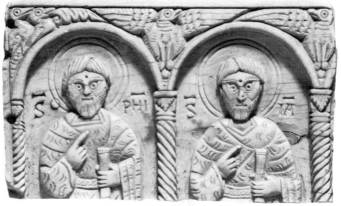

159. *Saints Philip and James*, ivory plaque, New York, Rabenou Collection

160. Two saints, ivory plaque, formerly in New York, Demotte Collection, present location unknown

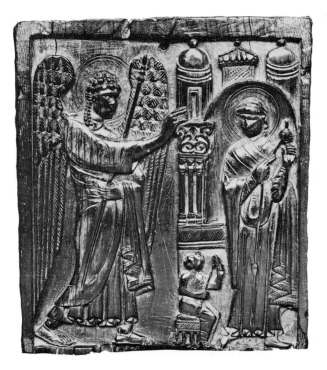

161. *Annunciation,* ivory plaque, formerly in Mannheim, Engelhorn Collection, present location unknown

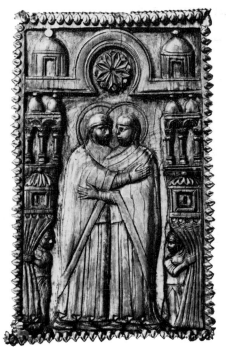

162. *Visitation,* ivory plaque, Leningrad, State Hermitage

163. *Joseph's Dream*, ivory plaque, Rouen, Musée des Antiquités

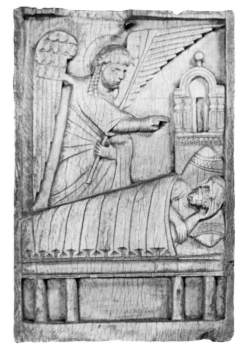

164. *Journey to Bethlehem*, ivory plaque, Cleveland, Museum of Art

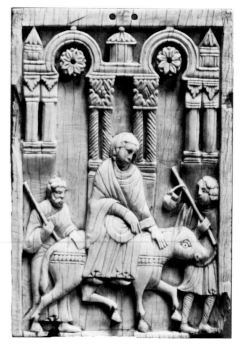

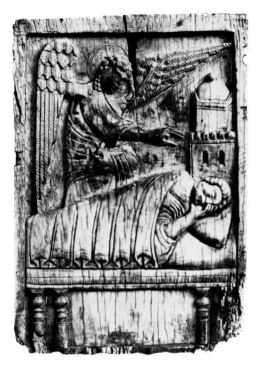

165. *Joseph's Dream*, ivory
plaque, London,
Victoria and Albert
Museum

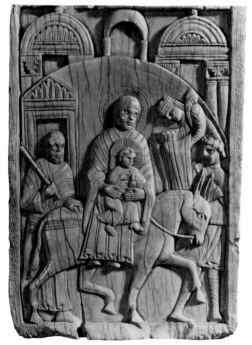

166. *Flight into Egypt*, ivory
plaque, Bologna,
Museo civico

167. *Adoration of the Magi,* ivory plaque, Frederikssund, Denmark, J. F. Willumsens Museum

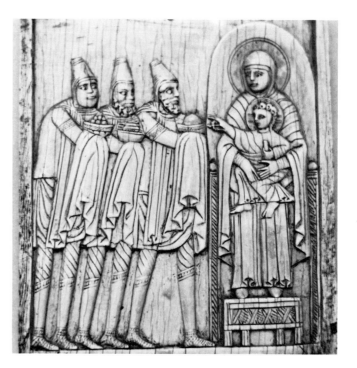

168. *Presentation,* ivory plaque, London, Victoria and Albert Museum

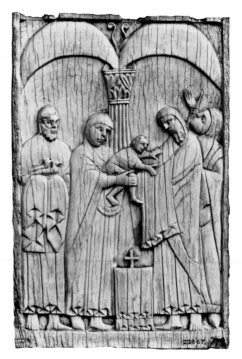

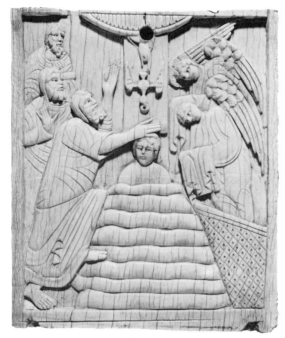

169. *Baptism,* ivory plaque, Lugano, Thyssen-Bornemisza Collection

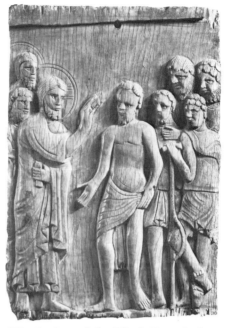

170. *Healing of the Blind, Dropsical, and Lame,* ivory plaque, Boston, Museum of Fine Arts

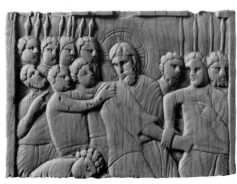

171. *Arrest of Christ,* ivory plaque fragment), Berlin-Dahlem, Staatliche Museen, Preussischer Kulturbesitz

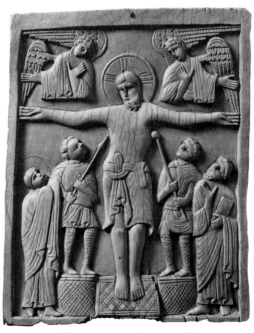

172. *Crucifixion,* ivory plaque, Berlin-Dahlem, Staatliche Museen, Preussischer Kulturbesitz

173. *Crucifixion* and *The Marys at the Tomb,* ivory plaque, Paris, Louvre

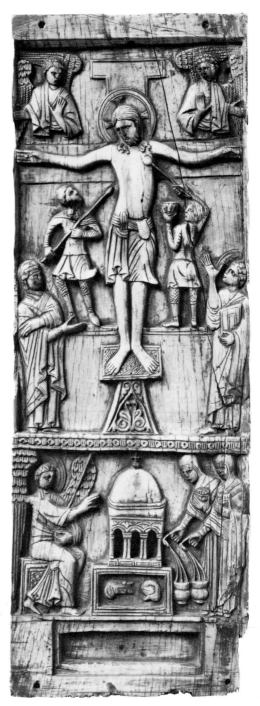

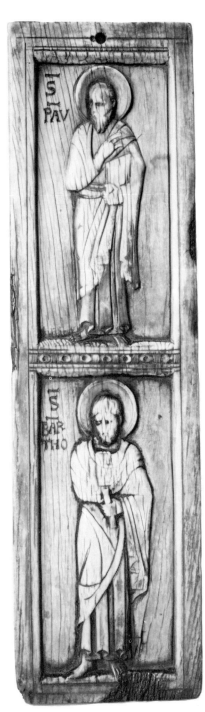

174. *Saints Paul and Bartholomew,* ivory plaque, Paris, Louvre

175. *Crucifixion* and *Entombment,* ivory plaque, New York, Metropolitan Museum of Art

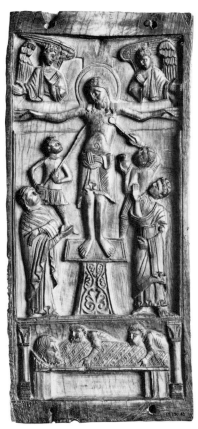

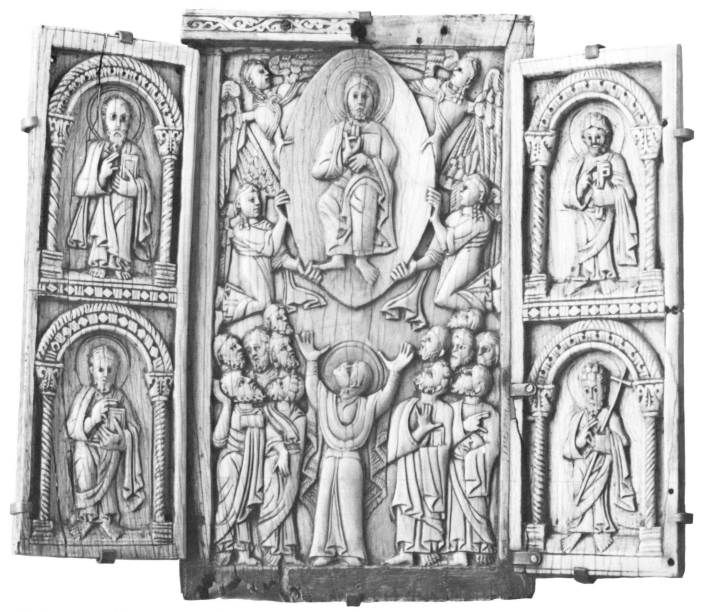

176. *Ascension* and four saints, ivory plaque, Paris, Louvre

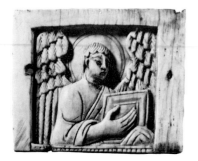

177 and 178. Symbols of St. Matthew (left) and St. John (right), ivory plaques, (fragments), Leningrad, State Hermitage

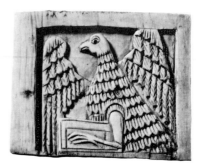

INDEX

Acts of the Apostles, 48

Admonitio synodalis, 100–101

Aelfric's paraphrase of the Heptateuch. *See* London, British Library, cod. Cotton Claudius B, VI

Alfanus I, archbishop of Salerno, 10, 93, 116

Amalfi: Cathedral, 87n34, 91n59, 102; origin of ivories in, 90–91; history and character of, Chap. 5 passim; trade and colonies of, 112–115; school of ivory carving in, 120–121

Amatus of Monte Cassino, 114

Antependium: reconstruction of Salerno ivories as, 92–93, Fig. 139; in Sant'Ambrogio, Milan, 93; in Città di Castello, 93

Antwerp, Plantin-Moretus Museum, cod. M.17.4 (Sedulius, *Carmen* paschale), 37n127

Apamea, Museum, coin, 27

Apostle busts from the Salerno ivories, 91, 127, Figs. 40–41

Arechis I, duke of Benevento, 109

Assisi, San Francesco, frescoes, 8

Athens, National Library, cod. gr. 93 (Gospels), 68, Fig. 115 (*Last Supper*), 70n112 (*Christ and the Samaritan Woman*)

Athos. *See* Mount Athos

Atina, Cathedral, frescoes, 7

Augsburg, Cathedral, bronze doors, 41

Augustine, St., 3

Bamberg, Staatliche Bibliothek, cod. msc. Bibl. 1 (A.1.5) (Bamberg Bible), 13n6

Bari: Cathedral archives, Exultet Roll, 19; San Nicola, sculpture, 76

Barisanus of Trani, 103

Becherucci, Luisa, 89, 93

Berlin, Staatsbibliothek, cod. gr. qu. 66 (Gospels), 70n112 (*Entry into Jerusalem*)

Berlin-Dahlem, Staatliche Museen, Preussischer Kulturbesitz: ivory plaque (*God and Abraham at an Altar*), 1, 34–35, 45, Fig. 15; ivory plaque (*Christ at Emmaus*), 1, 51, 54, 73, 74, 86, Fig. 36; ivory plaque (*Crucifixion-Genesis* scenes), 14, 15, 16, 21, 43, 130–131, Figs. 156–157; ivory plaque (*Resurrection of Lazarus*), 58, Fig. 101; bronze plaque (*Flight into Egypt*), 61; ivory plaque (*Washing of the Feet*), 69; ivory plaque (*Crucifixion*), 80, Fig. 127; ivory plaque (*Crucifixion*), 82, fig. 156; ivory plaque (*Arrest of Christ*), 141, Fig. 171; ivory plaque (*Crucifixion*), 141–142, Fig. 172

Bernward Gospels. *See* Hildesheim, Cathedral, Gospels of Bernward

Bertaux, Émile, 49, 93

Biblia pauperum, 3

Bible of Guyart Desmoulins. *See* London, British Library, cod. Harley 4381–4382

Biscop, Benedict, 46

Bloch, Herbert, 88

Bologna, Ferdinando, 76–77, 89, 94

Bologna, Museo Civico, ivory plaque (*Flight into Egypt*), 137–138, Fig. 166

Bonanus of Pisa, 103

Border plaques from the Salerno ivories, 87n34, 127–128, Figs. 41–43

Boston, Museum of Fine Arts: ivory oliphant, 89, Fig. 137, ivory plaque (*Healing of the Dropsical, Blind, and Lame*), 140, Fig. 170

Bruno of Segni, 4

Budapest, Museum of Fine Arts, ivory plaque (*Creation of the Birds and Fish*), 1, 19, 122, Fig. 4a

Byzantine bronze doors of southern Italy, 108n75, 113

Caedmon, poems of. *See* Oxford, Bodleian Library, cod. Junius 11

Calvi, Grotto of the Saints, frescoes, 19, 82, Fig. 130

Cambridge, Eng., St. John's College Library, cod. K21, 70n112 (*Christ Appears at Bethany*)

Campanian sculpture, 87

Carucci, Arturo, 32, 38, 121; reliquary-urn theory, 100–102

Castel Castagna, Santa Maria di Ronzano, frescoes, 7

Castro dei Volsci, San Nicola, frescoes, 7, 14n14

Cava dei Tirreni, Abbey of Santa Trinità, 99

Cavallini, Pietro, 6, 13, 44

Chloudoff Psalter. *See* Moscow, Historical Museum, cod. add. gr. 129

Cimitile, Santi Martiri: frescoes, 72, Fig. 102 (*Incredulity of Thomas*), 73, Fig. 122 (*Anastasis*), 80; marble pilaster, 83n34

263